1977

In Memory of

Phillip N. Parker

Diary of an Artist

Diary
of an Artist

Raphael Soyer

New Republic Books

Washington, D.C.

Published in the United States of America in 1977
by New Republic Books
1220 Nineteenth St., N.W.
Washington, D.C. 20036

Portions of this book have been published as *A Painter's Pilgrimage, Homage to Thomas Eakins, Etc.,* and *Self-Revealment.*

Library of Congress Cataloging in Publication Data

Soyer, Raphael, 1899-
 Diary of an artist.

 1. Soyer, Raphael, 1899- 2. Painters—United
States—Biography. I. Title.
ND237.S636A226 759.13 [B] 77-4798
ISBN 0-915220-29-6
ISBN 0-915220-33-4 (deluxe edition)

Trade distribution by Simon and Schuster
A Division of Gulf & Western Corporation
New York, New York 10020
Order No. 0-671-22965-6
Order No. 0-671-22966-4 (deluxe edition)

Printed in the United States of America

*Dedicated to Mary Soyer Lieber and her children
David, Joseph, and Katherine*

*Without the help of my wife, Rebecca,
this book could not have been written*

Contents

Illustrations

Preface

When I was young people would stop me and crudely say: "What's the matter with you, Soyer? You look terrible!" Now that what's left on my hair is white, I am greeted with a "Mary Hartman"-like exclamation: "You look wonderful!"

I am aware of my age when people ask the invariable question: "Are you still working?" I am puzzled by this. When I mentioned it to Marchette Chute, she said, "It's like asking you are you still breathing." I work without ever thinking that some day I would stop. No matter what was going on around me, I always worked. I remember—like a dream, it was so long ago—a room in the art school of the National Academy. I was painting. Only the model and I were in the room. From far away came sounds of celebration. It was Armistice Day, November 11, 1918—and I was painting!

And again: War had just been declared after the attack on Pearl Harbor. The sky light in my studio was blacked out. Two young men already in uniform came in and exclaimed in disbelief: "Look, there's a war on and he's painting!" Another occasion: I had an exhibition, and nothing was sold. My vivid memory of that time is of a sense of embarrassment and a feeling that my paintings were of no value. We were in great financial need, and when someone offered to buy the contents of my studio—drawings and paintings, all for $1000 plus an old Packard—I consented. Two men came with a pushcart, and while they were loading my work, I was painting.

All my adult life I have made painting my livelihood, working at it as a matter of routine from morning until light failed. I have had no hobbies, but periodically, since childhood, I have had a desire to write. It would flare up at intervals, and I would be impelled to begin a diary, keep it going for months and destroy it. One such diary I started and destroyed in the 1940s when I was painting a series of portraits of artists, many of whom have since passed away. What wouldn't I give to

have this diary now—the conversations with and descriptions of Stella, Marsh, Sloan, Gorki, Weber, Hartley.

It seems to me that for artists writing is closely related to, and is an extension of, their work. The aphorisms of Michelangelo and Degas, the letters of Van Gogh and Pissarro, the diaries of Delacroix and Gauguin are remembered and read. They are of great interest, for in them the artists try to explain themselves and their art and to make sense of the phenomenon of art.

One day while Van Wyck Brooks was posing for me, I mentioned that I was writing a journal. He eagerly said: "Let me see it. I like to read what artists write." I later published that book as *A Painter's Pilgrimage*. It was followed by *Homage to Thomas Eakins, Etc.* and *Self-Revealment*. All are collected here, with other things I have written since.

What I said in the Foreword to that first book seems appropriate here too. "This is not a world-shaking document; it was not meant to be—it is an expression of one artist's view on art. It is more or less spontaneous, for it was not really planned. It is haphazard . . . personal . . . intimate . . . not to . . . I hope . . . that's it."

New York City RAPHAEL SOYER
January 1977

Publisher's Note

These are the intimate diaries of an artist. They are not the secret or—as false modernity demands of anyone claiming to tell his deeper truths—the tortured confessions of a sordid life. What Raphael Soyer has done, in fact, is to demystify the special exultations and discouragements of creative work. Which is to say that he has made them more accessible, more pertinent, more real. There is an intimacy that does not intrude on the private and yet has absolutely nothing public about it. This is Soyer's intimacy. He has written these journal entries to himself and, it would appear, to just one other reader. Pick up this book, and it is you who are his friend, you who are privy to his perceptions (and anxieties) about artistic immortality.

These diaries cover, just barely, the last two decades. But they also evoke—with memories that are at once discriminate and spontaneous—his childhood in Russia, his student days, his associations with other artists, the forgotten ones and the permanently remembered. Soyer has lived longer than the century, lived it full, lived it observing, lived it ever responsive to the passions and excitements of newer generations. No other artist—to be sure most artists these days communicate more obscurely in words than they do in images—has a greater sense of the collegiality of his vocation. Soyer admits you to the circle of his peers, much as Delacroix, whose words were also as direct as his images, might have done. And since Soyer's circle encompasses the past as well, his visits to the choice museums and collections become the reader's own. He is not reticent with his meticulous discernments and the rush of ecstasy that carry him yet again to his sketchbook.

With hardly a doubt, Raphael Soyer is the great realist artist of our time. But his art has never been subject to placard slogans. If he has a fault, it is a fault that compensates somewhat for the harshnesses of

the age: He will find and depict in a person that which is gentle, however slender. All of this can be seen in the illustrations in these pages: the mellow decency of his own eyes in the faces of others. His traditions are those of the painters he loves—Rembrandt, Vermeer, Degas, Eakins. If he refuses the shallowness of sheer geometric design or tinsel-glare color, he is nonetheless a contemporary artist, an artist confident of the judgment of the future, an artist of life.

MARTIN PERETZ

Diary of an Artist

A Pilgrimage to Europe, 1961

May 15, 1961

It is a little over an hour now that I am in the jet bound for London. Over the loudspeaker the invisible captain called our attention to icebergs below. I can spot them way down through rents of the clouds. They look like jagged white marbles. Flying in the jet is not as smooth as I was led to believe. Vibration and motor noise are constant. It may be so because I am sitting in the back.

It is 12:30 now. Four more hours to go. For fifty cents I am served a scotch and soda.

A week ago Monday I finished a small painting of a reclining nude, cleaned my palette and brushes, and put my studio in order. I closed shop, so to speak. The six days that followed were slow and tedious. Sleep became nightmarish. I was tormented by fears of flying across the Atlantic and of the impending loneliness (Rebecca will not join me for a month) which I knew would not be dispelled by visits to the many European museums.

Well, here I am in the jet anyway, above the clouds, sipping my second scotch and soda; a lot of conversation is going on, but I have not as yet had the opportunity or the inclination to say "boo" to anybody.

Long ago, this morning to be exact, my wife Rebecca, my daughter Mary, and my son-in-law Arnie accompanied me to Idlewild in Mary and Arnie's Volkswagen. Mary and Arnie had to leave soon for work. Rebecca, of course, stayed till I entered the jet. I shall meet them all in Paris.

One more hour to London. Time does pass. Am beginning to have faith in the jet. It is an honest, powerful, dependable machine. Above is a deep blue sky, below is a thick blanket of lavender clouds, and below the clouds I guess is the Atlantic.

London, May 16

Called up an acquaintance from New York, the art dealer Julius Weitzner, whose daughter once painted in my studio under my supervision, telling him that I am in London. He promptly invited me to dinner Friday, May 19.

My first full day in London was spent in the National Gallery. The collection will grow upon me from day to day. What is there left to say about Rembrandt any more? One can only sit in long and deep contemplation in front of the three portraits of old men, the one of himself in the center.

Van Eyck's "Giovanni Arnolfini and His Wife" is abstract, stark and opaque. Compared to it, Vermeer is pure genre and Holbein's "Ambassadors" glow with life. It is lusterless, sparkless, devoid of "flesh tones." The highlights are suppressed. The man with his ashen face, the doll-like wife and toy-like dog are inanimate. The gestures frozen. All is still and airless.

May 17

Last night I called the young English painter J. B. Bratby (I saw an exhibition of his work in New York—was impressed by it—vital, free, nonconforming), and told the woman who answered that I am a New York painter, that I am acquainted with his work, and that I would like to meet him. The woman asked me to hold on, and soon her shyly excited voice was saying, "Mr. Bratby said he is interested in New York and would like you to come." "When may I come?" I asked. "Any time. Mr. Bratby never goes out, he always works."

This morning when I got into the taxi the driver anxiously told me that Bratby's address is on the outskirts of London, that the fare would amount to a considerable sum, and in the nice helpful British way advised me that I would do better to go by train. When we got to the gate of Bratby's house I made an arrangement with this man to call for me in an hour. A short stocky young woman with wide open blue or gray eyes, red nose, disheveled hair opened the gate. Her legs were stockingless and varicose-veined. She greeted my shyly and I didn't see her again. Two boys were about, one a four-year-old, the other a barelegged blond toddler. Both were lightly clad, although it was quite raw.

Then Bratby came out, bearded but very young-looking, his even, pale complexion accentuated by red lips, small brown eyes behind thick, horn-rimmed glasses, high forehead with long, soft dark brown hair. The part of his face above his eyes, just forehead and hair, which he is already beginning to lose, made me think of Cézanne's self-portraits. He brought out chairs and we sat down; the sun reappeared from behind the clouds every now and then. Bratby began to ask about New York—the art situation, galleries, etc. He told me that he paints all the time, that he has a problem—that of overproduction—an unusual thing in Great Britain where preciousness and sterility in art are traditional.

Although he sells a great deal and at the moment is well off, in fact very well off, especially considering that he is only thirty-two, he would want to create "another market" for his work, a "New York market," since Great Britain cannot absorb all his paintings. The amount of work he can put out is "preposterous." His studios—there are a few on the premises—are filled with as yet unsold paintings and drawings.

For the present he has decided to refrain from painting except for a portrait commission now and then (on the way out he called my attention to such a portrait hanging on a wall—a striking full-length one of a man), and to write novels instead. One novel, *Breakdown,* if I remember the title correctly, has already been published, he said. He has by now written five novels. "They will all be published." When he smiled his white even teeth showed; he looked very young and at moments kind of idiotic. When he listened, or was thoughtful, his face would age, shrink, its expression withdraw, the eyes would close and almost disappear behind the thick glasses, and with his high forehead and beard he would bring to mind a character out of Russian literature.

Eventually we entered one of his studios; it was stacked with paintings, some huge. The "small ones" also were quite large. Something about his work, too, looked Russian to me—some of the faces he painted and the manner of painting brought Burliuk and Grigorief to mind. I mentioned the name of Burliuk to him, saying, "He sometimes paints as thickly as you," but he had never heard of him. I recognized some paintings that had been displayed in New York. He painted them a few years ago. "How do you compose these huge paintings? Do you make preliminary sketches for them?" I asked. "No, he said. "I start with one figure, anywhere on the fresh canvas, then add another and another, etc., without any coherence. At one time I painted everything I saw before me, the model, the objects, the

3

furniture, my own feet on the floor, my painting hand, without composing, in disorder, in fact."

"You're thirty-two now. You'll probably change as you go on," I said, "in your point of view, your state of mind, in technique." "No," he answered emphatically, "I'll always paint like this. I once made an attempt to change but with unsatisfactory results."

He paints very rapidly—the "small" paintings one a day. "My goodness!" I exclaimed. "Think what your output would be in, say, thirty more years of painting." "Yes, preposterous," he said, and smiled his childish and idiotic smile. In the center of the studio was a big billiard table, occupying most of the space. "This was recently brought in," he said, pointing to it. "I paint in my other studios." The green-covered table with its many balls has already been depicted in many of his recent canvases. He seems to be a Brigitte Bardot fan—for one of the walls in the studio was covered with pictures of her cut from newspapers and magazines.

When the taxi man called for me I expressed a desire to come to see him again. I told him that I would like to sketch him. "Sure," he said, "any time. I always work, I never leave this place. I never go anywhere."

May 18

Am spending most of my time in the National Gallery. Rembrandt's brooding old man in the armchair with his head leaning on his arm is, to me, one of the most satisfying paintings in the world. The deep harmony of browns and reds and still darker browns that border upon black is truly symphonic.

I was never too fond of Rubens. But today something impelled me to open my sketchbook and draw the beggars of his painting, "St. Bavo," the two big-boned heavy women, each with an infant strapped to her back, each with more babies sucking her breasts and swarming about, stretching her naked fleshy arms for alms. I felt as if a veil fell off my eyes and Rubens's genius revealed itself to me. No gesture, no movement of body, no facial expression was foreign to him. How he expressed the vitality of the flesh, the quivering of muscle, the fierceness with which the clothes accentuate the free and shameless movements of these female bodies, the folds of these stinking rags, kerchiefs, swaddling clothes, the lust for alms, for mother's milk, for life!

In "The Rape of the Sabine Women," lusty, brown men pull, grab, lift the big, pliant, white, bare-bosomed, bare-legged women. These is a wonderful sense of commotion, yelling, squealing, noise—in short a sense of "sound effect" in this painting. No abstracting, tentativeness, "leaving things to the imagination of the onlooker" for Rubens. How he sinned against aesthetics! How tangibly he depicted everything living at its most fecund moment—man, beast, earth. In "Chateau de Steen" the earth itself sprawls and writhes like one of his giant females.

May 19

"It's like the National Gallery," I said as I entered the Weitzner home and saw a Rubens, a Rembrandt, a Madonna by the Master of Flémalle and other paintings on the walls. "Well, not quite," proudly murmured Mr. Weitzner. There were a couple of European art dealers who left before dinner. Chuck Parker, who was a teacher or a curator, or both, at Oberlin College, and I remained. The Weitzners (Mrs. Weitzner is a pianist, a student of Schnabel's) were warmly hospitable. We drank scotch on the rocks and conversed mostly about art and artists. Mr. Parker asked me whether the purpose of my coming to Europe was to hold exhibitions of my work." "No," I answered, "I came here to look at paintings. I am a museum fiend. No," I found a better word: "a museum pilgrim." "A museum pilgrim," repeated Mr. Parker. "I like that!" He seemed interesting and informed.

May 21

Peter De Francia, to whom my dealer Bella Fishko wrote, asking him to take me around London and introduce me to some artists, came to my hotel and took me to his studio by bus. It is cold all the time in London—the chilly air seems to irritate the skin, men and women go about with red noses and generally blotchy faces, and the stockingless legs of girls are crimson with cold. It was freezing in Peter's apartment and in his studio above the apartment (he rents a small house and garden).

Peter is a big florid man of forty whose blue eyes are at times questioning, puzzled. He is well informed about politics, art, literature, theater, etc. He is a socially aware man, has friends all over Europe. I repeat he is full of all sorts of information. When the name Kokoschka

came up in conversation, De Francia said that he (Kokoschka) is a typically Viennese artist in his color schemes and feelings; as a matter of fact he was greatly influenced by the work of Multspatch, an eighteenth-century Austrian baroque muralist who painted in lavenders, blues, grays and pinks (Kokoschka's colors). "There is a story," he said, "no doubt apocryphal, that Kokoschka in his youth promptly fainted upon seeing a mural painted by this predecessor of his—so great was his emotional experience." Peter took me upstairs and showed me his own paintings, and slides of a huge painting, commemorating a contemporary uprising or struggle, I think, in Algeria—all good, furious-on-the-surface paintings, but all unresolved abortive, unfinished. He is completely unsuccessful materially, can't sustain himself on his art at all, and has to lecture and teach for a living. No gallery (he unconvincingly blames his leftism for it) would give him an exhibition. And yet he is as good as, and better than, many artists in London, who do exhibit and live by their art, and whose work is on permanent display in the Tate Gallery. He suggested that I visit Joseph Herman, a good painter according to him. When I mentioned that I visited Bratby, he seemed surprised and displeased and muttered something about Bratby's sensationalism. I didn't tell him I had made another appointment to see Bratby, in fact tomorrow. Peter's remarks did not dissuade me from keeping it, for Bratby interested me very much.

In the evening I met Peter again at a small peace meeting where an American woman spoke about the progressive movement in the United States. She was factual and mildly interesting. Afterwards, Peter, his saucy, charming young girl friend, Susanna Bott, and I went to some pub and had drinks. Peter decided to go to Paris at the end of the week to find a gallery in which to exhibit, since all London gallery doors seemed closed to him. He entrusted me to his girl friend, and instructed her to take me to a woman artist, Frishman, whose dead husband had been a well-known and excellent draftsman on the *Simplicissimus*.

May 22

My second visit to Bratby. Again his interesting, shy, untidy wife opened the gate, and Bratby led me into his studio. Only one little boy was seen around this time—the bigger one; the younger could only be heard, monotonously crying and whining, as if in pain and discomfort, in a nearby room. I asked about the child. "He has the measles," Bratby

said. "He already had it when you were here last time, but we didn't know." That chilly day, I remembered, when he was walking about so lightly clad, bare-legged. "How about him?" I pointed to the older one. "He had it."

Again I was impressed by the amount of Bratby's work, its vigor and vitality, also by its lack of polish, and by its repetitiousness. I thought of his resolve not to change in manner or technique the next thirty years. The thought depressed me. Thirty years more of picture production by even a Van Gogh or a Modigliani above what they had already produced would have been unbearable. . . . He is obsessed by the idea of creating an "American market" for his work. He showed me also his drawings, life-size ones on rolls of paper—all of girls in different postures and dress and different states of dishevelment, but not nude. These huge drawings were crude and searching, some in lead pencil and some in lead pencil and crayon. He talked again about the official encouragement of sterility and preciousness in art in Great Britain. "Isn't it also true of the United States?" he asked. "There is an artist in New York I read about who does one painting a year." "Peter Blume?" I asked. "No," he answered, "his name starts with an H." "Oh, Edward Hopper!" I exclaimed. "Yes, yes," he said, "Edward Hopper. I don't hold it against him that he paints so slowly; as a matter of fact I like his work, judging from reproductions." He also mentioned Grant Wood's "American Gothic" and "Daughters of the Revolution," which he admires, especially the "American Gothic." "I think it is wonderful," he said. "I don't know your work at all. You'll have to excuse me."

Mrs. Bratby shyly and mutely brought in two mugs of coffee. The whining of the sick child continued somewhere nearby. I made two sketches of Bratby, one sitting on a hand-carved wooden claptrap of an armchair with some of his wild figure paintings behind him. He posed without moving, withdrew, became old-looking, didn't talk, and evinced no interest whatsoever in what I was doing.

I liked him for his simplicity, for his not spouting intellectual clichés, for his natural or feigned eccentricity, for his industry. I suspect that he is quite a sophisticate.

In the afternoon I went to the Tate Gallery. Downstairs is a good collection of French Impressionists, Post-Impressionists, single paintings by Munch, Kokoschka, Chagall, and others of the same caliber. The English paintings bored me. I dislike even Turner and Constable. If Turner is a genius, as it is fashionable to claim today, he is the most boring genius that ever was. One good Claude Lorrain for all

7

the Turners. Constable is fussy, literary. One good Corot for all the Constables in the world, his sketches and all. The two early English paintings I liked were by Hogarth: "The Shrimp Girl" and "Hogarth's Servants." Also liked (some more, some less) paintings by Sickert, Augustus John, Gwen John, Nevinson. Of the contemporary artists represented, I remember Bratby, Herman, Passmore (his early, intelligent but too sweet paintings), Lucien Freud (his small intense portrait of Bacon). But the most impressive and best contemporary representational painting there, in my opinion, is "The Meeting" by the Italian Guttuso, vital and strong, with some collage, very functionally applied, of fragments of newspapers and wallpaper. Needless to say there were nonobjective paintings galore, a couple of them by Americans, hung on side walls. There was a wilted look about them; they were loosely stretched, the unpainted patches of the canvases were gray and muddy, and the painted parts passive and dull.

In the morning before going to Bratby I sent the following postcard to Paul Robeson, whose address in London was given to me by Peter De Francia:

> Dear Paul Robeson,
> Many years ago in my brother Moses Soyer's studio, a party took place in your honor. A book on the work of Leonardo da Vinci signed by the artists present was given to you. Do you remember? I was one of the artists. Am now in London and would like to visit you.
>
> Raphael Soyer

Next day I was told that there are rumors that Robeson is in a hospital, or in the Soviet Union. Subsequently the combination of both rumors proved correct. He is in a hospital somewhere in the Soviet Union.

May 24

Visited Joseph Herman. Friendly, intelligent, buoyant man. Aware (happily) of the fact that he is one of the accepted artists in London, has a gallery, exhibits, and sells. As a matter of fact when I mentioned names of English artists to Bratby, Herman's name among them, Bratby promptly found and gave me a magazine with an article about Herman. That is another trait that I liked in Bratby: he never spoke negatively about his fellow artists. Joseph Herman lived for many years in Wales, isolated, lonely, and inspired. His art was formed by that experience. He still paints the Welsh country, the primitive

village, the limited life of its inhabitants—squat men and women at work, at meals, in pubs, at rest. Dark and moody paintings. The color too rich and heavy, I thought. "Completely imaginative [the color]," he told me, "not like it really is." I couldn't help feeling that if the color were more factual, the paintings would have been more interesting. I have seen paintings of this sort; they seemed strangely familiar to me—the work of Rouault, Permeke came to mind. As a matter of fact, Peter De Francia described him to me as influenced by Permeke. I think that the Italian Ottone Rosai is of the same type, as is the American painter Kopman. Each, of course, has his own individual flavor. They are real, professional, on a good level, artists. We spoke a great deal about the Russian Constructivists, the Cubists and the Abstract Expressionists. We deplored the predominance of nonobjectivism in art at the moment, and tried to find and explain the moral, psychological, the timely reasons for it. We both agreed that contemporary art is in a state of havoc, and that museum directors, art critics, dealers, historians, teachers are to blame for this. I bellyached as usual against the New York museums—the Museum of Modern Art in particular. Herman complained about the art atmosphere in London. One thing he said stuck in my mind, "We in England have many good twenty-year-old artists but very few good forty-year-old artists. Artistically we die at a very early age."

This evening went to see *La Dolce Vita,* the movie that was made so much of in New York. I was disappointed.

May 26

Morning spent at the National Gallery. In the afternoon made two drawings at the British Museum of the Elgin Marbles—the same fragments I drew in 1959. Time and weather patinated and abstracted these stony youths and horses. Their being out of place and element— on the walls of the museum rather than on the pediment of the Parthenon—seems to add to their air of detachment and timelessness.

May 27

Went to the National Gallery again. My time in London is getting short. May 31 I shall be in Paris. At the museum concentrated again upon my favorite artists, so well represented there: Van Eyck,

Rembrandt, Titian, Rubens. They have spoiled my taste for the lesser men—the "little Dutch masters," the Dutch landscape painters, Teniers, Brouwer, Franz Hals, and others. I have no patience for them and have no time. I like the early Velasquez, "Christ at the House of Martha." I went to see the wonderful "Water Carrier" by Velasquez at the Apsley House, the two melancholy-tinged Michelangelos, the two Piero della Francescos, the Masaccio, the portraits by Lorenzo Lotto.

In the afternoon met Susanna Bott, who took me to the artist friend of hers, the widow, Mrs. Frishman. She and her architect son live in the usual cold and drafty London apartment, filled with her paintings. I marveled at the vitality of this frail (very ill, I was told) woman. Her expressionistic paintings of Israeli landscapes, of seaports, of still lifes, are vigorous, full of character. In the evening I had dinner with Susanna Bott. We talked mostly about art, the low ebb of it today, in London, in New York, in Paris. Again I put the onus for it upon the Museum of Modern Art in New York. I found myself blaming the New York museum for all that is wrong with contemporary art. My contention was that the devotion of its zealous directors to nonrepresentational art, the promulgation of it with the museum's modern propaganda facilities and American wealth, have influenced other museum directors, art officials, critics, dealers, collectors, and finally, artists, all over the world. Art today is in an indescribable state of havoc, I said. I expressed the opinion that the only art of our time that will count for something in the future is that which is being done by the few persisting representationalists, not the banal, platitudinous "academicians," but those who make tradition live, and ever renew itself; those who find dynamic, personal, timely ways to depict our civilization and our life. Like the work of Kokoschka, I said, Manzu, Balthus, Guttuso, Siqueiros, Dix, of a few American painters, and the work of course of George Grosz, Orozco, Rivera, Epstein, who so recently died. I was about to blame the museum for all that is wrong in the world today . . . and suddenly remembered how the sardonic Picasso blamed all misfortunes on the Ecole des Beaux-Arts. There is that haunting description by Alfred Barr, in his biography of Matisse, of a casual meeting on a Paris street corner between Picasso and Matisse on the eve of the Nazi invasion. Matisse, about to flee the invaders, talks unhappily about the state of affairs and Picasso says:"It is the fault of the Ecole des Beaux-Arts." Of course, the Museum of Modern Art is not the Ecole des Beaux-Arts. Or is it? Or becoming it?

May 28

Ira Moskowitz wrote to Henry Moore that I am in London and would like to meet him. As a result I received a letter from Mrs. Tinsley, secretary to Henry Moore, to call and make an appointment. I hesitated and procrastinated a day before I called. I felt that Mr. Moore will not know me from Adam, that the response was only in deference to Ira, who is compiling, with Sam Shore, a huge volume of drawings in which one of Moore's will be included. But when I told my London friends of my chance to visit Moore and of my reluctance about it, they said, "Go to see him, he is a fine artist, and we hear he is a very nice man." He seems to be respected both as an artist and man. He is not treated lightly in conversation, as other artists are. I called finally last evening. A woman was on the phone. "Is this Mrs. Tinsley?" I asked. "No, Mrs. Tinsley is off weekends." "This is Raphael Soyer, an artist from New York. Mrs. Tinsley wrote to me to call for an appointment."

"Henry dear, it's Mr. Soyer from New York."

Henry Moore's voice on a different phone: "Dear, get me my daybook."

"Henry, tomorrow the man from Holland is coming to look at the drawings."

Mr. Moore's voice: "And in the morning they are coming to look at the small sculpture. Oh, dear!"

And so on, till finally it was arranged for this afternoon. Mr. Moore told me to get the train at the Liverpool Station and to go to Bishop Stortford and then take a taxi.

As I suspected, Mr. Moore, in spite of his consulting his daybook, was not appointment-free when I arrived. (I had hoped I would have time to make a sketch of him; he would have been nice to draw, with his questioning blue eyes, iron-gray hair, ruddy complexion, but it was out of the question.) Two men were there, an important architect, I gathered, probably Dutch, and a man who, I think, was employing him to build a house, and Moore was being commissioned to do a sculpture to decorate the house. Mr. Moore was friendly, but I felt I was intruding, and was glad that I had told the taxi man to call for me in an hour. When I came, Mr. Moore was about to lead his visitors to his several studios and show them around. I was invited to join the procession. The studios were filled with old and present work. In one big studio there was a huge carving he was at the moment engaged

upon—a reclining figure typically hole-y. He showed us bones that he collects, talked to us about the beauty of their forms. To some of them he adds particles of clay. There were also some early bronzes, somewhat more naturalistic. I think that he tends progressively toward complete nonobjectivism. He would point to a form (sculpture) and ask his two visitors every once in a while, "Is that what you want?" or "Is that what you have in mind?" and would suggest a change here and there or a combination of two forms. At one time the question came up of the danger of a child sticking his head into one of the holes and not being able to extricate it. Well, Mr. Moore said, he could see to it; he could have the holes higher, too high for a child to reach them, or a hole could even be blocked.

The grounds were beautiful. His bronzes, huge male and female figures, sitting or reclining on the lawn, assumed a primordial aspect, became vaguely expressive and moody, for it was toward evening. The house, too, was lovely. A little Cézanne oil of bathers, two Seurat drawings, a Modigliani drawing on the whitewashed walls—everything was costly, but not ostentatious. Moore was offering drinks, when to my great relief the taxi called for me.

May 29

Yesterday while at dinner with Susanna Bott, again talking about art and artists, I said, "Susanna, you seem to be a person in your own right. Would it be possible for me to see *your* work?" She invited me for an early lunch today, because later in the day she was going to Trafalgar Square to a meeting in sympathy with the three-day strike in South Africa in protest against apartheid. She told me which bus to take to her neighborhood, which stop to get off at, and where to meet her. Unfortunately, something went wrong with my watch: It was three-quarters of an hour slow (usually it is fast). I was unaware of this till I got back to my hotel in the evening. I found Susanna frozen at the stop. She must have waited for me a long time, and have cursed me under her breath. She did mutter something about time and lateness, but it did not penetrate to me, because I wasn't aware that my watch was out of order.

Again, it was cold in the house, but in the studio there was a small electric heater. Her pictures were all around. I was impressed by her talent. I liked especially a painting this twenty-six-year-old girl did a few years ago—of a seated, brooding woman with another, a pregnant

one, standing against a fence in the background. Her current work was experimental—landscapes, still lifes, hurriedly executed with emphasis on pattern. There was great facility and not enough probing. I told her that she had a dangerous talent, one that makes things come too easily to her, and suggested that she attempt to paint a composition that would be difficult, almost impossible for her to do—with a change of style and technique. She agreed readily, but I think in principle only. "The best advice I ever had," she said in her flippant manner. There was something restless, flighty, uncertain about her. Again, Joseph Herman's words, "We have many good twenty-year-old artists in England, but very few good forty-year-old artists," flashed through my mind.

We went to Trafalgar Square. I listened to the speakers for a while. They sounded so much like the Union Square speakers in the old days. The National Gallery was right there—the temptation was too great. I said good-by to Susanna, after having made a final appointment—this time at my hotel, for tomorrow afternoon, to make a few sketches of her and then to meet Peter, who by that time will be back from Paris, and all have dinner together. "Come to my hotel informally dressed, disheveled, like I saw you the first time at the meeting," I said to Susanna, and added half in jest, "In New York I am known as a painter of disheveled girls." Before going to bed made a water-color drawing of Henry Moore from memory.

May 30

In the afternoon made sketches of Susanna Bott. She was in an orange pullover and sat against an orange wall in my hotel room. In the evening we met Peter De Francia, had dinner together, and parted warmly and exchanged hopes to meet again. Tomorrow am off to Paris.

Paris, May 31

In the evening, while registering at the Paris hotel, Mary called that she and Arnie are coming over. Perfect timing. They looked well. We ate somewhere on Boulevard St. Michel, out of doors. They make themselves understood in French, enjoy French food (which always rubs me the wrong way), became wine-drinkers. It was rainy and chilly in Paris (as in London) but we were happy and cozy. Mary and Arnie

had already been in the Louvre and at the Musée des Impressionistes, and tomorrow we made arrangements to meet in the Louvre on the top of the stairs near the Victory of Samothrace. "Daddy," Mary said, "you know which painting I really love—I think it is just beautiful . . . Leonardo's 'Madonna of the Rocks' . . . and those portraits by Holbein of the Astronomer, the Bishop, and of Erasmus." Arnie's favorite was that gem by Vermeer, "The Lace Maker."

June 1

We spent the morning in the Louvre. We had lunch somewhere across the bridge and returned to the Louvre to see the "Reserve" collection of countless paintings by David, Ingres, Corot, Delacroix, Géricault, and others. It was an exhausting day.

June 3

Tomorrow early, Mary and Arnie are going to Italy.

June 4

If I were a poet I would compose a poem in praise of the following big paintings in the Louvre:

"Feast at Cana" by Veronese; "Oath of the Horatii," "The Sabine Women," and "Coronation of Napoleon" by David; "Liberty Leading the People" and "The Massacre at Scio" by Delacroix; "The Studio" and "Burial at Ornans" by Courbet.

It was Courbet's "Burial," when I came upon it two years ago, that prompted me to exclaim spontaneously to my wife, "Rebecca, we're kidding ourselves, the best of us are kidding ourselves!" I studied the "Burial" intensively and long this morning: the eloquent and restrained color harmony of black, white, and red, with the brown of the earth and the gray of the sky; the oneness of this color scheme with the content, the composition, the complete absence of melodrama, gesturing, and story-telling. And the technique! Who can paint like this today?

Who in the whole world today, including the internationally acclaimed "geniuses" (the contemporary nonobjectivists as well as the "prophets" of the many so-called modern movements: Klee, Miro,

14

Mondrian, and the *demi-dieux* themselves, Picasso and Braque), can achieve, say, a "Coronation of Napoleon" or a "Massacre at Scio"? Who today has the will to exert the effort, with the ability to sustain it, necessary to produce masterpieces of such scope and character? Yes we artists are kidding ourselves today. We seem to be playing at being artists. We are like children playing the "Let's Pretend" game. Is profound, thematic, contemplative painting becoming extinct?

June 5

I spent this afternoon at the Musée des Impressionistes. I am in love with the three group paintings of artists and writers by Fantin-Latour. There are some early dark still lifes by Cézanne, heavily and gropingly painted, which Arshile Gorky especially loved and imitated in the 1920's. Here, too, are Monet's vigorous paintings of nature in all its aspects, and his last paintings of pond lilies in which the culmination of all his knowledge, observation and love of nature are expressed. What talmudic sophistry and flippant thinking can claim these as the basis for nonobjective, expressionistic painting of today, which so completely divorces itself from nature! The Renoir masterpiece "Moulin de la Galette" is on view here—but of course I like Manet and Degas best. Degas's "Absinthe Drinkers" has influenced me all my life—modest in size, quiet, almost colorless, aloof, abstract, it is, to me, at any rate, the modern "Giovanni Arnolfini and His Wife." "The Laundresses" is another unique, inimitable painting—influenced by it, I once painted a yawning girl, for which the actress Maureen Stapleton posed.

How modest in size most of the paintings in this museum are! Van Gogh never painted a large painting. Cézanne, Gauguin, Degas, Renoir, even Manet and Monet, only occasionally. The group paintings by Fantin-Latour are small canvases when compared to those painted today, especially by nonrepresentationalists. When I look at the magnified nonobjective doodles in paint, I think of an article by that charming columnist, Heywood Broun, that was published long ago in the old *World*. I do not any more remember the theme, but it began with a detailed description of a louse (yes, a louse) under a microscope. The insect becomes "formidable like a battleship." It is effective to magnify, and deceptive.

Met Harry Jackson, the sculptor of cowboys, looking with concentration at the Degas horses. (Wonderful Degas again! How

personal, different, thoughtful, meaningful everything he touched became!) Quite a character, Harry—with his thick reddish-brown beard, shaggy hair, sweet voice, and embroidered cowboy boots. He took out a little package from the pocket of his corduroy jacket, slowly unwrapped it, and we both looked reverently at a tiny Rodin bronze— the head of one of the citizens of Calais, which he had purchased at the Rodin Museum.

Munich, June 8

Am looking out of the window in the Orient Express approaching Munich. It is not quite 6 a.m. It is drizzly and seemingly chilly. We pass towns and villages with smoking chimneys, which make me think of the smoking chimneys of Auschwitz.

Munich is a big, unattractive, semimedieval and semimodern city. Many wide squares, or rather unnaturally empty spaces. I suspect there were buildings there that were bombed out and their traces and rubble removed. There are many city gates and many churches that resemble armories. In the late afternoon or evening, the city was noisy with traffic, there was a lot of movement and commotion. I watched the hurrying pedestrians. The men were smaller than American men, the women larger than American women. There isn't that contrast in size between men and women as in the States.

I registered, had my continental breakfast, got a taxi, and went to the Alte Pinakothek. This building, too, outside and inside, resembles an armory. It is huge, high-ceilinged, cold, uncomfortable, minus the usual lavish baroque decorations. Everything seems made of concrete, the floors, too, and they were hard on my back. The paintings are hung high, many are under glass and stupidly enough there was a lack of benches and chairs to rest on. In an enormous room filled with astonishing paintings by Rubens, there wasn't a chair or a bench. But the museum is filled with great paintings. "The Apostles" and the Christ-like self-portrait by Dürer. Holbein and Dürer are the two German painters who rose above their contemporaries. Their work is serene and intense, so unlike the grimacing, contorted, clumsy, naive and at times even comical work of the Cranachs, Altdorfers, Pachers, and others. Even Grünewald is not to my taste. There is an extraordinary painting by Altdorfer, though—"The Battle of Alexander"—one of the strangest, minutest-in-detail paintings. There is a group of intense, smallish paintings by Rembrandt illustrating Christ's Passion. They are grippingly realistic. Convincingly realized is

the unnatural, miraculous aspect in the paintings—the terrific light that emanates from Christ which dramatically pierces and illuminates the darkness of time and place. There are extraordinary Rubenses. I liked particularly the double portrait of himself and Isabella Brandt, a lovely full-length portrait of Helena Fourment, and one of a shepherd and a nymph, almost like a Rembrandt, so warm and human. Unfortunately, these three paintings were under glass.

There are many Titians and Tintorettos, a troubled Botticelli, "Entombment," three Raphaels even, which I liked immediately without reservations, an unusual thing with me, for I was habitually disappointed in the Raphaels in the Ufizzi, the Pitti, and the Vatican. Two years ago I admired only his "Stanze" in the Vatican; the "Madonna di Tempi" is of a woman and child painted with deep insight, and freely, with the discernible brush strokes so dear to artists. I made a drawing of it in pencil, there and then, noted down the approximate colors and went over it in water color in the evening in my room at the hotel.

June 9

Went to Alte Pinakothek again. I discovered a small painting of the Virgin by Antonella da Messina, a portrait, really, of a young, sweet, pious woman with slender hands crossed on her chest, enveloped in a blue shawl against a black background. Am always captivated by the small, dense, cubistic canvases of da Messina. Also am always affected by color combinations of black and blue in paintings. Made a drawing of it at the museum, and for the life of me, couldn't get the Virgin's facial expression of almost inane piety; noted down the colors and in the evening colored it. Wanted very much to draw a detail from a Rubens painting, that big female satyr with two horned and bearded baby satyrs sucking at her breasts, her hand lying limply in the genital region of one of the little satyrs, but my back ached from standing on concrete floors in front of paintings and I was tired, so tired in fact that the rest of the afternoon I sat in an interesting park, opposite a huge fountain with a statue of a properly testicled Nordic, with a Buster-Brown haircut and a farm implement over his shoulder, his stance a steal from Michaelangelo's David, and some corny horses with water coming out of their nostrils. It was a warm and sunny afternoon. Many young people were sitting around the fountain. I made a drawing of it and colored it in the evening.

17

Vienna, June 10

Came to Vienna in the late afternoon, unpacked, and took a long walk. Located the Kunsthistorisches Museum, which was already closed for the day, entered parks embellished with lavish baroque monuments to Goethe, Schiller, Mozart, and Maria Teresa, religious monuments, fountains, bronze horsemen, galloping horses with naked youths holding them back, and whatnot.

June 11

Spent this morning in the Kunsthistorisches Museum, one of the finest in Europe. Best, well-cleaned and well-preserved examples of European painting beautifully and intelligently hung. A room of portraits by Velasquez. Four portraits of children, three of Maria Teresa in three stages of early childhood, and a portrait of a little boy. It is difficult to describe them. They are alive, in space, with objects around them. They exist. And yet there is something unmaterial about them. Is it because they are painted with such infinite and mysterious delicacy? Suffice it to say that Vermeer's "Artist and His Muse" seemed labored and naturalistic in comparison. There are Breughels, Rubenses, Titians in profusion. Of particular significance for me were three self-portraits of Rembrandt in one of the side, gray-satin-covered alcoves. The "big self-portrait" is three-quarters length, full-face, confident, virile, arms akimbo; the small one—just head and shoulders, also full face, intensely living; the third slightly turned, his brooding forehead and eyes in shadow, cast by the beret. I had for a moment an uncanny feeling that Rembrandt was in the room. There is also that moving early portrait of his old mother with red-rimmed eyes. In a nearby room were Frans Halses. I swiftly stepped out; I couldn't bear them after Rembrandt, they seemed ugly and obstreperous.

June 12

Saw drawings by old masters at the Albertina, famous drawings, often reproduced, by Michelangelo, Raphael, Rubens, Rembrandt, Holbein, Dürer. Quite a collection of Dürer drawings: of his mother, of landscapes and cityscapes, of Apostles, of flowers, of marsh grass, of a bird's wing, of a rabbit. One can truly say of him, "He loved all things

both great and small." But the drawing that made my heart melt was the silverpoint of himself at thirteen years of age. Subsequently, Dürer wrote above this drawing that he drew this of himself in the mirror in 1484, "when I was still a child." It was this drawing that I had referred to months earlier in a letter to artist Rudolf Baranik:

February 19, 1961

Dear Rudolf,

First let me thank you for your sincere and thoughtful letter. However, I would like to explain myself more fully to you.

In the discussion, not "lecture" as you call it, at your school, I attempted to negate the validity of nonobjective painting—the premise of it. It is not a matter of "the better or worse artist"—you like Rothko and De Stael—others swear by Mondrian and Still. I am indifferent to the four of them. As a matter of fact I went to see the De Stael exhibition the day after my encounter with your students. I thought his paintings would make fine textiles for women's blouses. I kept asking myself—"what does Baranik see in them?" For me they had no further meaning.

To me [Alfred] Barr and Greenberg, whom you mention are sheer esthetes, sophists, rationalizers, but I can't understand why *you* are antagonistic towards them. Aren't they proponents of nonobjectivism like you? It seems to me they are justified in seeing or searching for moral or cosmic values in it. After all great paintings should have more than just mood. Van Gogh is not merely turbulent, nor Rembrandt merely sad, nor Corot merely lyrical, etc. Perhaps your turbulent, lyrical, sad, joyful moody nonobjectivists would do better as musicians, poets, philosophers. These media are by nature more abstract.

I was not moved by the student who pleaded with me, according to you, not to repulse her. Her effort, even with your description of it, "works hard and long till her canvas has just the right poetic color she likes, the right fluidity to keep it from being static"—seems to me, who does not accept the basic premise of nonobjective art— mere miasma.

What really concerns me is your giving so much of yourself to your students. There is no little Albert Dürer among them. There isn't even one *professional* art student there. Your students are men and women who attained a certain station in life, some may have a little talent, some are more sensitive, some less. Why make them feel they are artists? Why destroy art standards completely? Why add more confusion?

Sincerely yours,

Raphael Soyer

19

June 13

Studied Breughel with great attention. I would call his paintings colored drawings—so thinly painted are they, tinted rather than painted, usually on wooden panels. No paint-quality, impasto, "métier," brush strokes; not that his painting is sleek and smooth—it is strangely vigorous, in fact—but its basis is drawing. He was a genre-ist—an unpopular term today, but does it matter? I recalled the argument in Moses Soyer's studio on the eve of my departure for Europe. Joseph Floch and Alex Dobkin were there. It began with Floch's dismissal of some artist's work by calling it genre. I laughingly remarked that everything Floch dislikes he calls genre. And the argument flared up. Moses and Floch insisted that genre is an inferior branch of art. I, supported by Dobkin, maintained that genre can be great—that it depends upon the artist—and mentioned Vermeer, Chardin., Louis Le Nain, Breughel, and Rubens in his "Kermesse." We tried to define genre, we named great and no so great artists and tried to classify them and their work. Now, in the Breughel room of the Vienna Museum I ruminated: "What is his (Breughel's) 'Road to Cavalry' if not vast genre in what it encompasses?"

Rubens again overwhelmed me. The three couples of cavorting and prancing nymphs and satyrs in the "Venus Feast" openly and unrestrainedly making love . . . the nymphs voluptuous and as big as the satyrs . . . one satyr embracing his aroused companion's underbelly . . . his hands fumbling in her pubic hair . . .

Went to Belvedere by Strassebahn. Saw a big Cézanne exhibition. There was a strong self-portrait and a variation of his two card players at the table. They were beautiful paintings—generally speaking I like Cézanne's paintings of men better than his still lifes, landscapes, and his paintings of women. There was also a silvery study for his big unfinished, unrealized "Bathers"—his "project of doing Poussin over entirely from nature." I remembered this quotation* from the moving letter Cézanne wrote to Emile Bernard shortly before he died, in which he cites the difficulties and obstacles encountered even at the mere contemplation of painting the big canvas from nature, literally from nature—to find the proper setting for the picture "which would not differ from the one I visualized in my mind," to get the many models of

20 *Artists on Art, compiled and edited by Robert Goldwater and Marco Treves.

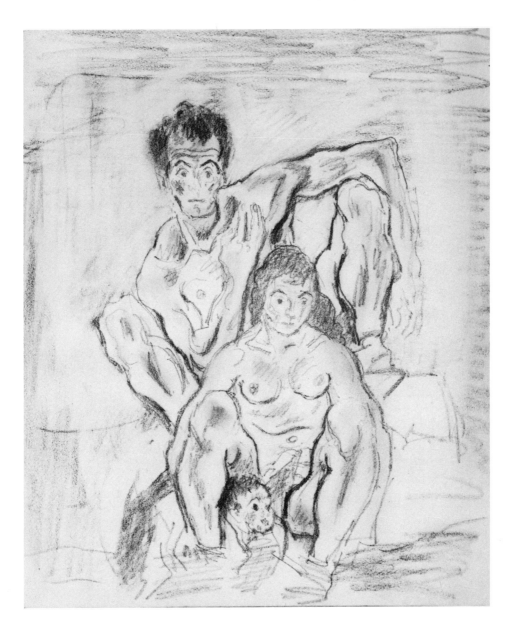

"Family Portrait" by *Egon Schiele*

men and women willing to undress and motionlessly pose, the difficulties with the out-of-doors weather, and of carrying about so big a canvas Good old disheveled Cézanne, how deep and wonderful was his preoccupation with nature!

On the top floor of the Belvedere saw a collection of contemporary Viennese art. I was pleasantly surprised to find a small painting by my friend Joseph Floch. There were two big rooms, one each devoted to Kokoschka and Schiele. A very early—simply beautiful!—painting by Kokoschka, "The Visitation," and a portrait of Oscar Moll, impressed me, but Schiele, who died of Spanish influenza at the age of 28 in 1918, was the revelation to me. His three big paintings are there: "A Mother and Two Children," "Death and the Maiden," and "The Family"—of himself, his wife and baby, in reality unborn, for his young, pregnant wife also died of the 'flu–nude, squatting one in front of the other. The first two are masterpieces of a sort. The painting in them is wretched, worried, fussy, the color is spotty—bright and muddy in parts. One feels, however, the terrific effort to master the sticky, messy oily paint. They are works of a young genius. All the morbidity, macabreness and schizophrenia of youth are there. All the storm and stress, the drive and joy of sex and the anguished suppression of it, the wonder and fear of life, and the preoccupation with death. The "Family" was painted in 1918, the year he died. He was beginning to master the technique of painting then— it is painted with greater ease and fluency, especially the nude figure of his wife. The intensity is about to give way to almost happiness. I liked this painting less. But its content and composition impressed me very much. The figure of himself is well realized, the drawing and painting of the conceived child who was never to be born, touchingly tentative.

I, too, was stricken by the 1918 influenza and survived. I was eighteen at the time. Surrounded by the Schiele paintings, I recalled to mind and visualized my first one-man exhibition at the Daniel Gallery in New York. I was twenty-nine then, a year older than Schiele was when he died. There were about twelve paintings in all on the gallery walls. I tried to remember them—a few street scenes and still lifes, a portrait of my mother, a family scene, some nudes—all small, withdrawn, restrained. I remembered my then confused state of mind, my social retardation, my fears, my constant suppression of all desires, awareness of my unprepossessiveness, my inarticulateness, etc., etc., also the tensions that came with our large family and the torture of sibling rivalry that never subsided.

. . . What an outburst of self-revealment!

Paris, June 18

Met Rebecca at the Orly Airfield.

June 19

Called up Floch. He came to the hotel. It was nice to see him. In the afternoon he took us to the studio of Joseph Constant, a Parisian sculptor of animals, a whimsical, gray-haired man, vaguely resembling Charlie Chaplin. Both he and his wife emigrated to Paris from Russia after the First World War. They speak Russian beautifully. We liked his animals in wood, terra cotta, and bronze. We purchased a kitten— we thought it would make a good present for Mary and Arnie. Constant was pleased. He fondled the bronze kitten as if it were a live one, firmly and tenderly, with a big and masculine hand, talking the while with charming Russian intonation. "It is a young one, still blind. Look, his eyes are just about ready to open," etc. His wife is a good painter of portraits and still lifes.

June 20

Rebecca and I spent this morning in the Louvre and looked at the Flemish paintings. The small "Madonna of Chancellor Rolin" by Van Eyck is in wonderful condition. It is indestructible. It was painted, if I remember correctly, in 1436—525 years ago. It was not merely painted, it was architected, molded . . . and painted . . . jeweled and brocaded. We looked long at the Avignon "Pieta." This is what Rebecca wrote to a friend about it: "Hanging alone in a small alcove, it is almost a shrine for those who believe that painting is one means of communicating deep human emotions in a tangible representational manner, universally understood. And it is permeated by an aesthetic quality that none of our barren practitioners in contemporary abstraction can hope to attain."

The Louvre is exciting and noisy. It is ten museums in one. There is a continuous and restless quest for Mona Lisa, Venus de Milo, the Victory, and loud exclamations of awe and admiration in front of them. The clatter of shoe-clad feet, the sharp click-clack of women's high heels, especially, on the wooden floors, the sound of countless voices of the herds of men and women following the loudly expounding guides, create a veritable cascade of noise.

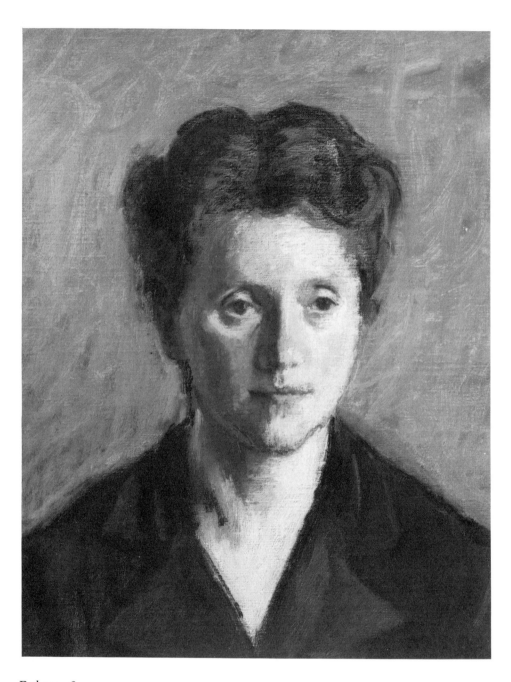

Rebecca Soyer

June 22

Saw the Chagall exhibition of stained glass windows for an Israeli synagogue exhibited in a specially erected pavilion in proximity to the Louvre. Typically Chagall—in color and symbols—twelve windows in all, for each of the twelve tribes. We liked them, Rebecca especially, due, I think, to her interest in history. In the evening we went with Joseph Floch to the opening of a very comprehensive retrospective exhibition of Maillol, his sculpture, paintings, drawings, prints—his life's work. It was an impressive and beautiful show. That such serenity existed in our epoch of wars and social and political upheavals and all sorts of cultural confusions is sort of miraculous.

Met the sculptor Ossip Zadkine at the exhibition, a small, thin, handsome, snappy man, with pink complexion and snow-white hair and eyebrows; gives one a sense of vitality and versatility. Speaks English well—he lived in New York during the Second World War and taught sculpture at the Art Students' League.

June 24

Visited Ossip Zadkine in his studio in a private little copse in a courtyard in the heart of Montparnasse. There are a few studios and living quarters on the premises where he and his wife, the painter Valentine Prax, live and work. I asked Mr. Zadkine to pose for a drawing. He sat down without much ado. I liked him a lot. Some of his work, too—his imaginative and poetic versions of "Poet," "Orpheus," etc., the tragic feeling in his war themes. Vital, spirited, moving work. He just completed a monument to Van Gogh which will be unveiled in a week (he invited my wife and me to the ceremonies of the unveiling but we will have left Paris by then) about 50 kilometers from the city, in the square opposite a little church that Van Gogh immortalized in one of his paintings. He showed me two tragic, Rodin-like, manly heads of the one-eared Van Gogh—studies for the monument. Zadkine seems to be becoming more figurative in his work. We conversed in Russian, one of the several languages he speaks well. I mentioned his international fame and his ready retort was that fame is nothing—that a man is no greater or smaller than he is. He asked me about an artist who has been living and working in New York these many years. I said that materially he is successful, but that morally he

has lost ground. Well, Zadkine said, this man always impressed him as carrying a fear within himself, but that he was unable to do anything with this fear, to artistically exploit it. Some artists, he said, were able to do this, and their work was enhanced. He cited Otto Dix as an example. I was impressed by his mentioning the comparatively little-known Dix, whose work when I come upon it, invariably impresses me.

In the evening we met the Detroit art dealer Bob Garelick who had stopped in Paris on his way home from Germany and Italy. For the second time today Otto Dix was mentioned in conversation. Garelick showed me European art publications and catalogs among which was a paper-backed book of reproductions of Dix's work, some in color. Upon seeing the deep interest I evinced in Dix, Garelick presented it to me.

Mr. Garelick talked with his customary enthusiasm about contemporary art in East Germany and in Italy. He told me that he'll put on an exhibition of representational Italian sculpture and painting and call it "The New Renaissance of Italian Art," or "The New Renaissance of Figurative Italian Art," his aim being, he told me, to counter the many officially and popularly encouraged nonfigurative exhibitions that prevail today, and to impress upon the public that good figurative art is being created, that artists are returning to representationalism. As always, he oversimplified things and spoke with his habitual lack of restraint. Irritated, I advised him to desist from using words and phrases like "Renaissance" and "New Renaissance," that the figurative painting that is being done at this moment should be subjected to strict scrutiny and criticism before it is acclaimed. I was, however, for putting on, if at all possible, high-level exhibitions of figurative art, and if it is to be of Italian art, I suggested titles like "Contemporary Representational Italian Painting and Sculpture" or "Representational Painting and Sculpture in Italy Today," or even, "Re-emergence of Representational Art in Italy." I am skeptical about Italian art of the moment, especially about painting. Only one of the younger Italian painters impresses me: Guttuso. Sculpture fares better in Italy—but certainly the outstanding ones are only Manzu and the early Marino Marini; there are others, gifted but inferior.

June 25

Rebecca and I visited the young American painter John Dobbs and his

wife, and had dinner at their house. We saw his year's work, done in Paris. It is talented, impetuous, uncertain as yet. But he made progress. Plans to live and work in Paris for some years, and in a year to have an exhibition there. There is some logic in young artists wanting to exhibit and gain recognition in both America and Europe, and even wanting to work in more than one country or continent. And yet great art was always local. Degas wrote from America, where he visited and painted for a brief period, that he needed his Paris in order to create. "I want only my own corner and devote myself to it fully." I always liked an aphorism that I have encountered somewhere in my reading, and I think the author of it was Derain: "Stupidity is national, intelligence is international, and *art is local.*" However, the world is getting smaller all the time, and the phase "art is local" is beginning to lose its meaning.

June 26

Joseph Floch took me to Mrs. Kars, widow of the painter who committed suicide during the Nazi occupation of Paris. Kars was in the circle of Pascin, Utrillo, Valadon, Soutine, and others. She is old and florid, her big face lavender with powder. On the walls hang a portrait of her in her youth by Valadon, Kars's self-portrait, and a fine early figure painting by Pascin. She has many drawings by and mementos of Modigliani, Pascin, Kandinsky, Picasso, Juan Gris, and others—quite a valuable (artistically and money-wise) collection. She was disturbed this morning, and understandably so, because (she told us) a dealer came to see her the evening before in the hopes of acquiring part of her collection, and insensitively hinted at her age, the proximity and inevitability of death. He said, "Well, Mrs. Kars, now that you will soon have to prepare yourself for the long, long journey, what are the plans for your collection?"

June 28

There is a feeling of corruption in the contemporary art atmosphere of Paris. Galleries are rented by artists for their exhibitions, art critics literally sell themselves and accept money from artists and galleries for mentioning them and criticizing them favorably in their art columns. Clever, superficial, even mediocre art is taken for granted, is accepted, and no one pays particular attention to it.

June 30

Went to the Rodin Museum with Floch. In the garden was an international exhibition of sculpture. Emilio Greco, the Italian sculptor, was featured. He was represented by a number of sculpture pieces and drawings. There was a repetitiousness about his work, both in content and technique. We saw some banal representational pieces by sculptors from a socialist country; absurd American, British, and French nonobjective contraptions, devoid of meaning and aesthetics; and some of the "New Images of Man" variety of sculpture of big-bellied, spindle-legged or legless figures with testicles as if eaten away by rats, with faceless physiognomies; sculpture, in short, that revels in death, decomposition, necrophilia.

We went inside the Rodin Museum and looked at and studied his well-known pieces, the plaster casts of his countless studies for them, and his inimitable drawings so thoroughly pulsating with life. "You know," said Floch musingly, "it seems to me that so much that's wonderful, deep, and profound has already been explored by man, and expressed in art, but there is still room in art for nonsense and exasperating foolishness. What we saw in the garden will not subside so soon. Absurdity in art may continue for a long time yet."

Basle, July 5

Spent two days in Basle, two mornings in the Fine Arts Museum, which is divided into two parts—on the upper floor is the display of the more recent painting beginning with Cézanne, while the old masters are shown on the lower floor. To me, Holbein's portrait of his wife and children is the finest painting in the entire museum. Mentally I compared it to Rubens's gay, warmly humorous, and colorful portrayal of his family in the Louvre. As a matter of fact, many artists have painted variations on this theme—Holbein's is the least sentimental and the least adorned. How powerfully modeled are the heavy-featured faces of the sad mother and the two disturbed children. The background is a dark green, without any suggestion of place or space.

Upstairs is the so-called modern section (how I dislike to use the word "modern" in relation to art!), too systematically, too neatly

arranged; there are, however, some fine examples of early Picasso, one—a favorite with me—of a nude boy carrying a younger child on his back, and Kokoschka's "Tempest"—perhaps too poetic an idea and color. I was impressed this time by some Corinths and, to a lesser extent, by some Hodlers. In a dark room on the ground floor I found Otto Dix's portrait of his parents, perhaps too deliberately crude and objective a painting. I liked it.

Milan, July 6

Arrived in Milan at 6 p.m. after a six-hour train ride through the panoramic Alps scenery. Milan is noisy, big, bustling. Subway digging is going on all around the Cathedral.

July 7

Went to Brera in the morning. Among many run-of-the-mill Italian *seicento* paintings, saw Mantegna's foreshortened dead Christ, a good Tintoretto of the "St. Mark" series, the early Raphael, "Marriage of the Virgin," and the very beautiful Piero della Francesca of a "Madonna and Child surrounded by Saints." The Raphael and the Piero are in a separate alcove of a room and the visitors are routed to them after seeing all the other paintings. The guard in that room was proud of the two paintings in his care, and seeing how interested we were in them, asked which of the two pleased us more. He was gratified when we pointed to the Piero della Francesca and informed us that he, too, preferred it to the Raphael. Of course, he said, Raphael is a great name, but look—and he gestured to the Piero—at the *"perspettiva,"* the *"architettura,"* the composition, and the faces of the Saints, one of them—he singled out a figure—is an *"autoritratto,"* a self-portrait.

In the late afternoon we went to the Colonna Gallery, which is run by Madame Usiglio, whom Peter De Francia from London advised me to see, since she is in contact with contemporary Italian artists. She was very helpful, gave us names and addresses of artists to visit in Florence, Rome, and Venice. While there, made an appointment with the Milanese artist Pino Ponti, who happened to come into the gallery just then, to visit him in his studio tomorrow.

July 8

Rebecca and I spent an interesting morning with Pino Ponti. Ponti, a wiry man with warm, swift eyes, was friendly, animated, and articulate. He showed us his paintings and drawings—completely representational work. His theme is young women, singly or in groups, usually in street clothes, handbags hanging from the wrist, black or red hair slightly disheveled or tousled, often smiling, parted lips showing teeth. Inwardly I criticized the similarity of their faces and bodies and the prevailing mood about them of sweet morbidity. He had a painting called "Anne Frank," which impressed me more. It was painted with greater vigor and, strangely enough, seemed less romantic. And frankly I was impressed with the idea: now, why hadn't it ever occurred to me to paint an Anne Frank? I asked myself. Goodness knows, I painted many girls who could have evoked the wonderful Anne Frank.

He showed some of his landscapes, too, city-scapes, rather, of weather-tempered and time-patinated facades of Italian houses. In a sense I liked them more than his figure paintings—they were less showy.

He willingly agreed to pose for a sketch. We conversed the while—that is, my wife translated the questions I asked him in her *"petit peu"* French and his answers into English. His French wasn't too good, but the three of us understood one another. I wanted to know what kind of relationship the artists in Italy have with one another, about artists' organizations or groups, exhibitions, etc. Since I am so impressed by Guttuso and so eager to meet him, I asked what he thought about him. Well, his answers to my questions were negative: there is no such thing as close artists' relationship, as a matter of fact there is not much love lost among them, because there is too much competition for economic and artistic status, for attention recognition, prizes and sales. Guttuso, he said, as an artist is too propagandistic, as a man too ambitious, that his following is among the younger artists, who expect favors from him, for he is very influential in the official artistic circles and serves often on prize-awarding art juries.

After lunch went to a small church where Leonardo's "Last Supper" is found. We were impressed, nay, amazed to see how much beauty and strength this semiruined mural still retains. How durable these masterpieces are—the Sistine Chapel, the Carmine Masaccios, and this Leonardo, how indestructible. For centuries they had been

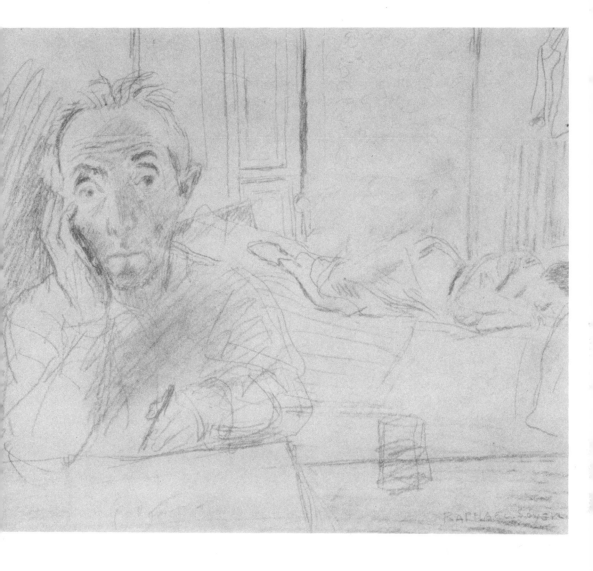

Self-portrait in a Hotel in Milan

neglected in dank churches, blackened and discolored by dust and candle smoke, cracking, peeling, repeatedly repainted and restored and otherwise mistreated. Yet enough beauty and life still emanate from them to make nations wonder.

While writing the above saw my reflection in the mirror, the reflection of the hotel room with Rebecca asleep on the cot; the scene was so hotel-like and dreary—quietly not to awaken Rebecca I got my sketchbook out of the suitcase and made a drawing.

31

July 9

Set out 9 a.m. in the morning in a bus for Venice with stops and guided tours at Verona, Vicenza, and Padua, which needless to say proved unsatisfactory, for the stops were brief, the guides mediocre. But we did get an inkling of the beauty of Verona, of its squares and courtyards. In Padua we stopped on the big square, where we admired the Strozzi monument by Donatello. The Church of St. Anthony appeared huge and clumsy and its interior glitter and clutter repelled us. There was no time to see the great Padua Giottos; we considered ourselves lucky that we saw and admired them two years ago.

Venice, July 12

We spent four full days in Venice. Saw the sumptuous Venetian paintings in the Accademia, the Scuola Tintorettos, and the Carpaccios in the Accademia, and his murals in a little church in a very picturesque section of Venice. One day while waiting for a church to open, where there are some splendid Tintorettos, we sat down somewhere in the shade. I made a drawing of a deserted street—it was still siesta time, the afternoon was wonderful and crystalline, the street was half in shade and half in light; the ancient walls of the buildings were almost as luminous in the shade as they were in the light. Rebecca was busy the while, both writing a letter and paying heed to a little girl and pretending to understand the chatter addressed to her. The child had a red balloon attached to a string; she held it in one hand and kept pointing to it with her other hand. She spoke with animation and expressive gestures, little Italian that she was, for some time, but suddenly realizing that something was amiss for no response was forthcoming from Rebecca, abruptly ended her monolog, shrugged her shoulders, and walked off.

We spent a good deal of time with a New York acquaintance, the painter Enid Smiley, who has been coming to Venice for many years. We were introduced by her to the charming restaurant "Montin" frequented by writers, intellectuals, and artists. Through her we met a few Venetian artists, one of them being Cadorin, the director of the Accademia Art School, a man in his late sixties, tall, heavy, pink, with the distinguished features of a Roman Senator. We visited him in his studio. He dressed himself up for the occasion in some kind of a

Chinese robe of heavy material with wide silver-embroidered sleeves—a fancy smock, I guessed. The gradually increasing midday heat forced him to shed the robe after a while. He asked us to sit down (there were other visitors—Claire Hooton, the Lishinskys, New York artists, and Enid) and ceremoniously began to show his paintings, setting them up one by one on a tremendous easel that must have been centuries old. There was something ceremonious also about his paintings—static and dignified—painted thickly and smoothly, smoothly plastered rather than painted, chalky in color. There was something not quite right about the paintings—they were like strange fruit that one wouldn't eat and yet would hate to throw out. I made a quick sketch of him with Claire Hooton in the background. He posed immobile as a statue.

Venice is beautiful this year. Every inch of it is beautiful. The weather is pleasanter than two years ago. It seems also quieter. San Marco is dimmer at night, there seem to be fewer tourists than two years ago, and as then a good percentage of them are leather-hosed, camera-laden, arrogant Germans.

July 13

The nearer we approached Florence the more beautiful the landscape became and the more familiar, for the terraced hills, the olive trees, the hill towns recalled to us the backgrounds in the paintings of Mantegna, Piero della Francesca, Botticelli, and others. Half an hour after we registered in the hotel we were in the Uffizi—it was a joy to behold again the Filippino Lippis, the Botticellis, Titian's "Venus of Urbino," Raphael's "Pope Leo," and above all, Hugo van der Goes's "Portinari Altarpiece." Later we walked up and down Ponte Vecchio, sat down in an out-of-doors cafe in Piazza Signoria, ordered drinks, felt at peace and at home, watched the tourists, the natives, and the children feeding the forever gluttonous and defecating pigeons.

Florence, July 14

"Daddy, you were right, Florence is a golden city," wrote Mary to us from Italy. It seemed even lovelier this time than two years ago. Again we began our round of visits to museums, churches, palazzos, etc. Met the Rabins. Bernie, knowing of my desire to meet some of the local

artists, said he will contact one Grazzini, whom he knew when he was here a few years ago, and arrange for a visit.

July 15

We couldn't find the Alexanders in the phone book (Sidney Alexander—poet and author of *Michaelangelo the Florentine*, the first volume of his projected trilogy), so we decided to walk over to his house, and much to our delight we remembered the way to Porta Romana and up the hill to Via Ugo Foscolo where the Alexanders live. We climbed up the four or five "pianos" only to find them out, and be greeted by Arno, their terrier. My wife left a note with the maid.

Went to the Duomo to see Michelangelo's "Pieta." I sketched it hurriedly two years ago. Will try to make a more elaborate drawing of it this time. The head of St. Nicodemus is sculpted broadly, the way Rembrandt painted at the end of his life. The figure of Mary too is wonderful. They are not the proud, disdainful figures of Michaelangelo's youth—they are compassionate and sorrowful. The St. Nicodemus, Michaelangelo's self-portrait, is as full of humility and resignation to life and death as Rembrandt's "St. Paul" in the Rijksmuseum, which also is a self-portrait.

July 16

Mrs. Alexander called us and invited us to a cocktail party, the day after tomorrow.

Have been to the Uffizi every single morning. This afternoon we went in quest of the Castagno mural, the "Last Supper." When after some wanderings and circling about the neighborhood we found the former monastery where the mural was painted, we didn't know the entrance to it and a passerby had to show us the door and point to an almost invisible bell button to press. A tall, ascetic-looking Italian let us in and proudly directed us to the fresco, and in basic Italian, understandable even to us, told us that it had been cleaned, simply washed with water, that no restoration of any kind was needed, it was well preserved under the centuries' accumulation of dust and dirt, but that the interior of the building itself is in the process of restoration, which was evident to us from the bags of cement and the bricks on the floor. The Castagno is strong, decorative and nonemotional. The design of the composition and of each individual figure is powerful and

expressive. The figure of Judas is particularly striking—shaggy, dark, sinister, distinct.

On the way back we found ourselves at a street where we knew Mimi Gross, daughter of sculptor Chaim Gross, had been living and painting for a year and a half. We decided to look her up there and then. We found the number of her house, wended our way through a courtyard, onto which several gaping doors opened. We found Mimi's name among others on a mailbox, with an arrow pointing to the left. Up one flight we met someone who directed us to a door in a long corridor of doors. This led out to an open empty terrace at the other end of which was a partly open door, decorated gaily, childishly, with painted clowns, animals, flowers; that of course was it. We knocked; there being no response we peeped in and beheld a mass of color on the walls (paintings, reproductions) and a mess of clothes, bundles, palettes, etc. on the floor. We left a note for Mimi to call us.

July 18

Came back from Pitti Palace. Impressed this time by some of the Raphaels. But they and other great paintings are poorly displayed and submerged in the great number of third- and fourth-rate old master paintings: the Dolcis, Del Sartos, the Guido Renis, etc.

In the hotel lobby we found Mimi and her friend Red Grooms waiting for us. Mimi, chubby, disheveled, the eyelids of her warm, brown, inward-looking eyes painted blue. Red, a cross between Li'l Abner and Bergman's *Seventh Seal* knight—tall, hungry-looking, sharp-elbowed, red-haired. They were dressed beatnik-ly, bizarrely, sloppily. Mimi was genuinely happy to see us; Red, shyly so. We told them of our date this afternoon (at the Alexanders') and that we would love to meet them tomorrow in their studios (same building), see their work, and have dinner together.

The Rabins, too, were invited to the Alexanders' and we went together. The party was dull, the conversation lagged. But we admired the panoramic view from the veranda of the city with its overpowering Duomo, its church spires and towers, and its hilly outskirts. The Alexanders, who love their Florence, would from time to time call their guests' attention to its beauty and its soft light. We had a few drinks and left early. I told Sidney that I would like to sketch him before we left for Rome next week.

35

July 19

The Rabins took us to visit Grazzini, a Florentine artist of some reputation. On the way we stopped into Santa Croce and saw some fragments of Giotto's murals on freshly replastered walls. Rabin, who is a restorer by profession, explained to us that later repainting of and additions to the murals had been scraped or washed off and only what was genuinely by Giotto is left. These fragments of groups of heads, or say, of a single kneeling figure, float disconnectedly and surrealistically in the expanses of fresh plaster.

Grazzini, a pleasant, smallish, disarming man, had his young son in the studio. Theirs is a warm father-and-son relationship. Grazzini told us with restrained emotion that his son's young comrade, a schoolmate, had died from leukemia that morning. He shook his head from side to side, and gently patted the boy on the back; the boy also shook his head in thoughtful resignation. Grazzini then showed us his paintings and drawings. They were good, or rather, not bad. They were too sketchy for me, not conclusive, but did in some way reflect the genuineness and modesty of the man. He, too, told us that there was not much friendliness and socializing among artists in Florence and in Italy generally; that they work in isolation; that he and Guttuso are of the same generation, that they were friends once. "But I don't see him now. As a matter of fact, it is easier for you American artists to get to Guttuso than for us Italian artists." There was a note of bitterness in his voice. It is becoming apparent to me that a very small group of Italian artists have far oustripped their contemporaries in achievement and fame.

In the afternoon went to Mimi and Red. They have adjoining studios. Mimi's studio was orderly, neatly swept that morning, sunny and cheerful. On the walls hung her exuberant, completely uninhibited paintings. She told me in her low—as if talking to herself—voice, that she likes German Expressionism and is influenced by it. I readily saw this. Her work certainly is expressionistic, with abandon, childishly, uninhibitedly, unself-critically so. On the walls, beside her own paintings, hung many reproductions of Sienese paintings, interesting photographs, carved and gaily painted Sicilian donkey cart slats, Mexican votive pictures, etc.

Red's studio was austere in comparison, less cluttered; his work, too, less gay and colorful, but sensitive.

It was still too early for dinner so I asked them to pose for me

36

Mimi Gross and Red Grooms

which they did, sitting next to one another. Mimi was attired tightly in red and brown, her hair like Medusa's; Red Grooms in a turtleneck mustard-yellow sweater which, with his red hair, created a strange harmony, or rather combination of colors. There was a large canvas on the floor beside them. Mimi called my attention to it. It was recklessly painted and raucous in color. "I had the 'Jewish Bride' by Rembrandt in mind," she said, looking at me with her soft brown eyes that at the same time seemed to be looking stubbornly into herself, "when I painted this of me and Red."

"What a travesty," I said to myself, and smiled to her as one does to a child.

While posing Mimi talked incessantly, telling about her travels with Grooms all over Europe and the Near East, their experiences, amusing and difficult ones, their occasional financial crises, etc. They

were both pleased with the drawing I made of them. "I like the way you made me," Mimi said simply.

The time had come to go out to dinner. Mimi, for some reason, suggested one of the swankiest Florentine restaurants. We ate well, but we were under constant scrutiny. The fashionable diners and formal waiters looked at Mimi and Grooms with frank amazement. I suddenly noticed that the legitimate split on the side of Mimi's skirt was enlarged by a rent, and her thigh, which was covered with oil paint smudges, exposed itself every time she moved or gestured. Both Mimi and Grooms, who resembled a parrot with his red hair and yellow sweater, were aware of the sensation they caused and bravely tried to ignore the diners and the waiters, but once in a while cast angry and moody glances in their direction.

They told us that they were living these summer weeks outside Florence in a villa on a farm with other young artists, poets, musicians, communally, all guests of a young art historian whom they call "captain" because he always wears a hat with a visor and who at this time is in Rome, doing research for his M.A. thesis on the work of, "Guess who?" Mimi said to me in derision. "Guido Reni! As if there are no other artists to write about!"

I couldn't more heartily agree with her. Mimi said she would call us in a day or two and invite us to spend an afternoon and evening at the villa. "It is on a farm. There are many animals there, horses, cows, dogs, ducks." Mimi's eyes glowed with love and pleasure. "The villa is on a hill; we have a wonderful view of Florence." She mentioned a few times a particular horse that was left in her charge, and a carriage—"a surrey with a fringe on top," which she was decorating at the moment (hence the painted thigh, I thought). She said something about traveling with Grooms all the way to Verona with this horse and carriage, with some kind of puppet or movie show.

It was late when we walked home. How small European cities seem to me! How every place is within walking distance! As now, we walked through almost half of Florence to get to our hotel, and it wasn't tiring. It was interesting to pass churches and palazzos, to cross piazzas and wind ourselves through narrow, smelly, ill-lit alleys unchanged since Cellini's time.

July 20

The Van der Goes "Portinari Altarpiece" makes the Lorenzo Credis,

the Ghirlandaios, and even the Filippino Lippis in the room look positively insipid. Every time I look at it I discover something new and wonderful—the differences in scale of the figures, the moody angels— some strangely still, some fluttering about like bats—the animated shepherds, the portraits of the Portinaris, the fascinating and meaningful still life of wheat and flowers at the bottom of the central panel.

There is insane poetry in Botticelli's "Spring" and in his moody religious compositions. One of the most interesting paintings to me in the whole of the Uffizi is his "Adoration of the Magi." It is like a Flemish painting in its beauty of detail and in that many of the figures are portraits. Only the Botticelli is mellow in color, and the figures, at least, in this painting are relaxed, fancifully attired, debonair—unlike their severely draped pious, Flemish counterparts whose hands are always folded in prayer, fear, and supplication.

Red Grooms and his friend, Paul Suttman, a shaggy, red-bearded giant, called to take us to their villa. We all piled into Paul's small car, where huddled was also Paul's wife, Gwynne, a tall stringy girl with very delicate features. Distances are small in Italy, and in no time we were on the farm where their villa was on top of the hill. Mimi, shining with welcome, descended some stairs and approached and kissed us. Her hair was wet, she just took a bath, she told us, and began taking us around. She introduced us to the inhabitants of the villa—Natasha, a lovely girl of quiet mien, a poetess, born in Paris of Russian parents, who lived and went to school in the States for the duration of the war and at present a student of literature of a fellowship in Oxford University, England; Peter, a young bearded folk singer with the naive face of a saint. (Rebecca was taken by the beauty of his eyes, his whole being, she said, seemed to breathe music.) Mimi reintroduced us to the Suttmans; Paul, a sculptor who studied with Manzu and served as a model for his teacher's "Caravaggio" of all things—this tall, shaggy, buck-toothed American—and Gwynne, his wife, a painter, tall, thin- armed, with a cameo-like face. Needless to say, they were all informally dressed, in shorts, or tight, faded, patched jeans, except for Natasha, who was in a neat summer dress. The quiet air about her was almost tangible. Mimi took us around the farm and introduced us to the farmers—men with open, tanned, sun-wrinkled, wine-loving faces. They looked with tolerant amusement upon Mimi and us, laughed readily, and pointed out to us the beauty of the "panorama."

We saw and expressed our admiration for the carriage, every bit of which Mimi had vividly and gaily decorated. There were farm

animals, cows, ducks, geese, prowling cats, and frolicking dogs, and there was Mimi's big horse, around whom we all gathered in great concern of what to do about the millions of flies that buzzed and hovered about him, clung to his flanks and head, around his big shiny eyes especially—"maybe to tape his eyes for a few minutes and spray him with some insect repellent?" Rebecca, as always interested in the trees, flowers, plants of a place, would break off a small twig, pluck a leaf or a flower, examine it, and give it its name. Two little Australian sisters appeared on the scene, shy at first, but friendly and boisterous after a while. The smaller of them went off suddenly and came back with a posy of field flowers and offered it to Rebecca with the words, "Flowers for the lady visitor." All around us were hills, some with towns perched on them, their sides terraced with cultivated patches. Below lay peaceful valleys. Close by, a tenant farmer with a team of white oxen plowed his portion of the field and far beyond him was the beautiful silhouette of Florence.

Finally we entered the house and found ourselves in a tremendously large, high-ceilinged bare room with paintings and prints on the walls, books and magazines strewn about. I was shown an issue of *Art News* with an article by Allan Kaprow called "Happenings on the New York Scene," about a group of young artists, "who are translating painting into a new kind of Drama." I had no time to read the article, but I glanced at it. Well, I guess one can make of it what one wants . . . the big thing was that there was a picture of Red Grooms in the magazine, creating, or acting in, one of the "Happenings." Also an issue of *Life* was lying around opened to an illustrated article on Kokoschka's school at Salzburg. This was where the Suttmans and Mimi Gross and Red Grooms studied sculpture and painting last year, met and became friends. Manzu was the sculpture instuctor there and seeing for the first time the tall, red-bearded, shaggy American, exclaimed, "Caravaggio," and asked him to pose. Red's, Mimi's, and Gwynne's opinion of Kokoschka was not a flattering one because (I suspect) he didn't make much of them and these kids, independent and full of bravado though they seem to be on the surface, are really as insecure as orphans are and crave attention and approval.

The lights were turned on. The little Australian girls went off to sleep. We sat around the table subdued and silent, waiting for dinner. Presently, at the quiet order of Natasha the clean tablecloth was spread and enormous amounts of meat, spaghetti, salad, and bread, and jugs of wine appeared on the table. Our contribution was a huge *panetone*—a

sort of coffee cake stuffed with nuts and fruit. Two strangers—Italian men—wandered in out of the night. The food was gone and they were offered wine. There prevailed a mood of relaxation and quiet merriment. Rebecca and I were moved by the friendliness these young people had shown us. One of the Italians, after a consultation with his friend, pointed to Rebecca and said that he wanted to sing a song to "Mama." The song was long and sentimental and was accompanied by the singer's histrionic gestures and pious eye-rolling at her.

We left the table finally, and sat in front of a lighted screen, in darkness, and the invisible Grooms proceeded to show his, and Mimi's, shadowgraph movie to the music accompaniment of the also invisible Peter. The main character was a Don Quixote figure on a horse, and whenever he jogged across the screen, one of the Italians would joyfully exclaim: "Cowboy *stanco!*"—"tired cowboy," which for some reason amused Rebecca and she would go of into peals of laughter. It was getting late and we were beginning to be tired. Our amusement became tempered by the pensive awareness of how young our hosts were, of our own age, of flight of time, etc. Before we left, we invited this lovable gang of fellows and girls to dinner, some evening soon, in a restaurant of their choosing. "Caravaggio" Suttman took us home.

July 23

In the late afternoon Paul called for us at the hotel and drove us to his studio. We were to meet Mimi and Red and drive to the restaurant where the others would be. The studio was in Via Degli Artisti, a little tree-shaded alley of a street. There was a row of studios. A young sculptor was busy casting in front of his doorway, his pretty wife with a baby in her arms, watching him. Everything was so damn idyllic! The Suttman place was high-ceilinged, square, bare of furniture except for a couple of taborets, a cot, a table, Gwynne's frameless paintings and drawings on the whitewashed walls, Paul's small sculptures, in the style of Madordo Rosso (a sculptor who died in the twenties, I think, and whose work at present is in vogue) on the window sill. There was a disorderly kitchen with the inevitable bundles of clothes, rags, palettes, and brushes on the floor, probably because of lack of closet space. We had tea, after which I sketched Paul and Gwynne. I expressed the hope of meeting Manzu, the Italian sculptor I like most, when we will be in Rome in a week or so, but Suttman dispelled it by telling me that by

41

Suttman and Wife in Florence

that time Manzu will have left Rome for somewhere near Bergamo, where he (Suttman) is to join him in a few days and together make a pilgrimage to Madordo Rosso's home where the bulk of his work is kept. There were some vague intimations that we might join them.

Soon we heard a motorcycle come to a halt in the alley. Mimi and Red came in, in a hurry. Mimi's glance hurriedly swept over the paintings on the wall and she perfunctorily exclaimed: "Gwynnie, it's terrific." The five of us piled into the Suttman car, all except Red who went on his motorcycle to get Peter and his guitar, and directed by Mimi, we drove in the direction of Piazza Michelangelo on the other side of the Arno, and we soon got to Beppo's restuarant.

We were seated out-of-doors under trees around a long table laden with food, wine, and fruit. Peter sang American folk songs and accompanied himself on the guitar and often we all joined in the chorus, as did the diners at other tables. There were newcomers with us

whom we had not met before—a young Italian novelist and his American girlfriend and translator. Red pulled out a huge sketchbook and began to draw Rebecca, energetically, stretching his neck out from across the table and peering at her at close range. Later I too tried to draw this group of festive young people—Peter, his smooth-complexioned head bobbing up and down making music on his guitar, songs pouring out of his open mouth; Paul, with his flaming beard and bucktoothed smile, and Red Grooms in an outlandish jacket also red, with sleeves too short for him; the handsome Italian novelist, and all the sweet girls. But I had too much wine and my pencil wobbled and fumbled over the white sheet, as I was drawing the profile of the Italian novelist's girl, nearest to me, with the moon in the black sky, partly veiled by a small transparent cloud, resting lightly on her head, barely touching her hair. "You have a beautiful hat on," I said. "It consists of the round moon and a small transparent cloud."

July 24

Siena is sinister, medieval, stony, hilly. It was hot with an oppressive, before-a-storm heat, and for the first time in Europe my head ached as if I were sunstruck. Rebecca, more alertly than I, responded to the strange beauty of Siena and was impressed by the shell-shaped main square. We went into the museum and saw the Sienese paintings, among which is beautifully displayed Duccio's big altarpiece of the enthroned Madonna surrounded by saints—his masterpiece. Frankly, early Italian paintings never interested me very much. They are icons really, not paintings. For me Italian art begins with Masaccio, Filippino Lippi, Botticelli, etc. I was glad, however, that these paintings are in the museum. So well displayed and no longer in the churches for which they were painted. I wish all paintings, and wherever possible frescoes, were transferred from the dank churches, where they are either in complete darkness or cheaply illuminated by floodlights. How good it would be, for instance, to get the magnificent St. Matthew paintings of Caravaggio from the church of S. Luigi dei Francesi and hang them on a museum wall in good light.

July 25

At the American Consulate we were given the address and telephone of Kenneth Tilkemeyer, a former student of mine, who married an

Italian girl artist, and is settled or getting settled in Florence. Ken called for us this morning—there was one of those sudden, unexpected, unpublicized bus strikes in Florence and since he has no car, he walked, ran, rather, he told us, to be at our hotel at the appointed time. On the way to his house we stepped into the church, Santa Maria del Carmine, at my request, to take another look at the Masaccios. Well, again, I was deeply moved by them. I heard Ken saying rapidly under his breath, as is his wont, that nobody paints like this any more and therefore there is no point to do so. "You know, Ken," I said with deliberate slowness, "if I were a young man today, like you, this is how I would choose to try to paint, like Masaccio, unaffectedly, strongly, truthfully. I wouldn't give a damn about all the weird, ephemeral art movements of the moment, fashionable, publicized, and encouraged though they may be."

It was nice at the Tilkemeyers. His Italian wife is charming, a graphic artist of talent, their little daughter lovely. Ken's intention—it may not be conscious on his part—is to become thoroughly Italian both in life as well as in art. He signs his paintings "Tilke."

We ate delicious spaghetti, and drank *grappa,* a strong alcoholic drink, something like vodka. Later we went down to his studio and he showed us his work. He had not as yet accomplished much. Unfortunately he seems to have fallen under the influence of the late Italian artist, Ottone Rosai, whom he came to know through his wife. She studied with Rosai who, she told me, was her "second father." He died several years ago and is being made much of today. A big, lush monograph on his work was just published in Florence, his paintings are avidly sought after and command high prices. I don't like his work; it is soft and boneless. Occasionally there is a morbid quality in some of his paintings which intrigues me. But he certainly is not a master, and not a fortunate example for a young man to emulate. As it was, Ken's work seemed soft, careless, and weak. He has talent, though. I criticized him, too gently, I am afraid. But I did advise him to intensify his drawing and color and work long on his paintings, not to consider them finished, when they are merely beginnings, in fact.

July 26

We came to the Alexanders' about 5 p.m. Had drinks, and for the second time admired the view from the terrace. Golden and luminous,

Florence was like a jewel set in a ring of softly molded hills. I looked at it a long time and came to the conclusion that it was unpaintable. There was too much beauty right there, on the surface. I thought of New York, huge, unwieldy, unmanageable, where I have been living all my adult life and where my art was formed. There one has to scrape and dig to find beauty. It may well be to the good, I thought, from the artist's point of view.

While Mrs. Alexander was preparing dinner and talking with Rebecca, I made a drawing of Sidney with a framed reproduction of a fragment from Michelangelo in the background—the hand of God touching the hand of Adam, just the two hands. Sidney lives Michelangelo and his times. He told me of the great privilege he had been given, when through a secret passage he was permitted one day to ascend to the Sistine ceiling and examine the paintings at close range. "It was a great experience," he said. He made an exhaustive study of all of Michelangelo's work—in sculpture, painting, architecture. He has a great knowledge of the drawings, and considers Michelangelo as great a poet as he was a painter and sculptor. He doesn't think that Michelangelo was a homosexual. "Da Vinci yes, Michelangelo no." His long life was spent in a man's world, Sidney argued. He was always among men—his father and brothers, nephews, men servants. In the main, all his energy and sex drive simply went into his work. He lived a sexless life. He was aware that he was different, was troubled about it, but could not escape from himself. In one of the sonnets he prayed, "Make me want to want, O Lord, what I do not want." His identification was with the Old Testament rather than with the New. Except for the Madonnas and the Pietas, the bulk of his work was inspired by the Old Testament—the Sistine ceiling, the David, the Moses. He never carved a Christ on the Cross or a St. John the Baptist. I listened to Sidney with fascination.

At the table our conversation turned to their beloved Florence, which we are leaving tomorrow for Rome. I mentioned my regret that I would miss seeing Manzu in Rome and at my probably not finding Guttuso, who is rumored to be in the Soviet Union at this time. I also mentioned my regret in not having made drawings of Sartre and Aragon, whom I admired, when I was in Paris. A friend of theirs promised to send me introductions to them but they never reached me. I hoped to make a few portrait drawings in Rome. "I would like to do a drawing of, say, Moravia, whose *Two Women, The Two Adolescents,* and the *Roman Tales* I read and liked a lot," I said. Whereupon Sidney

said, "Moravia and I have the same literary agent. I'll give you her telephone; I am sure she will be able to arrange a meeting for you with Moravia."

After dinner the four of us went to the Piazza Signoria and at an outdoor cafe table met the Gillettes, who have been living in Rome these past months. Henry Gillette, an ex-student of mine, was passing through Florence on the way to Milan to get additional material for the children's book he is doing on Leonardo Da Vinci, both the text and the illustrations. Henry knew Sidney Alexander's volume on Michelangelo and wondered what effect on him and his work the publication of *The Agony and the Ecstasy* had. Sidney said that he is almost finished with the second volume of his projected trilogy on Michelangelo. He praised Irving Stone, the author of *The Agony and the Ecstasy*, as a skillful writer, as a man who knows his craft.

July 27

At the Uffizi to look once more at the paintings before leaving for Rome in the afternoon. In the Dutch Room we met the elderly and active New York councilman, Stanley M. Isaacs and Mrs. Isaacs, eager, intelligent, keenly interested in the paintings, and later in the Rubens Room, the art collector Eric Cohn and his wife. A few days before my flight to Europe, Rebecca and I had been invited to the Cohns to dinner, and had the second opportunity (we had been there once before) to see their art collection. It is an interesting and personal one, mostly of works by German artists, Corinth, Grosz, Kollwitz; also some paintings by Floch, Menkes, Kars, and others. His Grosz collection is particularly good.

Grosz is one of the artists of my time who never ceases to fascinate me . . . his draftsmanship, his powers of observation and trained memory. His drawings and prints of the so-called dada period are viciously expressive. Compared to them, Paul Klee's schizophrenic drawings seem like poetic doodles. The impact of George Grosz's work, it seems to me, lies in his power to identify himself with the characters he drew—all his characters, the villains as well as the victims. He himself is in turn the gluttonous, swine-like warmonger, the murderous Nazi, the tortured progressive, the striking worker, the degraded woman, and the hungry child. He must have experienced, to a hallucinating degree, the sensations of sadism, masochism, the feelings of humiliation, anger, passion, but seldom pity. It is

46

interesting to compare Kollwitz and Grosz. There are no heroes in Grosz's work, only villains and victims—he draws them with equal intensity. There is no element of compassion or sympathy there; it is biting, cruel, viciously satirical. Käthe Kollwitz's work is a constant, almost monotonously repetitious, hymn to her hero—the masses, exploited, poverty-stricken, ravaged by death. She never, as far as I know, drew a military figure or a "capitalist."

George Grosz influenced many American artists: Shahn, Levine, Gropper, Baskin, and a host of the younger. Only Levine, as far as I know, publicly acknowledged his debt to Grosz.

Apropos George Grosz and Jack Levine, about a year and a half ago the argument arose at the American Institute of Arts and Letters as to whom to award the gold medal for graphic art—to George Grosz or to another candidate. One Institute member after another made a little speech to the effect that George Grosz was great in his youth but that his work deteriorated as he got older. The refrain was "George Grosz is not what he was." Finally, Jack Levine arose and looked with a kind of cold attention at the Institute members around him (most of them older than he) and said. "Who of us, with the exception of maybe Jonathan Swift, is what he was?"

Rome, July 31

This morning went to the Vatican to see the Michelangelo and the Raphael murals. Because of a cardinal's death the Vatican was closed for a few days. I consider the Sistine Chapel one of the three high points of my art pilgrimage—the other two being Rembrandt in Holland and Van Eyck in Belgium. As two years ago, we soon became part of the awe-stricken, astonished, bewildered, ecstatic crowd. That a man in his thirties could have painted the ceiling and many years later, in his old age, the Last Judgment on the wall—natural organic continuation of the ceiling—single-handed! It is impossible to comprehend! Who could be compared with him?

I remembered how two years ago, the day we saw the Sistine Chapel for the first time, friends took us in the late afternoon to an art exhibition somewhere on an island in Trastevere. There they were again—European and American nonobjective paintings. To the charming girl at the desk we were introduced as an artist from New York and his wife. On the way out she looked at me and said something in Italian. "She is asking you 'What is your opinion of these paintings?'"

my friend translated. After some hesitation I said, "Tell her that I saw the Sistine Chapel this morning." Her soft face clouded and she commented, "True, this does not speak to the heart."

Raphael's murals in the Vatican are pure joy to behold—his "School of Athens" in particular, with the magnificently drawn and posed figures.

August 1

I called Milton Hebald, the American sculptor who has been living and working in Rome for several years now, and soon found myself in his studio on the other side of the Tiber, facing it. "Paint here," Milton said. "Look at the view—the river, the trees, the beautiful architecture on the other bank. I even have an easel here for you." His sculptures in bronze, wood, and plaster were scattered about—an ecstatic mother with a nude child clambering all over her, a sharp-kneed adolescent in skimpy skirt and amusing hat, nude men and women, singly or coupled. Talented, graceful, decorative work. He is one of the rare artists who enjoys commissions and has the knack of fulfilling them, with satisfaction to all concerned. In my mind was the first exhibition of his work I saw back in the 1930s—single figure pieces in neat white plaster, of people at work: a woman at a sewing machine, a shoemaker, etc. To this day I remember their simple and unpretentious quality.

In Paris Harry Jackson told me that he had met at a party someone who was introduced to him as Count-something-or-other, and who turned out to be the painter Balthus, whom Malraux appointed Director of the French Academy in Rome. Now, I know Balthus's painting well. "He is a sweet and intelligent guy," Harry said. "Call him up when you're in Rome, tell him you're a friend of Harry's."

I decided to call him right now. Milton helped me to get him on the phone. I soon heard Balthus's voice and told him that I was a New York artist, acquainted with his work and an admirer of it; that I was a friend of Harry Jackson and might I come and visit him. He asked me to come at 3 p.m. day after tomorrow for an hour. So much of his time, he said over the phone, was taken by his Academy duties. I asked if I might bring along my wife and my friend the sculptor, Hebald, who also knows his work. Balthus said, "Yes."

August 2

A few minutes before 3 p.m., Rebecca, Hebald, and I were at the gates

of the French Academy above the Spanish steps. We were ushered into a small elevator and taken to a spacious, columned portico. As in many Roman mansions and palaces, the important and beautiful part of the Academy was in the rear. We faced a cultivated park and below us were the Borghese Gardens. In niches along the portico walls of yellow ochre were antique marble figures. It was almost oppressively beautiful, timeless and still. I became moody. I looked at my wrist watch; it was almost twenty after. Finally, Mr. Balthus appeared, out of a side door, a thin, aristocratic-looking man. I had the feeling that he had had a nap and shaved himself before he made his appearance.

I introduced myself, Rebecca, and Hebald. We conversed haltingly and politely. He told us that his Academy duties were heavy and kept him from painting as much as he would want to. He said that it takes him a long time to do a painting. My wife looked nervously at me and her eyes said, "Get your sketchbook out, time is passing. Come, tell him you want to make a sketch of him." I finally did, and he sat without moving, a glazed look in his eyes, unconsciously and imperceptibly raising his finely chiseled face higher and higher. "Your face makes me think of Chopin," I said. (Actually I wanted to say Mitzkewitch, but the name of the Polish poet escaped me that moment and I said Chopin.) "Have you ever painted a self-portrait, Mr. Balthus?" asked Hebald. "Yes," said Balthus. I ventured to tell that I knew he introduced his own likeness in his "Wuthering Heights" illustrations. "Yes, yes," he readily responded, "long ago, when I was young."

I took special pains to draw this handsome, aristocratic, thin-blooded man and his finely featured face as accurately as I possibly could, not to err in proportion or to make an unnecessary line, for there was so little time left in which to do him, and to add further to my discomfiture, I'd forgotten to bring along my eraser. In the background I sketched in a classically robed marble figure in a niche. I showed my drawing to him and he smiled thinly. It won the approval of Milton Hebald and of course my wife.

August 3

This year again we visited the Fosse Ardeatina. The Hebalds took us to the cave, or series of caves, along the Appian Way where during the war the Nazis murdered 330 Italians in reprisal for 33 Germans blown up by partisans. They were Italian political prisoners, ordinary working men, merchants, etc.; 100 were of the Jewish faith. There was one boy of fourteen. The Nazis mowed them down with machine guns,

blew up the cave with explosives, and left the bodies there in the wreckage. After the war, the Italian Government had the bodies removed from the rubble, identified most of them, placed each one in a marble coffin and the 330 coffins were set inside the cave which had been cleared and enlarged for this purpose, with a marble slab as a ceiling over the entire area. On each coffin there is a photograph with the name, age, and occupation of the murdered man. The Christian coffins are marked with a cross, the Jewish ones with the Star of David. They are placed in aisles on raised platforms, to about table height, and at the foot of each one there is a perpetual memorial light.

Outside the cave there is a simple landscaped clearing separated from the road by Mirco's sculptured, wrought-iron gate. A heroic monument of white stone depicting three men standing back to back with interlocked arms, supporting one another, looms high above the gate, stark white against the blue sky. High above the entrance to the cave are the two religious symbols—the Crucifix and the Star of David.

It is ironical that the guide books no longer recommend visits to this cemetery; the public touring buses do not include it in their itineraries, as they used to, because of a tacit agreement not to offend the present German government. Very few tourists know about Fosse Ardeatina, although multitudes of them visit the Catacombs a very short distance away.

We walked up and down the aisles and exchanged comments in hushed voices and looked at the photographed faces of these victims of the Nazis. Some coffins were marked "Unknown" because the bodies were so mangled that they could not be identified. There were a few other visitors in the cave, some relatives of the killed ones, who brought their children with them and laid flowers on coffins. A small group of women led by a monk came in.

We left the dimly-lit cave and stepped out into the sunlight and when we got back to the road we heard from a short distance away gutteral exclamations of *"Ja wohl"* and noisy laughter, and saw a gay and arrogant group of Germans led by a guide enter the ancient Catacombs. We had a strong desire to pull them into the Fosse Ardeatina.

August 4

This morning called up Gabriella Drudi, Moravia's literary agent, saying that I am an artist from New York, that I am traveling about

Europe, keeping a kind of diary, both in words and pictures, that I have met and have made drawings of some artists and writers. I asked if it would be possible to meet Moravia and make a drawing of him. I added that Sidney Alexander suggested that I call her. Her answer surprised me: "Call him yourself. I'll give you his telephone number. He's probably home now." I called Moravia immediately. He spoke in an impatient tone of voice, and told me to call him Friday morning.

August 5

We were early for our afternoon appointment with Carlo Levi, whose house is somewhere off Piazza del Popolo. So we went into the Church of Santa Maria del Popolo to look at the Caravaggios. A genius again—a romantic and a realist—a Courbet and a Delacroix in one. The street to Carlo Levi's winds off the Piazza through a gate, to a woodsy park where his house stands in a grove of young willows. A hollow-cheeked, thin elderly housekeeper with beautifully set eyes let us into the disorderly anteroom. There were books on the shelves, on the chairs, on the floor, in Italian, in English, in French, some in Russian. On a huge table was a vast confusion of books again, paintings, drawings, reproductions, dried flowers and leaves and twigs, and among all this a plaster cast of a woman's head, her patient and meek face wrapped in a real black shawl, some of the leaves and flowers strewn about it.

Levi came into the anteroom, escorting a young man out, and asked us into the studio. It was a large room with more books and many more drawings. There were stairs leading to a balcony where his living and sleeping rooms are. One look at Carlo Levi fills one with friendliness toward him. His is an expansive and exuberant personality. He told us that the young man who just left came to enlist his interest in a new experimental theater venture. "One must help them," he said, more to himself than to us.

The many paintings were mostly of people: men, women, and children. There was something generalized and symbolic about them, with feverishly glowing eyes in hollow faces. The landscapes seemed to us of southern Italy—barren and poor. The colors were somber and gray, black, ochre. There was a good deal of the writer in the paintings. The technique, however, was professional, spirited, painter-like. He showed photos and slides of a huge composition he'd lately completed which was being exhibited in Turin at this time. Turin is the section of Italy Levi comes from, and is the locale of this painting, and the main

51

figure, the hero, was a poet and a dear friend of his youth. He is depicted a few times in this mural-like composition, first teaching and lecturing to the populace which is shown flocking to him on foot, on mules, in carts, old and young, a modern variation on the "St. John the Baptist Preaching" theme. Then it shows this poet leading the people in a strike or in some struggle against oppression, and finally dying surrounded by grief-stricken followers.

"This is my tribute to my friend," Levi said. The word "friend" appeared often in his vocabulary. "Guttuso? Why, he is my dear and intimate friend," he exclaimed. He has many friends in America. He mentioned his friend Ben Shahn, with whom he spent some time a few weeks ago. We told him that we saw his paintings in the Museo dell'Arte Moderna and liked his youthful self-portrait and a head of an old man. "The old man was my friend, the great Italian poet Saba," he said with feeling. "He died a few years ago."

I wasn't able to do Levi justice in my drawings. I failed to capture his aliveness. But then he posed badly. There were too many distractions. The telephone rang, he gave orders to his housekeeper: When so-and-so comes for a contribution for some cause, make out the check. He changed the position he was sitting in to stroke his big fluffy cat that passed by, and then a miserable little kitten that strayed in from the street; he told the housekeeper to give it food. He looked at the drawings of the artists in my sketchbook. They were his friends: "That's good of Zadkine," he said. "He, with many others, signed the statement protesting my imprisonment." He told us to go to Turin to see the exhibition there. He invited us to call and come again, and took down our address, with the idea of looking us up when he comes to New York.

August 6

This morning called Moravia again. I said, "I am the New York artist who wants to meet you and make a drawing of you. I called you a few days ago and you told me to call you this morning." "All right," Moravia said hurriedly," "come today at 7:30 p.m." Now, we had an invitation for this evening to the wedding reception of Hebald's daughter, and therefore I said, "Mr. Moravia, may I come at seven, because I have a later appointment this evening?" "All right, all right," was the hurried, impatient answer, "come at seven."

Promptly at 7 p.m. Rebecca and I rang the bell on the top floor of a

modern apartment building, just off the Piazza del Popolo. A typical Italian housekeeper, middle-aged, with deep-set friendly eyes, let us in and asked us if we had an appointment with Mr. Moravia. We said yes, and she left us to inform him that we were there. Well, we waited ten, fifteen, twenty, twenty-five minutes. Two silent fluffy cats moved noiselessly to and fro and every time they passed us, arched their backs for us to scratch them. It was oppressively warm. We went out on the terrace. Rebecca examined the plants and flowers and plucked off wilted leaves. We went back into the room, and still there was no Moravia. It was half-past seven, and getting dark. "Rebecca, let's go," I said angrily, when the door opened and the housekeeper came in, saw us in the twilight of the room, still waiting. She clapped her hands in dismay and went out, saying dramatically in Italian what probably meant that she had told Moravia about the appointment, but that he gets so engrossed in his writing that he forgets everything.

In about two minutes the door opened abruptly and Moravia limped in. He is a tall, thin, lame man (we were told subsequently that he had had infantile paralysis) with small eyes under bushy eyebrows, big flat nose, and thin mouth. His appearance was that of a retired baseball player. His behavior was as rough as his appearance. He said to me, completely ignoring Rebecca, in his hurried, informal manner: "You're the artist from New York. You'll have to draw me in my work room while I type." "May I come too, Mr. Moravia?" said Rebecca. "Well, the room is small," he answered ungraciously. "All right, all right, come."

The room was small, air-conditioned, with shelves of books by Tolstoy, Balzac, Stendahl and other famous authors. He sat at a huge table, cluttered with books, papers, manuscripts. He pointed to the sofa for me to sit down, from where I could draw him in profile only. Rebecca sat down next to me and began to read a newspaper she had with her. Moravia then commenced to pound his portable typewriter, I to draw, and to become witness to a strange metamorphosis.

Moravia's appearance changed. There seemed nothing crude about him any more. The light blue shirt clung softly to his shoulders and back. His profile, slightly lowered at his work, assumed an exterior and inner beauty. His head was well sculptured, with skull, forehead, nose, mouth, chin, ear, finely carved. His ear made me think of Tolstoy's ear, the way Maxim Gorky described it somewhere: "big, well-shaped, the kind writers have, the kind I remember Chekov had." His profile expressed benignity, repose, contemplation; it had an inner glow, to use a hackneyed phrase. He worked with great concentration,

53

and was also aware that I was drawing him, and held his pose. He typed with two fingers of one hand and with one finger of the other. Now and then he would stop typing for a minute, shade his eyes or rub his forehead with a well-shaped hand, and read what he had written. I realized that this man can work long periods of time, forgetful of everything about him. Rebecca read the first page of the newspaper over and over again. She didn't want to create noise by turning the newspaper pages. The muffled ticking of the typewriter was the only sound in the room.

Finally I closed my sketchbook, got up and said, "Thank you very much, Mr. Moravia, for letting me draw you. I feel we have intruded upon you." Moravia quickly got up, too. "I want to see the drawing," he said. I handed him the book, he quickly turned the pages. "Ah, Carlo Levi," he muttered to himself, under his breath. Finally he came upon the drawing of himself. He looked at it for a moment and smiled with approval. He said that we had not intruded upon him, but that he was pressed for time, and that he had to finish the piece he was doing. He escorted us to the door and warmly (it seemed to me) shook our hands.

"He liked your drawing," Rebecca exclaimed excitedly in the hallway. "He smiled—he really smiled when he saw the portrait you made of him. But, you want to know something, it occurs to me now that in all the portraits I saw in the newspapers, and on book jackets, of Moravia, he is always in profile."

We went from there to the beautiful apartment of Milton and Cecile Hebald, for the wedding reception of their daughter Margo. It took place on the terrace, dimly lit by candles set in lamp chimneys. Below were canyon-like narrow streets, and from the yellow, flat facades of the old buildings gaped blindly open, curtainless windows. Met John Manship there, a painter, son of Paul Manship.

August 7

I knew that Eugene Berman lives in Rome. Rebecca and I met him two years ago at a party George Biddle gave in his studio at the American Academy. He told me then that Rome is the city he loves; if I remember correctly, he naturally and simply said, "Rome is my city," and he chose to live there. A few months later I saw him in New York at Knoedler's Gallery where there was an exhibition of his paintings. Their theme was Rome. I called him to tell him we were here in Rome, and might we visit him? He very readily invited us to come Sunday and have lunch with him.

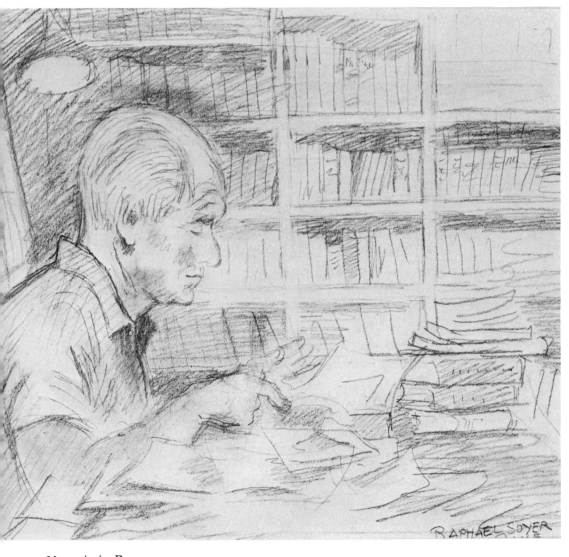

Moravia in Rome

We were overwhelmed by Berman's friendliness. He occupies two apartments, one above the other, in the Palazzo Doria. Both places are veritable museums filled with antique, Gothic, African sculpture, icons, engravings, his own paintings and drawings, and paintings and drawings by his contemporaries and friends. We sat in the shade on a beautiful terrace and he served us drinks. He is a fine conversationalist. He reminisced some about his past and his cultural background in Czarist Russia, especially about his life and art in Paris, where he emigrated during the First World War. I made a drawing of him sitting at a round table in one of the art-filled rooms.

He then took us down to his favorite restaurant nearby and with the suave assurance of a worldly gourmet ordered our food. His every whim was eagerly catered to by a friendly and respectful waiter who seemed to admire his tastes.

We continued to converse and Berman talked interestingly and feelingly about his friends, Paul Chelichev and Christian Bérard, who, with him, his brother Leonid and a few others, had founded the Neo-Romantic or Neo-Humanist movement in Paris. The group held exhibitions which attracted a great deal of attention. Both Chelichev and Bérard died not too many years ago. I think Berman said that of the whole group only he and Leonid are alive today. He talked about plans to organize and hold a historical exhibition of paintings by the Neo-Humanists in New York. I hope that this exhibition will take place. It would interest many to see the early works by these talented artists. I know some of these paintings—melancholy, moody, poetic, perverse. I would call Picasso's early blue paintings neo-humanistic. The work of Balthus, too. More about Chelichev and Bérard. Berman described how both, each in his own way, mistreated their talents. Bérard took his too lightly, and dissipated it by doing all sorts of trivial work. Chelichev, on the contrary, overestimated his talent and attempted the grandiose and unattainable, finally losing himself in metaphysics.

It was late afternoon when we said good-by to Eugene Berman. There was something essentially lonely about this cultured, gifted, whimsical, and capricious man, in spite of his many international friendships and connections.

August 9

Spent a couple of hours again at Galeria Nazionale d'Arte Moderna in one of the several beautiful buildings in the Borghese Gardens. This museum is analogous to the Whitney Museum of American Art in New York City. It houses a very comprehensive collection of nineteenth- and twentieth- century Italian paintings and sculpture. All the tendencies are shown, all shades of representationalism and non-representationalism. There wasn't the feeling of favoritism of one tendency over the other that one is aware of in the American museums. There seems to be an effort on the part of the directors to be fair to all decent artists of Italy today, no matter what their artistic persuasion is. Nor were the nineteenth-century narrative paintings discarded and put away in cellars, as often happens in American museums, where, at the

whim of directors, works of art out of immediate fashion are often even sold at auction.

There were some very interesting internationally known paintings by the futurists and the so-called metaphysical painters; a group of paintings by Casorati, an artist whose work has always attracted me, and paintings by many others. Of the artists more or less of my generation, I was again impressed by the vigor of Guttuso. There was a youthful, already masterful work of his—people fleeing the erupting Etna, a violent, dramatic work. Another painting was of a group of female nudes drawn and painted with great intensity.

There were three paintings by Carlo Levi I liked, especially his youthful self-portrait, and a head of an old man. An interesting group of expressionistic paintings by Scipione, an artist who died very young. Also paintings by Corrado Cagli, Mafai, Zigana and others. All artists were represented by several paintings, some by as many as five or more.

It goes without saying that abstraction and nonobjectivism are also here in force. There were some pleasant decorations among them, tasteful in color and shapes. But most of the objective seemed to be to attract attention. In spite, or because of this, there was a sense of anonymity about them. All the paintings seemed the same. Their authors seem to have lost their individual identities and their identities as artists as well. They are not painting any more, they are perpetrating acts of something or other—some of them say so themselves.

I was impressed by the early sculpture of Marino Marini, the portraits and the bronze nude, an excellent collection of work by Manzu—of his cardinals, dancers, the Crucifixion reliefs, and finally a whole room of Madordo Rosso's impressionistic, delicate, fugitive sculpture.

August 10

Corrado Cagli's studio is set in an old wall across the way from the ancient ruins on Circo Massimo. We got there late because we were misdirected a few times, and it took a lot of circling about till we finally got there and found Cagli and a younger man standing like two sentinels at the doorway waiting for us. Corrado Cagli introduced the young man as a pupil of his. The walls of the small anteroom were hung with his collection of drawings by his contemporaries and by

artists of earlier times. I recognized Eugene Berman's, Guttuso's, and Mirco's drawings among others. Also a drawing by the nineteenth-century artist Mancini.

He told us that he has a big collection of paintings by young artists who are or were his students. He is one painter who takes his teaching very seriously. In the course of the evening I realized that there was a master and disciple relationship between him and the serious-looking young man.

Unassuming, unspectacular, one cannot mistake Cagli for anything but the artist he is. There is something warm and self-contained about his bearing. He spoke briefly to his student, who brought out from the racks a group of canvases and, at his master's orders, placed them on the easel, one by one. The first was a portrait done quite representationally and muted in color. Then some gouaches, very beautiful ones, preliminary studies for a mosaic for a fountain, depicting fishermen and fishing.

Most of his present work, however, was semi- or completely abstract. Some of these paintings in color, light, and form were evocative of Roman walls and ruins. We told him this, and he was pleased. All over the studio, on tables, on shelves attached to walls, were some kind of sculptures, consisting of pieces of cardboard or thin plastic, tacked or taped together, in shapes of abstracted heads aand figures—eventually to be cast in bronze.

Cagli speaks English well, for he lived in the States and during the Second World War served in the American Army and was decorated for valor. Now he chooses to be an Italian citizen again. We talked about art in America and Italy. One remark I thought significant, that some Italian artists, the moment they begin to sell in America, become snobs. He named some of them. But he spoke warmly about Guttuso, Eugene Berman, Carlo Levi, and others. I was impressed especially by what he said about Carlo Levi, that at times he tends to be indolent and lax, but that in times of stress and need he is a great and trusted friend. He asked about American artists he knew when in the U.S., about Ed Melcarth and others.

Later, Cagli took us in a taxi to the huge studio where workers help him with his mosaic. It was quite unfinished as yet, but already very beautiful in design and color of ochres, browns, Venetian reds, dull blacks, and blues. Only one of the workers was in the shop, and we liked the friendliness and the respect he displayed toward Cagli. The walls of the shop were entirely covered by Cagli's collection of work by

young artists, some of them his students and ex-students. He buys their paintings. He invited us to visit him again, and I said that we would come and that I would bring my sketchbook along to make a drawing of him.

August 11

This morning visited Orvieto. At the station, went up in the funicular to the old city, perched high up on the mountain. It is a completely charming town, not as forbidding as Siena had appeared to me. The cathedral of white and black striped marble was truly beautiful and impressive, with its facade decorated with naive, amusing, and gruesome carvings in relief, illustrating events described in the Old and New Testaments, such as the Creation, Adam and Eve in Paradise, their expulsion, the Passion of Christ, the Last Judgment, etc. In a side chapel of the pleasantly unobstructed and spacious church are, of course, the Signorelli frescoes. They are unusually well preserved. The color is clear and bright.

August 12

Besides the beauty that European cities have—the historical flavor about them and their museums—they possess the wonderful institution of the outdoor cafe. In the late afternoons we usually found ourselves in one of these cafes overlooking the Seine in Paris, or on the Boulevard Montparnasse, in the Piazza Signoria in Florence, or here in Rome in the Piazza del Popolo or the friendly Piazza Navona, which especially endeared itself to us. We walked to it this afternoon from our hotel situated in the Via Veneto section of the city. We took our time and wandered leisurely in and out of the non-touristy side streets and alleys. Dark, windowless cavelike shops gaped like holes in the plain facades of ancient ochre buildings. Little groups of local men and women sat out-of-doors at rectangular wooden tables, not the round plastic cafe ones, eating, drinking, carrying on lively conversation. Intimate couples stood in doorways; messenger boys and girls, some of them mere children, dressed in black smocks (how I would love to draw them!) went about their errands. "Gee, it is much more interesting here than around the Via Veneto," Rebecca would say from time to time.

In the middle of the Piazza, on benches, on the long rectangular raised pavement, sat old men and women reading their papers, boys and girls having fun with one another, and a young mother who bared her breast to feed her baby. Around the Bernini fountains, children jumped rope and played other games known to children all over the world. There are no cars to disturb these people—traffic is restricted to a narrow road around this raised pavement. On the other side of this road are the warm-colored houses, the balconies decorated with flower pots, mostly geraniums, the restaurants and the cafes, and all this bathed in soft Italian late afternoon light. We sat down at a table at one of the cafes, sipped our drinks, rested from our walk, and I sketched.

August 13

Rebecca and I were at the Colosseum. It is impossible to describe the blue Italian skies, especially in the late afternoon, and the effect of the luminous light upon the Colosseum walls. I made a drawing of a section of the wall with a side view of Rebecca sitting on the ruins of a low wall in the foreground. When I was almost through with the drawing, a boy of about eight sat down near Rebecca. In sign language I asked him to sit quietly a few minutes, which he did. When I showed him the finished drawing, the little boy smiled, shook my hand, and said, "Bravo."

August 14

A few hours after we left the deliciously hot and sunny Rome by plane, we found ourselves in rainy and chilly Amsterdam.

Amsterdam, August 15

I have seen many paintings these months, yet here I was in the Rembrandt Room, gaping as though I had never seen a painting before, at the images of the man and the woman dressed in scarlet and gold, the intimacy between them conveyed by the moving gesture of their wonderful hands. How modern are the brush strokes, how like crusted lava the impasto, how smoldering the color! "The Jewish Bride" has been cleaned since we saw it two years ago, delicately cleaned, not violently scrubbed as they often do to paintings in

America and England. We walked over to the portrait Rembrandt painted of himself in the role of St. Paul. "How old he looks! He lost his teeth!" Rebecca exclaimed softly in compassion, as if Rembrandt were a living and old friend, whom one hadn't seen for a long time, and now came upon him and found him sadly aged.

"The Syndics" is one of the two greatest portrait groups ever painted; the other is Velasquez's "Las Meninas" in the Prado.

"The Syndics" . . . words fail me. I am only a painter . . . I find it impossible even to myself to sensibly rationalize my emotion in front of this masterpiece. These men, these Dutch contemporaries of Rembrandt, who lived and probably died in Amsterdam, are timeless and universal.

The paintings are excellently displayed in the Rijksmuseum. Other great paintings there, besides the Rembrandts, are Vermeers, and the many Jan Steens. Frans Hals emerges here as an inimitable and original master. Saenredam's church interiors in white, yellow ochre and brown; three interesting compositions by the fascinating Flemish master Joos Van Gent.

August 17

The Stedelijk Museum is enormous. Many activities go on at once. A tremendous Van Gogh exhibition, a show of recent Dutch paintings entitled "Holland 1961," a display of illustrated books for children, a photography exhibition, and more.

The one that interested me most was a theme exhibition called "Polaritet"—Polarity. The aim was to show that there are two strong pulls in Western art: The "Dionysian"—the Romantic—and the "Apollonian"—the Classical. The exhibition begins with Ingres and Delacroix, continues with the French Impressionists, German Expressionists, then Munch, Ensor, Kokoschka, on to Paul Klee, Kandinsky, the other two Russians Malevich and Lissitzky, etc., and finally the nonobjective painters of today. Not one representational painting after Mondrian. As if representational art had suddenly ceased to exist, at least as far as the arranger of this exhibition is concerned. All the paintings are neatly pigeonholed into the Romantic and the Classical compartments. The Romantic paintings are hung in partitioned sections on one side of the room and the Classical on the other side. In the aisle between the Classical and the Romantic paintings are two canvases by the unclassifiable Picasso, who is used

here as the proverbial exception to prove the rule, and thus add to the validity of the show. His cruelly distorted painting of a nude is, of course, Romantic, and the other one of a Hellenistic head of a woman Classical. In the pandemonium of nonobjectivism are a couple of American paintings—a Romantic one and a Classical one.

There were some interesting paintings by Cézanne, Seurat, Kokoschka, and others, and a most beautiful study by Delacroix for "Crusaders Entering Contantinople," which is in the Louvre. But all in all this thematically planned exhibition, constructed as it was to present some theory, seemed to me very much like someone's Ph.D. thesis to prove his claim to erudition. This type of exhibition is frequent and fashionable today. Every young museum director who wants to make his debut and every assistant museum director who has to prove his worth arranges one.

Whatever my opinion of the "Polaritet" show was, I could not help but ask myself: "Where do I belong? How do I fit in, in today's art world?" I have been aware these many years as a practicing artist of the changes in our world, our life, in art, in esthetics. Surely I have changed, too, and my art is different today from what it was, say, in the late nineteen twenties. My representational paintings I am certain reflect to some extent our civilization, our time, our moment. Yet my work is not to be found these days in "Polaritet" sort of exhibitions, nor in the sumptuous and empty international displays in the United States, Brazil, Italy for that matter. I fondly hope that this is so, not because I have been unable to keep "abreast of the times" as an artist, but because I have resolved years ago to paint the way it pleases me— representationally, for better or for worse. If nonrepresentationalism I then said to myself, is the only art of our time, I would rather not belong, artistically, to our time. Did not Ingres once exclaim in anger, "They (his detractors) say that I am not of the century. If I do not like my century, must I belong to it?"

August 19

We were charmed by the old cobbled streets lined with white and brown gabled houses of Amsterdam, by the many tree-lined canals which add sparkle and light to the city, by the parklike squares. We sat for long periods at a time in outdoor cafes and watched with fascination the stern and confident profiles of the swarms of cyclists of all ages, male and female. The city itself seems to have a face, an honest

and open one. The most impressive square, "The Dam," is dominated by a monument to the resistance fighters during the Nazi occupation. At the base of this monument and around it gather the local teenagers in their faded tight jeans and sloppy sweaters.

On a large market square in the working-class section called the "Waterloo Plein" is another monument. This one is in memory of the Jewish victims of Nazism. And of course we visited the Rembrandt house, old churches, the synagogue . . . and the famous red-light district.

August 22

It rained practically every day of our two-weeks' stay in Holland. But our activities were not curtailed a bit. In the Hague we saw more Rembrandts of all periods of his life. His earliest, or one of his earliest self-portraits and his last self-portrait are there, and Vermeer's "Young Girl" and "View of Delft." We went to Haarlem, of course, to see the Frans Hals group portraits. We were impressed particularly by the two paintings he did in his old age, when he was eighty-two years old, one of a group of old men, and one of old women. They lack, needless, to say, the technical bravado of his earlier works. Spiritually, however, they are on a higher level. There is a meaningful and expressive poverty of color about these two disturbing works. The faces and the many hands seem strangely scattered, the hands especially seem to flutter restlessly all over the two canvases.

In Rotterdam another fine museum with more Rembrandts, an early and rare Van Eyck, and my favorite Hieronymus Bosch of the "Prodigal Son."

Rotterdam is a new city. It is still in the process of being rebuilt since its devastation by the Nazis. On the square overlooking the harbor is Ossip Zadkine's monument to the Resistance. It looms dramatically against the swiftly moving clouds of the sky. This heroic but completely perforated and fragmented figure seemed to us the very symbol of accusation and anger. It is in bronze, and will last long.

We went by train from Amsterdam to Arnheim, and then by bus to the Kröller-Müller Museum where we saw another mammoth collection of paintings by Vincent Van Gogh, work by French Impressionists, and by Munch, Ensor, Kokoschka, and the inevitable Picassos, Braques, Miros, Mondrians, etc. There is a wonderful adjoining sculpture park studded with bronzes by Rodin, Maillol,

63

Bourdelle, Henry Moore, Zadkine, Lipchitz, Manzu, Marino Marini, Giacometti, and many others. There are many such parks in Holland and Belgium and probably other countries, but not once did I see a sculpture by an American.

August 25

We came to the Anne Frank house, walking to it from our hotel. As usual, although we had a map, we had to ask our way several times. Everyone knew where the house was, and seemed to take a personal interest in our desire to visit it. One shoemaker left his bench and went out with us into the street to show us more clearly where to go.

We climbed up the very steep and narrow stairway to the two upper floors of this old warehouse, grasping the steps with our hands, and found outselves in an entirely empty room. In fact, all the rooms were terribly bare and empty. There were an old iron cookstove, a sink, the water closet in the hall. Everything else had been looted by the Nazis. The only sign of Anne Frank's presence in this melancholy place were her pinups on the wall in the room where she slept. They were typical of any thirteen- or fourteen-year-old girl's pinups— pictures of handsome young men, actors, ballerinas, of the Queen, of the Royal Family. Yellow and brittle with age, they were covered by glass to preserve them.

Antwerp, August 29

At the Antwerp Museum—the van der Weydens, van der Goes, the Van Eycks, and the Memlings are the gems here. The wonderful unfinished panel of St. Barbara by Van Eyck, a miraculous drawing, really, just the upper part tentatively touched by color. The "Seven Sacraments" by Roger van der Weyden, a vertical composition of a fantastically rendered interior of a Gothic cathedral, with the typically wonderfully drawn (I am tempted to say Flemish-ly drawn) lamenting female figures in the foreground. And many of those small self-contained composed portraits by van der Weyden, van der Goes, Memling, Bouts and other masters. I didn't care particularly for the huge and sumptuous Rubenses here.

We went into the great Cathedral for which Rubens painted his famous "Descent from the Cross," and "Crucifixion," and the "Ascension." The "Descent" was not here. There was a plaque saying

that it had been removed temporarily for restoration. The interior of this cathedral seemed exactly like the one in Van der Weyden's painting, "The Seven Sacraments"—stark, white, extremely Gothic.

Near the Cathedral Square is the busy waterfront and a very interesting park with long rows of benches facing each other under strange, gnarled stumpy trees. All the benches were occupied, mostly by elderly middle-aged men and women, by couples with children, but not too many younger people. All of them seemed to be rather poor and drab. We found a place to sit down and I made my last European drawing.

Ghent, August 30

Came to Ghent by bus in the morning and immediately went to St. Bavo's Cathedral to see the Van Eyck altarpiece. Going on that morning, there was a funeral of an important citizen, evidently, for the cathedral was filled with the mourners. The matronly woman who was in charge of the Van Eyck Chapel was plainly involved with the funeral, to the extent that she neglected her duties. She would leave her post every so often to listen to the eulogies, and would return with tear-filled eyes and an absent-minded expression on her face.

To me this altarpiece of the Van Eyck brothers is one of the culminating works of Western art of all time. It is mysterious, supernatural, superhuman. All the aspects of the real and the spiritual are mastered here. The figures of Adam and Eve sent a shiver down my spine—so authentically and fatally human are they. Unfortunately, the altarpiece is overilluminated by floodlights.

As we were going out, we met Benjamin Sonnenberg, the art collector, about to enter the chapel. He greeted us as if he had seen us yesterday—we met him last about five years ago in Truro. "Is my son there?" he asked, matter-of-factly. We didn't know he had a son. "A Christlike young man with a beard?" "Oh, yes, I did see a young man with a beard, looking at Van Eyck with great intensity," Rebecca said.

Later on Mr. Sonnenberg joined us at the cafe on the square.

"What does your son do?" I asked.

"Well," he answered, "my son is what my mother would call in Yiddish a 'leidig-geher,'—a do-nothing. He is an esthete. He has a feeling for cathedrals, museums, and altarpieces such as this. He writes." Presently the young man joined us, thoughtful, obviously moved by the Van Eyck. He showed us a richly illustrated book,

65

L'Agneau Mystique, by Leo Van Puyvelde. When I expressed my admiration for it, he unexpectedly inscribed it:

> "For Raphael Soyer
> respectfully,
> Ben Sonnenberg, Jr."

and gave it to me.

And they went off to somewhere in the South of France, in quest of a famous cathedral.

Bruges, September 1

Spent the whole day in Bruges. Walked from the pretentious and modernistic station along a modern road, both strangely out of character with the medieval town we soon entered, of cobbled streets, its low brick and plaster houses, its picturesque but dirty and smelly canals, and its cathedrals disproportionately huge.

At St. John's Hospital were the Memlings. What a portraitist Hans Memling was! The portrait of Martin Nieuwenhove, in a wonderful interior, with hands folded in prayer, and of two men and two women donors also with hands folded in prayer on the reverse side of the triptych "The Mystic Marriage of St. Catherine" are full of character, austere in color and composition.

In the Communal Museum again many detail-filled triptychs and altarpieces by Memling, Van der Goes, Van der Weyden, Gerard David, Dirk Bouts. One can study them endlessly. But the pièce de résistance in the museum is Jan Van Eyck's monumental and architectural "The Virgin and the Canon Van der Paele." The portrait of the Canon is one of the most searching and analytical ever painted. The infinitely detailed delineation of the features of the old man's face, every wrinkle of it, and of the pudgy hands that hold the prayer book and spectacles, of the texture of the eyes, of the white garment, are truly miraculous, as is the powerful drawing of the outline of the head. The psychological insight is extraordinary. How penetratingly Van Eyck expressed the anxiety of this man, his sense and fear of mortality!

September 3

We're in the jet homeward bound. I wonder how I will react this time to New York, after being in beautiful Europe almost four months. In

1959 when I came back, New York seemed impossible—park-less, cafe-less, harsh, impersonal. Men and women walked hard pavements silently, abstractedly. The Second and the Third Avenue bums depressed me. My work displeased me. I was melancholy for weeks and painted pictures of aimless, introverted pedestrians with masklike faces. It took time to get into stride.

I feel that I know Europe better this time, the famous European cities, at least, London, Paris, Rome, Amsterdam, etc. Of course I know them only as a tourist does, a tourist whose interests are limited to art, at that. My knowledge therefore is superficial. I had no time or inclination to penetrate beyond the facade of beauty and quaintness presented to the tourist, yet occasionally I did get an intimation of what was behind this facade. After visiting some families of European friends, I suddenly realized that the reason for so much public lovemaking in Paris or London, for instance, is the drabness and meanness of the homes of these young people. Their lack of privacy makes it necessary for them to seek each other out in streets, in parks, under bridges. What the tourist sees as a romantic aspect of European life is really a makeshift caused by necessity.

But as far as art is concerned I have had my fill. I have seen all I set out to see. I feel proud and content like a gourmet who ate well. This whole trip was really a pilgrimage to museums. I saw the bulk of the work of Rembrandt, who painted the human image in the center of the canvas as if it were the center of the universe; the altarpiece of Van Eyck—that miraculous fusion of the infinitesimal with the infinite; the cycle of life and death in Michelangelo's Sistine Chapel; the timeless frescoes of Giotto, Masaccio, and Piero della Francesca and the deeply disturbing altarpieces of Grünewald and Hugo van der Goes. I am inspired. This is the heritage of the human spirit, the constructive, creative force of man which we must continue and extend if art is to survive. From all that I have seen I am more than ever convinced that art must communicate, it must represent, it must describe and express people, their lives and times.

Homage to Eakins (I)

January 1963

I am planning a large painting, "Homage to Eakins." What inspired me to attempt this project was "Homage à Delacroix" and the Eakins exhibition in Philadelphia, which I went to see twice. I felt it would be good to make a painting honoring this great American realist. Also, for many years I've had a gnawing desire to do a large group portrait.

I contacted a few artists and Lloyd Goodrich, the biographer of Thomas Eakins. I wrote first to Edward Hopper, saying, "I'm writing to you first because I cannot conceive this composition without you in it. In other words, I consider this projected painting not plausible unless I have you in it."

I promised to use as little of their time as possible, to make a quick oil sketch of each artist, and then to compose the large canvas with Eakins's "Gross Clinic" in the background. All the artists agreed to pose, but since each one was involved with his own work, it was difficult, as I had thought it would be, to fit their schedules with mine.

Each one, it seemed to me, responded characteristically: Hopper, for instance, warned me that there might be some artists who would want to be included not for their love of Eakins, but for reasons of publicity. Baskin wanted to know who else would be in the picture. Jack Levine and Goodrich both called and said, "Of course I'll pose for you," and so did John Koch. The active interest of Lloyd Goodrich was most encouraging and helpful. It was he who suggested the inclusion of an old portrait I had done of Reginald Marsh.

The first one to come was Hopper. I had arranged with Abe Lerner (a lover of art, a collector, and by profession a book designer) to fetch him and take him back home.

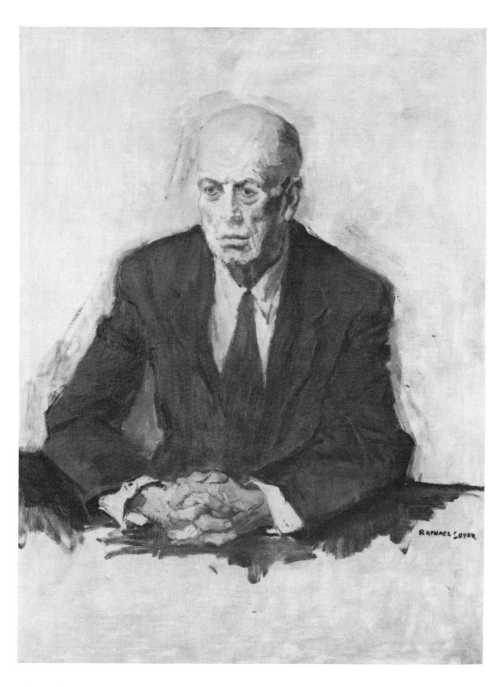

Edward Hopper

Hopper has just left after two hours' posing for a study of the projected painting. The sitting was quite an ordeal for me. I painted carefully and intensely, almost without resting. He has, to use Jack Levine's description, a "granitic" head. Curved and bent though his body is, his height comes through. I imagined him in the role of those fantastic saints who flagellate themselves, or meditate in deserts, in the paintings of Carpaccio and de La Tour. There is a loneliness about him, an habitual moroseness, a sadness to the point of anger. His voice breaks the silence loudly and sepulchrally. He posed still, with folded hands on the table. A few times he raised his folded hands to scratch his ear with the tip of one of his intertwined fingers. We hardly conversed. He was interested in the paints I used, their make, and expressed the opinion that lead white is preferable to zinc because the latter has a tendency to peel. His paintings, he said, withstood time rather well on the whole. He hasn't gotten to paint yet this year and was troubled about it "like hell." My wife came up and invited him to come down for tea. He resolutely refused. I asked him when he would come again. "I'll call you," he said. I was disappointed, for I hoped he would say "next Saturday."

February 1

Hopper didn't call. Every day I waited in vain. Rebecca, my wife, strongly advised me to telephone him, for "he may have forgotten about his promise to call, and it may even be that he expects Lerner to come for him tomorrow." But I didn't want to intrude upon him, and I phoned Lerner not to call for Hopper the next day.

February 2

Upon coming home in the late afternoon, Rebecca told me that Hopper called and said, "Where was Lerner? I waited for him all morning." I called Hopper back immediately telling him how I waited all week for his call in vain, that I didn't want to intrude upon him, and how sorry I now felt that I had not followed my wife's advice not to stand on any ceremonies and to call him to remind him about coming to pose.

"You're not intruding upon me," came Hopper's answer. "I'll come next Saturday."

February 9

Again uneasy embarrassment. At 9:45 (Hopper and Lerner were to be here at 10), Lerner phoned that the cold weather temporarily disabled his car, and he couldn't start it, and so he couldn't call for Hopper, but that he would be glad to drive him home, for in a few hours he thought the car would start up. I immediately rang up Hopper. "Eddie, it's for you," I heard Mrs. Hopper at the other end. Worriedly I explained the situation to Hopper.

"I'll get a taxi and will come down." I went down to wait for him, and soon saw the taxi from which the long Hopper extricated himself with some difficulty. We were soon in the studio again. I worked with combined frenzy and timidity. This time there was more conversation in which Lerner joined when he arrived.

"You don't have to bother to come for me," said Hopper.

"I do it for myself," answered Lerner. "It is my pleasure."

Again Hopper was interested to know whether I use zinc or lead white in the ingredients of the paints. He regretted that there are no brushes to be had today of the quality of the prewar Rubens brushes. He was interested in my easel.

"Where did you get this easel? I made mine myself. It is so big it has to be taken apart to move it out of the room."

The conversation turned to Eakins, and photography. "I would think Eakins used photography to some extent in his paintings, but Goodrich says 'No, he did not' I don't know."

Ever so often Hopper ends a statement complainingly with "I don't know."

"His (Eakins's) paintings are so dark, it is a disadvantage." He wondered how an Eakins exhibition, a comprehenisve one, would be received in Europe. He repeated a few times that Forbes Watson wrote (to him?) that When Eakins's "Concert" was shown somewhere in Italy, the spectators did not know what to make of it, and laughed.

"They simply laughed at it," he said in worried tones a few times.

I said I vaguely understood this reaction to Eakins's "Singing Woman," that static, almost mannequin-like portrait with the open mouth that looked as if it would never close. "How alive," I said, "compared to her, are the *chanteuses* of Degas, so mobile in facial expression and gesture."

In talking about Kuniyoshi's work, Hopper said: "His work is oriental, and oriental painting does not go so far as Western art. It stops."

71

I agreed with him and said: "Yes, that's very true. It does not go so far as a work by Van Eyck!"

And Abe Lerner, in his well-constructed-sentence-way, said that "Western art has an element lacking in oriental art, which once you become accustomed to, you cannot do without, and that is psychological penetration . . . in addition to the esthetic elements."

"Of course," said Hopper, "it's a very formalized art. Hiroshige is more realistic, because I think he was influenced by Western art."

We talked about photography again, about its use for painting. I said that photography could be helpful at times. "Your jacket, for instance, does not retain the same folds each time you come to pose."

"I took a photo of a landscape once and could not use it," Hopper said. "Photography is so light, no weight to it."

I then mentioned the early photographs of the Parisian, Atget, and the American, Brady, whose portraits and Civil War pictures do have a three-dimensional quality. Lerner praised Nadar and Bresson, but Hopper ponderingly insisted, "They can't get the same weight as painters can . . . I don't know."

"As Hopper can," I thought. His paintings of dunes, bridges, houses, have this weight.

Hopper often talks about movies. "Jo and I go to movies a lot." He mentioned the *Long Absence* and *The Twelve Angry Men*. "Did you see the French movie, *Mon Oncle?*" he asked. "It's a good satire on modern technology."

After two and a half hours of painting without a stop, I asked Hopper if he was tired.

"No," he said. "I can pose more. You don't have to hurry."

But just at that moment my wife came up, carrying our grandson, snub-nosed, lively-eyed, full of promise and potential, but as yet unable to walk or talk. "May I introduce David to you?" she asked. "This is David. David, say hello to Mr. Hopper."

"He doesn't have to say it, if he doesn't want to," said the octogenarian in a sepulchral voice; and there was some warmth and humor in his eyes, I thought, as he glanced from under his forehead at the infant.

February 16

Abe Lerner came in with Hopper at 10 a.m. As always, we immediately went to work. Hopper looked older, quite haggard, his lips purple,

almost bluish, and at times he seemed to have difficulty focusing his eyes. Conversation was desultory. I told him that I heard that the Kastor Fund recently purchased a painting of his for the Metropolitan Museum.

"Yes," Hopper said, "a painting of a lighthouse. The museum acquired it from my dealer, who, in turn, got it from its former owner. I painted it long ago—about forty years ago."

He said he met a niece of Edvard Munch, the Norwegian painter, a trained nurse, who took care of him when he was ill in the hospital. He happened to talk about her because when he came he was holding an opened letter, which may have been from her. "We became friendly," he said, "and correspond. She gave me a book on Norwegian art. It is terrible. They haven't ever produced good painters. Draftsmen, maybe."

A professor, head of an art department, recently asked him to participate in an art symposium with the nonrepresentationalist Motherwell and others. "I said *nix*. Painting has become a matter of words to such a great extent." he said sadly.

I told him that since I've decided to paint this "Homage to Eakins," I have been looking at paintings of portrait groups, the Franz Hals paintings, the "Syndics" by Rembrandt, etc. There is the problem of combining the various faces and figures, different in size and complexion. "Jack Levine is quite tall," I said, "but would appear small next to you."

"Yes," Hopper answered, "he has a narrow face," and with sudden interest he asked: "Have you started him?"

"I was looking at Rembrandt's "Syndics," I continued. "He did a marvelous job of harmonizing the different sized and complexioned people."

"Where is that painting . . . in Amsterdam?" Hopper asked.

"Yes," I replied.

We then talked about writers on art and critics. We discussed their virtues and shortcomings.

"They don't seem to write what they think," Hopper said. "Of course, there are pressures. They weave a fabric of words that doesn't seem to have much to do with painting. I don't know," he continued, after some brooding, "they don't actually paint themselves, they are looking inside from the outside, you know."

"Did you know McBride?" I asked. "He wasn't bad."

"He was amusing . . . Guy Pène du Bois was better." (He

mentioned du Bois's name several times with something like fondness.) "He knew more about painting, for he was a good painter himself. I was a fellow student of his at the Chase School. We both studied with Henri, too, who was a good teacher, talked a lot about life in connection with art, and revolution in art. But he was a limited painter, just the model and the background."

"I think that all of them," I said, "lacked quality, style—Henri, Bellows, Sloan."

"Their movement was important in American art, but they were not great painters at all. Du Bois had no use for Bellows; Glackens became arty after a while."

Hopper was last in Europe in 1910. He lived in Spain, Paris, Holland, Belgium, and for some time in Germany and England.

"I would like to see Italy. I've never been there," and he added, as if to himself, "Gulack doesn't like Italy." (Gulack is an artist who recently became friendly with the Hoppers.)

We talked about Italian art. "It is too lush, and sweet at times," I said. I mentioned Van der Goes's "Adoration of the Shepherds" at the Uffizi, which surpasses its contemporary Italian paintings of similar content. "I love Masaccio, he is so human," I said.

"Mantegna is very masculine and vigorous," said Hopper, "and Piero della Francesca seems to be the idol today."

We discussed the state of preservation of these paintings and murals. Hopper described a Dutch or Flemish painting he had seen at a dealer's. "I don't know the artist's name. It was just a square, a beautiful sunlit pavement and houses—no figures."

He talked about Mexico where he painted some watercolors. Had he met any of the Mexican painters who were quite popular here at that time?

"No. At a hotel where we stayed once, Siqueiros stayed, too. I didn't meet him."

"Did you know any of the French painters when you lived in Paris?"

"No, I didn't know anyone. Gertrude Stein was on the throne when I was there."

It was twelve-thirty, and I told Hopper that I had finished for the time being. I asked him if I might call upon him again should I need him.

"Yes, you may," he answered.

74

I was flattered and even moved that this seemingly unfriendly and

aloof old man posed for me so willingly and patiently. One artist once told me that when he asked Hopper to sit for a drawing, "his face assumed the expression of one who stepped on a rattlesnake." When I asked Hopper if he had ever done a self-portrait, he said: "Only once, and, according to Jo, so mean looking I never showed it."

I think by now Hopper wants to resemble the popular image of him: an objective, aloof man, cold, without an emotional interest in life or the art of today. His work is like himself—frugal, lonely, weighty, truthful, unadorned, unsentimental. I remembered seeing him recently at a gathering sitting on a hard bench all by himself in a roomful of chattering cocktail-drinking men and women. There was an aura of aloneness about him. How much like his paintings he seemed!

He's "worried like hell," he complained the other day, because he hadn't begun to paint this year, but I believe that he paints mentally all the time. The composition, the content, has to be clear and accurate in his mind before he begins to lay it out on the raw, white canvas. On the Cape, he sits against the wall of his white house, perched on a hill facing other hills, and studies the landscape weeks on end. He waits patiently for the fall "when the shadows grow longer and, in fact, wonderful."

April

When Lloyd Goodrich strongly urged me to include Leonard Baskin in the Eakins painting, I did not realize to what extent Baskin had become involved with Eakins. From what I had seen of Baskin's work until that time, I could not find any influence of Eakins in it, and I still am not able to see any relation of Eakins to Baskin's work. He seems to be attracted to him personally rather than artistically. Baskin's predilection for little-known, not widely popular, and nonglamorous figures in art may have led him to Eakins, who worked in loneliness and was known to few in his lifetime.

His preoccupation with Eakins is revealed in a series of etchings which Baskin made of him, imaginary portraits of different periods in his life, showing movingly his industry, integrity, persistence in his strivings in the face of rejection. To Baskin, Eakins represents a tragic figure. He showed me a photostat of a photograph of Eakins in his late years, and said, "Look at his eyes!" And his eyes were big, wide-open, and seemed to me at that moment, terribly sad.

One evening, in his house, Baskin showed me his treasures:

75

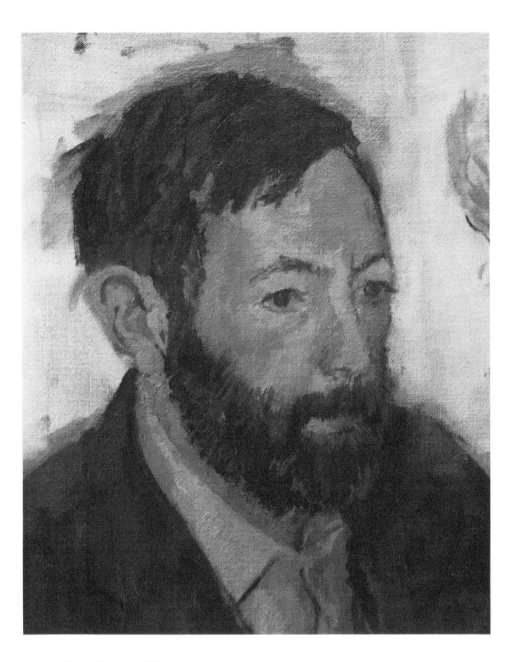

Leonard Baskin (detail)

several paintings by Eakins; old photographs of him and photostats of photographs; a letter in Eakins's handwriting, carefully enclosed in transparent plastic; Eakins's tiny brushes, one of which seemed to me encrusted with paint; and a small wooden penholder whittled by Eakins himself, with a nib in it, black with dried ink. All these objects he handled with reverence and tenderness.

The first time I met the Baskins, Leonard and Esther, was at a party, and they were sitting by themselves, a young, handsome, and shy couple. Ten years later in the summer of 1962, we visited them, my wife and I, at their summer home on Deer Isle in Maine. I did not recognize him. He looked like a hermit, with reddish-brown hair and beard, stooped and hollow-chested, with an indoor pallor and red-rimmed light eyes.

It was a gray and moody day. He took us for a walk from one end of his land to the other, along the water's edge. From the house to the water he had built a trellised walk, and had already planted climbing roses along its path, which would eventually cover the entire overhead structure. I visualized this rose arbor in bloom, and it seemed to me like injecting a bit of Fragonard into a Ruisdael landscape. "I'm building this for Esther. She will be able to use this as a sort of promenade in her wheelchair from the house to the water," Baskin said.

Inside the house where Esther had already been seated at the table, we had tea, and we talked. Esther showed us her recently published book, *Creatures of the Night,* illustrated by Leonard, and mentioned another book she was planning to do.

I went to Northampton to make the study of Baskin for the Eakins painting, and I was a guest at his home several times. We took a walk the first evening through a small woods surrounding his house, and soon his small son joined us, taking his father's hand. After a while I felt his other hand in mine as he walked between us taking part in the conversation.

His house was filled with many books, paintings, and drawings. Everything there revealed his particular interests—the drawings were by old masters not generally known; many of the books were in old print, decorated with woodcuts, and he had them for that reason rather than for their content. The walls were literally covered by shelves with books, by drawings and paintings. Some pictures had no room to hang, and were standing along the walls and on tables. The furniture was antique and unusual. After dinner he brought out portfolios with more drawings by obscure masters, anatomical drawings, and etchings.

Baskin posed well, and made me feel absolutely at ease. He was interested in the way I worked from a living model, for he himself never works from life. He told me he never sculpted a female figure. We talked about art and artists and I found he has strong opinions, definite likes and dislikes, and is intolerant of pretense. We often used Yiddish and Hebrew expressions. He prefers Yiddish, he said, because it is a folk language.

I worked two days, mornings and afternoons, with time out for lunch. While painting him, I was always aware of his paleness in spite of his living in the country all year around. Once while walking with him through the campus, I noticed he deliberately avoided the sun. He showed me his bronze sculpture, set up against a brick wall on the campus, of an untidy owl whose talons and beak were powerful, shiny, and polished, in contrast to the ruffled texture of the rest of him.

On my way home I thought a great deal about Baskin. Now that I have met him in personal surroundings his art has acquired more meaning for me. I watched him work for a while on one of his wood carvings of a male neo-mythological figure, without a model or a drawing to guide him. He worked with great assurance, as if from a vision. Personally, I am intrigued by and amazed at artists who work completely from imagination. For I, in my work, have held back from surrendering to it, or to invention, and have always based my work upon factual reality.

Baskin's art is as complex as he is, as his life is. Among other traits in it, I have been aware of what I would call a strain of Jewish lacrimosity, deep-rooted. His drawings of metamorphic faces, with eyes shedding tears that form lakes, recall to my mind such an intrinsically Jewish phrase as *teichen-treren*—rivers of tears. He makes use of in his art whatever life brings to him, and thus creates a sort of personal mythology tinged, of course, with many influences from ancient arts, the sculptures and mummies from Egypt, the lavafied forms of humans and animals from Pompeii, and other similar influences, symptomatic of an almost medieval concern with death. Like Bosch, Holbein, Baldung-Grien, Grünewald, with their dances and triumphs of Death. Throughout the ages artists have been thus involved with mortality—now recently Lovis Corinth in his paralyzed old age; also James Ensor and Edvard Munch, of course, painted pictures with death as the central figure. It may be that Baskin belongs to this group.

Europe, 1963

They are cleaning Paris these days, washing off the dust of centuries from the old buildings. They are doing it carefully and delicately, trying to preserve the stone with which the public buildings and churches were constructed. They are not sand-blasting, but washing them gently, with the same care with which they have been cleaning their treasured paintings.

Paris museums have a great fascination for me because there is such a variety of art, unlike the Italian museums where art is predominantly Italian, or Belgian museums, where it is predominantly Flemish, or Dutch museums where, of course, their native art predominates. The Louvre is ten museums in one. It contains the greatest collection of French art, from the Avignon Pieta to the wealth of Corots, including Poussin, LeNain, de La Tour, David, Ingres, Delacroix, Géricault, Courbet, and in such profusion. Besides the French works, there are the unique masterpieces: the da Vinci "Madonna of the Rocks," Van Eyck's "Madonna of Chancellor Rolin," Rubens's "Kermess," Rembrandt's "Bathsheba," Tintoretto's self-portrait as an old man, Bellini's "Risen Christ," and the gigantic, serene, great technical achievement of Veronese's "Marriage at Cana."

The distribution of paintings among the three national museums in Paris is a very intelligent one: in the Louvre are all old masters and schools through the period of Corot; in the Jeu de Paume, the Impressionists; and in the Musée d'Art Moderne, the Post-Impressionists through the contemporary artists. The Louvre contains artists of many nationalities, the two other museums are strictly for French artists—not a Mondrian, Paul Klee, or Kandinsky, no Beckmanns, no Munchs, no Kokoschkas, Corinths are to be seen in them. A few foreign-born painters, however, who lived and worked

mainly in Paris, have been accepted—Chagall, Soutine, Pascin, Modigliani. I am accustomed to, and prefer, the international character of the Museum of Modern Art in New York, where artists of other countries, besides the Americans, are found.

In the Jeu de Paume I looked again at the group compositions by Fantin-Latour, and wondered about my "Homage to Eakins" for which I have made a few tentative studies. Already I'm running into some difficulties because of lack of knowledge of how to do a big painting like that. Where should such a big canvas be placed in relationship to the subject if I want to work on the figures from life after the composition has been formed? Were these paintings of Fantin-Latour really done from life? They seem to have been.

Another thing that interests me is the feeling of unity and intimacy prevailing in these compositions, "Homage à Delacroix, "Le Coin de Table," and the Batignolles painting. Was this achieved by the chiaroscuro in them? The artists depicted here seem to have known one another. Manet is surrounded by his friends. In "Le Coin de Table" the romantic poseurs are alike in age, dress, and beard, except for the very young Rimbaud. The group in "Homage à Delacroix" consists not only of those who remembered him but also of his youthful admirers— Manet watched Delacroix's shadow through the lighted window of his studio, and observed his movements.

I can see from the preliminary studies that the painting I am planning will have no such feeling of intimacy or unity. The light will be flat and sharp. There is also a difference of age, from the youthful Dobbs to the eighty-year-old Hopper. I wonder if even the painting, the "Gross Clinic," which I shall paint in the background, will create some feeling of unity. None of these artists who have posed for me for this painting has been so involved with Eakins as those in the Fantin-Latour painting were with Delacroix. They were his young contemporaries and they intensely admired the older Delacroix. None of these whom I am painting had any similar relationship with Eakins; he had no such influence on them. This forgotten-during-his-lifetime Philadelphia painter is now looming as the great figure in American Art.

Of course, the fact remains that I haven't even begun the large canvas.

This was a Delacroix summer—one hundred years since his death in

1863. Paris was busy with Delacroix exhibitions of his paintings, his murals, his drawings and graphics. The Louvre had the greatest display. It is hard to imagine what other artist's work could have covered so much wall space. Half of the tremendous Gallery Appolon was given over to the show.

What was interesting to me were the drawings: hundreds and hundreds of them, studies for the large paintings, and small studies in oil, were hanging alongside the finished compositions. Near "Liberty Leading the People" were many studies of the heroic figure of the woman, holding the flag aloft. Near the "Death of Sardonopolus" were magnificent studies of nudes for the painting in black-and-white and in pastel. There were many drawings of animals in all sorts of action, done in pencil, pen-and-ink, and in water color for the paintings of hunting scenes; there were also bright and delicate sketches in water color of oriental men and women, and of interiors for the Algerian paintings—drawings for the "Ship-Wreck of Don Juan," for "Medea Killing Her Children," and many others, including studies for the wonderful "Massacre at Scio."

This gave me insight into the way Delacroix worked: how this visionary romantic conceived the large paintings; how he enlarged upon his visions from small sketches to more elaborate ones for the final composition; how he painted separate detailed studies for the figures in the composition. It is interesting to compare him with Courbet, who painted the "Burial at Ornans" and the "Studio" directly, without any preparatory studies. My favorite Delacroix paintings still are his early ones: the 'Visit of Dante to Virgil," "Liberty Leading the People," and the "Massacre at Scio." To me they are his three faultless, spirited works. There is a complete fusion in them of conception with execution. He labored long and arduously on them without losing the fiery spontaniety of the original conception. In his other paintings there are outstanding, unforgettable details such as the raped women in "The Crusaders Entering Constantinople," or the nude in the "Death of Sardanopolus," but the other parts of these paintings do not carry forth the quality of these details, thus lessening the unity, the wholeness of the entire picture.

There is a startling picture, or rather a huge fragment of one of a lion hunt, a bloody chaos of struggling animals and men, of fiercely clawing lions, of men desperately trying to spear them, of a fallen horse (always horses with dilated nostrils, with wide-open frightened eyes. It is painted riotously, with the kind of fury such subject matter

demands, with colors of crimson lake that bring to mind the occasional violence of a Soutine. There is a sadistic element here inherent in romantic paintings of this kind.

As part of the centennial celebration, the house in which Delacroix lived and worked was converted into a museum containing his memorabilia and was open to the public. We visited this with our friend, the painter Joseph Floch, who excitedly told us about some Delacroix frescoes decorating the libraries in both the Senate Building and the Chamber of Deputies.

An amusing sidelight on the character of the French was revealed in our efforts (successful) to see these murals. Neither of these buildings was open to the public at the time we got there, but Floch, in his determined way, was able to convince the guards that it was important for us to be admitted that day. Not only were we allowed in, but we were given a guide to lead us to the murals, to light them for us, and to conduct us politely out. How different was this attitude from what prevailed in New York, where a guard would point at a sign and rudely say, "What's the matter with you? See the sign? Can't you read? It's closed!"

Milan, July

The big experience in Milan was to see again Leonardo Da Vinci's "Last Supper." Before entering the Chapel of Santa Maria della Grazie we wondered how we would react to this painting. Was our reaction to it two years ago conditioned by the universal adoration of da Vinci, by the accustomed awe in which we held him?

When we looked at the "Last Supper" this time, in the morning light of the empty chapel, it seemed to us even more satisfying than we had remembered it. We wondered if its present condition, with so much of the final layers of color rubbed off and faded by time, does not add to its abstract beauty. We had seen two well-preserved contemporary copies, one in the Louvre and the other in the Ambrosiana in Milan. Both were rather dull and academic. But here we were deeply moved by the gray softness of the Apostles' robes, with tinges of orange, old rose, green, yellow—all, now, tentative colors; by the deeper warm grays of the walls and ceiling; the marvelous perspective congenital to the composition; the wonderful space and light behind Christ; and contrasting with the serenity generated by all these qualities, the feeling of utter agitation in the painting expressed

by the faces, the movements, and gestures of the disciples. The feet of all the figures have become completely obliterated. There is nothing but different shades of grayness left; the hands and faces, though distinct and living, have lost their absolute delineation, have become somewhat blurred, thus acquiring a metamorphic quality, lending to the whole work an atmosphere found in some of our own contemporary art.

The rest of the art in Milan was rather dismal. Of course, in the sea of *seicento* paintings in the dark and gloomy Brera are the magnificent "Madonna and Saints" by Piero della Francesca; Mantegna's foreshortened Christ; moving compositions by Bellini, and a very fine portrait of a red-bearded man by Lorenzo Lotto.

Shockingly neglected are the outside walls of the Ambrosiana Museum, their age-old mustard yellow peeling and showing dirty gray plaster. The interior, evidently a former well-kept palace with marble columns and tiled marble floors, resembles a huge antique shop with its indiscriminate collection of paintings, sculpture, fragments of sculpture, and even dishes, bric-a-brac, and furniture. But it does have the huge, original cartoon of Raphael's "School of Athens," a portrait of an unknown lady by de Predis, and a "Musician" by da Vinci.

I had always wanted to meet Renato Guttuso, whose work I have known for some time, but somehow on our previous trips to Europe we were unable to make contact. This time, however, we did get to see him at his summer home in Velate-Varese, a small town in the hills not far from Milan, where everyone seemed to know Guttuso, and we were soon directed to his house. We were greeted by both Renato and his wife with unaffected warmth. We spent three hours with them in interesting conversation. We saw his work in his studio, and we stayed for lunch.

He thanked me for sending him my book, *A Painter's Pilgrimage,* but even before he got it, he said that John Rewald, the art historian, had sent him an Italian translation of the allusions to him in it. That surprised and pleased me very much. One of the passages referred to the negative attitude other Italians had toward Guttuso and toward one another. He seemed to accept it for a fact. But I said again what I had written in the book: that in Italy today a very few artists have so far outstripped their contemporaries in achievement and fame, that there is a sense of resentment on the part of those who are left behind.

I spoke very freely and frankly. I said that when I mentioned his name, or that of Manzu, to some people in Italy, there were such comments as "Oh, Guttuso, he's a Communist!" or "Manzu? Why, he's a Catholic!" To which I would reply that my interest was purely in their art, and that, moreover, Catholicism has certainly created a great art, and surely good painting should not be incompatible with Communism.

All this, and other conversations, were held in Italian, French, and English. Guttuso understands quite a bit of English and is able to interject an English phrase effectively into the general thought, and Madame Guttuso, with her excellent command of English, translated for him. Whenever necessary, Guttuso tried to communicate in French with my wife, who translated into English for me.

I told him that one day, while working in my studio, I heard his name mentioned in a broadcast on culture in Europe. It turned out to be a discussion on Guttuso in which his work was described rather intelligently, linking it to Delacroix and Géricault. To this he commented that he had gone to Paris just to see the Delacroix exhibit, and while he was greatly impressed by its vitality and spirited romanticism, he feels, at this particular moment, a greater affinity to Gericault, and especially to Courbet. I was delighted by his mention of the great realist who painted the "Burial at Ornans."

Then I said, "You know, I often think of you as a present-day Tintoretto. In your drawings and paintings there is a tumultuousness and restlessness which can be described as 'Furioso de Guttuso,' to paraphrase an old Tintoretto epithet." To which Guttuso shrugged his shoulders and quietly said he was greatly honored, but embarrassed by this comparison.

He asked me about my work. I told him with some hesitation that I was of an older generation than he, and of a different course of development; that I began to paint comparatively late; that it was only after World War II that I became aware of other artists besides the French Impressionists. For it was then, after the war, that the Museum of Modern Art in New York put on the great exhibitions of Kokoschka, Munch, and others. I told him that I was quite accepted in America as an artist in the thirties, but there came a period of decline for some time due, perhaps, to the ascendance of the various *isms* in art and, perhaps, also to a temporary slackness in my work. "At this moment, however, I have a feeling that my reputation is rising again."

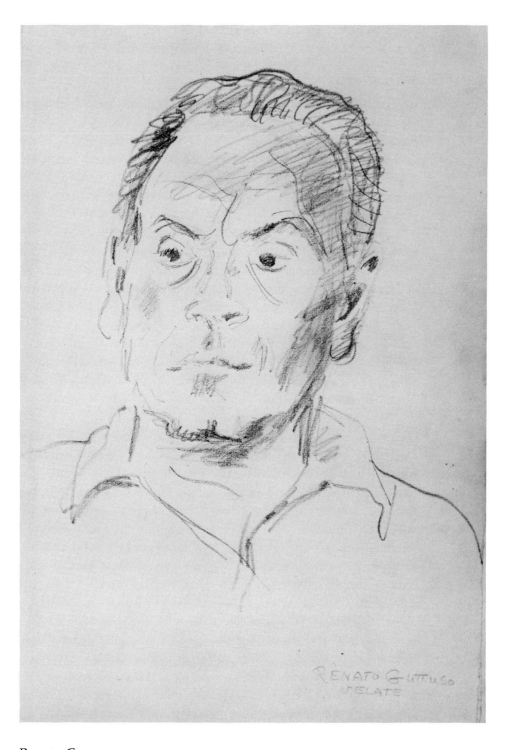

85

Renato Guttuso

I told Guttuso that we expected to be in Leningrad and Moscow, and I wanted very much to hear about his experiences there—how his exhibition was received, what he thinks of the art there, etc. He said he was officially invited to exhibit and was received very well everywhere. The authorities went out of their way to be friendly; he was honored, and was made a member of the Academy. But, nevertheless, he felt an antagonism towards his work on the part of the Academicians, and also (he said, smilingly) on the part of the young rebels who are trying to embrace abstraction. But, he said, there was a good core of those who accepted his work with approval, who were also members of the Communist party.

We talked about art in the Soviet Union. He did not absolutely decry it, as has been the fashion all this time. He found much ability there, but he thought their art criticism was old fashioned, not developed. They are still looking for content mainly, at the expense of form and aesthetics.

"Their paintings," I said, "have a literary quality which is more suited to writing rather than painting."

With a thoughtful expression on his face, Guttuso said he is now working on a pamphlet, "Art and Socialism in a Socialist State." It will be ready in October.

We continued our talk about Italian art, and he spoke thoughtfully and honestly about his contemporaries. I was amused to hear him describe a certain artist as lacking in *samo-critica*—the Russian phrase for self-criticism.

He showed us his paintings: a magnificent reclining nude, her thighs and knees expressively raised forward; two canvases painted rapidly and thinly of heads and busts of young girls; a tall canvas of a standing worker, in vivid reds and blues with an almost black background; another upright canvas, which he calls "A Deadly Wind Blows," has its title from a poem by the Italian poet Saba and represents a semi-kneeling back view of a man (an Algerian or a Negro; Guttuso said, "It could be any man") caught in the web of the evil menace of the world as symbolized by a roughly painted black swastika in the murky, threatening background of the canvas. He likes to paint and draw very free variations of some of his favorite pictures: a self-portrait of Van Gogh, the "Death of Marat" by David, the "Head of an Executed Man" by Géricault, a detail from the large "Studio" of Courbet and his model. These are done very freely, convulsively, almost in a sleight-of-hand manner which distorts them and gives them his mark.

At lunch I constantly kept my eyes on a huge early canvas, hanging in the dining room—a modern, stormy version of the Crucifixion with a naked, lamenting Magdalene, nude soldiers on horseback, and an extraneous still life at the bottom of the canvas, beautifully painted, colorful, vivid, and plastic. It was painted in 1940 and condemned both by the fascist government and by the Catholic Church. Mme. Guttuso good humoredly told me that the Church conducted a trial against her husband for painting this Crucifixion, but the verdict was that, although he painted it with the help of the devil, his intentions were good, and therefore he was acquitted.

After lunch I did a quick drawing of Guttuso. We parted very warmly, and he presented us with a huge tome of facsimile reproductions of his black-and-white and colored drawings, inscribing the book affectionately to us. Now, as I look through this book of drawings, and also a book of his drawings and paintings compiled by Diulio Morosini, I continue to feel impressed by the vigor, the temperament, and by the contemporariness of Guttuso's art, so intensely preoccupied with people, life, and events, by his draftsmanship, lightning-quick and bold; the vivid, almost brutally direct color.

Rome

Raphael's monumental portrait of Pope Leo and the attending cardinals at the Uffizi, his other portraits in Florence, as well as his murals in Rome, have raised him greatly in my estimation. Until now I had the feeling, commonly shared, that his painting was too suave, too polished in technique, its surface almost eleographic. But there is nothing soft, prettified, or saccharine in his portraits of women.

There is a noble earthiness about his "Donna Gravida," and her hand placidly resting on her pregnant belly; and the magnificently attired "Fornarina;" and the "Madonna of the Chair," her full shoulders and bosom wrapped in a green shawl. Their serious, almost austere faces have no highlights, no lustre, no superficial liveliness. I began to understand why many artists, the great Ingres among them, were so moved and influenced by Raphael.

The "School of Athens" at the Vatican Museum was simply a feast to the eyes (to use a threadbare expression). It is in a beautiful state of preservation; the color is unusually fresh when compared to other frescoes of that period. The harmony and the rhythm of the composition, the noble figures of the philosophers, scientists, artists,

87

poets, are wonderfully posed and drawn. The architectural background functions so well in relation to them. Even the way the painted plaster has cracked in that mural serves to add to its textural quality. A warmly intriguing note in the painting is provided by his own self-portrait, together with that of his master Perugino, on the right side of the mural.

And talking about self-portraits, we saw for the first time the one of Raphael in the Uffizi Gallery—the most lovable, delicately drawn-and-painted self-portrait ever done.

One day in Rome, walking through a crowded street, I heard someone call me by my name. A small, dilapidated car stopped and we saw Judith Shahn and her poet-husband, Alan Dugan. They invited us to visit them at the American Academy in Rome. There we saw Ben Shahn and his wife, Bernarda Bryson, together with the young Italian artist, Bruno Caruso. Judy showed her work. Her father's influence seems to be on the wane, and her own individuality is becoming more assertive.

I watched the silent and cadaverous Dugan, who was helping his wife pull out her canvases. In New York I had read his slim volume of poems, and I was interested in seeing him at close range. He seemed a difficult man to know. I made a drawing of him. He posed for quite a while, and then, without warning, got up and said, "I can't pose any more," and, without looking at the drawing, walked off.

The next day we visited Bruno Caruso, a very able artist, but whose facility may spell danger for his future work. The influences I noticed particularly in his paintings were George Grosz and Ben Shahn and, hanging on the wall among others in his collection, were examples of these two artists. Caruso's work doesn't have, as far as I could see, the simplicity or the genuineness of either one of them. He seems to elaborate too much upon the more obvious characteristics of these two painters. This may be natural for one who is under the spell of those who inspire him, and with time he may grow out of this imitation and become himself.

Known European artists seem to live better than artists in America, more "graciously," more artistically, in seemingly more relaxed and spacious surroundings. For example, in Paris, Zadkine lives in the

heart of the city, in Montparnasse, but his house and studio are set in a charming walled-in private garden; Carlo Levi's house in back of the busy Piazza del Popolo in Rome, seems to be situated in the midst of a willow grove, which has to be reached by walking through a wooded road. Also in Rome, the narrow Via Margutta where many artists work and live, hides behind its old facades many exotic studios overlooking charming gardens. In New York, this would be out of the question.

When we visited the studio of our old friend Corrado Cagli, tastefully appointed, but less impressive than the others mentioned above, he invited us to his "new apartment" a few blocks off, where we gasped at the luxurious suite of rooms, lavishly furnished, decorated with some of his recent very beautiful tapestries. Here he has installed his interesting and comprehensive collection of drawings, which range from the work of some famous old Italians, to his contemporaries, and students. Among them, in this good company, I was gratified to find my sketch of Eugene Berman, which I had presented to Cagli two years before. Corrado showed off this place with modest pleasure.

He talked about his work, the tapestries he had made, two of which are based on his abstract paintings, the color inspired by the ancient brick ruins peculiar to Rome; another tapestry romantic and classical at the same time (if possible?), a bust of a young man picturesquely clothed and hatted, in colors of burnt umber.

On a portfolio of reproductions of his work he made a pen drawing for me, and presented my wife with a volume of Ugo Foscolo, the Italian poet, illustrated with Cagli's beautiful drawings in classic style.

We left him sitting alone on an antique upholstered couch, leaning forward, his head and neck deeper than ever in his shoulders.

Munich

Two years ago when I visited the Alte Pinakothek in Munich, I was somewhat repelled by German art, except for the serene and intense work of Holbein and Dürer. The compositions of Cranach, Pacher, Altdorfer, and others appeared to me melodramatic, at times gruesome and comical, peopled with contorted, gesticulating figures, with grimacing physiognomies. This time, however, I reacted differently to them. I was fascinated by the curious imagination of these artists, and by their mysticism.

An unusual painting is the "Battle of Alexander" by Altdorfer,

where on the same canvas, one sees in a turbulent, apocalyptic sky, the sun setting and the moon rising. Thousands of mailed horsemen are battling in a landscape of mountains, lakes, seas, and forests. Suspended over all this, in the middle of the picture, is a framed tablet proclaiming Alexander's victory.

And Cranach, whose portraits I am amusedly fond of, but whose compositions and nudes I frankly dislike, impressed me this time with his expressionistic painting of a blood-streaked Christ on a cross, in a barren, hilly landscape, the white loincloth fluttering starkly in the wind against a bleakly-clouded sky. An awkwardly kneeling, heavy, blank-faced cardinal in crimson and white robes, contrasts sharply with the tortured Christ.

A unique painting of Grünewald is the large "Saints Erasmus and Maurice." It is completely devoid of his usual exuberant, if tragic melodrama, and is permeated instead with a subdued animation. The life-size figures in apparent conversation are oddly detached from each other. In the background, between the two saints, is a wonderful old open-mouthed, toothless man.

Dürer is here in full force, with his two panels of the "Four Apostles," and some religious compositions. Outstanding is a group of portraits, including the one of himself, full-face, symmetrical, visionary, with an intense and continued gaze that is not of this world.

The Holbein family is represented by several altarpieces of Hans the Elder and Sigmund Holbein. Strangely enough, there is only one very small portrait by the genius of the family, Hans the Younger. In Basel we saw some very sensitive paintings by Ambrosius, who died very young. This makes quite a painting family.

There are some fine portraits. The Germans have always excelled in portraiture. Even in recent times great portraits have been produced by Leibl, Lieberman, Corinth, Dix, Grosz, Beckmann. As a matter of fact, the Apostles of Dürer are really portraits; the magnificent figure of St. Erasmus by Grünewald is a portrait of Albrecht von Brandenburg dressed in gold-embroidered and bejeweled bishop's robes; the head of the old man in that painting is that of a known abbot; and Cranach's clumsy, kneeling cardinal is also a portrait of the much painted von Brandenburg.

There are two large panels, humorless portraits by Bernhard Strigel, one of a melancholy widower, and the other of his eight children of serious mien, with a madonna and child and angels fluttering hoveringly above them. In the background of this panel is

the legend: "We beg thee, pure Mary, be a mother of us." The father's panel has an inscription begging the Lord to guard him against temptation.

Two small, very fine portraits by the intriguing painter Hans Baldung-Grien are immediate and direct, one of a richly clad young prince, and the other of a bearded man with an aquiline nose, thin lips, and heavily-lidded, rolling eyes.

Among the early Flemish paintings is one of Roger van der Weyden's masterpieces, the "Coloumba Alterpiece." It is faultlessly composed, and everything, to the smallest detail, is perfectly rendered. But to me there is something wanting, as in all of this master's work. There's a complete lack of modulation of tone; it is flat, like a tapestry; the figures seem carved in very flat relief, engraved. Space is suggested only by diminished sizes of the more distant figures and objects. This lack of tone, this lack of recession in color, this sharpness, may account for the painting's surrealist quality. There is something formal, austere, and abstract about his work, with its cool colors and cascading folds of the garments. This formalism is accentuated by the vertical architecture of the two side panels, the interior of the Annunciation, and the courtyard of the Presentation.

The other van der Weyden is also a flat and airless painting of St. Luke (a self-portrait, I would like to believe) gazing with reverence at the posing madonna, and making a charming drawing of her.

One reads Memling's "Seven Joys of Mary" rather than looks at it, so much story-telling is in it. I liked particularly the two tiny portraits of the donor and his son.

By Hugo van der Goes there is a small painting, probably a fragment of a larger work, of a madonna and child and an angel holding a cross. Although it is in very poor condition, the troubled undertones, characteristic of this artist's work, are evident.

There is a surrealistic composition (how often I find myself using the word "surrealistic" in describing Flemish paintings!) by Dirk Bouts, of a startling, slender, risen Christ, half-naked and half-covered by a red cloth, with a group of suddenly awakened soldiers, one of whom, seen from the back, is still asleep and partly covered with a gray quilt, a steel helmet on his head—altogether a strangely inanimate-looking apparition.

The sixteenth-century Flemish painters are well represented— Massys, Van Cleve, Cossaert, and others, an able but inferior and decadent group of artists. Their compositions, compared to earlier

masters, are flamboyant, over-elaborate, mannered to the point of eccentricity, trivial, and sentimental.

The Rubens paintings at the Pinakothek are astonishing in quantity and quality. Seeing his work in profusion makes me think of Shakespeare, for certainly in subject matter he is as encompassing. He painted men and women in the act of love; women suckling babies; men abducting women; men hunting and at war; women crowning victors; men massacring the innocents; women turning into clawing furies, shielding and mourning their children. He painted historical pageants, triumphant entries of victorious warriors, saints theatrically performing miracles. And the populace in these paintings—the spectators, the cheerers, the beggars swarming with children—painted with the kind of observation found in a Breughel.

His mythological subjects! The obese, carousing Silenus; the satyrs pursuing, capturing, and caressing buxom nymphs; a huge female satyr crouching and nursing her horned babies, the moist nipples of her full breasts pouring milk into the gurgling throats and wetting their faces with the overflow—fantastic! And the splendid nakedness of it, the draperies accentuating bodily movements and physical fullness!

The same exuberance is in his landscapes. He painted storms, sunsets, rainbows, everything that ever happens in nature, and all that lives in the landscapes—animals, shepherds, woodcutters, milk-maids, lovers.

Often I found myself copying details from Rubens. It was like drawing from life, from living models in action.

The Pinakothek, like other European museums, has a collection of Rembrandts. "The Passion of Christ," a series of six paintings, is here, describing the events of his life in a universally human manner. Unlike the German and Flemish paintings dealing with the same subject, they are not sermons on Christianity. They are devoid of symbolism, the only supernatural element in these dark paintings being the light which radiates from Christ and illuminates the interior.

Broadly painted predominantly in brown in a very wide range of tones are two portraits—one of the sympathetic Hendrickje Stoffels, and the other of a hairy, bearded peasant, an apostle, his rough hands folded in prayer. There is nothing monochromatic about them. They are vivid with life.

There are two of the greatest Titians, the portrait of the ashen-

92

faced Charles V, sitting on a fringed, red satin chair, his full-length figure a black silhouette against darkish backgrounds, but, mysteriously, the silhouette has weight. Only the face is fully lighted, sometimes a hand. What always impresses me about Titian is the unostentatious way in which he paints details, like the golden thread fringe of Charles's chair, or golden sword hilts, necklaces. They don't stand out as details, they seem to be woven into the paintings. The other great Titian is "The Crowning of Christ with Thorns." It was much superior to the early version in the Louvre. How he grew with age, like Rembrandt, Velasquez, Degas! These masters reached maturity after forty, and went on from greatness to greatness up to their deaths. How different it is with many famous artists of today, about whom one often hears the comment, "I like his early work."

Masaccio, Van Eyck, Rembrandt, Velasquez, Rubens, Vermeer, Degas—what personalities they were! The aloofness and objectivity of Degas and Velasquez; the emotional warmth of Rembrandt and the uninhibited exuberance of Rubens; the religious tranquility of Van Eyck; the enclosed quietness of Vermeer; the precocity of Masaccio—what force impelled them? One thing they all seemed to have had in common: a great response to the world about them. With the exception of Masaccio who died so very young and Van Eyck who is an artistic and historical enigma even to art historians, the work of these artists who lived long, went through organic changes in their lifetime, came to fruition at the ends of their lives.

Of the three Raphaels I preferred the "Madonna Della Tempi." It is a beautifully painted composition, with visible brush strokes, so dear to artists, of a young woman with the child nestling in her arms, walking in a landscape; wonderfully composed, the figures occupying almost the entire canvas, looming big, as if approaching you like a close-up on a screen; the colors are harmonious—pale crimson, soft blue, and yellow.

I saw again my favorite Antonella da Messina, the small "Virgin of the Annunciation"—a young woman with an inanely pious expression on her simple face, long-fingered hands crossed on her chest, completely covered by a blue shawl, against a dense black background—the blue and black a telling color combination. And the "Lamentation of Christ" by Botticelli, so different in composition and spirit from all the other "Lamenatations" with which European museums abound. It is somber, metallic, and harsh.

On Lenbach Square I came upon a charming building in a garden, which turned out to be the Lenbach Museum, also known as the National Gallery of Art. It has the collection of paintings of Kandinsky presented to the museum by Gabriel Munter, who was his mistress and also an artist herself. These paintings show the evolution of this typical Russian artist's work from his colorful but ordinary small landscape sketches from nature, into the now famous Kandinsky abstractions and improvisations. Together with the more extensive exhibition of his work I had seen several weeks before the Musée d' Art Moderne in Paris, these strengthened the impression I long had of Kandinsky—a feeling of noisy emptiness. It reminds me of flimsy poetry full of loud fireworks, clever rhymes, alliteration, but shallow and without content. This exhibition again exposed the self-imposed limitation of nonobjectivism, with its resulting sterility, for despite all protestations, it precludes the all-encompassing art that representationalism has achieved throughout the ages. Its premise is hopeless.

Some of the more interesting items in this museum were a few late paintings by Corinth, one of a life-size nude woman and two nude children, painted with powerful desperation; a roomful of Klee; a Kokoschka, Jawlenskys, some Gabriel Munters and, to my personal delight, two early canvases by David Burliuk. History is beginning to catch up with my old friend.

In the same building is the work of Franz Lenbach, a famous name in my youth. I remember the fascination a portrait of his in the Metropolitan Museum held for me—that of an old, bearded man with glittering eyes, done in what was then know as the "Munich style," formless and muddy, the only thing projecting itself from the canvas was the head, which was searching in character. Here I saw several such portraits, one of Bismarck and some of pale, aristocratic women and neurotic-looking children.

Munich seems to be the art center of West Germany. Besides the magnificent Alte Pinakothek, there is the Neue, containing French Impressionists, German Impressionists, and Expressionists, as well as work by Runge, Gaspar Friedrich, and others of the Nazarene School. In a separate wing there was *Ein Grosse Ausstellung* of contemporary Bavarian art. *"Grosse"* it certainly was, but to me quite unsatisfactory and boring. The many paintings were either weak figurative or hodge-podge nonobjective, all seeming to be the efforts of a desperate compulsion to do something "different."

Berlin, August

When I came to West Berlin I was really amazed by the unattractiveness of the city. I had always heard that Berlin was beautiful, and I kept saying to myself, "Is this Berlin? It is so ordinary and characterless." On Kurfurstendam there were many street cafes filled with tourists as well as Berliners who were dressed well, but dull in comparison to the promenaders in Milan, Rome, and Paris. Many displays of clothing, shoes, and other commodities were seen in store windows, but there were rather few bookstores, which again surprised me, for I had always thought that Berlin was a cultural center.

The buildings were of the uninteresting contemporary "international" architecture, and I asked myself, "Could the whole of Kurfurstendam have been rebuilt since the war? A new quasi-skyscraper, housing the Berlin Electric Company and other offices, loomed within walking distance of this famous street, which seemed to me to be a combined version of Via Veneto and Broadway. And the inevitable Hilton Hotel towered some distance away, above empty vistas of bombed-out, unreconstructed streets which were turning into jungles of weeds, bushes, and young trees, part of a remaining wall appearing here and there among them.

Over all this hovered a touching provincialism, a desire to live up to the style of big cities. There were even a few sidewalk "artists," dressed like beatniks, without shoes, unkempt, the colored dust of the pastels adding to the dirt of their unwashed faces and hands. Copying from postcards, they drew such pictures as details of the "Surrender of Breda," and stained glass compositions. As art students they were not very well informed. To my questions about art life in West Berlin, one of them, a young girl, answered that she was just a student and did not know about that. She had never heard of George Grosz or Otto Dix. Another such "artist," somewhat older, a barefoot blond young man with Franz Joseph *backen barden,* had some knowledge of the name of George Grosz, whom he called an American artist, and also had heard of Otto Dix. He complained it was difficult to sell paintings in West Berlin; in Paris, he heard, it was easier to sell.

Regretfully, I did not stay in West Berlin long enough to explore the contemporary art situation any further. The one gallery I knew of and wanted to visit was closed for the summer.

It was only when I entered East Berlin, after passing through all the red tape at Checkpoint Charlie, that I exclaimed to myself, "So this must be the beautiful part of Berlin!" For there it was, the well-known Unter den Linden, its four rows of trees stretching out toward the Brandenburg Gate in the distance. It was Sunday morning, and except for some tourists, there were hardly any people in the streets, practically no traffic. One had an unusual sense of perspective, of streets unmarred by the ever-present automobiles.

The first door I entered was in a newly constructed exhibition hall on the corner of Friedrich Strasse and Unter den Linden, which showed a group of international paintings and watercolors. I made a mental comparison with West Berlin. There was more life along the busy Kurfurstendam, but here there was a feeling of cultural activity in the prevailing atmosphere of unreconstruction.

I asked a policeman where the National Gallery was, and I was directed to the *Kunst Insel* (Art Island). I crossed a small elevated bridge over a canal and found myself in a wide square with beautiful churches, monuments, and other structures. They had all been bombed and their state of semidestruction seemed to add a tragic beauty to the square. The stupidity and the futile waste of war struck me forcefully. How quick was destruction, and how long it will take to bring back these buildings to their former grandeur and beauty.

The paintings and sculpture of the museums are now housed in the restored parts of these buildings. There is an excellent collection of recent German art in the National Gallery, beginning with Max Lieberman, Corinth, Schlemmer, Schrimpf; some Expressionists— Dix, Beckmann, Kirchner—as well as some current German work; also a few French paintings of the Impressionist period, including two Cézanne still lifes.

Dahlem

The great collection of Old Masters is in the nearby West Berlin suburb, Dahlem, in the Dahlem Museum. In the Pinakothek, in Munich, I was overawed by the monumental works of Rubens, Titian, Grünewald, Dürer, large in size and in conception. In Dahlem, on the other hand, I was fascinated by the numerous, rather small but precious paintings of Van Eyck, the Master of Flémalle, Petrus Christus, small portraits by Holbein, Dürer, Mantegna, Signorelli, Botticelli, Rembrandt, and Franz Hals. When I looked at Van Eyck's "Madonna

in the Church," a very small painting, I was again puzzled, as I always am, by Van Eyck: How did he manage to work in all these minute details? What kind of eyes did he have? Did he use a magnifying glass, special brushes? And the all-important question: how, with the clarity and precision of infinite details in his canvases, was he able to maintain the wholeness and the unity of conception? Again I was struck by the state of preservation of his work. How was that achieved? His paintings even crack preciously. The blemishes are precious, such as the small discoloration on the face of "The Man with the Pink." I hope it will not be removed.

"The Madonna in the Church" is not so formal as a van der Weyden painting. It seems more realistic, more human; the interior has light and shadow, giving it depth. It actually has patches of sunlight on the floor, reflected from the doorways and vaulted windows, something that a late nineteenth-century painter would do. In "The Christ on the Cross" the two mourners, a man and a woman, have faces that show real grief, and natural gestures painted with deep, not idealized realism. Besides these two compositions, there are three inimitable, infallible portraits by Van Eyck: the bust of "Arnolfini with the Red Head-gear;" of "The Man with the Pink," and the portrait of the "Knight of the Golden Fleece."

There is another tragically expressive "Christ on the Cross" by one of my favorite painters, the Master of Flémalle, who also has two other small paintings, very intense male portraits. Between these two portraits, and contrasting strongly with them is the delicate, sensitive in color and beautifully designed head-and-shoulders of a young girl by Petrus Christus, one of the most aesthetically satisfying pictures ever painted. Mentally I compared it to all the abstraction of Juan Gris and Braque, much to their disadvantage.

I find myself often making such comparisons, altogether out of historical perspective. For instance, when I looked at Caravaggio's painting in the Church of San Luigi Francesi in Rome, I compared it to Cézanne's "Card Players," to the detriment of Cézanne. For after all my visits to the museums my head has become a veritable museum itself, stacked with a multitude of paintings, from all places and all times, and although it may be historically incorrect to do so, I constantly juxtapose them and compare them.

There is, however, an incomparable portrait of a young woman in a stiff white headdress by Roger van der Weyden. It does not have the formal austerity of his compositions. It is warm, human, and soft.

Other portraits are: a youngish man against a red background by Lorenzo Lotto which has the vague Lotto quality about it, both inner and external, the melancholy aspect of the face, and the odd, isolated fold in the red cloth of the background; a monochromatic head of a youth by Botticelli; a strongly characterized head of a man by Mantegna; a deep, psychological portrait of a young Jew by Rembrandt, eight by ten inches in size, but huge in execution; and another of a young, poetic, introverted Jew who posed for Rembrandt as Christ.

The other paintings by Rembrandt in this museum are so badly hung that it is almost impossible to view them properly. They are all placed on a wall opposite windows, with the light shining full upon them, creating a glare so one has to maneuver in all sorts of positions in order to see them; to study them closely is very difficult. The "Man with the Golden Helmet" has a constant red glow upon it from the reflection of a red brick building opposite the museum. That destroys the spirit of the picture completely. The other Rembrandts are biblical in subject matter: "Christ Preaching to the People," all in sepia; "Moses Breaking the Tablets," "Jacob Wrestling with the Angel," "Samson Threatening His Father-in-Law"—Samson is apparently a self-portrait, his face turned awkwardly as though posing before a mirror; at the same time his fist is threatening the old man whose head is sticking out of the partly shuttered window.

Italian paintings are represented here by a group of small compositions by Masaccio—harmonies in gray and black with patches of warm red; a weirdly charming Madonna tenderly supporting the head of a sleeping child wrapped in swaddling-clothes, in dull gray and yellow, by Mantegna; Ghirlandaio's "Judith and her Maid," a small painting in which both women stride across an Italian courtyard or street, a wonderful little canvas permeated with the essence of the Renaissance. There are Botticellis and Titians, including the latter's portrait of the little girl of the Strozzi family.

There I also came across a small, dark, very early Velasquez— "The Three Musicians"—a painting I liked very much when I was young. I used to make drawings of it.

Dresden, August

My trip from West Berlin to Dresden and return to West Berlin via the red tape of the border was quite an odyssey. But it proved to be well

worth it. Even though I had only a day and a half in Dresden, I was able to visit the great Dresden Museum twice, see an excellent exhibition of contemporary Roumanian art in the Albertinum, and find time to rest in the shade of a tree on the banks of the Elbe River.

Like in East Berlin, the Dresden Museum is also situated in the most beautiful and showy part of the city, where, as in Berlin, the historical structures and churches are still half-destroyed. The museum is the first completely restored building. At the head of the central stairway there is a large wooden sign which in golden letters tells the public that the paintings in this museum were saved from Nazi destruction by the Russian army which, after the war was over, returned them to the German people and to the world. Unlike the museums in Berlin, East and West, this one was extremely well attended and busy, most of the visitors coming in groups with guides and interpreters. There were many children with their teachers and, of course, individual museum-goers.

The Dresden Museum has it equivalent of "Mona Lisa" and "Venus de Milo:" Raphael's "Sistine Madonna," biggest in size and conception, a very symmetrical, imposing composition, and Giorgiones's "Reclining Venus," one of the most perfectly composed paintings and probably the most idealized nude in Western art. Here again I found a miraculous Van Eyck, a small "traveling" triptych of a Madonna, donor, and saints, still in its original frame, upon which there is hand-written: *"Van Eyck me fecit"*—"Van Eyck made me," and another inscription along the same frame: *"Als Ixh xan"* ("the best I can"). One of my favorite Holbeins which I have admired in reproduction for many years is here, "Thomas Godsalve and his Son, John," a smallish painting of an older and a younger man, against a green background, as well as the powerful portrait of Morette, a dark gray and green harmony.

Among the Italian paintings, besides the above mentioned Raphael and Giorgione, were two very interesting St. Sebastians, one a contortioned and tortured figure by Cosimo Turo, and the other a placid, tall youth, expressionless though arrow-pierced, leaning against a tree, with a background of a street in deep perspective, facades of balconied buildings and small figures of dignified people in conversation on the balconies and in the streets below—an unusual and fascinating painting by Antonella da Messina.

And here too I saw the painting of the red-tunicked long-haired youth by Pintorucchio, delightful in color and composition, which

aroused memories in me, for my mother had bought a fine and large reproduction of it decades ago, and it used to hang in our living room for many years. It became the main ornament in our home, and we were all very much attached to this picture. It is now still hanging in my niece's house.

In a roomful of Veroneses there is a particularly outstanding one of a female saint, a statuesque and vigorous woman, tenderly presenting the Suchini family to a Madonna who is surrounded by other saints. This family portrait is typical Veronese at his best—ruddy, bearded Venetians, and a full-bodied woman surrounded by her brood of children, and, as is characteristic of Veronese, wherever he has children in his paintings, there are also dogs and puppies.

The Dutch School is represented here by some of its most interesting paintings. There are two masterpieces by Vermeer: one is the unusually large (for Vermeer) and colorful "The Procuress." The color is extraordinary, deep reds and yellow; the composition, too, is unusual, constructed with a great sense for abstraction. Looking at this painting, I was at a loss to understand why Vermeer is grouped with the Little Dutch Masters. It so completely transcends their small, anecdotal, busy pictures. The other Vermeer is "The Woman Reading at the Open Window"—with the high wall and the long drapes, painted with great freedom.

Dominating the group of Dutch painters is, of course, Rembrandt. Here I saw "Deposition from the Cross," similar to the series of paintings in Munich; the lifesize "Manoah and His Wife," a masterpiece of his middle period depicting two elderly people in a prayerful attitude, emotionally affected by the visit of an angel. It is nobly conceived, painted in deep reds and browns, with intense, transcending realism.

There is also the youthful portrait of himself with Saskia on his lap that I always had a desire to see. I compared it, with its strange air of restlessness, to the self-assured, self-contained portrait of Rubens and his wife Isabella Brandt in the Pinakothek. The Rembrandt also is baroque in composition and character, with its air of histrionics, masquerade, and noise, but it has a certain modernism about it. It would not be impossible to imagine a Kokoschka painting a picture like that. It is tangible, but seems strangely unreal. The figure of Saskia is especially unreal and airy; her pose seems impossible, practically full-face, yet with her back to the onlooker. The color tones are soft and fused, not so deep as usual.

Of a group of paintings by Rembrandt's pupils, Ferdinand Bol,

Karel Fabrizius, Van Gelder, and others, I liked Van Gelder's best—an extraordinary painting of "Presentation of Christ to the People," which I am certain was done after one of Rembrandt's etchings. It almost has the calligraphy of Rembrandt's drawing, plus a personal color sense which I had noticed before in other Van Gelder paintings such as the "Jewish Bride" in Munich, a warm, almost pinkish tone as though he saw things through rose-colored glasses.

There was a good deal of art activity in Dresden. Near the Dresden Gallery there was another museum, the Albertinum, where I saw an exhibition of Roumanian art. In the visitors' book I wrote: "It is a vigorous and vital exhibition, by any standards," and I signed my name as "New York artist." Later I wondered why I had not written "American" instead of "New York." Can it be that I identify myself so completely with New York, where I've worked all my life? I remembered that long ago on one of my first self-portraits I signed "Raphael Soyer, a New York artist."

Vienna, August

With the exception of the Louvre, the Kunsthistorisches Museum in Vienna contains the most varied collection of paintings I have ever seen. I shall not attempt to describe the rooms full of Veroneses, Tintorettos, Titians, and the numerous Giorgiones. What held a great fascination for me was another masterpiece by Vermeer, a strong, impeccable work, that of the artist in his studio painting from life a young woman, classically dressed, with a laurel wreath on her head, holding a huge volume in her hand. It was wonderful for me to see Vermeer actually painting from life.

In another alcove are the Rembrandts: three self-portraits (1652-55) of his vigorous years, in different moods, one with his arms akimbo, magnificently self-confident and magnificently painted; one, heavier in face, frowning and intensely living; and the last one, in shadow, his head raised, abstracted and brooding. Here is also his early portrait of his patient mother, eyes red-rimmed, gnarled hands resting on a cane; and the very poetic painting of his son reading a book.

The Kunsthistorisches Museum is noted for its room of Breughels. (I have seen books entitled *Flemish Art from Van Eyck to Breughel,* therefore he is a Flemish artist.) But he is so different from all the others. He seldom painted religious pictures *per se.* There are no portraits by him. In Munich there is a small profile of a shrewish

kerchiefed woman with an open mouth as though she were talking loudly, which may be a fragment of a larger composition. He painted people, the everydayness of their life and their celebrations. His religious paintings are not devout like those of other Flemish painters who preceded him. Even though the events described in them are religious, such as the "Road to Calvary" and the "Massacre of the Innocents," they are set in Breughel's own milieu, realistically, without any supernaturalism. In the "Massacre of the Innocents" a group of helmeted and armed soldiers invade a Flemish village on a winter day, drag the peasants and their clumsily dressed children out of their homes, and, like medieval Nazis, kill the children before the suppliant parents' eyes. In "The Road to Calvary," we see a throng of people coming from all directions to witness an execution. Again Breughel depicted that event with an observant realism: the horsedrawn peasant cart that carried the two thieves to be crucified is part of the crowd, as is the Christ stumbling under the Cross—neither is dramatized. At first glance there seems to be an all-pervading confusion in this painting, but a further look shows how Breughel handled these crowds in the composition, much like a movie director manueuvering masses of people on a set. I shuffled the many pictures that filled my mind to find a counterpart to Breughel. Perhaps Daumier with his keen observation of the life around him, comes close to him, or, in a lesser way, maybe our own John Sloan.

"The Return of the Hunters" is probably the most popularly known work of Breughel, with its silhouettes of the trudging men, followed by the weary dogs with curly tails sharply standing out against the snow, as is the black tree with its lacy branches outlined against the green winter sky; the view of the village; the skaters on the frozen pond; the black crows flying overhead. All this brings to mind Japanese art, which it certainly surpasses in depth.

How can one describe Velasquez—his technique, strong and delicate at the same time, his colors of soft rose, silvery blue, his particular kind of white and black? The five paintings of children in this museum are like no other paintings of children. There is a lightness about them, and yet a positive existence. The serious little figures are in space, with objects around them, furniture, rugs, drapes, giving them a confined, indoor quality. The delicate skill and deep perception with which these portraits are painted and composed, the unusual harmony of color, justify the awe and the wonder that artists have always had at the infallibility of Velasquez.

Through the efforts of Dr. Kurt Eissler, we were able to meet Prof. Novotney, the director of the Belvedere Museum, a well known European art historian, author of, among others, *The End of Scientific Perspective in Art,* and of a book on Cézanne. He came up, to keep our appointment, to the room where I was sketching from the "Family Portrait" by Egon Schiele. He is a charming man. We talked awhile about art in Vienna. When I expressed my surprise at not finding more art books in this city, he said, "But Vienna is not a city for painting. It is a city for music and the theater."

I asked him whom of the Viennese artists I could visit, since I was interested in the contemporary art scene. He suggested Wotruba, as the best known Austrian sculptor. When I mentioned Paul Meissner, with whom I had an appointment later in the day, Prof. Novotney said, "Yes, you should see him. He is the president of the New Secession. He is a taschist, but you know, taschism is now passé," making a negative gesture as he said this.

We visited the studio of Fritz Wotruba, whose work can be found in various European museums, and in private collections, including the great American collection of Joseph H. Hirshhorn. He works mostly in metal, welds cylindrical forms into all kinds of figures, sometimes enlarging them into huge proportions. He showed us some of his work, earlier representational pieces, as well as the more recent work in his new style. Although he was friendly enough, we did not pursue our conversation to any great extent, for we felt he was pressed for time. However, I did make a quick sketch of him.

Paul Meissner lives in an outlying district of Vienna. His studio has a view of rolling hills and cultivated fields. He never paints it. He showed us many paintings, most of them of equal large size, on masonite board, in varied and elaborate techniques, vague in conception. I was impressed by some of his harmonies in black, white and gray, and when I complimented him upon these colors, he said bitterly, that his color is not appreciated in Vienna, that the Viennese "have ears, but no eyes." "This was, in essence, a repetition of Novotney's comment.

While showing his paintings, he talked about experiment in art, about expressing an experience or feeling, about the novelty and the limitless possibilities in this technique. I asked him about the result of all this—is it worthwhile? Can it be like a Van Eyck, of permanent value, difficult to repeat and to emulate? In reply, he pulled out one of his typical paintings, a golden-brown mass, spattered with black spots,

103

in a background of marblized gray and white, and said: "This is impossible to copy or repeat." My answer was, "Yes, it is difficult to repeat, for so much here is accidental and capricious."

Of course, this was not all I had in mind to say, but I could not press the point any further, being his guest, and not wanting to offend him. Again I could not understand how this artist, a seemingly sincere and talented man could have become so satisfied with this kind of involvement with just color, accidental forms, and mere evocativeness instead of content.

During this visit my mind was full of the work of Egon Schiele, which I had seen that morning at the Belvedere. That was also experimental, searching, novel—but it had content and was steeped in tradition. I recalled a conversation with a composer, a student of Schoenberg, who told me that Schoenberg once said, "Experimentation is fine. But so much can yet be said in the Key of C."

I cannot write about the art in Vienna without mentioning the memorable afternoon we spent with the Viennese-born New York psychiatrist, Dr. Kurt Eissler, who is also an art connoisseur and historian. He studied art history for two years with renowned Viennese specialists in the field, and is the author of a book, a psychoanalytic study of Leonardo da Vinci. He fairly flew through the old, familiar, narrow streets of his city, with us gasping after him, and showed us beautiful old Gothic monuments in courtyards unknown to tourists. He led us to a fine, late painting by Titian, hanging among many nondescript paintings in the almost deserted old gallery of the Academy of Fine Arts. And to change our diet from the artistic to the gastronomic, he introduced us to Demel's, a left-over spot from old Vienna, a cafe (or should I say *the* cafe? for we were told that revolutions and wars may come and go, but Demel's stays on forever), where, if one has time and patience, one may savor the original sandwiches, pastries and ice cream for which Vienna has been famous among gourmets the world over. But we parted with Dr. Eissler in an artistic setting, in the Helden Platz, where, in a spacious area, surrounded by impressive baroque architecture, stood one of his favorite monuments, an imposing equestrian statue silhouetted against the evening sky.

Moscow

Our art experience in the Soviet Union began when we stepped off the plane in Moscow and were greeted, much to our unexpected pleasure,

by Professor A. D. Chegodaev, the art critic and historian, author of many books, including a comprehensive history of American painting (in Russian). This was followed the next morning by a visit to our hotel room from Orest Vereisky, a graphic artist and water colorist who had come to see me in New York two years before. And again, in the afternoon, another art historian whom I had met in Net York, Prof. Prokofiev, came up with a monograph of Favorsky and a guide-book on Moscow and said he would like to take us to the Tretiakov Gallery, the museum of Russian art, the next day. Also, a phone call came from Chegodaev inviting us to visit with him the Pushkin Museum of Plastic Arts.

This was the pattern of our stay in Moscow. We were moved by this completely unexpected attention and hospitality, and we were involved with these people the week we spent in the capital of the U.S.S.R.

First, was the visit to the Tretiakov Gallery under the guidance of Prokofiev, where he gave us an excellent, chronological survey of Russian painting. Personally, I do not care for icons, I do not even respond to early Italian, pre-Fra Angelico paintings that resemble icons. But in the company of the enthusiastic Prokofiev, I was impressed by these sombre-sweet artifacts, some of mural proportion, taken from old churches and monasteries. Prokofiev pointed to a semi-obliterated, devout image of some saint and said modestly, as if to himself, "This is my favorite of all the icons here."

We saw the art of the seventeenth and eighteenth centuries, the work of Bobrikovsky and Kiprensky—analogous to the early American painters Copley and Stuart. In this group I liked very much the portrait of the bright, blue-eyes Pushkin by Kiprensky. We passed through rooms and rooms of genre painters. Outstanding among them were Fedotov and Venetzianov, particularly the latter, who seems to me comparable to Louis LeNain in the choice and treatment of subject matter, although less austere, softer and less structural in composition than the Frenchman. Now and then Prokofiev would lead us quickly through a picture-filled gallery without pausing, saying, "This is academic."

We did stop for some time in a room with the huge painting by Ivanov of "Christ Appearing Before the People," upon which he worked for many years in Rome. Imposing as this work is, more interesting to me was the vast amount of preparatory studies for it—figures, nude and draped in various poses, landscapes and fragments of landscapes, stones and grass, and many variations of the composition.

Ivanov is an example of an artist who becomes completely obsessed with an idea, with subject matter, with a painting, like a minor Da Vinci with a "Last Supper."

Then we came to the many rooms allotted to Surikov, Riepin, and Serov—painters of the middle nineteenth and early twentieth centuries. My favorite is the painter of Russian history, Surikov. He seems so Russian. He loved to paint snow and ice and cold weather and dark interiors with lighted candles in front of icons. His intense and deep identification with his subject matter lifts him out of the category of the usual dull historical painters. There is a sense of seriousness, dedication, in Surikov's work, of great effort, a feeling of grappling with difficult content and with almost insurmountable technical problems. His rooms, too, like Ivanov's, are filled with countless vivid studies for his complex compositions so densely packed with drama and action.

I found the work of Riepin extremely talented, but often lacking in taste and esthetics. His exuberant naturalism became the model for much that is being done in Russia up to this day, just as Winslow Homer gave rise to the brand of the banal American school of seascape painting, which is still in vogue in the less sophisticated art communities in our country. There are at least two of Riepin's paintings, however, which are masterpieces of portraiture—one of the composer Anton Rubinstein with baton in hand; the other, a portrait of a dishevelled and bewildered Mussorgsky, painted a few days before the composer's death.

As for Serov, there seems to be in the Soviet Union today a predilection for him, a sort of cult, to the point of placing him above Riepin, who has long been considered the great Russian master. To me, however, Serov is simply a Riepin with a lighter touch, which is deceptively more modern, and perhaps for this reason is more satisfying to those who crave a less heavy-handed approach to art. Prokofiev pointed to a painting by Serov and said: "This is as good as a Manet." This comment, as well as others by several cognoscenti in Moscow, revealed a weakness in their critical evaluation of esthetics. But on closer contact with these people I sensed a groping towards the more complex and sensitive values in contemporary art.

We had time only for a quick glance at the Soviet painting of today. There is a lot of lively realism. I liked a Hodleresque painting by Deineka and a few canvases by Pietrov Vodkin, a very interesting painter who died in the thirties or forties. He was, apparently, the only

artist who consciously based his work not on Riepinesque naturalism, but found his roots in the images of the old Russian icons.

I had an opportunity to talk about the problems of painting, to a limited extent, at the *Dom Droozhbi*—the House of Friendship—where, with Prof. Chegodaev as host, a few artists and writers came to greet me. I say "limited" because when I am called on to speak extemporaneously, the best ideas, what I really have in mind to say, come after the event. I spoke about the great danger that faces representational art—the loss of its utilitarian function to the new media for recording and describing events. I even projected the pessimistic thought that art, as we have known it, may not be compatible with our scientific age and may well be facing extinction. A symptom of this is the empty confusion of nonobjectivism so widely promulgated today.

The Russians were more optimistic than I because from their point of view art still has a vital social function: that of propagandizing ideas and graphically presenting the goals of their society. They did not seem to be bothered by the doubts that beset me. In answer to this optimism I emphasized the hardship of the representational painter: the danger of being banal and pedestrian; the problem of finding a new way of saying what has already been said before an infinite number of times; to add to art something that is expressive of our unusual era, so different from any other era in history. Representational art, I said, must constantly rediscover itself and renew itself to justify its continuation.

As I write this I am reminded of a conversation I had sometime ago with a contemporary poet whom I asked: "What is and what is not poetry today?" The simple answer has remained with me: "If one has read Ecclesiastes, Shakespeare, Keats, T. S. Eliot, etc., one realizes that all possible ideas have already been expressed. There are no new ideas. What may make poetry is a new way of expressing that which has already been said."

Our visit to the Pushkin Museum was guided by Chegodaev and three members of the museum staff. This museum is particularly proud of its collection of French Impressionists and Post-Impressionist art. Prof. Chegodaev pointed to the early Picasso of a circus girl balancing on a ball and murmured proudly, "This is the most beautiful Picasso in the world." The Cézannes took my breath away. I have seen many more Cézannes in the United States, but at the Pushkin Museum I found the choicest of all—the Harlequin and the Pierrot; a most

"realized" self-portrait (like a green bronze); a very late small masterpiece, "Mt. Sainte-Victoire;" a monumental composition of a "Man at the Table;" and more landscapes and flowerpieces. The quality of this group made a deeper impression upon me than the profusion of Cézannes in the Chester Dale and Barnes collections. The finest paintings by Van Gogh, Gauguin, Matisse, Derain are found here. Also many strong and simple landscapes by Marquet. We were shown a unique collection of Fiume portraits, pictures of amazing vitality, as modern in spirit and feeling as any Rouault. Also there were rare examples of Egyptian sculpture.

The high point in the personal, friendly attitude of our guides to me, and through me to Americans generally, came when we were led into a room which Chegodaev called, "The Room of American Art in the Pushkin Museum." There was a good Mary Cassatt, several examples of Rockwell Kent, an Anton Refregier, a Gropper, a drawing by Alice Neel and, to my surprise, two old lithographs of mine.

"This is the only room in any European msueum devoted exclusively to American art. We hope to enlarge and diversify it," said Chegodaev.

Then it became clear to me that the *idée fixe* of this quiet, patiently perserving man is to promote friendly relations between the Soviet Union and the United States through closer cultural, especially artistic, ties. He has already written a book on American art, and he dreams of exchange exhibitions of art of the two countries. Another hope of his which appealed to me very much is to have in Moscow an international exhibition of realism on the highest possible level.

I was also impressed by the staff members accompanying us, by their modesty and unpretentiousness. Occasionally they would comment intelligently on some painting or other. When one of them, an elderly woman, called our attention to a Zurbaran, Chegodaev said, "She just wrote a book on Zurbaran." It would be of interest here to mention how many books and monographs are written about artists in the Soviet Union. Almost all the people we met in the circle of artists have written books—on Velasquez, Gainsborough, Millet, Zurbaran, etc., and the young Prokofiev is at present working on a book about Manet. I saw some of their books. They are attractive without being lush, and I was told they are very popular and sell in large quantities.

Our visits to the homes of the artist Orest Vereisky, and Prof. Chegodaev where we met some of their friends, somewhat deepened our acquaintance with Russian intellectuals. In Vereisky's pleasant

home, surrounded by a garden and tall birches (trees so sentimentalized in Russian literature), our charming hostess introduced us to Ludmilla Tolstaya, the widow of the famous novelist, Alexei Tolstoy. Before dinner we were joined briefly by Soifertis, a satirist whose water colors and graphics are sensitive in spite of their sharp and biting content. We had in common an admiration for George Grosz, and we talked about him. With Soifertis was his wife, the daughter of the well-known late Yiddish poet Quitko, one of the writers who perished in exile in the 1950's. Vereisky showed his work to all of us, and when I praised one of his drawings, he gave it to me.

The intellectual-pastoral setting of this house, the potent Armenian cognac, the lively conversation made this visit a memorable occasion. Mme. Tolstaya reminisced about her husband, we talked about his books and about his place in Russian literature today. In this warm and friendly company my halting Russian became more fluent, and I found myself using long-forgotten, appropriate proverbs. Later in the afternoon some more literary people dropped in, and the conversation continued in the same vein, comments on art and literature.

In Chegodaev's small apartment, filled with more than eight thousand books, the talk was centered on art, for we found ourselves in a group of artists and art historians exclusively. I leafed through monographs on the work of some of the artists present, and coming upon some reproductions of ballet dancers by our chief toastmaker, Pimenov, I was prompted to say, "You like Degas, don't you? He is my favorite artist, too." And I whimsically added: "He was the last Old Master." To which Pimenov replied in his deep, eloquent manner, "Not the last Old Master, the *first* modern master, whose new themes and new ideas inspired his contemporaries, those who came after him, and will continue to inspire future artists."

I was a little startled by this emphatic pronouncement of a rather accepted opinion, and said, "I agree with you, but Degas was a paradoxical man, and this is one of the paradoxes—he was the last Old Master, and a great new one."

Many toasts were made and downed to all present, even to two babies—to the grandson of the Chegodaevs, and to our grandson. Emboldened by Armenian cognac again, I talked freely, perhaps superficially, about tendencies and values in art in both our countries. Throughout this conversation there was in back of my mind the thought that I was perhaps expressing the usual glib and dogmatic

opinions of Americans about contemporary Russian art. I felt in the artists there a disillusionment with their art of the last few decades which portrayed an optimistic heroism, and with their own present work still steeped in a naturalism which impedes its progress. I felt a restlessness, a groping toward some of the esthetics and the refinements of Western art.

But what is it that Western art has for them? Is it abstract expressionism or any other kind of ephemeral "ism" that follows one another in quick and restless succession? Is the intrinsic value of this so-called avant-garde art greater than the intrinsic value of Russian art, platitudinous though it may be at this moment?

The formalism and stylism with which "Western" art is hoping to penetrate the socialist countries is foreign to and has little meaning for the Russians, is counter to their esthetic tradition. Russian literature has always put the importance of content above that of style; and as for art (Lissitzky, Tatlin, Malevich, Kandinsky notwithstanding), its mainstream has always emphasized subject matter rather than style.

How well this thought was expressed by Boris Pasternak (who was embraced by the Western world for his artistry as well as for other reasons). In an interview with Olga Carlisle (*Writers at Work*, Viking Press, New York) he said:

> I have never understood those dreams of a new langauge, of a completely original form of expression. Because of this dream, much of the work of the twenties which was but stylistic experimentation has ceased to exist. The most extraordinary discoveries are made when the artist is overwhelmed by what he has to say. Then he used the old langauge in his urgency, and the old language is transformed from within.

Within the framework of this quotation contemporary Russian art can be criticized. It lacks the intense reaction to reality which alone can make traditional art living. For what the Russian artist is saying today is not what he is "overwhelmed" by, but what he is told to say.

Literature seems to fare better. Some writers are beginning to free themselves, according to Giacomo de Bendetti, an Italian writer from whose comments on this subject I quote:

> Today the novel in socialist lands is being enriched with more complex, more intimate and psychologically deeper nuances. Authors approach men conscious of the entire complexity of life and feel themselves freed from their earlier aims to describe the fate of positive heroes only. Socialist realism today is more encompassing, more contemporary than it seems to the somewhat superficial Western judges.—*Literaturnya Gazetta*, Aug. 20.*.

*My own free translation.

But then it is well known that Russian literature has always been on a more universal plane than Russian plastic art.

We had an althogther unusual afternoon in Moscow, at the home of the widow of the great Russian filmmaker, Sergei Eisenstein. A former actress, she is known by her stage name of Pera Atasheva. Her small apartment is almost choked with memorabilia of her late husband. The walls are covered by shelves of books, and etchings by Pironesi, by Japanese woodcuts, a drawing by Picabia, an original poster of the film *Potemkin*, and numerous photographs of Eisenstein at different stages of his life. One of the two rooms is almost entirely devoted to the Eisenstein "archives."

Although Mme. Atasheva is now an invalid with failing eyesight and rarely leaves her home, she is devoting all the energy of her active mind to bring to greater public notice those aspects of her husband's talents and achievements not yet popularly known. At the time of our visit she was engaged in arranging an exhibition of Eisenstein's drawings in London's Victoria and Albert Museum, and asked us to contact Mr. Herbert Marshall there who is in charge of the exhibit. She also told us that Lincoln Kirstein is planning to bring this show to New York. We met in her house Valia Millman, an old friend of Pera and Sergei Eisenstein. This scintillating lady, also dedicated to the memory of the great filmmaker, is Mme. Atasheva's indispensable friend and almost daily companion.

We talked in English, which both ladies speak fluently. They are well acquainted with American literature, and have a great interest in Hemingway, an interest which is widespread in the Soviet Union. They also like the work of Faulkner and Salinger. On our way out, Valia Millman, who accompanied us, spoke with great warmth of her friend's indomitable spirit, of her interest in young people to whom her home and archives are always open. We left, feeling that we had visited a shrine to the memory of Sergei Eisenstein.

Leningrad

One of the objectives of this trip was to see as many paintings by Rembrandt as I possibly could, to look again at those I already know in Amsterdam, Vienna, the Louvre, and, with more expectation, to see for the first time those in Berlin, Dresden, and particularly those in The Hermitage of Leningrad. I have already touched upon some of them, but when I have seen them all I hope I shall be able to describe their cumulative effect upon me.

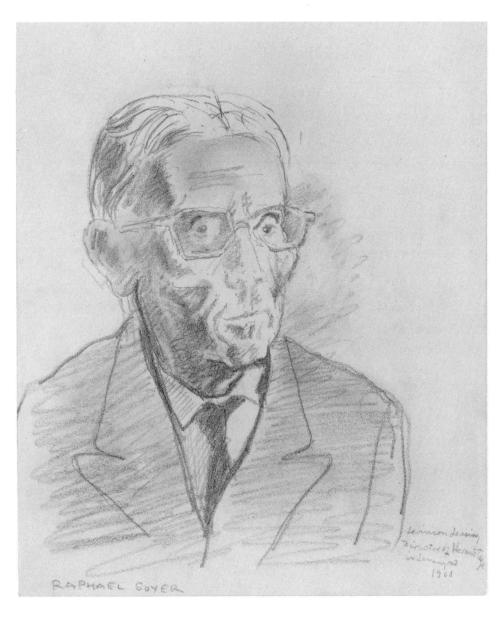

RAPHAEL SOYER

Levinson-Lessing

112

In Leningrad I went to visit the director of The Hermitage, Professor Levinson-Lessing, whom Renato Guttuso urged me to see. I found him frail and elderly with a sensitive face, altogether charming. He told me he has been with The Hermitage since 1921. I commented upon the excellent state of preservation of the old paintings, of their "genuine" appearance. I said I felt there was a minimum of tampering with them—to which he replied: "I'm glad you noticed that." From his tone I sensed he was really pleased by this recognition of the great care that is being taken of the paintings. We talked about contemporary art in America as well as in the Soviet Union. When I expressed my surprise that the director of the old treasures of The Hermitage is also keenly aware of what is going on in the world of art today, Levinson-Lessing answered: "For me art cannot be confined to things of the past only. For me it is ever continuing."

After he was called away, the conversation continued with the young art historian and assistant to the Director, Alexander I. Rusakov. He spoke specifically about the work that is being done in Leningrad. For some reason, he said, there is no outstanding painter in Leningrad, but the city has become the center for graphic art, with the old and esteemed Favorsky as its acknowledged master. There are printing workshops for lithography, etchings, woodcuts, conducted by the artists themselves. Exhibitions of these graphics have been held in various European cities, and even in New York.

From further conversation with Rusakov, I learned that his father, Isaak Rusakov, who died in 1952, was an artist also. He gave me a catalog with reproductions of his father's work, and I was surprised to find it artistic, sensitive, influenced by the French art of the fauve period. "Where are your father's paintings now? Are they known?" I asked.

"No, they are all in my house. My father had no success at all. He was unrecognized." I thought how sad and difficult it must have been for such a man to have lived at a time when brazen naturalism was in official vogue, and I expressed the hope that with the present tendency toward a re-evaluation of their art, painters like Isaak Rusakov may find a place.

In Leningrad besides the Hermitage there is the Russian Museum, devoted entirely to Russian art from the icon period to the present time, like the Tretiakov Gallery in Moscow. I was impressed by these two huge museums. They represent fully the work of their own artists from the very earliest time on. There is no mere sampling of so-

called characteristic examples of their important artist, but rooms and rooms are set aside for Surikov, Riepin, Serov, Ivanov. Nothing so comprehensive can be found in our country. How good it would be to have museums in New York, Boston, Chicago solely for American art, with rooms dedicated to Eakins, Homer, Prendergast, George Bellows, etc.

We walked along the streets of Moscow and Leningrad, both quite different from other European cities. In Moscow its over-sized squares, its wide boulevards lined with newly planted trees and modern apartments, presented an almost discordant contrast to the old, narrow, crooked streets or *pereuloks,* with fenced-in courtyards and antiquated wooden buildings which are still found there. The section known as *Zamoskvaretchiye* (the other side of Moscow River, analagous to *Trastevere* in Rome) is particularly quaint, and not, as yet, so much affected by the changes brought about by modern city planning.

Of course the most striking spot in Moscow is the Red Square with the gilded cupolas and towers of the Kremlin behind the parapeted brick walls. I discovered that contrary to popular belief the name Red Square did not originate with the present regime. Centuries ago, when it was constructed, this square was named *Krasnaya Plostchad*—Beautiful Square, for *krasnaya* means beautiful in old Russian, and it also means red. It is the most majestic square I have yet seen, with the whole length of the red-brick wall on one side, and the fantastic, colorful St. Basil's Church at the far end. In harmony with this architecture, and, as if growing out of the brick wall, is Lenin's Tomb, and an impressive aspect of this square is the long, patient line of thousands of reverent people waiting to visit this Tomb.

One morning, in a driving rain, we were taken by our guide to the Kremlin. The downpour did not deter the great numbers of people from thronging to see this place. Our guide kept close to us, and as we vainly tried to avoid the puddles that were filling the cobbled courtyard, we heard above the splashing of the rain our guide's voice dutifully reciting the history of the churches we were passing. When we reached the Church of Resurrection, we found our wet trek worthwhile. The walls, the ceilings, and the columns were completely covered with religious frescoes of great simplicity and intensity. Without the usual paraphernalia that clutters up churches, the entire interior became a unique museum.

114 Before leaving Moscow, we walked around inside the Kremlin. It

was late afternoon, the light was soft and clear. The ancient towers and the stony gray facades relieved by trees gave the place a medieval charm.

On the way into Leningrad from the airport, we were struck by its difference from Moscow. There were comparatively few pedestrians, the traffic was less. There seemed to be an overall quiet, bordering on melancholy. That was our first impression, to be rather modified when we arrived at the center of town and found our hotel above a construction site where a new metro station was being built, the noisiest spot both day and night. As for people, we could see crowds of them from our window, going in and out of the metro station, and strolling, almost parading, after work along the Nevsky Prospect. Both in Moscow and Leningrad, by the way, one notices how straight the women walk, especially the young, like dancers.

Leningrad, that is old Leningrad, is very beautiful. It did not "just grow" like Moscow, but was planned and designed carefully on the style of a European city of that period, with long straight parallel streets and wide avenues. The Neva River and the numerous canals with bridges over them add to the city's unusual character. Delightfully pleasing is the architecture of the old low buildings with their flat or colonnaded facades in faded pastel shades of green, blue, orange, yellow—all with trims of white, brought in tone by the soft pearl-gray light which reminded us of the light on the islands off the coast of Maine. Here too, as in Moscow, the squares were large, well-proportioned. No parked cars marred their space and perspective, and the monuments were in keeping with the general architectural effect. The square with the equestrian monument to Peter the Great, which was made famous in Pushkin's poem as the Bronze Horseman, is at the end of a park and faces the Neva River, and is particularly beautiful.

The greater part of our stay in Leningrad was spent in The Hermitage, but the most unforgettable of the few trips we took with our guide was to the mass cemetery of nearly a million civilians, victims of the long German siege of the city. Like all such places, it had its usual effect upon us: It filled us with anger and with sorrow. It is a vast area, a park with many lanes, and large mass graves, the smooth grass bordered with flowers, with a single headstone marked *1942* on each. We walked down the main path toward the monument at the far end, the figure of a woman symbolizing Mother Russia, standing tall in front of a low, gray, stone wall upon which is inscribed, in poetic prose, the epitaph to those buried there. Our walk was measured to the music

115

of threnodies broadcast over the large field. Our guide's demeanor changed—she became silent, walked with bowed head, her lips pale and tightly compressed. Suddenly she exclaimed, with unexpected vehemence: "Nu, all right, Mr. Soyer. In wars soldiers kill one another. But does one have to do *this,* kill civilians and children, torture?"

Both Moscow and Leningrad seemed to us poorer in a material sense than other European cities. The window displays were meager, the people's clothing, especially the men's, lacked the style and the well-cared for look one sees in the main streets of other European capitals. There were markedly fewer cars, especially in Leningrad. But both cities were abundantly stocked with books. Besides the many bookstores, there were stands and pushcarts on the sidewalks, in the middle of squares, and in their clean, spacious, overornate metro stations. These book displays were at all times surrounded by browsing, and buying, men, women, and even children. In one of these crowds, I overheard a young mother scolding her eight- or nine-year-old son, as she tucked his shirt in: "Nu, look at yourself, what an untidy fellow you are! I'll take your school books away from you if you don't take better care of yourself!"

Coming into the Soviet Union from Western countries, one is struck by a sense of nonrelationship of Moscow and Leningrad to the rest of Europe. Nor do the numerous tourists add to them the cosmopolitanism one finds in Rome, Paris, London. There seems to be a feeling of tense patience in the air, especially in Moscow, a seriousness in the faces of the people, as though weighed down by worry and responsibility. However, it may very well be that a visitor to New York could get a similar impression from the people in the streets and in the subways.

One morning in The Hermitage, I simply gasped at the beauty of Rembrandt's "Prodigal Son." It is golden, soft red, and deep brown. Time may have added its quality to it, mellowed the colors, hardened the paint into stone. Sensitive care has not destroyed these chemical changes which have become part of the painting. Standing in front of it that morning, I thought how unimportant and trivial discussions on aesthetics, abstraction, literariness in art can be. This painting defies such rationalizations. It is the most tangible, the most emotional painting I know, and it tells its story with deep eloquence. What keen and merciful observation Rembrandt must have had to be able to depict with such truth this meeting between father and son, the

prodigal's head burrowing into the folds of the old man's clothes, and the old hands comforting with their touch.

These hands, and the hands in "The Jewish Bride," symbolize for me the phenomenon of the old Rembrandt: his feeling for people, his acceptance of life and awareness and the acceptance of death. How deep the sympathy in his portrayals of people; in his moving self-portrait as St. Paul; in the trembling gestures of the blind Homer and of the questioning St. Peter; and in the series of portraits of his son Titus, from the old-faced boy at his school desk (in Rotterdam) to the deathly pale young man (in the Rijksmuseum).

In The Hermitage there is also the "Danae." The first thought that came to my mind when I looked at it was that here is indeed the antithesis to Giorgione's idealized reclining Venus, and to all the other elegant nudes ever painted. I ignored all the paraphernalia in this painting, and was hypnotized by this homely woman with her animated face, her big hands and soft belly, reclining, reaching out, her weight making a hollow in the bed clothes. It is truthful, touching, and human. One has to wait for a Degas to find again this profound treatment of a nude, though on a less epic scale, and without Rembrandt's unrestrained emotion. I must say here that I found Rembrandt's paintings in The Hermitage so delicately cleaned they were a joy to behold.

Rembrandt's "Holy Family" shows his unique treatment of religious themes. It is not religious in the sense that the Italian and Flemish pictures are, it is simply a painting of a biblical story in a human setting, beyond any Dutch genre. Painted in his warm browns, reds, and ochre, it has the feeling of peace and quiet, and the tenderness of a young mother watching over her child. The scene is not the usual manger or church found in other paintings of the Holy Family, but is an ordinary human dwelling. In the background, in deep shadow, is the carpenter at work. Only the stiff angels in the upper left corner of the picture are indicative of any religious significance.

I imagined a gallery with Rembrandt's major paintings—the "Prodigal Son," "The Jewish Bride," the "Nightwatch," the "Syndics," the nudes of the "Danae" and of "Bathsheba," his brooding self-portraits, "Saul and David," the paintings in Brunswick, Stockholm, and Kassel that I know only from reproductions—what a staggering impact a room like that would have! This work is not confined to time, and is beyond the borders of any place. No erudite historian can pigeonhole it, can adequately classify it.

Today there is (or there *was*—how ephemeral are these *isms!*) so

much talk about "action" painting, about taschism, etc. One has to study the brush strokes on Saul's cloak; the way the paint is applied to the tablecloth in the "Syndics" and to the sleeve of the man in "The Jewish Bride;" the way the entire "Prodigal Son" is painted. The objectives of all the *isms* can be found there, and, of course, infinitely more—deep, human reality.

Amsterdam, September

In Amsterdam I renewed our acquaintance with Lex Horn, whom we had met two years before, a serious painter and a stimulating, thoughtful person. We spent an interesting evening at his home, talking about the *isms* in art, about the life of artists in Holland where the government commissions painters and sculptors to decorate buildings, paint murals, and make monuments. Lex Horn told us that private sales of contemporary, native art are practically nil in Holland except for the work of those few who have attained an international reputation. It is the government's active interest in the arts which makes it possible for a man like himself to function as a painter, even though he is a well-known contemporary figure in Dutch art whose work is shown at The Municipal Museum of Amsterdam.

We went to his studio in a former schoolhouse which has been allotted by the city to several artists at a minimum rental. There is a number of such old buildings which they keep in good repair. In this way the city of Amsterdam retains some of its fine old houses and at the same time provides artists with much-needed studios (New York, take notice!).

Horn showed us his work—landscapes, harbor scenes, streets, and portraits, all done in a few years' time and showing developmental changes. There is a variety of influences—The French Fauves, Soutine, German Expressionism, Kokoschka, Munch, leading up to recent semi-abstract trends. But basically, from the beginning, his work has had a strong expressionistic strain and his development has been a natural one, emanating mainly from within himself.

Before we left Amsterdam we had the pleasure of visiting the home of Ina Bakker, a Dutch ceramicist. She posed for me in New York when she lived there the previous winter, a charming and moody young woman who returned to Amsterdam with her American husband, the young scientist Michael Corner. He had a fellowship to

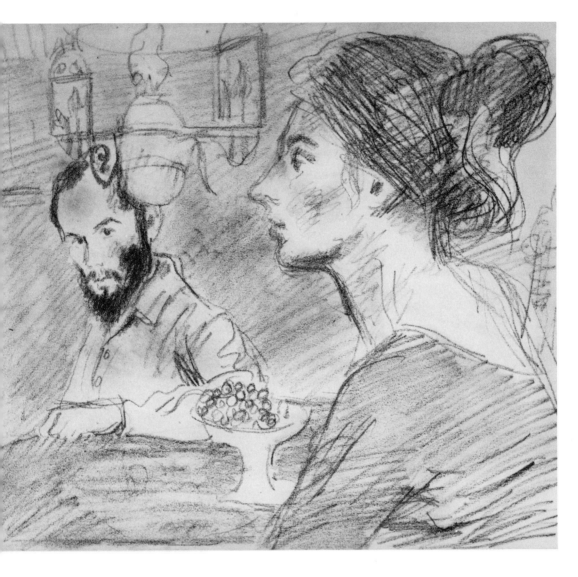

Ina Bakker and Michael Corner

119

study science at the university. We found them in a house so old it had to be propped up with heavy beams. Their small apartment, with sloping floors and low windows, overlooked the canal at Prinsenkracht.

It was a still evening, the street lamps were lit and they and the trees and buildings along the canal were reflected in the water. Upon the dark window panes, added to this mirage-like landscape, was the reflection of the lamp-lighted interior, like a montage. We relaxed with these people, enjoying the exotic food prepared by our hostess, the wine, and the animated conversation. A personal tone was added to our memories of Amsterdam.

Another interlude in our artistic wanderings was the visit to the home of an attractive Jewish woman, a widow, who bears a concentration camp number on her arm. She and her children are reconstructing their lives, not merely through the instinct for survival, but also with a strong social awareness to make a better life. From this family, as well as from Ina and Michael, we learned how the people of Amsterdam participated in our Freedom March to Washington, by staging a sympathy march of their own on that same day.

Hans, the fifteen-year-old son of our widowed friend, was packed full of all kinds of information, and told us about the underground in Holland during the Nazi occupation. One curious item relates to the finding of Hebrew words in the Dutch language. For instance, the Dutch word for prison is *bayit,* which means *house* in Hebrew; the Dutch word for wild beasts is *chayot,* which means *animals* in Hebrew. Hans told us about an inscription on the wall of a prison in which the anti-Nazi underground fighters were incarcerated: "In this *bayit* there are no *chayot,* but the finest men in Holland."

London

Coming to London we felt at home in a big city again like New York, with wide sidewalks and more controlled, although for us, confusing traffic. We loved the expanse of parks joining one another, and the many small squares filled with trees and flowers and benches. One sunny afternoon we came upon a monument to Franklin D. Roosevelt in Grosvenor Square, in the middle of a terrace, surrounded by a low stone fence upon which were inscribed the Four Freedoms. We had a warm feeling of recognition. Flower beds brightened the terrace, and

people were sitting on the stone steps and benches around the statue, enjoying the sun.

What a wealth of museums there is in London! We visited the National Gallery the very first afternoon, and looked again at the great paintings there: The Van Eyck portraits and the "Arnolfini Marriage"; the portraits by Petrus Christus, van der Weyden, the "Master of Flémalle," and the religious compositions by Flemish masters; Holbein's "Ambassadors," Dürer's "Father," Velasquez's early painting of "Christ in the House of Martha;" Rembrandt's portraits, one of which, "The Old Man in Red" resting on his elbow, seemed to have been recently overcleaned with lamentable results; the Titian group portrait of "The Vendramin Family in Adoration;" El Greco's "Agony in the Garden"—a strange composition in one, eerie in color; the two Piero della Francescas; the Masaccio "Madonna," the portraits by Lorenzo Lotto, the Bellinis, the Mantegnas, and many more. There are several huge rooms with more recent paintings: Ingres, Manet, Renoir, Cézanne, Pissaro, and a wall with paintings by Degas.

The wall of Degas at the National Gallery seems light and delicate in contrast to the symphonic paintings in Munich, Amsterdam, Leningrad. In the five canvases on this wall can be seen the organic development of the artist. The early work, "The Young Spartan Boys and Girls," always strikes me as unusually original in composition, in mood, and in drawing. I have always tried to understand this peculiar originality. It is true that he was influenced by Poussin, Ingres, by figures on a Greek vase. Yet there is about it this originality which I find difficult to explain. There is in it a youthfulness, combined with an ancient wisdom. Many changes are evident in this painting, corrections which Degas made no effort to hide, as though he were painting this picture just for himself. The group in the background is unfinished, tentative and fragmentary, which gives the painting an elusive quality of promise—it is not brought to culmination.

The "Femme Assise," the portrait of a dark-haired woman, a gray-green shawl over her shoulders, seated in a red and white covered boudoir chair, is like a Vermeer with the addition of Degas' deep, psychological insight. This painting is ingeniously composed, full of abstract shapes.

With what amazing accuracy the "Acrobat Girl" is painted, hanging by her teeth under the vaulted dome in the circus. And the

121

architectural background! One has to go back to Saenredam to find such sensitive and truthful rendering of this type of interior. If this comparison seems forced, it is certainly more reasonable and not so far fetched as that which links Mondrian to Vermeer and Saenredam.

Finally, the extraordinary painting, "Combing the Hair." This is of the series of "women bathing, washing, drying, rubbing down, combing their hair or having it combed." It is a masterpiece of Degas's old age, painted roughly on rough canvas, with fauve-like breadth and almost a modern disdain for technical refinements. It is unusual in color, all red, the background, the robe, the hair. The figures and their living gestures, the mood of the entire painting, have the Degas precision and objective truth. Here Degas finally achieved the kind of universality and abstraction that comes only after a lifelong involvement with reality and human affairs.

In the Tate Gallery there are a few more Degas, some Impressionists and Expressionists of various schools, and examples of all the international art movements of the last half-century. I was most interested this time in the English painting, to which the greater part of the gallery is devoted. Of the early English school, two Hogarths— "The Heads of the Servants" and "The Shrimp Girl"—are unique in their directness and spontaneity. They seem commendably not "dated," fresh and unencumbered in comparision to what came soon after Hogarth. I have in mind Reynolds, Gainsborough, etc.

There are some visionary landscapes by Turner here. But in his desire to express the cosmic forces of nature, he often muddled around in a grandiose morass. Nor was I impressed by Constable—so naturalistic and fussy. I cannot understand why he was admired by his great French contemporaries, Géricault and Delacroix. He was so inferior to their countryman, Corot.

In the Tate Gallery, as in other European museums, I noticed how fully represented were the native artists. There were rooms and rooms filled with pictures by Turner. There were many Constables, Hogarths, Reynoldses, and Gainsboroughs. A large room was devoted to pre-Raphaelite paintings. Of these I liked most two very early canvases by Dante Gabriel Rossetti, done at the age of twenty-one, which he never surpassed.

Of the more recent paintings I preferred the work of the lesser-known artists. For example, Gwen John's small, unostentatious, very

personal portraits and figure studies, including an unusually perceptive self-portrait; Walter Greaves's "Hammersmith Bridge"—a positively unique painting of crowds of people watching a boat race. It is beautiful in color and pattern, and made me think of some early water colors of our own Prendergast.

There is a fine collection of tasteful and intelligent work of Walter Richard Sieckert.

In a long hall devoted to contemporary art I found interesting the work of John Bratby, Joseph Herman, Lucien Freud, Jean Bratby, Peter Blake, some early, too sweet though, works of Victor Passmore, and a group of nightmarish pictures by Francis Bacon.

There is a very comprehensive collection of twentieth-century art representing artists of other countries besides England. There are also some very recent contemporary American paintings. In this respect the Tate Gallery is similiar to the Museum of Modern Art in New York. Not all the pictures at the Tate are masterpieces of lasting importance, as its director, Sir John Rothenstein, admits. He convincingly states the reason for this in describing the function of the museum in his introduction to the publication *The Tate Gallery*, p. 52:

> A gallery only of established masterpieces, skimmed off, as it were, from the art of their time, would be like a city whose every building was an architectural triumph that has alone been allowed to survive from among its fellowsAn understanding and a relish for any period, and of the classics of any period, would seem to demand at least an acquaintance with the period's ebb and flow . . . and accordingly with those works which fall short of being classics.

When we met Sir John Rothenstein at the Tate Gallery, our brief conversation revealed a person who, besides knowing the art of the past, has an enthusiastic interest in the many aspects of present-day art. He spoke with animation and warmth, and we got the impression that he makes it his business not only to know the work of the artists, but to have personal contact with them as well.

In London we met some of the people I visited two years ago: Peter De Francia, Joseph Herman, and John Bratby. Again John Bratby, both by his personality and by his work, captured my imagination. I vividly remembered the Bratby family, and I looked forward to seeing them again in their extraordinary habitat in Blackheath.

The garden was more overgrown, and the house more neglected as a dwelling because the canvases seemed to have invaded the living

quarters. Every room became a studio stacked with paintings and drawings, for they all paint—John, Jean, and their older boy of seven. I was surprised to find Bratby without his beard, having gained weight, and without that Dostoevsky look which had impressed me the first time I saw him. Now he looked much younger and his round, pink-complexioned face was completely unlined. His wife this time, friendlier and more outgoing, greeted me like an old acquaintance and stayed with us the afternoon.

Bratby himself was disturbed about some money and dealer difficulties, but when he began to show us his work his money worries seemed to disappear. He showed us a huge "mural" which he was commissioned to do for a Jesuit school. He wasn't being paid for it, except for the cost of materials.

"I do it for nothing. I like to do murals, and I want to do more," he said. Like at our first meeting, I was moved by this total obsession to paint. The mural, propped against an entire wall of one of his studios, depicted the New Testament parable of the fish, in modern clothes. It was filled with many gesticulating, gaunt men and women with intense faces and convulsively begging hands, painted with feeling and vigor.

"I'm here five times," Jean Bratby said. Indeed, her disheveled figure and her round, strangely beautiful eyes, were repeated in different spots of the canvas.

Back in the house, we saw many paintings of boats in several rooms, and in the hallways. "People here are fed up with my figure work, so I'm doing boats," Bratby said in passing. Jean shyly offered to show her work. In a room messed up with paintings and drawings, tubes of paint and rags, she pulled out canvases from behind chests and beds. Self-portraiture was the main theme, sensitive and searching, very often in shadow. Restlessly she began to look for some drawings, and for photographs of paintings, and soon gave up. She could not find them.

While John was out of the room, calling for a taxi for us, I asked his wife, "Was he always like this? I mean, did he always paint so much?"

"More so," she said. "When the baby would cry and I wanted to pick him up to comfort him, John would say, 'Leave him alone. Let's draw him crying.'" And there was an anxious look in her wide-open eyes. "Now he sometimes takes care of the garden."

"How does he manage to make so many paintings?" I asked.

"I don't know. I find him in the kitchen a lot, drinking coffee."

The next day at the Tate Gallery we saw the work of both Bratbys, both self-portraits, vividly revealing themselves in their environment: John painting in chaotic disorder, with his bewildered wife at his side; an extra pair of hands with paint brushes in the canvas, descriptive of his attitude to life, in which painting matters most. This picture is called "Self-Portrait, Hands and Jean." Jean's self-portrait is actually an image of herself in a mirror, as if confined within it, moody, in the reflected shadowy atmosphere of the room. Both paintings were outstanding in this room of contemporary British work.

Joseph Herman's invitation to visit him in his home in Surrey gave us an opportunity to see the English countryside. The region is known as Thomas Gainsborough's country because he was born and painted here. That day was the most beautiful one during all our stay in England, sunny and warm. The house is an old, rambling stone one, set in very idyllic farm surroundings. We had lunch out-of-doors with Herman's family—his wife, a very handsome, stately young woman who is a doctor, and their two lively sun-tanned children, a six-year-old boy and a sixteen-month-old baby girl.

Like many other artists, Joseph Herman has a collection of drawings and paintings, Pascin and Joseph Israels among them. Also a choice group of antique African sculptures. An old barn on the premises was converted into a fine, workable studio. He showed us his recent paintings which retain the content of the painting I saw two years before: miners of Wales, in and out of doors, at work and at rest; interpretations of nature at its moodiest—evening scenes, sunsets with broody richness of color. Again I felt the early impact of Wales, of Permeke, and, at times, of Rouault, hang over his work. Their sonorous quality seemed to me almost oppressive.

I like Herman's exuberance and enthusiasm, his many plans for future work, his social awareness, and the intelligent way he talked about the art trends of our time. One of his comments was that the supposedly original and individualistic practitioners of the many current *isms* are really the conformists among the artists of our time because they all paint alike, all follow the fashionable trend and paint according to what is expected of them by those who wield power in the art world.

With Peter De Francia, the London painter, as a guide, we visited Hampton Court. There, besides some very good old masters—Titian,

Holbein, Lorenzo Lotto—I saw the very early anonymous English paintings, portraits of ghost-like men and women in beautifully rendered costumes of the period, bejeweled and embroidered. They were almost abstract in the designs formed by the figures on the canvas, and in their featureless faces. They were dreamlike in color. These are the English paintings that fascinated me most.

Outdoors, the clear gray light unified even the more harmonious colors—the gray and the brick-red of the buildings with the richness of the flower beds in these famous gardens. Architecture-minded De Francia pointed out the stately beauty of the old stone buildings, and we were thrown into a poetic mood by the tranquility of the ancient courtyards.

Before leaving London we spent an afternoon in Peter De Francia's three-story house, where he lives, works, and stores his paintings. His work reveals his interest in the issues of our time: large turbulent, exotic, and expressive canvases of struggling people.

We acted upon Pera Atasheva's suggestion and wrote to Herbert Marshall, one of the men in charge of the Eisenstein drawing exhibition at the Victoria and Albert Museum. The response was prompt, with an invitation to visit him. We were greeted by a tall, exhuberant, pug-nosed Englishman. Inside the doorway, he pointed up to some broken beams in the ceiling, and said, "This house is the Last of the Mohicans of the Victorian Age. It's about to be demolished. We sold it and are moving to the country." This was in explanation of the general disorder around us. There was something unusual and unorthodox about Mr. Marshall's friendliness and informal hospitality.

"Come into the studio," he said, "I'll show you my wife's sculpture. She's Fredda Brilliant." The huge room with the double skylight was filled with skillful likenesses of Mayakovsky, Nehru, Krishna Menon, Pera Atasheva, and others.

Herbert Marshall studied with Eisenstein in Moscow for several years. He mastered the Russian language well enough to become a recognized translator of Mayakovsky. He gave us a book of his translations, and inscribed it to us.

Many people outstanding in various fields, such as poets, novelists, singers, also liked to draw. Among them were Pushkin, Victor Hugo, Mayakovsky, Caruso. From their drawings one can learn

much about their personalities, their active minds. Sergei Eisenstein's drawings reveal his creative, imaginative, restless spirit, his sense of humor, his keen and satirical power of observation. These drawings are skillful, intense, rapid, urgent. Some of them are quite complex, with elements of cubism and futurism. A few are moody and delicately Picassoesque. Others remind one of Gauguin and Lautrec. This exhibition, which marked the fifteenth anniversary of Eisenstein's death, also contained his photos, letters, and old clippings, and books about him. One poignant item was a page from a notebook upon which Eisenstein wrote in Russian: "Today I am fifty years old," signed and dated. This is exhibited upside down to show how his unique signature in this position resembles the battleship Potemkin. The day after Eisenstein wrote this, he died.

Homage to Eakins (II)

We very often talk about the Burliuks, what interesting and unusual people they are; about their home on Long Island filled with pictures and books; their unusual habits; their complete devotion to art. Some friends of ours, newly come to art, wanted to meet the Burliuks, and drove us out to Long Island to see them, on a rainy after-Thanksgiving day.

As always, we were greeted very warmly by David and Marusia. Their faces lit up with genuine joy at seeing us, joy that is an outgrowth of many years' friendship. As always, we were impressed by the earthiness of these two old people, by the originality of their speech, their homey dress, their polite manner, the interior of their house crammed to overflowing with books, pictures, and sculptures; their huge homemade table, roughly fashioned by their vigorous sculptor son from a tremendous tree trunk split in half, planed and polished with use into a smooth, almost silky finish, and resting on short tree stumps for legs.

Immediately after the ceremonial greetings they offered to take us to their "gallery," about a quarter of a mile from their home, a simple structure of cinder blocks, built to house the many pictures collected and painted by David Burliuk. During the summer months it is open to the public under the direction of Marusia Burliuk, who takes pride in having brought the "museum," as she calls it, to Hampton Bays.

It was still raining hard, and Burliuk put on an ancient gray herringbone tweed overcoat, which beautifully enveloped his aged figure. It had stains of green paint, thinned by time, which, on the yellowed gray of the coat, looked like moss on earth.

In the "gallery" Burliuk showed us paintings by many artists and also his own work. After he set up a whole line of his own vigorous and colorful pictures, he suddenly walked away to the far side of the gallery,

128

David and Marusia Burliuk

where he sat down on a chest, as if to rest, and for a while seemed to become oblivious to the activity at the other end. Mrs. Burliuk took over showing the pictures. To the great and unexpected delight of the Burliuks, our friends bought a painting. After this we went back to the house.

On the oaken table there soon appeared quantities of bread and cheese, wine, vodka, and tea. The conversation became very lively. Burliuk was in an unusual merry mood and held forth loudly and eloquently. Every once in a while he was interrupted by Marusia in Russian. "Father, stop hollering. You're not a priest in a church." Whereupon his face would assume an expression of sweet condescension, and he would say to his audience, "Dear Marusia tells me not to talk so loud."

He told us about his art in the days of the *Blaue Reiter,* describing Kandinsky to us; the melodramatic days of Futurism in St. Petersburg and, of course, talked about Mayakovsky. Burliuk loomed big in these reminiscences. He was boastful, exultant at his long life.

"I almost died last winter," he said at one point. "But you know who did it for me? Georges Braque!"

I was glad to have taken my sketch book. I made a drawing of Burliuk talking, with one hand raised in a posing gesture; wine, bread, and books on the table, and pictures on the wall. I sketched Marusia Burliuk, her limpid eyes and disheveled hair, while she was animatedly talking to my wife about our recent visit to Leningrad and Moscow. This wasn't all. A huge guest book appeared, in which we all had to write personal comments, and I doodled in it and in other books and catalogs. Before we left we exchanged presents.

February 1964

I'm finally at work on the large version of "Homage to Eakins." I have made for it ten preparatory portraits from life: also three group compositions in various stages of completion. In the past year I examined and studied group portraits by Rembrandt and Franz Hals, as well as compositions by Veronese, Caravaggio, and, of course, Fantin-Latour. In one of the Skira books I came across a painting by the Spaniard Solana, a simple and direct composition consisting of a long, rectangular table with men seated along both sides, like Franz Hals, but without his gusto, exuberance, movement. It influenced me in

planning my work. Its stillness, I felt, would be suited for my composition. I made a sketchy drawing of this painting from the Skira reproduction. My canvas with the "Gross Clinic" in the background has to be vertical, whereas the Solana is horizontal in position.

When the large canvas was brought up to my studio I was appalled by its size and by the raw whiteness of its surface. For two weeks it stood propped up against the wall without my approaching it, as if I were trying to ignore it, to pretend it wasn't there. I busied myself with other canvases. Finally I tinted it with the same ground which I used for the single portraits and preliminary studies, the same preparation of white, yellow ochre, and cobalt blue diluted in turpentine. Unfortunately, this canvas did not take the preparation as well as the others did because they were more absorbent. This one was smooth and began to look like a blotchedly-painted wall. I was quite dismayed by it and even thought of stretching another huge canvas of different texture. But finally I decided to use this one after all.

As soon as I began I was immediately confronted by the following problems (which, frankly, I had anticipated): On the large canvas I had to make the figures on the first plane, in the foreground, somewhat bigger than life, the size I painted them in the preparatory studies, so that the figures in the back should not appear too small. But the main difficulty I found to be copying my own work. I was amazed by what had gone into the making of the portraits, how meaningful each seemingly haphazard brush stroke was, how expressive was every varied patch of color. These were not definitive studies that could be accurately transferred to the final composition; they lacked absolute rendition. They were tentative, nervous, personal, calligraphic, immediate reactions of the artist to his subject. They became art works in themselves rather than functional studies for a larger work. And therefore difficult to copy. But I did copy them, realizing at the same time that it was impossible to maintain the spontaneity of the sketches, to copy each brush stroke as it was done originally, almost automatically.

May

I have been working on the big canvas for months now, but not every day. Sometimes a week goes by without my even glancing at it. During this time I have finished about half a dozen other paintings, one of

them a double portrait of John and Alice Rewald in their home, with the statue of the skirted Degas ballet dancer in the background. Another one, a small head of John Rewald, for which he uncomfortably sat in a hard chair in my studio. While he was posing, I threw out the thought that I might want to include his portrait in the large Eakins composition. Like Ingres, in his "Apotheosis to Homer," I wanted to include all those for whom I have regard, for one reason or another, and I admire Rewald for his work on the Impressionists and Post-Impressionists, Rewald said, "I really don't belong among American painters in "Homage to Eakins," but if you want to put me in, you may." And then he added in his somewhat dry, professional manner, "It's *your* 'Grand Jatte '."

He interests me, this writer on French art, this lucid, factual art historian, who on occasion is definite and personal in his opinions, if unobtrusively so. His extraordinary histories made the art epoch about which he writes real and alive to me. I felt almost in physical contact with Courbet, Manet, Renoir, Degas, Cézanne, Monet, Pissaro, Seurat, Van Gogh, and Gauguin, as well as with lesser personages of that milieu.

I was not completely successful in my portrayal of this chain-smoking, restless cosmopolitan with the worried blue eyes. It was difficult to get the ever-changing mobility of his face. He never looked the same for any length of time.

"I influenced a collector to buy an Eakins, a painting of children at play," he said, showing his regard for Thomas Eakins.

The Eakins canvas does not loom so unwieldy and big as it did upon its arrival. It seems to have been shrinking while I have been filling it with one figure after another. I am following the original plan of the first preliminary composition with this change: in the first study the "Gross Clinic" painting is right in the center of the background, so that the head of Dr. Gross is directly and awkwardly above the head of Lloyd Goodrich. To correct this I moved the Clinic painting slightly to the left on the canvas. Also, as I added more figures, I found it necessary to reshuffle the group from the original positions in the preliminary study.

Besides the "Gross Clinic," there are parts of two other smaller paintings by Eakins in the background, one on either side of it—the "Salutat" and the "Sculptor Rush in His Studio." My first sketch for the composition, with just a few figures around the table, had the portrait of Whitman and Eakins's self-portrait on either side of the "Clinic."

Lloyd Goodrich

June

The canvas is all covered. All the figures and faces are at last painted in their first state. I found a place for my self-portrait, for which I had made three studies in different positions on one canvas. I have also indicated a figure of a woman serving a tray with drinks, for which my daughter promised to pose. Now and then when I step back to look at this painting, I find it rather impressive. The composition seems to satisfy me. But it's a long way from being finished.

My goal is to make the whole painting as living and intense as each individual portrait of the artists. Will I be able to capture the tremor in the temples of Jack Levine's portrait, the anxious face of Moses Soyer? Or the aura of aloneness about Hopper? However, although I have hardly begun to dig into these portraits, their being next to one another seems to help to point up their individual likenesses.

It got around that I was doing this group portrait of the artists, and people frequently ask me how it is getting along. This worries me. It is still in its initial state, and its final realization is questionable. I am never certain of a painting until the very last brush stroke is applied. About this particular one I have often a very uneasy feeling that I simply am struggling with something beyond me for which I have not enough technical knowledge. Such paintings are not done today. The secret of doing big group paintings has been lost. Probably Fantin-Latour and Eakins were the last portrait painters of this type. It is impossible to paint that way now. The portraits painted today are fragmentary, personal, capricious, nervous, tentative. They are incomplete, accidental, at times full of inaccuracies. But they are fascinating—revealing the artist more than the subject he paints. If ever completed, my paintings should have some of these characteristics.

July

On the way to Vinalhaven we stopped at the Art Museum of Bowdoin College in Brunswick, Maine, to see the exhibition, "The Portrayal of the Negro in American Painting," a chronologically arranged historical selection of paintings, from colonial times to the present. Some of the paintings depict the events in the life of the Negroes in the

United States, such as slave market scenes, the visit of the Mistress to the Negro quarters (a Winslow Homer), Negroes at work, and early portraits of distinguished Negroes. The better pictures are simple genre scenes of Negro home life, like the water color by Thomas Eakins of a barefoot Negro boy dancing to the music of a guitarist, and an unostentatious study in oil of the same boy; also "Shooting Quail," another Eakins water color, as well as the "Masquerade Party" by Winslow Homer, his charming "Boy with Sun Flower," Haveden's "Their Pride and Joy," and Andrew Wyeth's painting of an old man and his granddaughter.

Among other painters was Alexander Brook, whose "Georgian Jungle" I hadn't seen for many years—a gray and brown landscape of scrawny, leafless trees and Negro shacks reflected in muddy puddles, and in the foreground some gaunt Negroes. Also Joseph Hirsch's "Lynch Family" and Jack Levine's "Birmingham 1963," which was especially timely. Jack Levine told me that for three months he worked exclusively on this painting.

I was gratified that my painting, "City Children," which included a Negro boy, was so well hung and looked so well. This is the kind of painting I do from time to time which leaves me uneasy because it is open to accusations of sentimentality. This particular one is of an actual scene I witnessed in front of a New York tenement of three somewhat melancholy children together physically, yet disassociated from one another.

I left a note for Marvin Sadik, the young curator of the museum, expressing my admiration for the painstaking research that must have gone into the preparation of this show, and praising it for its timeliness and excellence. Such an exhibition, I wrote in the note, should be circulated throughout the country.

Vinalhaven, July-August

My landscapes of Vinalhaven are really more like still lifes. I start out with the idea of making a landscape, but invariably it becomes still-life-like. Perhaps it's due to the content I choose—gray rocks, abandoned piers with their debris, piles of weathered lobster traps—excellent still-life material. Only a small part of the canvas is alloted to sky and that is gray and flat. The entire landscape gradually turns gray even if it started on a sunny day since gray days predominate on the island.

The aspect of these canvases, then, is such that they could very

well have been painted in a studio, under a skylight. The fact, however, is that I do paint them out-of-doors. Intrinsically I am not really interested in light effects, but in the foreground perspectives, in the shape and texture of rocks, in the architecture of the piled-up traps, in the depth of bushes, and in the contour of leaves when they enter into landscape.

I am conscious of the fact that I'm one of the very few now who paint directly from nature with their easels and canvases out in the open. This was the method of Pissaro, Monet, Cézanne, and Van Gogh, and of Courbet, too. I enjoy it. I feel the air and the wind, and once in a while I hear the sound of a jet plane, and it amuses me that while I am down here making a picture with the age-old tools of brushes and paints, there are satellites hurtling in space.

Vinalhaven, naturally picturesque and once a thriving and vigorous community, has acquired a peculiar charm that semi-abandonment and isolation give. It is the largest of the Fox Islands in Penobscot Bay, an hour and a half by boat from the mainland. When it was one of the busiest granite-quarry centers in the country it was thickly populated. There is no granite mining now; the quarries have become swimming holes, and the chief and almost only occupation has become fishing for lobster and herring. The young people leave the island, the old ones stay on, and when they die their houses are left empty, soon to deteriorate and fall apart, unless bought and restored by summer people. There are stretches of jungle-like wasteland, with gray remains of wooden houses showing through the trees here and there.

However, there is a well-organized township, and along the harbor, starting from the newly-built ferry landing, the old Main Street with its fish factory, power plant, post office, and the usual stores is still the center of activities. There are two or three churches, a movie house, two school buildings, and a new medical center.

Among the summer people are a few sculptors and painters, but there is no obstreperous art colony. The island does have an art tradition—Marsden Hartley spent several summers here with his friend, the poet Harold Vinal, now aging and semiblind; and Gaston Lachaise as well as John Marin are said to have worked here.

I became acquainted with a local painter, Brud Clayter, born and bred on the Island. In his adolescent years he was ill, and although his ailment was finally cured, it left him with a ravaged physique and a heightened sensitivity. He paints delicate water colors and admires

strongly the work of Andrew Wyeth and Edward Hopper. In a recent water color he depicted a solitary house in a hayfield.

We spend time together—he brings me work to criticize, and we talk about art, literature, politics, and life in general. He sometimes reminisces about what happened on the island when he was a child. One of the incidents he witnessed about thirty years ago sounds, as he tells it, almost like a folk story out of Tolstoy: A seven-foot skeleton of an Indian found in a grave on a wooded hill was to be viewed by an anthropologist from the State University. While people were waiting around the open pit for the expert to arrive, "the meanest and pushiest man in town," wanting to be first at the scene, rowed his boat frantically to the foot of the hill, rushed pantingly up, elbowed his way through the crowd, and dropped dead into the grave onto the skeleton, smashing it to bits.

There is one summer resident on Vinalhaven whom I must mention, the graphic artist Mauricio Lasansky. He has installed a real workshop with all the necessary equipment, light, and machinery in an old house overlooking a particularly isolated and picturesque cove on the island.

For the last three years Lasansky has been engaged in chronicling the Nazi atrocities in a series of twenty-five oversized drawings done in pencil and water color. He calls these emphatically "The Nazi Drawings." When I visited him last he showed me some of the still unfinished compositions, a group of intensely expressionistic drawings, gruesome, shocking, and brutal—a sort of neorealism familiar today. This work, however, has validity and purpose, exonerating it from possible accusations of sheer necrophilia and sadism.

The size of the drawings, the sparse medium of pencil with touches of dull water color tints, the irony of using pages torn from the Bible, indiscriminately collaged as a background, and the repetition of a tattooed concentration camp number, haphazardly stamped on the surface, all create a strong, new impact. A few drawings deal accusingly with the role of Pope Pius XII, a face and figure cringed with fear and remorse.

Coming out of the studio into the relentless sunshine (the island had been suffering from a long drought) I had to make an effort to free myself, like one awakening from an evil dream.

137

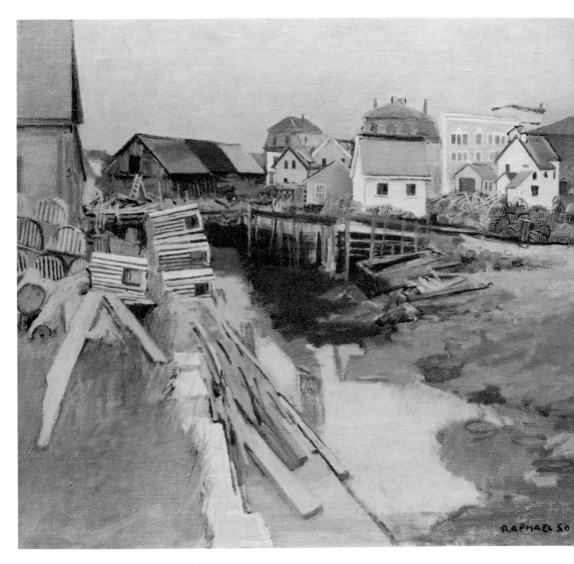

Maine Harbor

August

In the Ogunquit Museum we saw a small but quite comprehensive retrospective exhibition of the work of Jack Levine to which again I responded, as I always do, with heightened interest. For sheer painting ability, he is one of the most vigorous painters in America today. By comparison, the other paintings in the museum seemed anemic and tame.

To begin with, there were some remarkable Ingresesque drawings, some of them dating back to his early teens. The earliest painting shown here, which I had never seen before, was one of three men playing cards, painted when he was not quite twenty years old. Interestingly enough, it lacked the usual naive charm one associates with youthful work. It had instead an overall soberness of an older painter.

The other paintings familiar to me seemed even more striking than I remembered them because they were displayed under better-than-usual conditions in a spacious room with excellent light: a few early conversation pieces in dark red and slate black, of grotesque men; "The Passing Scene," a tableau of an old man and child, a fantastically rendered old workhorse, a black sky, old tenements, clotheslines, debris with a fragment of foreign-language newspaper. Chagall, Sholom Aleichem, the early George Grosz, came to mind. But this was different. There was no folklore or humor. It was grim, yet compassionate, not satirical. It was painted in tangible terms, yet it had a strange echo quality. It recalled the immigrant era.

Among other paintings were the powerful composition of "Cain and Abel"; the well-known "Medicine Man" (on loan from the Metropolitan Museum); the somber painting of the execution of a Spanish Loyalist; and the politically biting depiction of Parnell Thomas of infamous memory, stabbing Legislature in the back. There were also the humorous satires often characteristic of Jack Levine, the pathetically sentimental, garish couple of the "Black Freighter," the pleasantly soft Eve with her constitutionally inadequate Adam, and finally the unique self-portrait—a pale, precocious young artist being chucked under the chin by a ponderously floating Rubensesque naked muse.

This self-portrait made me think of Levine as I first knew him in the early 1940s. He must have already been well-known then, for he was among the portraits I painted of eminent artists—Sloan, Weber, Marsden Hartley, and others. I remember him in my studio, quiet, pale, with thick, heavily-rimmed glasses, "a veritable Shostakovich," Nick Cikovsky said of him when he too saw him that day. Since then I have begun to know him somewhat better. I privately place him, however, in the category of those whom, because I admire them, I shy away from knowing as intimately as I think I could know them. I had this feeling toward Guy Pène du Bois, who was my teacher, and later toward Kuniyoshi, Hopper, and a few others.

139

Jack Levine

While he was posing for the Eakins group, Jack Levine was silent, grim, immovable. The first sitting ended in complete failure, and left me dejected. "I'll have to do it all over again, on a different canvas," I said gloomily. "I'll need a couple of more sittings." He agreed without question.

The second attempt was more successful. This portrait is the most poignant and satisfying of all the studies for the Eakins painting. I think I caught his tenseness, the intellectual brooding in his blue eyes under the thick lenses, the mobility of his features.

Jack's studio is the messiest, the most uncomfortable I have ever seen. He comes there just to paint. "I can't even get a drink of water here," he says. There is no sink in his studio. I remember a winter afternoon when I visited him. There was a harsh overhead light. A huge canvas on an easel threw a thick black shadow on the wall. There was a model stand, with a great heap of cloths on it. On the floor, or perhaps on the stand, was a whiskey bottle. There were some art books on crude shelves. One of the walls was discolored and scaly from a chronic leak. Not a painting was on the walls, just a few photographs clipped from newspapers, one of a sanctimonious, well-known churchman fondling a baby who was bawling in his face, and others of similar tone.

The painting table was piled with used-up, but not discarded, paper pallets; with quantities of paint tubes, half-squeezed ones mixed with new ones; and with huge short-handled brushes of the kind used by house painters. When I expressed surprise at the size of the brushes, he said, smiling wryly, "Essentially, I am an action painter," and he pointed to the large seminude on the easel, which was painted with tremendous vigor and contained all the gusto, and more, of action painting plus, of course, the content—a young girl in the pose of a Medici Venus, but clutching a slip in front of her body.

He was at that time involved with a series of pictures on the mythological subject, The Judgment of Paris. Again there was satire—the old theme in modern dress—chorus girls in burlesque semi-attire with fantastic hats and hairdos, with their agents and pimps "in black tie" in a hubbub of bank buildings, automobiles, and neon lights. "I am a satirist, as you see," he said.

But then he showed me other paintings: a gentle and sympathetic study of a young model; a charming portrait of his daughter, and a directly painted head of Ruth Gikow.

141

He talked about technical matters of painting, various media, effects of one layer of paint upon another, glazings, etc. He was articulate and knowledgeable, but it was hard for me to follow, since my mind doesn't work that way. I have never given too much thought to such technicalities. What never ceases to fascinate me about Jack Levine is his mental alertness, his extraordinary talent, and the seemingly inexhaustable reserve of ideas for paintings to come.

Europe, 1964

Paris this year had somehow a greater impact on me than on the previous visits to it. The weather was particularly fine, the day was clear and sunny as we found ourselves in the planned vistas outside the Louvre. The epic paintings, so heroic in size and spirit, by David, Ingres, Géricault, Delacroix, and Courbet are to me the glory of France. Again I felt that Delacroix never surpassed his early "Liberty Leading the People" and "The Massacre of Scio," although he remained a great painter until the end of his life. And the three paintings of Courbet, the "Wave," the "Studio," and the "Burial" are enough to make anyone immortal. The "Studio," mural-size though it is, has the intimacy and quality of easel painting at its unsurpassed best.

In a section of the Louvre we saw a large and well-displayed exhibition of Rouault. He painted in a continuous mood of poetic exhaltation, but he is one of those artists, such as Van Gogh and Dufy, who have no personal hold upon me, brilliant and profound as they may be. The obviousness and the repetitiousness of their spectacular styles become monotonous.

I went with the artist Joseph Floch to an exhibition of the traveling Johnson Wax Collection, known as "Art: U.S.A." at the Musée d'Art Moderne. It was the usual type of contemporary painting one can find in Europe and America. More than three-quarters of it consisted of pictures in what is now rapidly becoming known as the "international style." In other words, they are all alike, no matter where they are painted—in New York, Amsterdam, London, Buenos Aires, or Tel-Aviv. These happened to be American paintings, most of them huge in size, "freely" painted, noisy in color, and themeless. Some were "absolutely idiotic," Joseph Floch said. There were representational pictures, too, but they seemed exasperatingly modest and were lost in the pandemonium.

"Even if there were a Cézanne here, no one would see it," remarked Floch. These "internationalists"—I am always amazed at their lack of artistic reticence, their almost hysterical clamor for attention, so obvious in the contentless gigantism and preposterous color of their canvases.

How different are the paintings at the Jeu de Paume, which I visited that same morning—quiet, serious, honest, workmanlike. Unforced, without public approbation in mind. Especially so Degas. He did not care at all for the opinions of the critics, the cognoscenti, the museum directors, and the public. He simply painted in a way that pleased him. He was his own severest critic. Very often he made revisions in composition and corrections in drawing long after the paintings were finished, and did not bother to cover them up. Thus in the group of girls in the "Jeunes Spartiates" in London's National Gallery, he changed the position of the legs without painting out the original ones, leaving an extra number of legs. This gives his work an added fascination for me because it creates an element of tentativeness and even of movement that brings a hint of futurism to mind. Some parts of his canvases are finished with the most delicate completeness, while others are left in the rough, strangely enhancing them.

Two of Degas's great paintings in the Jeu de Paume are "The Absinthe Drinkers" and the "Repasseuses." The first one is the quietest, even the drabbest painting I know. It is all in nondescript black, white, gray, some yellow ochre, with a touch of light green of the absinthe. Yet this poverty of colors adds to the deep and hypnotizing effect this picture always has on me. The relegation of two withdrawn people to one side of the canvas accentuates the mutual loneliness which gives this picture its strong psychological bent. It is as unique in its way as is "The Arnolfini Couple" by Van Eyck. It brings to mind the monochromatic paintings of Louis Le Nain.

The "Repasseuses," on the other hand, is colorful. Every tint adds to the reality and originality of this masterpiece. It is painted on the raw, unsized surface of the canvas with the most subtle economy of means. Every brush stroke is functional. Against all rules of art esthetics, Degas tackles such unorthodox subject matter as a woman yawning and transcends its literary and anecdotal aspect by means of great simplification of form.

I met in the Louvre Abraham Chanin, art historian and lecturer at the Museum of Modern Art of New York. In a room most of which was filled with very capable but mechanical French eighteenth-century

portraits, he was studying a group of small, modest still lifes and genres by Chardin. With great relish he pointed out to me the textural and paint qualities in these canvases: "Look at the reflection of the apples in the silver goblet."

Later we took a walk to the Rue St. Denis section. "It's like Fourteenth Street as it used to be," Chanin said. Bars and cafes filled the wide street, and prostitutes mingled with the customers. In doorways of narrow, dark streets there were groups of cosmeticized, frizzed girls. Some were charming and young. Older ones, bitter and tough-looking, wore tight leather dresses, their breasts and bellies accentuated by the light shining on them. "They look like the Maillol nudes in the Tuileries, lit by the sun," I said.

Interesting as well were the gray, shabby, scaly houses which seemed to be crumbling. Some unsafe, ancient buildings had been demolished, exposing a whole area of windowless walls. "These walls are straight out of Daumier!" exclaimed Chanin, "and these old gray buildings, you can see them in the background of Delacroix's "Liberty Leading the People."

But the high point of our stroll was the little Park of the Innocents. "Ironic," said Chanin, "a park with such a name in this section of slums and prostitutes." This park was reserved only for the neighborhood mothers and children. We went there to look at what served as an inspiration to the young, impressionable, avid Renoir. The attendant allowed us to enter and there in the center of the park, on a strange polygon structure, were the bas-reliefs by Cojon of sensuous, yet innocent, semidraped female forms. They were sparklingly clear, having been recently cleaned, like other monuments and buildings, by the order of Malraux. While we were admiring these we were also aware of the women and children, obviously from this slum area. The older children noisily circled around us, boldly touching us in their bid for attention.

Life was teeming and complex, real. I felt more than ever that it is the basis of all art.

Joseph Floch invited me to his "wonderful" studio: "I have a model, and you and I will draw for a few hours. It's much quieter and nicer here than any of the studios we had in New York.

I took my sketch book, its hard, blue covers worn and yellowed from being carried in my hands these many weeks. It was not Floch's

permanent studio, it was just rented for the summer, but it already had all the characteristics of any place where he happened to be working—neat, clean-swept, the cot and the wall above it covered with woven fabrics of South American design. No paintings or drawings on the whitewashed walls. So unlike my own work rooms which generally become messy, their walls covered with sketches, half-finished canvases, and reproductions clipped from magazines and newspapers. I remember in one studio how Arshile Gorky looked about him and said in his usual melancholy voice, "Gee, you still have a romantic life with pictures!" I didn't exactly know what he meant then, but that phrase has remained with me. To try to explain it now would be too much of an inquiry into Arshile Gorky.

Floch was absent-minded, didn't seem particularly interested in drawing, but fussed around with canvases which had beginnings of compositions. He made only half-hearted attempts at drawing from the model, not caring what the pose was. I had the feeling that he engaged the model that morning for my benefit, for he knows well how much I love to draw. As on many other occasions, I was grateful to him for this particular attention.

After the model left we spent the rest of the afternoon talking about art and literature, and also about music, with which Joseph, like many other Viennese, is well acquainted. We discussed particularly the drawings of George Grosz, Pascin, and Schiele. Among other things I remember Floch saying that these three, although labeled Expressionist, went beyond this, or any other, classification:—"They invented personal styles through which they expressed the dreams, the sufferings, the anxieties of life."

He found parallels for these artists in literature and music—the sensuousness and gaiety of Pascin in Offenbach, the cruelties and anxieties of George Grosz and Schiele in Kafka.

For many years Joseph and I were close neighbors in the Lincoln Arcade, lately demolished to make way for the newly risen cold, prophylactic, transparent buildings of Lincoln Center. This skillful and poetic painter would often quote from the Bible, from Goethe, Heine, and Tolstoy. We would see each other many times a day, show each other our canvases in all the stages of their completion, criticize each other honestly if delicately, work together from the same models, pose for each other. How often our long talks would help to clarify our artistic aims within this bewildering and confusing world. Our contacts now are mostly telephonic since we have become geographically separated in our monstrous, complex city.

At the Musée d'Art Moderne I again felt the intimate warmth of the two last impressionists, Vuillard and Bonnard. Bonnard especially was fascinating in color and in his absolutely personal simplicity of drawing. His composing, too, was very original in the way he placed figures in the immediate foreground of landscapes, resulting in an almost surrealistic illusion of space, with the pure Bonnard color binding earth, sky, and figures together in a living way.

Here I discovered another "Homage" painting, this one to Cézanne by Maurice Denis—a group of artists and critics including Bonnard, Serusier, Vuillard, Valloton, and Denis himself, with a still life by Cézanne on an easel. It was rather dull—a horizontal row of woodenly-painted heads near the top of the canvas, the rest of the painting consisting of their black-clad figures.

Suzanne Valadon's paintings stood out by their directness, good drawing, and folksy characterization. Her portrait of "Utrillo, Grandmère et le Chien" struck me as deeply indigenously French.

I was disappointed in the rooms devoted to the recent masters, Picasso, Raoul Dufy, Leger, etc. They seemed unbelievably hollow and weak after the Louvre and after the Museum of Impressionists. Matisse and Rouault showed up better here. Chagall was well represented by his early paintings, notably his self-portrait on his wife's shoulders.

In the profusion of other paintings at the museum I liked a few single, tortuously expressive figure pieces, one of them a self-portrait by George Gruber. Needless to say, a great deal of space was given over to the many varieties of nonrepresentationalism—all creating the usual meaningless confusion.

Madrid, September

I came to the Prado with great anticipation. I had been there thirty years ago when El Greco was all the rage (due probably to the Meyer Graeffe book about him). Nevertheless at that time I preferred Velasquez, and now he loomed even greater than ever. There is something impenetrable about his painting. It is deceptively simple, aloof, and warm at the same time. He painted mostly life-size, and full-length—people, horses, dogs. One gets the *feeling* of life-size.

I was really taken aback by "The Spinners"—it seemed so modern in content and spirit. I immediately thought of Courbet—he could have painted this subject. The "Las Meninas" with its interior and self-

portrait also brought Courbet's "Studio" to mind. But the paintings of Velasquez are more reticent, illusive, completely nondidactic.

Of all big paintings, "Las Meninas" is the most lovable—it is faultless in composition, technique, color. The figures are universal, and timeless, in spite of their period costumes, so human in movement and gesture. The little Infanta and her two maids bloom in the darkened space of the interior. It is unfortunate to show this painting in a room by itself with the tricky mirror that reflects it stereoptically. It should be hung alongside the other work of Velasquez.

It may seem strange, but in this hall of Velasquez paintings, Degas comes to mind. Magnified to life-size, the "Repasseuses" and the "Absinthe Drinkers" would not be unlike the pictures of the great Spaniard.

I'm beginning to feel as if I've had my fill of wandering, sightseeing, even of art. I am conscience-stricken for not painting all these weeks, so much so that I've been plagued again, as I often am in such situations, by this recurring dream: Unable to remember where my studio is, I wander about in a state of amnesia, and when I finally reach my studio, I find it in semiruin, the door without a knob, and when, in desperation, I try to pry it open with my fingernails, it gives way, hinges and all.

Venice, September

The twenty-third Biennale in Venice was well publicized by its sponsors, gossiped about, debunked and derided in many circles and manicly and pontifically lauded in others. Weeks before we left for Europe, I read the massive publicity on this show of paintings and sculpture, internationally agreed upon as the art of today by the museum directors, the art critics, the art dealers, the moneyed collectors, and the speculators—the molders of our esthetics. They have masterminded the Biennale—it's their baby.

It's impossible to describe the thousands of items in the labyrinthian array of halls and buildings. The goading of the artist by the art mart to be ever more novel has resulted in some insane productions: electrically "animated" plastic gewgaws with disgusting, maggot-like slow movements; chopped-up pianos, painstakingly but senselessly put together into meaningless and useless constructions;

the now not-so-novel crushed fenders, etc. The paintings were of the usual obsessively repetitious nonobjective type that we have long since become accustomed to, plus the latest variety of pop art.

There were a few genuine pieces of sculpture and paintings. Although not of great caliber, they were a relief: work by Giacometti; a cardinal by Manzu; several pieces of sculpture by, I think, Paganin at the entrance to the Italian Pavilion; a charming portrait drawing of Picasso by a long-forgotten contemporary of his, Assas. Even a nightmarish figure by Francis Bacon seemed plausible, and next to it was an interesting small canvas, a portrait of Bacon by Lucien Freud. No wonder that the attendance was small, and from the overheard remarks, exclamations, and giggles, it seemed to us that those who did come were there out of curiosity.

One section of the Biennale served for me as an antidote to all this—the showing in the Correr Museum of the Manzu studies for the door in St. Peter's. These affirmative, living, beautifully textured and patinated bronze bas-reliefs simply negated the lifeless atmosphere generated by the rest of the Biennale.

I've been following the work of Giacomo Manzu with admiration ever since I saw his sculpture, years ago, of a child sitting on a chair. In today's artistic chaos he is among the few whose work is a testimony to the continuity of the ever-renewable tradition in art embodied in the human image.

Near the Academia a painting in the window of a gallery attracted my attention, an expressionistic, vital portrait of a woman. I went in and saw the retrospective exhibition of Gabriele Mucchi, whose work I had first noticed and liked three years ago in a Milan gallery. These paintings, drawings, and water colors were particularly interesting because although they depicted the political and social struggles in Italy during this era, they transcended mere illustrativeness by sheer paint quality and by the personality of the artist—in the tradition of Goya, Orozco, Guttuso.

I met the artist and we were able to communicate in German, of which my wife has some knowledge. We were interested to learn that this Italian had been teaching for several years in East Berlin, where he tried to break through the dogmatism of the official approach to esthetics.

Although aghast and disturbed at the contemporary art situation, Mucchi told us he was nevertheless optimistic about

representationalism—that it has a great future. His manner was quiet, not emphatic. He struck me as a somewhat withdrawn intellectual, warmly appreciative of other artists.

Rome

We got to see Manzu the last day of our stay in Rome. A year ago I had a letter of introduction to him from Guttuso, but we arrived in Rome after he had already left for the country. When Guttuso gave us the letter he told us that Manzu was a quiet man, talks very little, only in Italian, "and that," said Guttuso goodhumoredly and fondly, "only in dialect."

When I mentioned Manzu in our conversation with Mucchi in Venice, he spoke with warmth about the man, as well as about his art. Mucchi thought it admirable for a man like Manzu, who did the doors for St. Peter's in Rome, to have sent one hundred red roses for the funeral of the communist Togliatti.

We made a special trip to St. Peter's to see these recently installed doors. They had all the beauty and the warmth that one finds in all Manzu's work. In the lower right-hand panel was the praying figure of the late Pope John XXIII, with the inscription *Pacem in Terris*. It seemed to have a special meaning for us in this era of social and political unrest, of race riots and atomic explosions.

The visit to Manzu was arranged by a young friend of ours who drove us there in her new, noisy little car, and who also served as our interpreter. We circled around several streets near the outskirts of Rome before we finally found the Largo where Manzu's studio was—a long, low structure in a bare courtyard. We were expected, and when we rang the bell at the courtyard gate, a young woman, her face and figure like a Manzu sculpture, let us in silently and politely.

The studio was huge, uncluttered, although here and there were sculptures of all sizes, in various media. Manzu came forward—stocky, heavy-nosed, with a small mouth, warm, alert eyes. He wore a small black-and-white checked cloth hat, deliberately, it seemed to me, askew on his head, and a black smock—altogether a droll, sympathetic figure, a combination of laborer and comic actor.

Through the interpreter we exchanged greetings, and I tried to express to him my admiration for his work, which, I said, I have been following since I saw his figure of a seated child. I told him that he

seems to me to be the most painter-like of all the sculptors, that he draws on his reliefs and composes his sculptures like a painter. He seemed to understand what I was trying to convey. He said, "There's little to show in my studio." But the "little" was enough to confirm my conviction that he is one of the finest sculptors today. There was a group of small clay studies of clothed, semireclining female figures. Some of them were cast in bronze. On the wall above them was a life-size, very complete drawing of a model in this same pose. In one corner stood a larger than life-size plaster nude of a dancer, reaching upward on her toes, her arms high above her head. That, he told us, was a commission, to be placed in a square in Detroit. Contrasting with her was a dark carving in ebony of a mother and child, roughly hewn and unfinished, but already eloquent in its beauty.

I was impressed by the compactness and self-containment of Manzu's figures. There were no unnecessary embellishments, no protuberances, spikiness, holes, and perforations abounding in so much of the sculpture today. "Surely," I thought, "they would pass Michelangelo's test for sculpture: There is nothing superfluous that would break off if they were rolled down a hill."

But our communication was very meager because of the language barrier as well as Manzu's reticence. The frustrations of talking through an interpreter were felt by both of us. As our interpreter later commented, "Manzu doesn't talk. He just answers questions."

When I asked Manzu to pose for a sketch, he smiled and said with a twinkle in his eye: "It will be a pleasure not to work, but to watch someone else work for a change."

Although he tried to keep his head in position while responding to the interpreter, his hands kept moving, as though they were unused to being idle. They moved in sculptor's gestures.

On the way out I noticed some canvases stacked up against the wall and I asked Manzu whose they were. "They're mine," he said, "I always painted." But I saw that he didn't think enough of them to show them.

Homage to Eakins (III)

November 1964

At last I painted Edwin Dickinson, having been after him for almost a year. After many disappointments and postponements, I brought my paint box and canvas to his studio and painted him there. When I knocked on his door, the slight, bearded Dickinson appeared with the suddenness of a Jack-in-the-Box, a tasseled red Turkish fez on his head. With a roguish look, his arms akimbo, he said, "How would you like to paint me like this?"

Very soon, however, we settled down to work. He posed seriously. Every half hour by his watch, he would take a rest, during which he circled his small studio several times. Now and then he would pick up a fragment of a canvas mounted crudely on pressed wood, and show it to me. About one he commented: "Some eyes that girl had!" It really was just a picture of one eye, no other feature of the face, on a flesh-painted canvas, a beautifully rendered blue eye. Another small unfinished painting was of a girl's head, with very black hair: "Some gal she was," and he clicked his tongue admiringly, "a beautiful head of hair!" These canvases were very dry and seemed to have been painted a long time ago.

Dickinson posed very quietly. Once in a while he would say to himself, or to me: "I enjoy being with my brethren" (meaning the artists). The chair he sat on was wide and low, and I had to sit down, too, to see him more or less at eye level, which made me uncomfortable because I usually stand when I do these studies. I could not judge the proportions too well, and soon it seemed to me that I was making his head bigger than life and I was unhappy about it. Dickinson is really a slight man with a delicate face. As I worked on the portrait, however, it seemed to lose its oversize quality and I felt more satisfied with it. Dickinson never looked at what I was doing even though we sat so near

one another. As he took his walks around the room he sensitively avoided looking at the canvas, not to embarrass his "brother artist" in the initial stages of his work. I was inwardly grateful for that. "Of course," he said, "I am very much interested in what you're doing, and I'll come to see your big picture."

I have often noticed how unpretentious and modest, even austere, are the studios of some of America's best-known artists—Hopper, Levine, Dickinson—quite different from the well-appointed studios of their European counterparts. Dickinson's was bare, neat and orderly. There was little furniture there, only one easel. The whitewashed walls were decorated with pale maps of the Mediterranean and of the Greek Isles. Two old violins were hanging on the wall, horizontally, one above the other. One was unusually red in color—"the reddest violin I have seen," said Dickinson. "I will pick it up one of these days and start sawing again," he said, pointing to them.

He held up a maul-stick and called my attention to its grace, the texture of the old wood, and to the rubber tip which he himself neatly attached to keep it from slipping on the surface of the canvas. On the wall there was also a double parallel ruler used in navigation. He showed me how to work it: he put it down flat on the map which was on the wall, moved each ruler alternately, saying, "You waltz it up to the compass rose." Although I understood but little of this, there was something very likeable about the way he said it.

Dickinson put his hand in his pocket, took something out of it, and let it fall to the floor. It was a plastic clothespin. "Did you hear the click?" he asked me. "As I was coming here a woman threw it out the window, and it fell with a click at my feet. When she shut the window I quickly picked it up and put it in my pocket. It's nice, so white."

On the floor, leaning against the wall, were old casts of the fragmentary Elgin Marbles, horses' heads and riders, revealing his well-known love for Greece, so often expressed in his paintings. Somehow the austerity of Greece was felt in this American artist's studio. Suddenly he said to me during one of his rests: "I can sing a Greek song for you," and he sang one of the monotonous Greek folk songs.

In a pleasant resonant voice he speaks in complex, rambling sentences that often end with prepositions. He gave me the impression in his conversation during the sittings that he was obliged to assume family responsibilities as well as teaching responsibilities. And his time for painting is precious. It takes him so long to finish a

153

painting, sometimes years. "And anyhow," he said, "my paintings are never completed. My 'finished' paintings are only three-fifths finished." I liked his arithmetical exactness—it is so much like him, meticulous and neat, like the lecture he was going to deliver soon at some university on "Application of the Principles of the Housekeeping of the Palette."

As the time of the first sitting was coming to a close, he said, "Don't forget to remind me to show you that book," and he turned his eyes toward a pile of small old books on the table. It turned out to be an old, worn little book, with a few illustrations, about some chateau in France where da Vinci was said to have died. He called my attention to a reproduction of a very ornate and complex staircase, which was supposed to have been designed by da Vinci. His interest in this was meaningful to me, having often seen in Dickinson's paintings architectural forms or staircases.

I finished the study, a head and shoulders on a large canvas (which I embellished with a sketch of a Greek horse). I put the canvas, which Dickinson had not yet looked at, face down against the wall. Then he pulled out a few old studies in oil, gray and brown in tone, which he painted as a student, with William M. Chase, of whom he spoke with respect and admiration. And finally a larger canvas, not of his student days, depicting a street, with a painting of the same street in the foreground. The effect was double-imaged, surrealistic. He painted this many years ago. Dickinson considered this also not completed—"I will get to it again someday, if I'm spared."

December

Now that I have finally made the study of Edwin Dickinson, and the drawing of my daughter Mary for the figure of the girl holding the tray, I am beginning to work steadily again on the big painting. The composition is rounded out, all the figures are now painted in. I have been working on the Eakins paintings that serve as a background from the colored reproductions in Fairfield Porter's book on Thomas Eakins. (As I am working on this huge canvas with the same small brushes I generally use, numbers 2, 3, 4, 5, I amusingly recall how I watched Rivera in the early thirties, painting his large complex, many-figured murals with a tiny brush.)

I went to the Brooklyn Museum to look at the Eakins painting of

the sculptor William Rush, and I was amazed how untruthful is the reproduction of it in the Fairfield Porter book. The original is predominantly brown, without any of the delicate shades of green, lavender and pink found in the reproduction. Next day I repainted that picture in the background.

The telephone rang. A sharp voice, cracked with age, was on the other end of the line. "Did you get my note? I sent you a clipping from the newspaper, a review of Hopper's show . . . I don't understand any more what's going on in art . . . The One who created people gave them very low intelligence . . . Look at the T.V. programs they enjoy . . . We've had ten thousand years of culture and most people will never know any better."

This was the voice of Charles Daniel. He is now eighty-six years old: "Soon I'll be eighty-seven years old, and I'm getting frightened," he said recently. Though once tall and broad-shouldered, he is now frail and toothless. His mind is very clear. I often get notes, clippings, art magazines or copies of *American Heritage* from him, with fond inscriptions to me and my wife.

In 1928 I took a painting I had just finished to the Daniel Gallery. The gallery was situated on the top floor of a small, charming red-brick building at 600 Madison Avenue, since demolished, of course. A tall ruddy-faced man, Charles Daniel, looked at the painting, showed it to his cadaverous associate, a green-looking, shaking individual, who, I later learned, was Clarence Hartpence, a frustrated poet. There was a murmured consultation between the two, then Mr. Daniel came back to me and said, "Leave this painting here. When you have twelve such pictures, we will give you a one-man exhibition."

It was as simple as that in those days, at least for me. There were only about a dozen galleries then, and the Daniel Gallery was known for its high priesthood in art. It was there that the best contemporary work produced in this country was exhibited. Besides, it had an aim— to discover and promote young painters who showed some individuality in their work. When I came to the Daniel Gallery it already had on its roster, among others, Kuniyoshi, Alex Brook, Peter Blume, Preston Dickinson, Nicolai Cikovsky, Karl Knaths. In 1929 I had my twelve paintings, and they were exhibited at the Daniel Gallery. Henry McBride, the avant-garde critic of that period known

155

for his sophisticated understanding of art and his engaging style, favorably reviewed the exhibition, and then and there I embarked upon my career of painting. But 1929 was a fateful year, and in the beginning of the Depression that followed, this gallery was forced out of existence. It never was able to make a comeback.

Now I no longer count the passing years. But a long time after his gallery closed, Charles Daniel was the guest of honor at a dinner party given by its former members. Yasuo Kuniyoshi was still alive then and was the charming m.c. at that party. We all made drawings that were presented to him in a portfolio that night. Everyone made a speech, and I still remember that I said, "When I was young my teacher, Guy Pène du Bois looked at a painting of mine and sent me to the Daniel Gallery with it. Now I am a teacher, and every once in a while I become interested in a talented student, and I regret that there is no Daniel Gallery today to which I can send him."

Since then I have been seeing Charles Daniel at intervals. Suddenly I would get a call that he's in town and is coming up. He is full of stories of the art world way back in the early 1900s. He mentions long-forgotten names of painters, collectors, museum directors, and critics. In his New Yorkese English this former gallery director, who gave up saloon-keeping for art-dealing, talks about how difficult it was in those days to sell the new art, not yet accepted in this country. He remembers how the rich homes of the collectors in Back Bay Boston or on Fifth Avenue were filled with paintings by John Murphy, Dodge McKnight, and others, and how hard it was to educate them to appreciate John Marin, Charles Demuth, Preston Dickinson.

Charles Daniel is puzzled and completely bewildered by the paintings of today. What he sees on Madison Avenue and on Fifty-seventh Street violates the meaning of art for him and is beyond his comprehension. But art is still the only interest of this amazing old man.

February 1965

For the figure of Reginald Marsh in the Eakins painting, I am copying an old portrait I did of him in 1941, which the Detroit Museum let me have for this purpose. At first I had sketched his head in from a black-and-white reproduction of that portrait. As I am working on Reggie now (the only one of this group who is no longer alive—he died in 1954), many memories come to me of our relationship when we were

Portrait of Reginald Marsh

neighbors in a building overlooking Union Square Park. I recall an article I wrote at the time of Reggie's death for *Reality, A Journal of Artists' Opinion.*

Now that Reginald Marsh is gone we may expect the usual appraisal and re-appraisal of his accomplishments. His thousands of drawings, prints, and paintings will be categorized and catalogued and he will finally be pigeonholed in his proper place in American art. My task is not in this field of appraisal. Having known him for many years, I would like rather to impart my memories and impressions of him. Actually there is nothing startling or dramatic for me to tell. One constant memory of him is that of a man always at work, drawing, painting, experimenting with different techniques, but above all drawing, drawing, drawing.

I remember painting a portrait of him. After half an hour of posing he could not bear being inactive and so he took a small copper plate, concealed it in his hand and, while holding the pose, managed to make an etching of me at the same time.

He had an intense and consuming interest in art. I would find him in various museums in New York, Washington, Philadelphia, studying one painting or another, often through a magnifying glass, oblivious to everything else around him. He must have passed this absorbing interest on to his students, for once I saw him with a group of them in the museum. He was not lecturing, not telling anything in words, but again looking at paintings, and his students, a silent and enthralled group, as absorbed as their teacher, almost looking like Marsh, their faces as close to the paintings as his was. Occasionally I meet some of Marsh's former students and I am always impressed by their enduring memory of him as an inspiring teacher.

Long ago in the 1930s, once after a day's work in the middle of the week, a party happened spontaneously in my studio, for we were young enough then to be spontaneous about such things. A few artists were there, a sculptor from across the street who has since been killed in one of the wars; a vivacious young girl who used to pose for the artists in the building; and a Union Square character, a homeless man, who attached himself to the artists, posed, ran errands for them and tidied their studios. We called him The Orphan. In the course of time the people became a little high and the first to pass out was The Orphan. Immediately Reginald Marsh, who had all along been drinking silently and broodingly, went into action. With unexpected tenderness he guided The Orphan to the cot, laid him gently down, removed his shoes and covered him. Like a dream, I remember the dry skin through the holes in the socks and the expression of concern on Reggie's face.

There was something childlike about Reggie. He took unabashed delight in little things: the staircase in the interior of the studio leading up to the roof; the Senator's chauffeured car, at his disposal in Washington. Like a small boy he had a great love for locomotives and

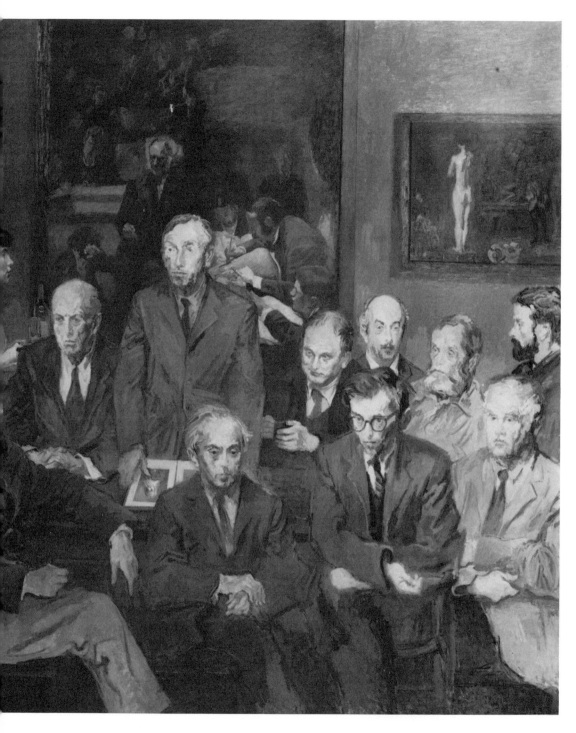

Homage to Thomas Eakins

tugboats, spending much time on the waterfront and near railroad tracks, drawing and painting them. This trait added to his mature knowledge and understanding, gave him a special charm, and endeared him to his friends.

I visited his home recently. There, on the walls beside Marsh's paintings, were a portrait by Eakins, a youthful portrait of Marsh in pastels by Peggy Bacon, a satirical tinted drawing by Guy Pène du Bois, and paintings and drawings by Kuniyoshi, Kathrine Schmidt, Felicia Meyers (Reggie's wife). I asked Mrs. Marsh if there was anything in the form of an autobiography left by Reggie, for as yet no monograph exists about Reggie's work. It is amazing how little is printed and published about our own artists during their lifetime in our country, rich as it is. After rummaging around, Mrs. Marsh found some articles about him and his work by his fellow artists Benton, Laning, Curry and others.

But I was most impressed by a comment that was written by Marsh himself in an old catalogue of one of his shows: "Painting is new to me, but I will conquer it."

Well, it seems I started something with my Homage to Eakins. These days it's such an offbeat thing to do—a huge representational painting, a group portrait of men. The news that I was doing this reached the ears of the avid collector, Joseph H. Hirshhorn. My dealer brought him, together with his curator, Abram Lerner, to my studio, and a collector's scoop was made by his quick purchase of the entire work—the as-yet unfinished large painting, plus all the studies for it. This event was reported in the art page of the Sunday *Times,* with a reproduction of the painting and a photograph of myself in front of it.

Hirshhorn's inclusion of this work in his famous collection pleased me very much. I sent him the following letter next day:

Dear Joe,

I am so pleased that you have acquired my paintings of the "Homage to Eakins" project. Secretly I had hoped all along that you would do so because more than anything I wanted these canvases to be part of a great collection.

It was quite an undertaking. There were moments when I didn't feel equal to the task. I would ask myself: what prompted me to do a composition of such magnitude and of such content? It seemed, on the surface, such an untimely thing to do. But then some of the greatest painters worked against their own *Zeitgeist.*

I have been wanting to do this for a long time—a group portrait of life-size figures. My admiration for Eakins provided the setting for such a composition. And since I know that you, too, are a great admirer of Eakins, it gives me heart to bring to completion this group of paintings.

The painting, however, is not yet finished. I am working on it now, inch by inch, and am beginning to have the usual anxieties about overworking it. It is a characteristic of artists—ever apprehensive, anxious, and uncertain.

Retrospectives, 1966-1967

April 2, 1966

My exhibition at the Forum Gallery is a sort of introduction to the forthcoming retrospective show at the Whitney Museum. There was a big crowd at the opening. In the sea of voices I heard phrases like "It's the event of the season." "He'll have a good press." I was excited to the point where I did not know who was there and whom I was greeting, a state of confusion heightened by the Scotch I was sipping throughout the afternoon.

I am always reluctant to have a show and I reacted against this one more vehemently than usual because of the scheduled retrospective; this would be unnecessary, I thought, and preclimactic. Also, I was anxious to spare myself the artist's well-known agony after his show has opened, the letdown, the feeling of uneasiness, of embarrassment brought about, no doubt, by self-exposure in his work.

And the critics, what would they say? While rationally an artist should be able to ignore their vagaries, the irrational fact remains that he is sensitive to criticism, is disturbed by it for a long period, making it hard for him to get back to work.

One may call this a theme exhibition. It consists of two major paintings: "Homage to Thomas Eakins" and "The Village East," and the studies from life for them. I've written about "Homage." "The Village East" is the result of my seven years' living and working on lower Second Avenue. I had become acquainted with some of the artists and writers, and I tried to capture the feeling of that area—the bearded, long-haired young men; the loose-haired, blue-jeaned girls with ecstatic faces; white mothers with black babies, against the background of drab walls bearing Fall-Out Shelter signs, above indecent and sentimental scribblings; barrages of green and red lights, and arrowed one-way street signs. I wanted to convey a feeling of

energy and life in an atmosphere of deprivation and drabness. Like "Homage to Thomas Eakins," "Village East" is a painting composed of portraits, some of them well known, for example, Allen Ginsberg, Gregory Corso, Diane di Prima.

I have known Diane di Prima for many years. In the early 1950s she was a slovenly, fat girl with beautiful red hair who came to my studio with her female companion, a strong contrast to her—tall, small-breasted and full-hipped. They were obviously involved with each other, posed nude together, talked to each other about poetry, the theater, with an intimacy and mutual understanding that excluded me from the conversation. Once I overheard them discuss Ezra Pound, their great desire to visit him in prison, and their feeling of frustration in not having anyone to drive them there. I ventured to say, "He's a Fascist. Why do you want to see him?" I still remember the lightning anger in their young eyes and their contemptuous retort that poetry had nothing to do with all that. Later I would meet Diane occasionally in the Village, without the other girl, but with some man or other, one of whom was the author Leroi Jones. Then one day she called to say she needed money and wanted to pose again. I painted her many times.

Now she is thin, her red hair in two long braids, and although still carelessly dressed, there is a greater display of femininity. She has three children, each one by a different father. She is full of an angry disregard for conventional living and behavior. I visited her in the house where she lived with her children and with Alan Marlowe, the father of the youngest one. It was an old, three-floor dilapidated house, with some broken windowpanes, rickety stairs, and holes in the splintery floors. Diane and Marlowe loved this house; it suited their needs for work and individual privacy. They made an attempt to decorate it with morbid sketches that had been used as stage designs for the experimental theaters Marlowe operated now and then in the neighborhood.

Diane is a sensitive poet, impatient with anything that is not avant-garde. She is an excellent translator of some very delicate poems from the Latin. I was repelled by her own volume of poems called *Dinners and Nightmares*, although I found them valid, real, and descriptive of a slummy, bedrugged intellectualism, in a terse, brittle, somewhat hysterical style. In my "Village East" Diane is the main character, aimlessly walking almost out of the painting, one hand in a pocket, the fingers of the other convulsively tensed. Her face is raised, her mouth partly open, her wide-open red-rimmed eyes are looking

163

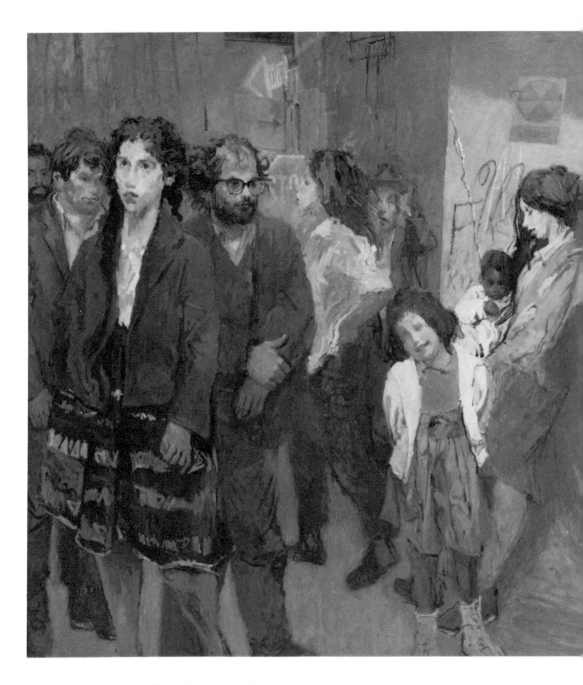

Village East Street Scene

upward (Marlowe told me that she cries on gray days). ("Who is this girl in the red dress with the red hair and the red eyes?" someone once asked about her at a party.)

Like other avant-gardists, Diane is obsessed by Hinduism or Zen Buddhism and dreams of the day when she "will leave Marlowe and the children and go off to Benares, to meditate." She's of the opinion that our Western civilization is rotten and doomed, on the verge of catastrophe; she has no sympathy for it and no desire for it to survive. It was she who first brought Allen Ginsberg to my studio, who later came with Gregory Corso. She also tried to get Leroi Jones to pose, but he was too busy and I had to use a photograph to paint his head in "Village East."

First Allen Ginsberg came up by himself, shabby, unshaven, but beardless, his black hair long and curly on his balding head, with a few strands clinging to his forehead. Under a dark blue jacket he wore a scarlet slipover on a blue denim shirt. He had the hollow-cheeked look of a young European-Jewish intellectual, and his lips seemed inordinately red in his pale face. As the painting progressed, however, his hair and beard grew, covering the hollowness of his cheeks, and his white teeth sparkled. He was beginning to look like a Hindu. He posed standing, patiently, and his warm, brown eyes behind the heavy horn-rimmed spectacles had a steady gaze.

Contrary to my expectation from rumors about him, Allen was unpretentious, sensible, and pleasant. At the very first sitting we touched upon many subjects in our conversation. He found similarities between my background and that of his father. He mentioned his mother. "Do you know De Kooning's 'Woman'? That was my mother. Is it surprising that I am a homosexual?" He told me about a vision in which William Blake appeared to him. He recited some anonymous, precious, medieval poems with quiet simplicity. He talked about his recurring emotional breakdowns which sent him from one "nut-house" to another. He referred to his moments of ecstasy and wanted me to include in the painting a button on his lapel: "Legalize Pot."

Later, Allen brought to the studio his friend Gregory Corso, and I made a small painting of both of them. "I want to be in a picture with Allen," Corso said affectionately. Since meeting Ginsberg I have noticed that young poets and writers speak of him fondly, with respect, as if he were a teacher. I've learned that he's very helpful, gives a lot of time to them, and is liberal with his money. When he first came to pose I offered to pay him like other models. He asked, "How much do you

pay?" When I told him, he said, "That's a lot of money. When I'll need it, I'll let you know." He never has.

At the time Allen posed for me I was still working on the large "Homage" which was always on the easel, with the individual portrait studies around it. He would look at them in passing, and once when I caught him at it I said I was more satisfied with the small studies than with the large paintings. To which he replied directly and simply, "But the big painting has an overall melancholy." When he happened to glance at the sketched-in composition of "Village East," he said, "Why don't you do something unusual and startling in this painting, like an erection on one of these fellows?"

One day he announced, "I won't be able to come for a while because William Burroughs is in town. He's my good friend and I want to spend all my time with him."

Gregory Corso posed twice for the small painting I call "Two Poets." I liked Gregory's face, at once saturnine and gentle, his shaggy tufts of hair, the changing expressions from moodiness to cheerfulness. This charming fellow, I was told, becomes obstreperous and belligerent when drunk. "I have to be careful not to get tight," Corso told me himself, "I'm liable to get into fights, and am often beaten up." The second time he appeared it must have been after a night out, or some weekend brawl. He was disheveled, tired-looking, unshaven, and untidy, as if he had slept in his clothes.

June 22

This is the last full day of our sea voyage to Europe, and the boredom is approaching its peak. I think I'll start drinking earlier today, not wait till six o'clock. But first I'll do some dictating to my wife.

That's how I've been doing my writing recently: I talk and she writes down what I say. It is disjointed, planless, and formless to begin with, but later on we try to put it into shape.

The *Oslofjord* is a small, pleasant trans-Atlantic ship. People are enjoying and praising the trip although the weather has been mostly cloudy. I am bored. I feel captive, enclosed, studio-less, forced into inactivity. I do not participate in the shipboard programs, except in eating and viewing dull travelogs. Little is left but to look forward to the cocktail hour, which somewhat lifts my stupor, at least temporarily.

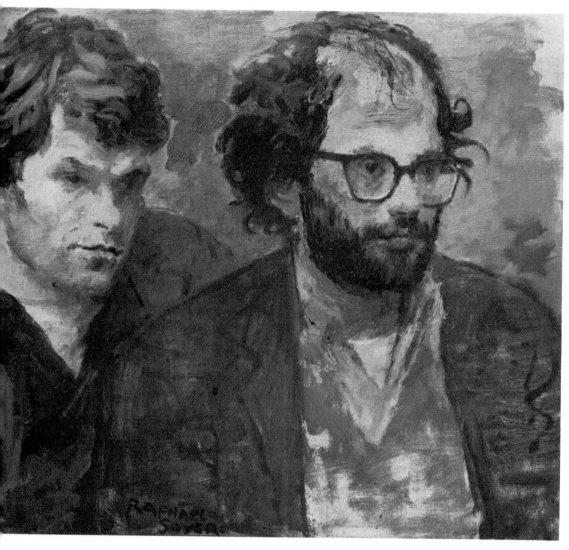

Allen Ginsberg and Gregory Corso

One pastime I indulge in is observing my fellow passengers. Besides eating, their main preoccupation seems to be showing off their wardrobe, men and women alike, and even children. There are many beautiful children on board and some excellent specimens of male and female youth.

A couple of passengers have caught my attention, one a "celebrity," an ex-diplomat, handsome, elderly, tall, without an ounce of extra weight, with an open, frank, absolutely non-conscience-

stricken face. Blue, direct-gazing eyes, the wrinkles under them precisely drawn as if by the hand of a Van Eyck, with a serenity which Van Eyck's faces do not have. His manner is friendly and solicitous, as if it were incumbent upon him to be so.

Another fellow passenger is a college teacher, tall, round-faced, big-nosed and small-mouthed, neatly and comfortably dressed, but with an easy carelessness. He is an introvert with a strong interest in people, soft-spoken, well-informed, considered in his opinions and with an eye for pretty women; the author of a forthcoming book dealing with some phase of human behavior. He too changed his clothes for the different occasions. I just changed my shirt every morning and wore the same suit all the time. I began to feel uncomfortable after a while. The last night of the voyage, for the final farewell dinner, I was prevailed upon by my wife to wear a dark suit and black tie.

I've been reading *Tropic of Cancer* on the boat. What would happen, I thought, if the Henry Miller of the thirties—hungry, unkempt and loudmouthed—invaded this respectable assemblage? Or a guy like Allen Ginsberg, in slept-in clothes? What wouldn't Miller say about these people in his torrential eloquence! Or my sardonic friend Allen, what kind of a prose poem would he compose about the voyagers on the *Oslofjord?*

I'm still trying to understand why at this time, and at this age, in my sixties, I began this business of writing about myself, my work, my predilections in art. After all, my profession is painting and there, automatically, my personality is revealed. But here I am consciously talking about myself, "revealing" myself in this amateurish prose. Is this a preoccupation of old age, like reminiscing, or eating, or like touring? After all, as I remember myself in my adolescence and youth, I was the shyest, the most inward, noncommunicative character, almost to the point of being retarded. In my early childhood I was told a story about an invisible hat. It appealed to me tremendously at that early age, and later too. To be invisible, unknown!

How, and when, did I become eager to be recognized? As a painter I have attained some recognition in my country. Then to what purpose is this journal? I vaguely feel that, as I continue, this will become clear. Though I wonder.

168

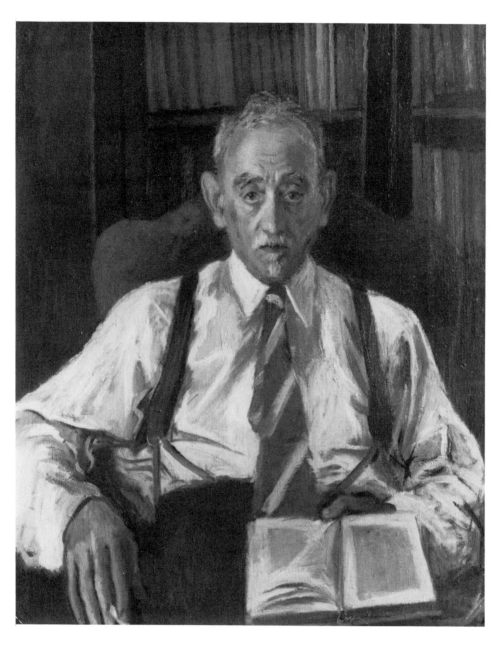

Portrait of the Artist's Father

169

If my father were alive today he would be one hundred years old, and my mother almost ninety. How brief life is! Suddenly I am no longer young.

My first memory—a young woman being pursued . . . trying to escape . . . the heavy calves of her legs . . . running around furniture . . . years later I asked my mother about this. Her answer was not reassuring . . . someone evil was trying to catch her.

Another memory, a more accurate one, of my mother struggling to make a fire in the stove, and the wood did not burn because it was damp, and she cried. There are other vague memories, of smells, smells of armpits, breasts, feet.

Recently, while reading Jones's biography of Freud, I came across two incidents in his childhood which also occurred in mine. The earlier incident: I wanted my mother to explain how we are made of earth, as the Bible says. She spat lightly on the palms of her hands, rubbed them together and showed me the particles of dirt that resulted. According to Jones, Freud related the very same experience and how impressed he was. So was I.

A later memory that Freud describes is not exactly the same as mine, but quite similar, and left a like impression. Little Freud and his, at that time to him, powerful father, were walking on the sidewalk, when they were ordered by a Junker—"Jude, get off the pavement!"— and Freud's father meekly obeyed, thus falling frighteningly low in the child's esteem.

My father came home one evening out of breath and upset. When my mother asked him what had happened, he told her, and I overheard, that two drunken peasants walking behind him said: "There goes a Jew, let's beat him up!" "What did you do?" asked my mother. "I made big strides." My all-powerful father sank in my estimation.

Speaking of Freud: My father was fond of telling what happened when my twin, Moses, and I were born. I was sickly, not expected to live, and had to be taken to a doctor some miles away. It was frankly hoped that I would not come back, since there was another child. I could consider this a rejection and an abandonment of me. Against all laws of Freudianism, I do not.

Another early memory: I had a toy, I don't remember what it was. I proudly showed it to a big boy. He said, "I'll make you a prettier toy." He broke off a twig from the tree we were under and cut it in half. He peeled the bark and with its lacy strips tied the two pieces of twig

together, forming a cross. I still remember the moist whiteness of the twigs, the sweet smell of the peeled wood, the symmetry of the cross. I showed this beautiful "toy" to my mother. She looked at me seriously and said, "I'll make it look nicer." With a penknife she made some cuts in the wood, changed the position of the twigs, and the whole thing became tragically cockeyed in my eyes. I still remember my disappointment and how I held back my tears.

To try the patience of the mythical reader, one more early memory (and one that would delight an Isaac Bashevis Singer!): In the courtyard where we lived an infant died. A woman lifted the stiff little body and held it up for me to see. To my horror I saw a tail curled between his legs! I was frightened by this tiny *tchort, shedd,* devil. I never told this to anyone. I kept this in me. Many years later it dawned upon me that what I had seen was the dead baby's penis.

This was not my only fear. Lightning and thunder, terror of losing my mother, fear of God, and other religious and superstitious fears troubled my early childhood.

Oslo, July I

How friendly these northern countries are: Norway, Sweden, Denmark. How naturally colorful and unostentatious the people. The Norwegians are particularly beautiful in complexion, feature, and carriage, and they are tinged with an air of melancholy.

In Oslo I became aware of the stature of Edvard Munch. As it happened, there was an exhibition of Munch at the Guggenheim Museum in New York several months before I came to Oslo. Having seen some of his work in both places, I can now report how impossible it is to show pictures on the walls of the Guggenheim Museum, so broken up in space, so concave, so deadly white.

In the National Museum in Oslo and in the Munch Museum— these small European countries honor their artists by permanently displaying their life's work to excellent advantage—I saw a great number of Edvard Munch's paintings, drawings, and graphics.

Like Daumier in France, Munch in Norway painted the collective face of his people. He did more. He captured the moody character and quality of his country's landscape, weirdly affected by the long days merging into white nights. This poetic morbidity of Munch made me think of the haunting loneliness in the work of Edward Hopper, my country's painter.

171

Daumier, Munch, Hopper: different eras, countries, even continents—yet in the Munch Museum I thought of these three artists simultaneously. The lifework of each passed through my mind. What fortunate figures in art they are. Like excellent machines with meshing gears, they appeared at the right time, their talents were sufficient, the circumstances were right, and they became the artistic exponents of their place and time. Unlike the Frenchman and the American, Munch was involved with sex and death, with fears, attractions, revulsions, an artist of the Freudian age. The titles reflect his themes: "Ashes," "Maiden and Death," the "Dance of Life" and "Cry," the "Dead Mother," the "Sick Child," "Jealousy," the "Day After." His scope was wider still. He painted children of all ages and sizes, singly or in groups, and old people. He was a fine and searching portrait painter, and his compositions of workers are unique in their social penetration. And his many self-portraits, from the earliest one with its proud Nordic features and abundant hair, to his troubled face enveloped in cigarette smoke, the tortured self in hell, his loneliness in a cafe, the insomniac wandering from room to room with the blueness of an opaque night in the windowpanes; and finally the frail old man between the clock and the bed. Looking at this, his last self-portrait, my wife thought of George Bernard Shaw who before dying said how tired he was of the limited world between his bed and the window.

Daumier, Munch, Hopper were separated in time by many decades. How timeless art is! When I see paintings that move me, I imagine my own pictures alongside of them and try to find my place. For instance, how would my "Homage to Thomas Eakins" look on the wall with Munch's paintings? Is my painting too rendered, too tangible? After all, I am working now, years after the element of abstraction in painting has become dominant. Munch's work does not seem to be out of kilter, it seems to fall naturally into this stream of contemporariness, figurative though it is. About my own work, I am uneasy.

In Munch's painting of the "Dead Mother" there is a child in the foreground clutching her head with both hands in shock and grief. I was familiar with this picture from reproductions before I saw the original. This child always made me think of my sister Fannie, who was a year and a half younger than Moses and myself, as she sat, her face cupped in her hands like an adult, while the house was filled with the moans of our mother in labor.

Fannie was the first to die (1963) of the brothers and sisters

brought by our parents from Borisoglebsk to New York before World War I. *Self-Revealment* is dedicated to her.

We were a dense pack of clamoring, greedy children. When our parents would take us visiting we were admonished by them not to grab from the table, to behave like guests. We would promise, of course, but grab, disregarding our embarrassed mother's angry glances.

As we grew older, our competitiveness became apparent. Sibling rivalry was actually encouraged in our house. Our mother and father were rivals, competing for our affection. "Whom do you love more?" a child would be asked "Father or mother?" If he would answer "Mother," Father would say, "Go away, I hate you." And mother would do the same. Although a jest, it was disturbing to the child.

Moses, Isaac, and I would show our drawings to our parents, and they would examine them for neatness and precision, then praise one above the others, thus encouraging rivalry. Isaac, much younger, already competed with us and very soon caught up. Except for our little sister, Rebbie, the youngest at that time, everyone in the family aspired to be something. Our father wrote his stories every morning; our mother constantly and bitterly complained about her lack of education, the lack of time for reading, for improving herself. Even in those early days Moses, Isaac, and I were obsessed by childish dreams of becoming Rembrandts and Raphaels, whose work was as yet completely unknown to us but whose names we knew and revered. The atmosphere of our home was charged with overtones of ambition, frustration, rivalry and jealousy of one another's little triumphs. Once I secretly cried when my much younger brother, Isaac, made a better drawing than mine.

In this clamor Fannie was a quiet, proud aristocrat. Already then, she had an understanding and perception of human relations beyond the grasp of her brothers. She was steadfast, responsible, dedicated. Unlike her brothers, she loved going to school. I still cherish an early memory of Fannie in her padded, bright overcoat on her way to school, with Moses and me following closely behind, making mocking noises, imitating her gait, jeering, ridiculing her devotion to school, teachers, and marks. She was aware of what was going on behind her back, but ignoring our stupidity and cruelty, walked straight ahead without turning around. Once in a while, however, when her brothers' crudeness would become too much, she would say, "I have such bad brothers." We did not live up to her conception of what brothers should be. Her standards were high.

173

With time we became more civilized, even courteous to one another. But a shy reticence restrained us from showing feelings of affection. How deeply I now regret this lack of demonstrativeness. I should have told Fannie at least once how much I valued her. In my secret and intimate appraisal of her, I put her on a plane with a Marie Curie or a Käthe Kollwitz.

My mother married at seventeen or eighteen. There are still a few photographs that show her rustic beauty, pompadoured and high-corseted. These pictures are old, and their original rich sepia has faded, as has the photographer's name in ornate gilt letters. In later life my mother became heavy and dissatisfied with her lot. From my early childhood, as a matter of fact, I knew her to be unhappy. I remember the sad Russian songs she sang to me in a pleasant, simple voice, even when she was young:

> Why did my mother bear me
> And not give me any luck?
> It would have been better
> If I had drowned when I was little.

or

> My fate is bitter
> It is bitter to live in this world.
> How to explain the force
> That makes one cling to life?

When I asked my mother what these songs were all about, she would answer, "When you grow up, you will know and understand." This was the standard response to all my childhood questions by both my mother and father.

July 2

Can one attribute gender to a city? Oslo is strong, and yet neat, colorful, and femininely graceful. It abounds in statues of naked bodies of men, women, and children. The vistas of Vigeland Park seethe with them, not only with statues but with bikini-clad bodies sunning themselves, and frolicking, naked children.

Like Bernini in Rome, the Norwegian Vigeland filled Oslo with his statues. Moralistically and repetitiously he dealt with human destiny through the medium of the nude of both sexes and all ages.

Recently, the American sculptor Nathan Hale, with great personal effort, brought an exhibition of Vigeland's work to New York. It called forth no response whatsoever. I must admit that even I failed to see it. The name Vigeland had no meaning for me. But here, in Oslo, I am impressed.

His work is forceful, skillful, vivid, and pictorial. He is concerned with birth, youth, fecundity, death, wisdom, innocence, love, struggle, friendship, sorrow, and exhilaration. Vigeland Park is an unusual achievement in architectural planning and in sculpture, a combined effort of an artist and his city.

In my "museum without walls," to use Malraux's famous phrase, I have added to the collection of Rembrandts his "Oath of the Batavians." I don't know what the painting is about historically. In a semicurve around a table, strange people of different sizes sit, stand and gesture. The main group is ceremonially crossing swords, in an oath of allegiance to a one-eyed, turbaned giant, the dominant figure in the composition. There is Rembrandt's universality about these inexplicable men. One of them, I could swear, posed for Rembrandt's "Isaac Blessing Jacob and Esau." The most fascinating part of the painting is in the lower right of the canvas: a carousing trio, painted in a fantastic, timeless manner, bringing to mind almost anybody—De La Tour, Fragonard, certainly Daumier and Goya—but surpassing and transcending them all.

Standing in front of this painting, badly displayed and lit in the old-fashioned Stockholm Museum, I said to myself, "Look at it long, study it. Who knows if you will ever see it again."

Copenhagen, July 3

To our great delight we saw in the museums of Copenhagen some unusual, intimate, unpretentious French paintings by Courbet, Corot, Daumier, the Impressionists, an unexpected Degas, some Matisses, including his legendary self-portrait showing the big, bearded head and slight shoulders, Gauguins and Bonnards.

Even apart from the museums, this first visit to Scandinavia was a happy experience. We walked the old streets of Oslo, Stockholm, and Copenhagen and their waterfronts; became part of the crowds in the shopping streets that were for pedestrians only. My wife was absorbed in window-shopping. I was entranced by the pretty faces of girls, their dimpled knees revealed by their short-short skirts; and by the young,

long-haired fellows. The human traffic was dense, colorful, and exciting. I wished I had more eyes, in the back and in the sides of my head. Both my wife and I were especially enchanted by the beauty of the children. In each Scandinavian little boy we saw something of our grandsons, David and Joseph.

Berlin, July 6

In the room of the Flemish masters, Van Eyck, van der Weyden, Petrus Christus, and the Master of Flémalle, at the Dahlem Museum, I heard Rebecca say, "You know, Raphael, I understand now what you meant three years ago when you said you were not going to Germany but to the museum in Dahlem, and to the Alte Pinakothek in Munich. Here I don't feel I'm in Germany; it could be anywhere in the world. Art is truly universal."

This gave me great pleasure, because it was hard to persuade her to come with me to Germany. Three years ago she refused to accompany me and I went by myself. Her comment referred to my response at that time when I was criticized for going to Germany. I said then, "It's not Germany I'm going to, but the Dahlem Museum and the Alte Pinakothek."

This time I was struck even more by the brashness and cheap glitter of *nouveau riche* West Berlin. Culturally and esthetically, East Berlin again makes more sense, but even though it is more restored than it was three years ago, there is still a pall of sadness over it. Rebecca said, "There's something ghostly about these quiet, empty streets."

Now we are in Munich, absorbing the great art of the Alte and Neue Pinakothek. But every middle-aged German is suspect in our eyes. "What was his role in the Nazi period? Was he a stormtrooper, a member of the Hitler Youth? And these old people, how acquiescent were they?"

Munich, July 13

A short train ride from Munich into the town of Dachau, a taxi ride, and we found ourselves in the former concentration camp, the first of its kind, the training center for the S.S. men who were to run other camps. The gate led us through a double barbed-wire enclosure into the

huge camp grounds. Where there had been thirty long wooden barracks we now saw thirty low, numbered, rectangular frames, fifteen on each side of a wide road, neatly filled with small stones. Still standing were the former infirmary and mortuary buildings, and one of the original wooden barracks, the windows of which were boarded up from within, their windowpanes broken. I wondered why these were broken when everything else was so tidy.

It was a beautiful day, and it was hard to visualize the hell that once reigned here. Nothing looked forbidding in this vast, sparklingly clean area in spite of the barbed-wire and the guard towers around it.

We went into the museum, an arrangement in black and white. Whitewashed walls. On black partitions, blow-ups of official documents, orders, edicts, questionnaires; letters from prisoners of one camp to those of another, a mother to her son, a husband to his wife; subservient, submissive, and ingratiating letters from doctors to their superiors describing their diabolical experiments upon human beings; and blown-up photographs of other concentration camps and ghettos, some of them well known, of the Crystal Night, of a group of men, women and children who had just been rounded up, of a book-burning, of people lined up, faces against a wall, in the Warsaw ghetto. In this chronological and orderly arrangement of pictorial documenta-tion, the most gruesome pictures were those under the heading of "Liberation," the famous photographs of the heap of naked dead, the mountains of shoes of those who had been tortured and murdered; and pictures of those who were dying from weakness and hunger while welcoming the liberation. One life-size blow-up of a little boy sitting on a curb made me realize the power of photography. No Goya, no Daumier, no Käthe Kollwitz, no George Grosz or Otto Dix ever created such an overwhelming image of the stark reality of a starving child.

I may add that in this museum building there was the usual museum desk selling literature and picture postcards to the visitors.

Opposite the museum, at the far end of the camp, was a modernistic monument of a fluted, metal Christ on the Cross in a vaulted, stone structure. Beside it a *Versohnungs Kirche,* a Church of Repentance, was being erected.

We have seen other monuments and memorials on consecrated grounds dedicated to victims of Nazism, in Leningrad, Rome, Paris, Jerusalem, Rotterdam, and Amsterdam. How many more such places are there on the face of our earth? In Hiroshima and Nagasaki too,

there surely must be neat and decorous shrines to those whom the American atomic bombs pulverized and mutilated. And after Vietnam—another monument? Another church of expiation?

July 14

We're in Munich now, but on this day in 1935—more than three decades ago, can it be?—we were part of the majestic outpouring of people in the streets of Paris in the famous Popular Front demonstration. It was Bastille Day. Tall, thin, Henri Barbusse was at the head of the procession, followed by old soldiers, survivors of the Paris Commune, their chests covered with medals and ribbons, by veterans of the First World War, many of them on crutches and in wheelchairs, and then—a surging sea of humanity. Especially vivid in my memory is the multitude of Algerians, arms interlocked, and all the others, young and old, filling the wide street from curb to curb, shouting *"A bas la guerre! A bas la guerre!"* The sidewalks and every window were crowded with spectators, pouring confetti, joining in the slogans, waving flags or holding out pillows in red ticking. The very houses seemed animated. We followed the route of march . . . it was from the Place de la Bastille to La République, and it seemed to us in our state of exultation that this huge maternal La République opened her ample arms to welcome her united people.

We were young then, married a few years, and this demonstration gave us hope for the future. In spite of the nightmare that followed, we shall never forget that day.

Berlin

In West Berlin we saw an inadequate exhibition called *"Von Neue-Sachlichkeit zu Kein-Sachlichkeit,"* that is, "from new objectivism to non-objectivism." The most important exponent of *Neue-Sachlichkeit,* Otto Dix, was not even represented, but I did have the great satisfaction of seeing one of those extraordinary early paintings by George Grosz: a cross-eyed, cruel, duel-scarred Junker in the foreground; a blind ex-soldier tapping the sidewalk with his cane, and a Dostoevskian dog. A meager painting in color and metier, more a drawing in gray and black. *"Und doch!"* as the Germans say.

In front of paintings by George Grosz I become so dissatisfied with the mildness, the "sympathy," the unexaggeratedness of my art.

178

In a civic gallery in Berlin we saw an exhibition called "75 Years of German Graphic Art." For some reason, George Grosz was not represented, but Käthe Kollwitz and Max Beckmann were. I was most impressed by a small etching, by Otto Dix, of an episode of World War I—a low-flying airplane strafing a city street. In the foreground, people run frantically, mothers clutching children. It would be Guernica, or any other bombed place. I imagined this 6 x 8 etching blown up to the proportions of Picasso's "Guernica." Perhaps it would lack the cherished esthetics of that mural, but how much more authentic, more moving, and more shocking it would be.

July 18

In a sense my father was lucky not to know that Hitler's program of genocide would destroy six million Jews. But he also did not live to see the establishment of the State of Israel. He was an enthusiastic Zionist all his life, yet never had a chance to visit Palestine because he was unable to save enough for the trip. That many of his colleagues and contemporaries did manage to do so made him more keenly disappointed, even resentful. Towards the end of his life things became easier, the children were grown, and both he and my mother began to hope to settle in Palestine. Then it was too late. Illnesses began to plague them.

When we were very young our father would drag the older children, Moses, Fannie, myself, and maybe Isaac to Zionist meetings where emotional, nationalistic oratory was always followed by the singing of *Hatikvah*. Usually we were the only children present, and I still have a clear picture of my father, out of whose full-lipped, open mouth, framed by a black, round beard, poured resonantly forth:

> Our hope is not yet lost . .
> To return to the land of our fathers.

He had the glazed look of one who saw glories of realized dreams.

Russian and Hebrew were the two languages in our home. Russian for obvious reasons: It was the language of our environment and school. Hebrew we learned by osmosis. Our father was the Hebrew scholar and teacher of Borisoglebsk. He had no time to teach us directly. But (again to use the word *drag*) he would drag us to the homes of his private pupils where, while ostensibly teaching them, he hoped that we would benefit by that instruction. And we did. I'm still

179

amazed every once in a while at how much of the Hebrew language, which I absorbed then, I still retain.

My father was also a Hebrew writer. He wrote children's tales, and for adults short stories and novelettes in the style of Chekhov. His children's book *From the World of Wonders,* and the two volumes of *The Passing Generation* and other titles may still be found in some stockrooms of bookstores and libraries here and in Israel. He would write early in the morning, a habit formed in Russia which continued the rest of his life. He would cut wrapping paper into long strips, which he covered with very straight lines of his beautiful Hebrew script. I often wondered why he used wrapping paper. Probably because we were poor and writing paper was costly and scarce. For many years there were rolls and rolls of them in our house. What finally became of them, I don't know.

It may have been shortly after our father's death that we found a bundle of old love letters from him to our mother. Her name was Bella, and in those letters he called her Belka, or Belotchka, which means both "little squirrel" and "little white one" in Russian. To translate freely as much as I remember, my father wrote: "My dear Belka, I will caress you, I will indulge you and spoil you, I will provide for you. You will never have to exert yourself," and other endearing promises. But after they were married these promises were apparently unfulfillable. A dark legend persisted in our family that promptly after marriage our father lost our mother's dowry in a lumber venture in some Lithuanian forest and became a *knecht* (Yiddish for "slave") to a lumber tycoon by the name of Avrom Kavnat. I knew this sinister name all through my childhood.

Perhaps my mother's melancholy spirit owed its origin to the early disillusionment caused by this unfortunate crisis. She acquired a propensity for silent weeping, which would come upon her suddenly, often for no apparent reason. This persisted throughout her life, and finally developed into the illness from which she never recovered. Yet she had a sense of humor, was earthy, and functioned normally, I should say remarkably, raising her brood of children. It was my mother who taught me to write the Russian alphabet in shaded monogram letters. In school I was noted for my excellent penmanship.

Now that I can look back upon all this with some comprehension, I can see that my father was not meant to be a businessman. He was a naive poet, a romantic, a hero-worshipper; he loved pictures, statues, monuments. He decorated the cold and dreary walls of our home in

Borisoglebsk with postcard reproductions of Russian paintings, in fan-shaped designs. It was from our father that we first heard the names of Rembrandt, Raphael, Michelangelo. He could draw, too. He would make pictures of Cossacks on horses and all the trimmings on both of them, the horses in prancing position showing their horseshoes, the Cossacks brandishing their sabres. Moses and I would copy these pictures, and I still remember how hard it was to draw horseshoes on hoofs. My father would "correct" the drawings and exhibit them as our own to friends, and to the young "gymnasists" and students who were constant visitors in our home. These young fellows in their brass-buttoned uniforms and visored caps were helped by our father in their compositions, and they in turn would devotedly coach us in arithmetic, spelling, and other subjects, much to our annoyance.

Our father also drew designs for tablecloths and other linens which our mother embroidered skillfully and colorfully. Some of them were complicated, of troikas, or of soldiers saying goodbye to their wives, and were copied from illustrations in poetry books. But he also made his own designs of leaves, flowers, berries, and chirping birds. The color schemes were always our mother's.

One evening, a young man named Ivan Ivanovich Pozdniakov, came to our house and did a drawing of our father from life. That one could draw a living person was a sudden revelation to me. I stopped drawing for several days, then asked my father to pose for me as he had for Ivan Ivanovich. When the drawing was praised, my elation was boundless. From then on I became a confirmed realist. I drew only from nature rather than from imagination, like other children. In retrospect, I believe that this limited my art, but perhaps my love for painting people stems from that incident.

As time went on I made more discoveries. There was a wood in the outskirts of town to which our father would take us on Sundays, to picnic and to draw. Even in those days, I was fascinated in a childish way by space and perspective. But I was always frustrated by my inability to indicate on paper the difference between the trees close to me and those far from me. One day I saw a picture of a forest in a magazine and I noticed that the nearer trees began at the bottom of the paper and as the trees receded, the farther up the paper they were. How this illusion of distance from tree to tree was effected was another revelation. I made many drawings of our woods according to this guideline, and I never ceased to wonder at the space and distance I was able to create on the flat surface of the paper.

181

Again, I discovered that by shading one can give a third dimension of roundness and solidity, and once while making a picture of the ever-present rubber plant, I had added some green to the leaves and was startled by the additional touch of reality this gave to my drawing. I was acquiring the habit of drawing the visible world, and with it the discipline that comes from daily application.

Vienna, July 20

I am always swept off my feet by the variety and the profusion of the paintings in Vienna's Kunsthistorisches Museum. I looked again so long and intently at the three self-portraits of Rembrandt, the inimitable and artistically infallible children by Velasquez, Vermeer's studio, the Breughels and Titians, the Holbein portraits, the Dürers and Van Eyck's "Albergati," that I feared the black spots always floating in my vision would turn into flashes of light again. (This had happened once when my eyes were overstrained, and I worriedly consulted a doctor.)

The Viennese seem to love statues almost as much as pastries. In a park we read an announcement saying that on this spot a monument will be erected to someone. As if Vienna lacks monuments or statues. They're all over the place: In public squares, in the middle of streets, in parks among trees and bushes can be seen statues of equestrians, of men and women in marble and bronze, sitting, standing, reclining, gesturing, all on lavish pedestals. On housetops they stand dangerously close to the edge, as if ready to jump. Even riders on prancing horses and chariots are up there overhead. Not to mention the fountains with their naked nymphs and cherubs, and the numerous churches with all the holy statuary inside and out.

We saw mostly older people in Vienna. They sat decorously on park benches, or in the outdoor cafes, genteelly consuming ice cream and pastry, or strolled sedately on the clean streets. We missed the young people who so animated the streets of Oslo, Stockholm, Copenhagen.

Vienna's Museum of the Twentieth Century was a disappointment, both in its supermarket-like exterior and in its meager contents. There were a few good pictures—a couple of Klimts, an Egon Schiele of characteristic intensity, an early Kokoschka portrait, early Jawlenskys, a few Kirchners and Schmidt-Rottluffs, a Guttuso. None

of them masterpieces. The rest was the usual sort of thing that by now we are accustomed to, and expect to see in a "Twentieth-Century" museum.

Twentieth-century museum! In another thirty years or so, if this pattern of fashion in art of a *dernier cri* persists, then, to continue this ephemerality, a twenty-first-century supermarket for art will have to be built. And if, as in everything else, this trend is accelerated, then perhaps every decade a new prefab will be assembled to contain the art of that moment.

The Guttuso was a simple picture of a young woman with two convulsive hands, one clutching a white cloth against her groin, the other on her chest, her wild-eyed head thrown back. Except for this cloth and the position of the head, the painting recalled the traditional Medici Venus pose.

Standing before this painting I was again assailed, as I often am, by doubts about my own work. It is painted so uninhibitedly, so freely, with deliberate avoidance of the refinement one gets from many repaintings; and hastily, preserving the artist's immediate reaction. I voiced my misgivings to my wife. She said, "But you go deeper than this. You get more psychological insight. You probe deeper." Then I called her attention to the colors in the picture, the yellow ochre tinged with the gray of flesh tones. "He, too, probes deeply," I said. "He expresses not only the living body, but hints also at its inherent deterioration. When I paint a nude, I'm also interested in the 'livingness' of it, and I too try to express what time will do to it. But in my desire to get a quality that can be attained only by many repaintings, I lose sight of this aim which Guttuso is able to realize by painting quickly. And then the Guttuso painting does have a quality all its own which, I suppose, is twentieth-century expressionism. I envy this ability to paint hastily, with momentary enthusiasm, without refinements, finesse, or regard for accuracy, precision, proportion. Compared to Guttuso and others, I feel out of time. Accuracy, proportion, even likeness, concern me when I paint."

Rome, July 22

Although we enjoyed the museums in Berlin, Munich, and Vienna, where I spent most of the time in contemplation of countless masterpieces, Rebecca and I felt relieved to be in Rome. Not even the

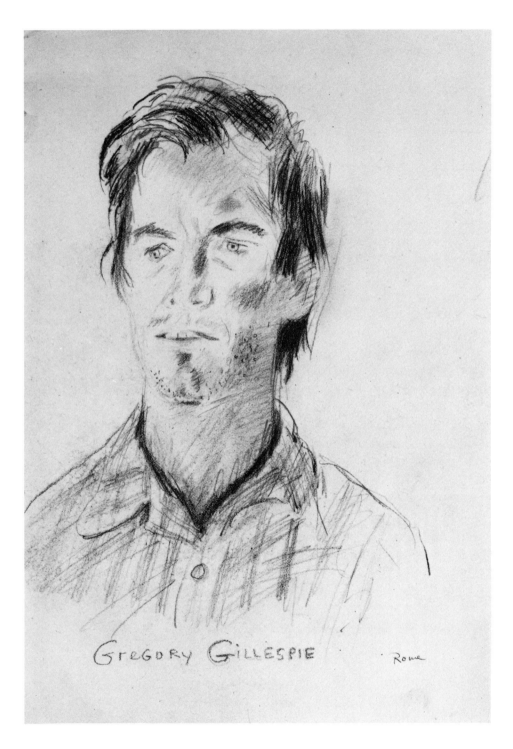

184

Gregory Gillespie

treasures of Dahlem, of the Pinakothek, and of the Kunsthistoriches Museum could erase from our consciousness the barbarism perpetrated by the Germans in the twentieth century.

What is happening to Rome? Space is destroyed by automobiles, the air is polluted by cheap petrol, clouds of it spurting out from exhaust pipes. Throats are irritated, breathing is stifled. It's hard to get around in the heavy, noisy, honking traffic, almost impossible to cross streets. If this goes on, people will have to wear gas masks! How nightmarish! Imagine the people of Rome walking around with their handsome, expressive faces covered by gas masks. But I must admit that the young people, tourist and natives alike, seemed unaffected by all this; they are as exuberant and good-natured as ever.

Several months ago I saw an exhibition of Gregory Gillespie's work at the Forum Gallery in New York which aroused my interest because it was so unusual in content and technique.

Gillespie's studio at the American Academy in Rome was in indescribable disorder when Rebecca and I visited him. He told us he hadn't swept the floor in two years because he didn't want his highly varnished pictures to catch the dust raised by sweeping.

"My pictures are offensive to some people," he said, probably because my wife was present. Reassured, he showed us his work.

Most of Gillespie's finished pictures were small and dealt with sex—more precisely, with sexual sadism: a fierce woman's head above naked shoulders and brightly nippled breasts, sinking gleaming teeth into an erect penis which alone, without the rest of the body, constitutes the lower corner of the composition; other small pictures of female figures vividly exposing their sex; a breach baby visible in an open vagina. There were two antiwar pictures—the face of a young man streaked with blood; a decomposed head in bas-relief, sealed in a shallow, glass-covered box, above which was a sign, "Fuck War."

What is unnoticed by others captures Gillespie's attention and preys upon his mind: a window in Naples; indecent drawings on moldy walls; innocuous and ordinary photographs of fashion models, of ads for bathing suits, for cameras or dog food. Extracted from their context, enlarged upon, these items become sucked into his work. The result is like distorted dreams, hallucinatingly concrete.

His technique combines many media, is involved and complicated. He cuts out photographs, mounts them, and repaints them. A bathing suit ad becomes indecent, the water disarranging the suit to

185

expose private parts. He uses epoxy, glues, plexiglass, cement and seals his little pictures under layers of smoked glass.

I said, "Gregory, do you call yourself a painter?"

He answered, "Yes, a painter, absolutely."

I pointed to the head in the glass-sealed box and said, "You could have painted this directly on canvas. It would have been very effective."

There was something religious about these paintings—artifacts, I should call them, rather than paintings. Highly varnished, murky and tallowy, sealed in old cast-off frames under multiple layers of glass, they suggest icons and blood-streaked relics, with the guilt inherent in them. There is the same focus on punishment of genitalia as in the medieval depictions of sinners in last judgments.

July 26

It is our last evening in Rome. We had an early dinner in our favorite Piazza Navona, the one piazza which the Italians have not yet completely relinquished to the tourists. As if they said to themselves, "This is our piazza, not like the Spanish Steps, not like Via Veneto, not even the Piazza del Popolo. This is ours, with its three Bernini fountains." Here the people of the neighborhood gather, whole families, in late afternoon and evening. Children play here, jump rope, run, fall, ride tricycles. Women nurse their babies. Old men meet their cronies and young people stroll intimately, not like the promenaders of Via Veneto to look and be looked at.

Here, as I sit in the early twilight, I remember my youth: the piers of New York along the East River where, shortly after World War I, I wandered with my sketchbook on summer evenings, noncommunicative and shy. Often I'd find a spot from which, unobserved, I would make drawings of people sitting around, talking, gesturing, eating, drinking, and of naked boys diving off the docks.

What a journey it was from Borisoglebsk to New York, by land and sea! A labyrinthian maze of third-class train interiors, of steerage corridors in old ships, of crowded halls in immigrant shelters. Our father, still in his prime, became known as the man with the big family. With his knowledge of Russian, Yiddish and Hebrew, with his strong voice and clear enunciation, and responsiveness to others, he became a spokesman for the immigrants. Many of their faces are still vivid in my memory. They crowded, pushed, quarreled, insulted one another, and begged forgiveness; they laughed, cried, and immediately worried

about their reddened eyes. They worried about lice in their hair, for infected eyes and hair lice were the two main reasons for not admitting immigrants to the United States.

We were seasick. We ate bad food. There was some sort of sweet jelly or jam that Moses and I liked. We ate so much of it that long afterward we were able to belch it up and spit quantities of it out at will. Our baby brother, Israel, whose vocabulary had consisted of *pusti* ("let go," in Russian), which he cried whenever we tried to hug him, now learned another expression, *nisht gut* (Yiddish for "not good"), used all around him to describe the feeling of nausea, thus becoming bilingual very early in life.

I've been feeling detached from painting and drawing during this trip and, unlike other times, I draw very little. The pictures I have painted and those I've been planning all seem to be fading away. Except for going to museums, I spend my time thinking about and writing this chronicle. Again, what's the reason for this? What is there for me to report? After all, my life has been very uneventful, for I escaped wars, being either too young or too old. How I "free associate" in Piazza Navona!

Mention of war reminds me of a friend, a history professor who teaches at a college which he calls a "cesspool," a "prestige mill," and who has bitter and fantastic memories of war.

"Why don't you write your memoirs, now that you are planning to leave the 'cesspool,' as you call it?" I asked him once. His lips curled in horror, his eyes became sharp and abstracted at the same time.

"You know," he said, "if I do, I shall call it my 'Me-moi-res,'" combining the Hebrew word *moireh*, meaning "fear," with *memoirs,* a play on words. "Frightful Memories," or "Memoirs of Fear." What a title for a twentieth-century autobiography!

But I have no such memories. I escaped the apocalypse of Nazism too, safe in the country *Gdie niet Iudea i Iellena,* "where there's no Jew or Greek.' This was how sophisticated Russian Jews described the United States when I was a child coming to this country.

I'm wandering off again. It seems I don't want to come to grips with why I am writing all this. Is there something in me of my father who filled rolls and rolls of brown wrapping paper with his constant writing? Lately, when I look at myself in the mirror, I seem to see him. All I need is his mustache and trim goatee.

How superficial is all this verbiage. I could dig much deeper if I had courage.

Florence

We had misgivings about Florence because we were warned that it was noisier than ever, that it stinks with gasoline; in a word, it was impossible. To our very pleasant surprise, we found the traffic more controlled, and the Piazza Signoria completely closed to cars. I once referred to Florence as a "golden city." It is. The whole city is a work of art, a planned work of art, although it may not have been planned, so far as I know.

In the Santa Maria Del Carmine are Masaccio's murals. They are not overwhelming like the murals of Michelangelo and Raphael in Rome, or Piero della Francesca's in Arezzo. It is difficult for me to comprehend the imagination, fantasy, and skill of those three giants, but Masaccio I understand more readily. He is more my speed, so to speak; not turbulent, nor olympically serene, nor mysterious. His murals are not gigantic in scale, and their eloquence is without oratory, if one may apply such a phrase to paintings.

The "Tribute Money," is of a group of people, a horizontal composition all on one level in even height. What can it be compared to? To the "Brera Madonna" of Piero della Francesca? To the "Surrender of Breda" by Velasquez? Or to Courbet's "Burial at Ornans"? What a strange grouping of compositions in my head!

All the figures on the walls of the Carmine have dignity: Christ, the Apostles, St. Peter, even the beggars and cripples. Everyone is human. One memorable figure of a beggar-mother holding her child is ultimate in its simplicity. The colors—browns, reds, yellows, greens— all muted (by time?), are intrinsic to the content and add to the overall humanity and warmth. But more than man's dignity is expressed here; one sees his vulnerability too: the grief of Adam and Eve expelled from Eden, the misery of beggars and cripples, the shivering bodies of people being baptized, all without a trace of sentimentality. And somewhere in the background of these compositions there lurks a brilliant young face with an energetic and restless expression, believed to be Masaccio himself.

In Rome, Florence, Naples, Vienna and Paris are Caravaggio's paintings of saints' miracles and tortures, of madonnas, of Christ, and of the Virgin's death. The characters in these nominally religious pictures are mostly poor, barefoot, ragged people. Unlike Masaccio's murals, Caravaggio's are theatrical compositions in which the figures

are arranged like the dramatis personae in a play, where the action and gestures are determined by the director. Caravaggio's great restraint and tempestuous emotion produce tremendous energy, like a welding of Delacroix and Courbet, romanticism and realism combined. The fantastic virility of his draftsmanship beggars description. Everything is full of movement, pulsates, and heaves with life: faces, shoulders, arms and hands, thumbs, veins in the ankles. His people are as real as the men and women in the paintings of Louis Le Nain. It interests me to find his frequent juxtaposition of youth and age, an energetic, smooth-browed face of a young woman next to an old wrinkled one.

These artists who died so young—Masaccio, Caravaggio, Géricault, Van Gogh, Seurat—fulfilled themselves. One need not bewail their short lives. But imagine if Titian, Rembrandt, or Degas had died at the age of Masaccio and Caravaggio! They needed long life. It is tragic only when artists live long without excelling, or even equaling their early achievements. But these too should be recognized and honored, even if they produce nothing else.

August 1

Before leaving Italy, we were invited by John and Alice Rewald to drive with them to Lucca. Alice was the skilled chauffeur and John the anxious navigator. We visited the home of Herbert Handt, the tenor, and his wife, Laura Ziegler, the sculptor, who a year ago made an excellent likeness of me in terra cotta, the way I am now, dentured and sunken-eyed. From Lucca, we went to Pietra Santa to the Fonderia d'Arte of Vignale and Tomaso, a foundry with a traditional reputation for skillful casting. Sculptors of various persuasions, academic, avant-garde, and everything in between, bring their work to be cast there. They also work there, in one tremendous common studio, indoors as well as in the open. The man most respected by the sculptor and casters at this time is seventy-five-year-old Jacques Lipchitz. We found him that morning working in the yard on one of his mythological compositions, a huge entanglement of figures, human and animal. In his beret and smock he looked like a sculptor, vigorous, generous in body, full-faced, sun-tanned, his gray hair picturesquely untrimmed. His welcome was warm and friendly, his speech peculiarly his own, intermingled with French, English, Russian, Yiddish. I've always liked Lipchitz's appearance, his voice, the fusion of sophistication and folksy

189

intelligence in him. He was most gracious that day, introduced us to the sculptors and casters and to the extraordinary proprietor of the foundry, Luigi Tommasi, whom everyone calls "Mama Gigi" because he's so helpful and solicitous of everyone's needs. We had an excellent lunch with him and Lipchitz in a simple, rustic setting which they said was a workers' club.

After lunch we went to Lipchitz's studio where we saw the plaster model of his monument to Duluth, a French explorer who founded the city in Minnesota that bears his name. (Now I'm not quite certain of the name of that picturesque explorer, nor of the city. I had so much wine and good food that afternoon. Shall I try to check it, or just leave it at that?) But I do remember the imaginative quality and animation of that carnival-like figure attired in an eighteenth-century costume, plumed hat, gauntlets, and all. Jacques Lipchitz told us he had no likenesses to follow, but had to base his portrait only on verbal descriptions in old documents.

In the studio there was also a large, unfinished plaster cast of Hagar and Ishmael. "I did this," Lipchitz said, gesturing vaguely, ". . . the idea is friendship between Arabs and Jews in Israel. . . an idea. . ." Lipchitz is one of those artists who are able to use mythological and biblical themes for plastic interpretation of contemporary events and concerns.

August 4

Now that I am engaged in writing this, I find that some early memories appear more vivid, in the literal sense of the word "appear." They come out of the deep recesses of my mind, like the incident of the dead infant with the tail between his legs. Some later memories are not so concrete.

Our arrival in America is vague in my memory. It seems that we landed in Philadelphia, where our father left the six of us and our mother to stay with her relatives, while he went to New York to find employment as a teacher of Hebrew.

We had Rembrandt eyes, all of us, father, mother, and children (except Isaac), heavy-lidded, soft, brown. The eyes of the two youngest, Rebecca and Israel, were huge, icon-like. They loomed big in their little faces. Isaac's eyes were different. He had Dürer eyes, but brown, not blue. There is a painting in the Alte Pinakothek in Munich, of one

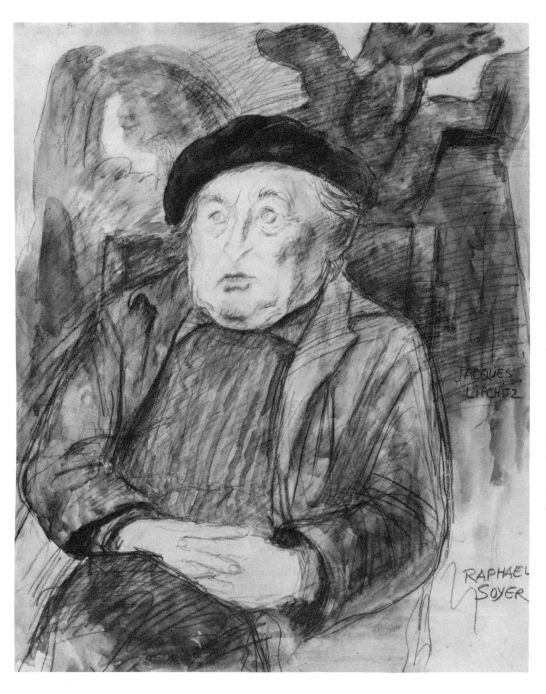

Jacques Lipchitz

Oswalt Krell, by Dürer, that always makes me think of Isaac when he was a child, and even now, when I saw it, although it's a portrait of a man, it brought to my mind vividly how Isaac looked when we were in Philadelphia, thin, intense, nervous. Seven or eight at that time, he was deeply religious, fanatically so—one of those inexplicable, mysterious phases of childhood. His behavior and moods were unrelated to those of the other children in that household of brothers, sisters, cousins. He prayed continuously, and when he prayed he seemed to be in a trance. One could do anything to him in those moments: pinch him, tickle him, slap him, lift him, and carry him about the room, as our brutish, much older cousin would do. He would not interrupt his prayers, although his Dürer, but brown, eyes would blink angrily. Only when he finished would he strike out at his tormentors, curse, and cry.

Moses and I were humiliated and angry when all five of us, even our little sister, were put in the same class of a Philadelphia public school. In Borisoglebsk we had just been admitted to the *gymnasia,* wore brass-badged hats and uniforms, and were already steeped in Russian literature, having read all the adult books in our father's library. We also knew, in Russian translation, *The Prince and the Pauper, Uncle Tom's Cabin,* and the novels of Charles Dickens and Thackeray. *Uncle Tom's Cabin* I knew almost by heart, having read it so many times to my as yet unlettered, but intelligent and compassionate younger brother, Isaac. The trials and sorrows of Uncle Tom and the death of little white Eva never failed to make him shed silent tears, and my voice, too, would tremble with emotion. In the *gymnasia* my compositions on Lomonosov (the Russian Benjamin Franklin), and Turgenev's *A Hunter's Sketches* and other books, were beginning to be read to the class by the teacher.

Moses at that time was considered somewhat of a mathematical wizard. He could multiply and divide any large numbers in his head. Also he was known to have surpassed his teacher in drawing. I still remember a pen and ink drawing by this teacher, of a boat in turbulent waters, given to Moses with the inscription: "To my favorite pupil."

And now here we were in a classroom with babies!

Nevertheless, during the several months of our stay in Philadelphia, Moses and I were often able to forget our advanced age, our sophistication, forget that we were foreigners, and in spite of the language barrier lost our self-consciousness and joined in schoolyard activities. It was only after we came to New York that we found ourselves suddenly plunged into a strange world. We ceased to be children and withdrew.

But in Philadelphia we were still children. We played, roamed the streets of the city, had encounters with native kids and defended ourselves when attacked. These were normal, boyish experiences.

Moses was the daring and assertive one. In the schoolyard, when a bully finally got Moses's goat by constantly picking on us, he suddenly hurled himself on our tormentor without warning. In a matter of seconds there was a cloud of dust, scattered pencils, books, even shoes, and a prostrate boy.

Once, while exploring an unknown neighborhood, we were accosted by a gang of jeering, hostile boys. It didn't take long for a fight to develop. Moses fought valiantly, but as for me, I must confess that I did not strike out, not even to defend myself, but let a boy jump on me and pull me down. Dazedly I was conscious of a pleasant sensation, and I somehow felt that the boy on top of me experienced the same satisfaction. After a while we disengaged ourselves and ran, with our "enemies" in pursuit. When we reached safety and the gasping, breathless little Isaac caught up with us, Moses declared, *"Nu, 'Volka boiatsia v lies nie khodit,"* which means, "Well, 'he who fears wolves should not venture into the forest,'" a Russian proverb which served as a slogan for us.

August 6

Though I often question the value of what I am doing, I find it delightful to involve myself in writing, in authorship. For me there is no competition here, no professional standard. It is an escape from my confusing, choleric world of art. When I was young and became unhappy with my paintings and drawings, when I thought I was not living up to my then naive, grandiose expectations, I would seek escape in any routine job—as an all-around boy in a shop, a dishwasher in an ice cream parlor, an embroidery worker—and find relief. Now I find similar relief in writing these lines.

Often, when traveling between France and Italy, we stop in the rather dull and stodgy city of Basel just to see the Holbeins again. I am always intrigued and impressed by the personalities of the great artists, Masaccio, Vermeer, Degas, Van Eyck, Cézanne, Seurat, Breughel, Rembrandt, Renoir. I like to take them out of their historical context. I wish there were a book written from that point of view. Then perhaps one could come closer to an understanding of what genius is. For those I mentioned are out of sequence of time and events.

Holbein was so unlike his German contemporaries—serene, gestureless, grimaceless. I'm referring to his portraits, which are monuments, rather than paintings, images for eternity. My favorite Holbein is the portrait of his wife and children, truthful, non-flattering, so tangible that you can smell the baby. This mother and her children are not medieval; they are out of time.

The top floor of this museum is filled with more recent and contemporary art, beginning with the French Impressionists. There is an interesting self-portrait of Cézanne, well-groomed, almost beguiling, a small canvas of a three-quarter view, unlike his other self-portraits which are mainly of a disheveled head.

Then there are rooms filled with the work of European Expressionists, Munch, Kokoschka, extraordinary, late paintings by Corinth, some Beckmanns, an excellent group of Chagalls; one youthful and one mature painting by Picasso—"Two Brothers," a naked young boy carrying his little naked brother on his back, and a still life of a brown, drop-leaf table with a bowl of fruit. This is followed by rooms of Légers, Braques, Juan Gris, and the many inevitable Paul Klees, Kandinskys, Miros, and . . . pandemonium: pop art, op art, kinetic and mobile art. We were amused by two American paintings, a typical Mark Rothko in brown, red, and white, and a Barnett Newman, also typical, I suppose: a tall panel of navy-blue with a sky-blue stripe on top and bottom. One was called factually, "Brown, Red and White," while the other was pretentiously entitled, "The Day Before One."

"Why not call the Barnett Newman 'The Day After Tomorrow?'" my wife said, and laughed.

Paris, August 10

I am one of the older people walking along Boulevard Saint Germain. My hair is white and I'm aware that Paris is a city of and for young people. What an abundance of thighs and legs! Apparently young women would like to go about naked, or at least in bikinis.

It's August, and Paris is in its full beauty. It's the beginning of fall, the season of *listopad* (in Russian, the "falling of leaves"). At this time of year the planned vistas are unmarred by traffic. How can one describe adequately the beauty, the esthetic wealth of this city, so filled to the brim with art?

As soon as we arrived we took a walk through the gracious

gardens of the Tuileries, and found ourselves in the Orangerie where we saw a profusion of Cézannes, Renoirs, Utrillos, Rousseaus, Picassos, Derains, Matisses, Soutines, and Modiglianis, the collection of Paul Guillaume. Again an evidence of how rich France is in art. It has produced many great painters and adopted many more from other countries; their work fills the museums of the world. I am poignantly reminded now of something that Yasuo Kuniyoshi wrote about himself in some publication a long time ago. He described his stay in Paris, how he worked there, how much he liked it and thought of remaining, but in the end he decided to return to New York because, as he said, "France is so rich in art and artists, and America so poor." He wanted to contribute to the art of his adopted country.

As always the Louvre overwhelmed me. Again I was held by Delacroix's "Liberty Leading the People" and "The Massacre at Scio"; by Courbet's "Studio" and "Burial at Ornans." These great canvases humble and inspire me. In front of the "Burial" I found myself muttering to myself, "What a painting, what a painting!"

August 18

Our stay in Paris was made more interesting by a friend who took us on a trip through the small towns outside the city: Argenteuil, Pontoise and others, the names of which I can't recall. This is the locale where Pissarro, Sisley, Monet, Renoir, and Cézanne painted their landscapes that became so well known and loved. Their motifs are still recognizable both in the canvases on the walls of the Jeu du Paume and in the locales themselves, in spite of the changes wrought by time and civilization. There are modern factories there.

The high point of this pilgrimage was Auvers, the town where Van Gogh worked at the end of his life and where he shot himself. His spirit still permeates this suburb of Paris. There is a cafe now in the house where he lived—or was it there then too? On the top floor is his room, small, stony, a dormer window near the ceiling, a narrow iron bedstead, an old, worn-out chair, an 1890 calendar on the wall. The austerity of it! A prison cell! I thought of his paintings, of his life. What tragedy and triumph.

We went to the cemetery where we found two simple tombstones side by side, one saying, *"Ici repose Vincent Van Gogh,"* and the other, *"Ici repose Théodore Van Gogh,"* with only the dates on each of his birth and death.

I stopped short at the sight of the fields around the cemetery. I felt a sharp pang; they were exactly like Van Gogh's last paintings in their flatness, shape, and expanse. The time of day was different, the season may have been different, there were no big blackbirds at the moment, but this was unmistakably Van Gogh's landscape.

In a small old park we found Zadkine's monument to Van Gogh, a Don Quixotish figure. Did Zadkine mean to imply that Van Gogh was another Don Quixote?

Though it was getting late, I made a quick, inadequate drawing in my battered sketchbook. Some young boys, giggling and making comments, were watching. I said to one, *"Asseyez-vous, s'il vous plait,"* pointing to the base of the statue, and sketched him in below Van Gogh's figure. Then I said, *"Merci,"* and we shook hands. I gave him my pencil and said, *"Nom?"* He wrote: "TRIQUET." *"Qui est le sculpteur?"* I asked. All the boys ran out to read the name on the plaque outside the gate of the park and came back calling out in unison: "Zadkine!" Talking all at once, they were telling me now about Van Gogh, a *"peintre fameux,"* his room, the cemetery, and so on.

August 24

We cut our stay in Paris short by a few days to visit the Rewalds in their medieval La Citadelle in Menerbes, in the Vaucleuse region of southern France. Our first stop was Autun to see the Nativity by the Master of Moulins. I have loved that picture ever since I first saw a color reproduction of it in one of the Skira books. With its delicate figure of the Virgin in blue and white it looked like an enlarged early French illumination (though, of course, one cannot generally judge color from the usual jazzed-up reproductions). To my disappointment, the Nativity was not there at the moment, but at The Hague, in an exhibition called "In the Light of Vermeer." (This was not tragic, for we were to catch up with it at The Hague the next week.)

Anyway, our visit to Autun was not a total loss, for in the medieval, turreted cathedral towering above this ancient little town, I found the "Martyrdom of St. Sophronia" by Ingres, a large composition, densely crowded with dramatic figures and faces. I knew this painting from reproductions, as well as the many complete and detailed studies for it of heads, groups of figures nude and robed, and of gesturing hands.

Next day John Rewald came for us in Avignon in his car driven by Joseph, the caretaker of his place.

"Where is Alice?" we asked disappointed. It's Alice who usually drives John around.

"There's a fête in the village tomorrow, and Alice took Victoria, Joseph's daughter, to buy her new shoes."

After the cold spell of Paris and Autun, we were grateful for the sunniness of that afternoon. John was in high spirits, which rose higher the closer we got to his Citadelle in Menerbes. Continuously he pointed out the picturesqueness of the area and extolled the fertility of the land, and he hummed buoyantly to himself as we drove along in the open car, enveloped by the warm wind.

"Menerbes is on the other side of the mountain," he said, pointing to a range of hills. "Now hold your breath," he said after a while, "we're approaching it." And there was La Citadelle, with its tower, the highest point of the village.

We were amazed at the comfortable, modern renovation, or rather reconstruction, of the interior of this ancient fortress. The triangular shape of the grounds is like a miniature Vert Gallant, not under a bridge on the Seine to be sure, but high on a mountain. From this height one could see the tiled roofs and steep narrow streets of the stony village. The landscape of vineyards and farmland surrounded by mountains was beyond description. It was breathlessly spacious. I was confused: Was it Cézanne? Piero della Francesca?

In renovating the house, the Rewalds utilized its original architecture and medieval oddities. The master bathroom in the tower is like a Guggenheim Museum, with its white, round walls and domed ceiling. There were even appropriate pictures on the walls, a Pascin drawing of a nude with spread thighs, as only he could do. From every aperture and window one could see the controlled profusion of colorful flowers and trees in the garden around the house. John was as proud of this garden as of the panoramic view and of La Citadelle with its rare furniture and objets d'art chosen with knowledgeable effort.

How unusual it is, Rebecca thought, for this urbane and famous art historian to be so absorbed in flowering plants and trees. He applies his esthetics to them, making color combinations of various flowers, harmonious and exotic.

The next day Alice Rewald gave a party. A group of people came, none of them natives of the region, all members of some kind of an international intelligentsia: Madame de Staël, a neighbor in Menerbes;

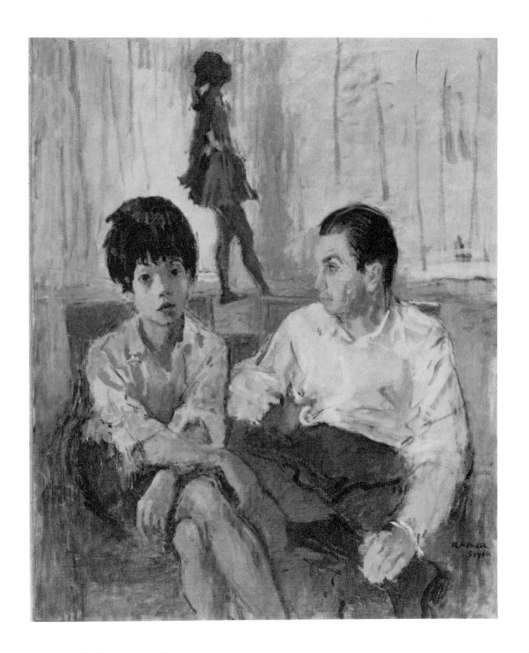

John and Alice Rewald

Julien Levy, the former art dealer and biographer of Arshile Gorky, and his wife; the artist Bernard Pfriem, who has been summering in the nearby village of Lacoste for many years; his next-door neighbor, an English painter and friend of mine, Peter De Francia; a French winner of the Nobel Prize in biology, Professor Lwoff, whose mother posed for Serov, the famous Russian painter.

In a good mood because of several drinks, I talked with pleasurable ease in Russian to the professor. He paints too, he told me, and likes to make pictures of the East River when he visits New York. From a window, I surmised, high up, from a bird's eye view, not like me who painted it close at hand in the late twenties.

But really it was not the liquor but the warmth and charm of Alice Rewald that put me, a stranger to this multilingual, worldly group, at ease.

I wandered through the rooms of La Citadelle and found myself in John's study, his "office," as he calls it. In a bookcase that took up an entire wall were Rewald's *History of Impressionism,* and *History of Post-Impressionism,* in several languages and editions, also his works on Cézanne, Degas, Maillol, Pisarro, and others. On the table were more books on Cézanne by different authors in German, English and French, probably references for his forthcoming definitive book on the life and art of this great painter. I leafed through one of these books and was pleased to find a reproduction of a drawing made by Cézanne of Murillo's painting, "Little Beggar Boy," which is in the Louvre and which I've always been fond of.

A sketch of Alice by Kokoschka, a pen and ink nude by Guttuso, were on the wall, and, of all things, a battered oil painting, meagerly framed, of Gauguin's two squatting Tahitian women.

"What's that?" I exclaimed to John as he came into the room.

"That's a copy of the Gauguin in the Jeu de Paume," he answered.

"Who did it?"

"I committed it," John answered.

I laughed as I realized that he used the word "committed" advisedly.

The Rewalds took us to see Lacoste, a smaller, even stonier village, poorer and more primitive than Menerbes. Adding to the gloomy beauty of this place is the ruined castle of the Marquis de Sade. Originally a fortress, it was rebuilt in the seventeenth century as a luxurious chateau for the noble de Sade family. Now only zigzag ruins of stone walls remain. Like the Rewald's La Citadelle, it commands the Cézanne-Piero della Francesca view from the mountaintop.

199

Macabre platitudes filled my mind. How perishable everything is! Will the same happen in time to La Citadelle, so cleverly transformed and modernized, with its Vert Gallant triangle and its colorful flower arrangement, its furniture and objets d'art, its Guggenheim Museum bathroom? *Vanitas vanitatis,* all is vanity.

September 2

For some reason, I have no great interest in sculpture. I have made a few sporadic attempts at it, with little result. Often I even forget to look at it when I visit a museum. But I can become spellbound by an Egyptian, Gothic or Romanesque figure, and I am in awe of the sculpture of Michelangelo, Donatello and Rodin. During this trip, however, I was glad to see the lifework of two sculptors, the Giacometti exhibition in Basel and the work of Bourdelle in the Paris museum that bears his name.

I had previously seen a Giacometti retrospective in the Museum of Modern Art in New York, selected and edited to the point of preciousness and sterility. (Why does the Museum of Modern Art at times so dehumanize its one-man shows? It had once an exhibition of De Chirico where nothing but his metaphysical street scenes were shown, none of his self-portraits or figure compositions, making it monotonous and gloomy.)

For the first time, at the Giacometti exhibition in Basel, I warmly responded to the work of this limited and obsessed man. It was a huge, all-inclusive, diverse show, from talented youthful drawings, paintings and sculpture, naive and fresh, to the very last repetitious, fleshless, and sexless figures, striding or standing still. There was a large group of his mature paintings, predominantly in slate gray touched with yellow, red, or some other color, lava-like in texture from having been painted, scratched, scraped, and painted again many times. His abstract, experimental and surrealistic bronzes which were given such prominence in the Museum of Modern Art show, were here shown in their proper context. From this all-inclusive show I did get the feeling of a rare, searching, noncompetitive and altogether humble artist and man.

Before leaving for Europe, I read James Lord's book, a poetic account of how he posed for Giacometti. What trials and frustrations they both went through! Unbelievable! And judging from the reproduction in the book, the painting remained unfinished. But

Giacometti never considered any of his work finished or completely realized. I can imagine the painter who did the Frick portrait of Philip IV in three sittings in a makeshift studio under unfavorable conditions, saying, after reading Mr. Lord's book: "What's all the fuss about? It's only a simple portrait."

Yet I left the show in Basel with a greater understanding of the work of Giacometti. I felt that in its frustration and obsession, even in its limitations, there is something redeeming.

A good way to describe Bourdelle's work is to say that it is entirely opposite that of Giacometti—loud, huge, lusty, rhetorical and dramatic. There is no searching, experimenting, or frustration here: It is confident, strong, imaginative, and staggeringly skillful. The portraits of himself, of Rodin, of Anatole France, the beautiful heads and figures of Junoesque women, the deeply expressive madonna and child, are inspired.

But I really went to the Bourdelle Museum to see the exhibition of drawings of Isadora Duncan by Segonzac and Bourdelle, plus a few by some others, notably Rodin. These were all as good as one would expect from artists of such stature, and they did evoke some of the spirit of Isadora's dancing. Personally, I was sorry there were none of the numerous watercolors of Isadora by another of her devoted admirers, the American painter Abraham Walkowitz.

As part of her program to bring back to public attention the work of painters who, for whatever reason, become neglected and forgotten even during their lifetime, Virginia Zabriskie recently put on a small posthumous exhibition of watercolors and drawings by Abraham Walkowitz. His work always made me think of what Chekhov said of his own early stories: "I wrote them completely without effort, as a bird sings."

I think Walkowitz never worked hard on paintings. There was no effort in them. He never attempted themes demanding much grappling with content and technique. His work was always youthful, colorful and cheerful. It has its own profoundness.

This show was mostly of New York before the World War I, with a few scenes prophetic of the megalopolis that it has become. Even these are disarming, and lyrical, so unlike the dynamic watercolors of New York by Walkowitz's contemporary, Marin.

I first met Walkowitz in the middle twenties, over forty years ago, in an obscure little club of writers and artists called the Jewish Art

Center. Who sent me there I no longer remember. I came with a few small, tentative pictures which I had brought back from a month's painting in Gloucester. Diffidently I showed them to the artists who were present. Among them was the buoyant, stocky little Walkowitz, who looked at my work and said, "Say, he'll be an artist." A still smaller man, a hunchback with a constantly emotional face, nodded approvingly. Later I learned that he was Jennings Tofel, who, together with Benjamin Kopman, was one of the initiators of this group. Slight though it was, this was my first professional recognition, and I still feel deeply grateful to these two men, for I was very shy then, and young, not in years (I don't remember myself ever having been young in years) but in any kind of experience and social behavior.

I was accepted as a member of this club. The pictures were exhibited and immediately sold for ten or fifteen dollars apiece. One was a small oil on beaverboard, of a street after a rain, the sunset reflected in a puddle, with a sailor and his girl walking away in the distance and a boy peeing against a fence. Another oil showed a façade of a Gloucester frame house, with women and children sitting on the stoop or climbing the outside stairway. Two or three watercolors of similar subject matter were also sold. I wonder where these pictures are now, or if they still exist.

I believe that by the time I met Walkowitz he was no longer painting; at any rate, I never knew him to have a studio. For many years he would complain of his failing eyesight, but he would still get around, see exhibitions, look at pictures, praise or criticize them, discuss art at great length. Finally he did lose his sight, and then this charming, rosy-faced, white-haired old artist, who was seen for years on Fifty-seventh Street, in museums, at concerts, and dance recitals, dropped out of the artistic scene of New York.

But about two years before his death, Walkowitz finally had a bit of gratification; he was recognized and honored by his peers. At a meeting of a committee for grants and awards of the American Institute of Arts and Letters, I suggested that he be considered for the special award that is granted to an older artist. A restrained discussion followed. Some said other artists were more worthy; one opinion was that this was not meant to be a charity award to a needy artist, but recognition for accomplishment; still others that Walkowitz had stopped being an artist since he hadn't painted for many years. To all this I replied that it was unjust to forget the early contributions to American art of men who in their later years became inactive for

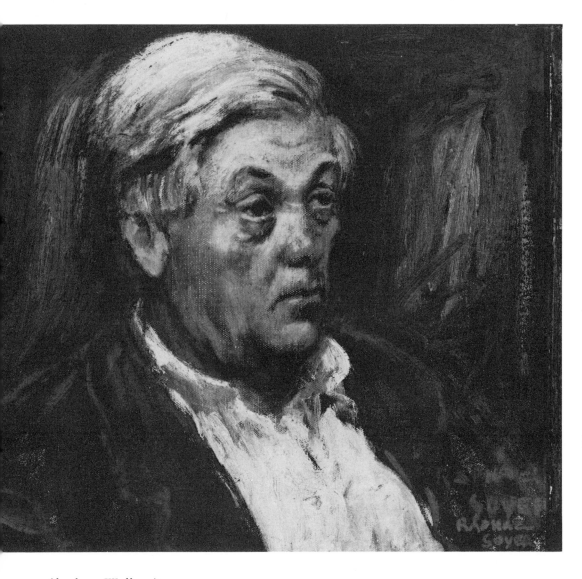

Abraham Walkowitz

various reasons: illness, discouragement, disillusionment. I cited the names of authors, composers, and painters of other countries who are honored for even a single creative work in their lifetime.

That May ceremonial of the Institute was memorable. It was dramatically moving to see the old, blind, white-haired Abraham Walkowitz led to the platform for his award, to the acclaim and standing ovation of the audience.

203

Later, probably the last time I saw him, Walkowitz told me that the award came too late.

That was an inbred group at the Jewish Art Center—proud, touchy, self-conscious and pretentious in its Jewishness. The painters wrote, the writers were involved in painting. Both Tofel and Kopman wrote books à la Nietzsche, and painted mystical and confused pictures. Tofel's canvases were poetic, nebulous in color and drawing, compositions of dwarfed, religiously posturing people.

The glamorous figure of the Jewish Art Center was Benjamin Kopman. No one questioned his talent. He was virile, wiry, handsome, curly-headed. In 1963, about two years before he died, I saw him at an opening of his exhibition, frail, but distinguished looking. His art was intense and personal, but affected by a number of tendencies prevalent during his lifetime. His earliest work, for instance, which I vaguely remember, had a "Munich school" look, popular then in this country. Later there was a Ryderish quality, and then a number of influences: Rousseau, Chagall, Rouault. Towards the end, when his art mellowed, as often happens with older artists, it assumed the quality of a sort of German Expressionism, but gentle and benign. His own gifts, however, his integrity and intensity, endowed his painting with individual worth. There was something tragic in Kopman. His shy pride, his reticence, and his withdrawal limited his milieu to a circle of Yiddish intellectuals, poets, writers, and actors who admired him and in whose parochial acceptance he allowed himself to bask.

My wife and I attended Benjamin Kopman's quiet and humble funeral. By a strange coincidence, there appeared in that day's *New York Times Magazine* a long, elaborate and well-illustrated article on Marc Chagall, entitled "Little Boy from Vitebsk Makes Good." Vitebsk was also the birthplace of Kopman, and he was born the same year as Chagall. Two painters from the same world and era, but what different lives and fates!

Chagall well deserves his great fame. Whenever I see an early painting of his, I marvel. What a medley of Jewish and Russian life and lore, reality and fantasy, Sholom Aleichem, Gogol . . What were *his* influences? Certainly not traditional ones. Is he what the Russians call a *samorodok,* that is, born of himself? Is he really naive or is he sophisticated? Shrewd or simple? In old Russian culture, folk religion, there were the "holy simpletons" who were endowed with a mystic and prophetic talent. Is Chagall one of art's "holy simpletons," like

Rousseau, for instance? But then he's also Cubist, Surrealist, Expressionist. I'd better not become too involved here. He is a phenomenon.

The Hague, September 4

We caught up finally with the Master of Moulins. His "Adoration of the Shepherds" at The Hague exhibition, "In the Light of Vermeer," was as beautiful as I had imagined it.

It's wonderful to be in a room full of Vermeers, with the miraculous "View of Delft" and the "Turbaned Girl," but for me the great single painting was the De La Tour. It is called "The Virgin and St. Anne," and again is one of those nominally religious pictures that fascinate me, of two women by candlelight, tenderly watching a swaddled baby.

We stood in line for half an hour waiting to get into the Museum. With what loving attention the visitors studied these modest paintings centuries removed from them! So unlike the viewers at the various Biennales where nothing is for study, scrutiny and contemplation. Did I say centuries removed? There were also paintings by Corot, Degas, and Cézanne. They held their own in the company of the older masters. How timeless great art is!

Amsterdam, September 12

For me, Holland is Rembrandt; yet nothing I saw in Holland recalled Rembrandt's paintings.

This is our last day in Amsterdam. In the morning I went back to the Rijksmuseum, to take one last look at the Rembrandts. Once there, I just had to stop and make a quick sketch of a figure in "Adoration of the Kings" by Geertgen tot Sint Jans. I love that painter of plain, awkward people; of women with retroussé noses; of simple colors, rose, brown, tan, and black. Then I spent the rest of the time in front of the "Jewish Bride," "The Syndics," the "Questioning St. Peter," and Rembrandt's self-portrait as St. Paul.

Yesterday a friend of ours took us in her car to the Zuyder Zee country. The small towns which we passed through were like paintings by Heyden and Berckheyde, only more beautiful now with age. Time

205

has weathered the bricks, tilted the equilibrium of the houses, and buckled their walls. Only the cars create a disturbance; here, like everywhere else, they destroy space and perspective.

It was a typical September day in Holland, with rapidly moving clouds and intermittent sunshine. We passed pastures of grazing cattle, farms, canals. We got out of the car to look at cathedrals, into courtyards, even into windows of houses. Ruisdael, Van Goyen, Cuyp, Van de Velde, de Hooch and Terborch, even Saenredam and Vermeer (we saw a girl or two who looked like the "Turbaned Girl" in the Hague) came alive. But not Rembrandt. He is beyond time and place. We encountered no "Blind Homer," no "Jewish Bride," not even one of the "Syndics." In the homeless faces on Second Avenue I saw, many times, Rembrandt's self-portrait as St. Paul.

September 13

Soon after joining our father in New York, I destroyed the notebook containing my Russian poems. I tore it up, page by page, and flushed it down the toilet. They were written under the spell of the romantic, altruistic Nadson, and were about birds who lost their nests and about wandering children who had no homes. All the poems had quatrains added by my father to the effect: "Thus art thou, my people. Thou hast lost thy nest (or 'home,' as the case might be) but one day thou shalt find it, recapture it and return to it."

The last poem in that notebook was one I wrote shortly before leaving Borisoglebsk. It was not about birds or children any more. I described myself musing on the banks of the river Vorona, watching its flow carrying heavy beams and stones, and asking it why it was unable to carry away my heavy thoughts. It was without my father's quatrain.

When our father ushered us all into the apartment he had rented in the South Bronx, our mother said, reproachfully, "Are these the rooms? They look like closets."

The same pattern of disappointments she experienced all her life. And a succession of our father's failures. I'm not implying our father was a failure; it was simply that his concrete accomplishments somehow never measured up to his talents. He was a naive romantic who was not able to realize his hopes. He was childishly uncompromising, unable to cope with the inconsistencies of his world. He did not even grasp the turbulent inner life of our bewildered mother, bewildered by the children who came one after another when she was

still so young, by her inability to cope with them as they grew, by the void in her own intellectual growth, the realization of which made her alternately angry and melancholy.

London, September 14

We're in London. The tree outside the window of our hotel is rustling in the wind. In two weeks we'll be on the ship taking us back to New York, my world, my country. I must hurry. I want to end this compulsive writing.

Our father changed. He now had a trim goatee, his hair was gray, his cheeks hollow. There was a feverish look in his heavy-lidded eyes. His voice was hoarse from outshouting his unruly pupils. He coughed. He wrote no more in his beloved Hebrew, but turned to commercial writing for the Yiddish newspapers "to make a living."

Later, in a more spacious Bronx apartment, our mother let Moses, Isaac, and myself have a room in which to draw and paint. On its glossy, cream-colored walls, we thumbtacked our drawings and nailed our earliest canvases. The disorder was indescribable. We were almost adults. Cramped, restless, and irritable, we got into one another's way and quarreled.

Isaac, the youngest of us three, often amazed me with his talent. When, several years later, I needed a back view of myself for one of my first compositions, a subway scene, it was Isaac I asked to make a drawing of me holding on to an imaginary subway strap. He did just what I wanted. I copied it onto the canvas, and had only to fill in the greenish gray of the long coat and the brown of the beat-up hat.

Moses and I became increasingly and painfully aware of the special problem of being twins who had the same interests and attitudes, which tended to make our paintings look alike. When the time arrived, on Moses' initiative we decided to go to different art schools. He enrolled in the then fascinating school at the Educational Alliance on the East Side, I in the more traditional National Academy. Isaac hesitated between the two, attended the Academy for a while, then left for the Alliance.

We neglected our academic studies, though Isaac did finish high school. Fannie, the sister closest to us in years, became absorbed in mastering the English language and going to college. I do not

207

remember much contact with the two younger children at that time; we loved them as older children love their younger siblings, without understanding them. We were so young ourselves. Nor do I know how much attention our parents, in their own daily turmoil, were able to give them.

I am here writing about my brothers and sisters in the years of their own growth, which they surely remember themselves. They may question what I say. But these are my memories.

The patriarchal quality of our family living came to an end. Everyone became involved with himself. I entered into a long period of fog from which I emerged only at intervals. I functioned after a fashion; I went to art schools and took on jobs. At home, of course, I felt more at ease and constantly drew the immediate members of my family, which now included our grandmother. She would sit in a rocking chair under our mother's large rubber plants, like an Henri Rousseau painting.

But I withdrew almost completely from other social contacts. Whenever the doorbell rang I would run off to my room. Harassed though he was himself, my father noticed this strange behavior and tried, in his way, to shame me out of it. He would say, "Hurry, hide under the table; Dominic the ice man is coming in." I rarely talked, and perhaps my persistent Russian accent and low voice can be traced back to this period. I simply didn't give my vocal cords enough exercise.

I neglected my appearance. I took long, lonely walks. Barbers standing in their doorways on the Bowery would beckon to me, trying to persuade me to submit to a haircut. Jeeringly they would say "For nothing." Smart-alecky kids would stop me in my most withdrawn moments and ask, "Hey, where's the nearest barber shop?" Bewildered, I would look around to find one, much to their amusement.

My mind was filled with fantasies. I was a kind of Walter Mitty, imagining myself in flamboyant roles, a great painter, a poet, even a strong man or acrobat. But any slight happening would jolt me back into my anxious reality. Once, on such a trance-like walk, I found myself following a boy my age who was walking jauntily, carelessly. Before I realized what I was doing I began to imitate him, became youthful, carefree, and skipped along like him. Suddenly I caught myself and felt shamed and embarrassed at playing a part out of character.

I stopped. I still can see my dim reflection in the dark glass of the store window, stooped, unkempt, slinking away.

Artist's Brothers

Moses was the first of the brothers to bring friends into the house, boys and girls. Our mother greeted these young art students warmly and became fond of them. Young Chaim Gross, a picturesque, penniless foreigner from Galicia's Carpathian hills, came and was welcomed. Louis Riback, a native East Side kid, both tough and sensitive, was a frequent visitor. But the youngest, handsomest and most precocious of all was the talented, red-haired Peter Blume.

My brothers and I saw a great deal of Chaim. Time had a different property then—there seemed so much of it. We spent long summer days together in City Island, Pelham Bay, and Spuyten-Duyvil, then undeveloped and picturesque, more like outskirts of New York. Chaim was a curious product of the First World War: unlettered, his normal education neglected, but rich in native intelligence, and talented. On these outings we took along our sketch pads and watercolors. We would swim in the Hudson, row in Pelham Bay and draw and paint landscapes. Chaim's watercolors had a semiwild flavor. I became critically aware of how accurate and tame mine were in comparison with his imaginative, expressionistic ones.

Peter Blume soon left our group, becoming a celebrated painter before he was twenty. He went off to Connecticut and began to paint sophisticated, neoprimitive pictures of New England which seemed extraordinary, beyond my understanding at that time. He was far ahead of us with such complex, composite paintings as "Parade" and "South of Scranton." A few years later I was overwhelmed by his "Eternal City." Even today when I look at it in the Museum of Modern Art I marvel at the skill, the persistence which went into the making of this unique composition.

Once Moses came with a pretty, plump girl, Eugenie Silverman, and later our mother cried when she looked out of the window and saw her oldest son go off with a girl for the first time.

Beyla (we called our mother Beyla now, father Avrohom) would often come into our room. One day while she was quietly watching us work, the telephone rang. Someone called to say that Leo Jakenson had drowned. Our mother began to cry in her silent manner. The whole family was attached to this friend of Moses, a strange, slight, elusive fellow. Moses and I were almost in awe of him. He was our age, but far advanced in art. In our eyes he was already a master. His work even attracted the attention of Robert Henri and George Bellows, the two socially minded leaders in American art at that time. With skill and understanding extraordinary for his age, he painted life-size portraits

of the East Side people who posed in the school. Death became a reality—a contemporary had died.

His thin, inconsolable mother began to visit us after his death to talk with Beyla. Upon leaving our house she would invariably stumble over the last few steps because her vision was blurred by tears.

When I entered the life class at the National Academy for the first time, I was as overwhelmed by the work of the students as Gogol's hick, Vacula, was when he came to Moscow. In my untutored and inexperienced eyes, their work seemed as wonderful to me as pictures by Velasquez and Frans Hals. After a while this initial excitement and amazement wore off, for I soon realized that art is more than skillful imitation of nature. One by one these able fellows received medals and prizes and immediately plunged into obscurity.

But there were others, restless, searching, dissatisfied with their drawings and paintings, who were not cited for awards: Ben Shahn, as much involved with theorizing about art as with painting; a bright boy in knee pants named Mike Schapiro; the exuberant young Sol Wilson, interested in music as well as in painting; Paul Cadmus, Lewitin, Martha Rythers. There were even some Cézanne-ists among us. These heretics would walk out of the classroom whenever the instructors came to criticize. We were a class of young, neurotic, dedicated students dreaming of fame, so unlike the art classes of today that seem to be filled with elderly amateurs.

I must not forget to mention that when I entered the Academy, the life-size paintings of Jan Matulka, a recent student who was becoming known as an artist at that time, were hanging on the classroom walls. His name was still on the lips of the older students. We were thrilled one day when he appeared in our class. We asked him to criticize and correct our pictures, showing him greater deference than we did to our old teachers, Francis C. Jones and Charles C. Curran.

But I was fond of George W. Maynard. He was then in his eighties, and had the head of a Roman senator. George Luks painted a life-size portrait of him in some kind of ecclesiastical robes. Mr. Maynard came to class at irregular intervals. He would childishly spout at me a few Russian phrases, which he had picked up in his youth when he was a sailor he told me. One day he looked at one of my studies of the model and said, "Why don't you go ahead and finish it! Now. You're quite young and have lots of time, but not an ocean of time." To show how he employed the word "ocean," I would have to write it like this, O-C-E-A-N.

Then this ancient artist failed to appear. Some time later a tall, masculine woman came in with a palette and mumbled that George W. Maynard, her deceased husband, willed his palette to his class. The moment she left we snickered and joked, youthfully thoughtless of age, authority, even of death.

I lacked the ability to associate freely and naturally with my fellow students. Years later, when I unexpectedly met one of them and we reminisced, he told me that I was considered aloof, proud, snobbish. The truth was that I desperately wanted to be friends with them, but didn't know how.

During all this time I was aware of another art school. Students talked about its radicalism and its modernism. Great men taught there at one time or another—George Bellows, John Sloan, Max Weber. I longed to go there, but its fees, about $14 a month, were way beyond my means, in spite of my odd jobs. Then one day my uncle, who was interested in my progress, offered to pay three months' tuition for me at the Art Students League.

The League was livelier, freer, noisier, less orderly than the National Academy. Fellows and girls worked in the same classrooms together, and the students had the privilege of choosing their teachers and changing classes every month. George Luks and Kenneth Hayes Miller were the most popular teachers when I was there. Once I watched George Luks give a painting demonstration to his class. He was in his element, a little drunk and exhilarated. He painted a child from memory, talking to the image on the canvas as if it were alive. "Ah, you're coming, you little devil. I'm getting you now." He pressed the brushes so vigorously on the canvas that he broke the handles of two of them. We watched him in fascination. After he finished he ceremoniously presented the picture to the monitor of the class. Privately, I thought it was too much of a display.

Kenneth Hayes Miller was the most influential teacher at the League. He was long-nosed and grim-visaged, but had a kind smile. He taught some of my brilliant contemporaries—Peggy Bacon, Reginald Marsh, Alex Brook, Kuniyoshi, Isabel Bishop, Edward Laning—with all of whom he had a continuing friendship and whom he influenced even after they became established artists. Years later, when I was posing for Alex Brook he said "You know, when Miller finishes criticizing a painting of yours, you feel like pushing your foot through it."

I joined the class of Guy Pène du Bois. He was one of the most

unobtrusive of the teachers. I didn't know his standing in the art world, but somewhere I may have seen and liked one of his small genre paintings. Inarticulate and timid as I was in those days, I was able to establish a rapport with this red-faced, also essentially shy man, who looked at me with sarcastic attention from behind his thick glasses. Actually he made no attempt to teach me anything. I realize now that he was not what is known as an "involved" teacher. As a matter of fact, there was something slightly cynical about him, as if he had said to himself, "I can't teach anyone to be an artist, but I have to teach to make a living." I liked and respected him, and my work changed merely from being with him. In the National Academy I had learned to paint cleverly from models, like my older fellow students, à la Sargent and Chase, who were our standards then. But at the League I made a conscious effort to shake off all that I had learned at the Academy. When I left the League I isolated myself in my parents' house and began to paint my immediate environment in an altogether personal manner.

After I had left his class, I met du Bois at gatherings in the Whitney Club. On one occasion he approached me and said in his friendly but sarcastic manner, "The trouble with you, Soyer, is that you don't drink enough." This has since been rectified.

Slowly I was coming out of my foggy existence. At infrequent intervals I would visit du Bois, overcoming my shyness in my desire to know him, and would show him the paintings I was doing. One day he said, "Take this one to the Daniel Gallery and tell them I sent you."

It was a 20 x 24 canvas, which I called the "Dancing Lesson," depicting our sister Rebbie teaching Moses to dance to the harmonica music of our youngest brother Israel, who was pictured sitting on the sofa with Avrohom and our grandmother. Near them, on a heavy rocker, sat Beyla with a Yiddish newspaper in her lap. On the floor was a flower-bordered rug. The light blue wall was embellished by an enlarged framed photograph, popular in those days, of our grandparents. Beyla's rubber plant was in the corner. This painting is now owned by Chaim Gross. One may call it naive; it is flat, without chiaroscuro or attempt to create depth. I consider it significant in my development.

When I brought "Dancing Lesson" to the Daniel Gallery, unwrapped it and propped it up against the wall under paintings by Niles Spencer, Pascin, Preston Dickinson, Cikovsky, Kuniyoshi, and Peter Blume, I felt a great joy, which I tried to suppress, at seeing that

213

my work looked as good as any of those already well-known artists. I could hardly believe it. After a whispered conversation between Mr. Daniel and his haggard associate, Mr. Hartpence, I was told that when I had twelve such paintings I would be given a one-man show. It took me a year to paint those twelve paintings in my spare time, and I had my first show in 1929. I now considered myself a full-fledged painter.

I began to work in studios, at first sharing them with other young artists, but soon having my own, all of them on the Lower East Side.

Time is measurable in months when one is young. Half a year is a period long enough in which to change, to grow, even to succeed. I was in the process, a prolonged one, of leaving home. I saw everything around me with clear, young eyes.

A tallish, slim girl, Rebecca, who wore her red hair in braids like a crown around her head, made curtains for the windows in my studio. She was my sister Fannie's school friend, whom I used to see in our house in the days of my deepest withdrawal. She became my wife.

It may have been after my third one-man show that I was invited to teach at the Art Students League. It was during the Depression, and a whole new staff consisting of, among others, Yasuo Kuniyoshi, Reginald Marsh, Harry Sternberg, Wortman of the "Metropolitan Movies" in the old *World*, and myself, was being hired. I considered this altogether unexpected invitation to teach a great honor, but I accepted the job with trepidation, for I felt ill-equipped. I had some experience as a volunteer teacher at the old John Reed Art Club, but this new situation was in an established school with a great art-teaching tradition. I had no theories about how to teach, no formulas for making pictures.

For me painting has always been a matter of trial and error. Even now, when I approach a new canvas I feel as if I had never painted before. I had no rules for composing; I never could understand formal analyses of composition. I was ignorant of all color theory and of anatomy, and I had no knowledge of media other than the basic one of oil and turpentine. What kind of a teacher could I have been? What could I then have told William Kienbush, who was in my class at that time, when he asked me how to proceed with his work? I still remember his questioning look. To Corinne West, later known as Michael West, I remember saying, "You're too brilliant. You use color too strategically." Even now I don't quite understand what I meant by this. I could not cope with the more advanced students. I could not give them any positive guidance.

However, in retrospect I think I was helpful after a fashion. Now and then I would find a young student with an odd ambition to become a Vermeer, a Van Gogh or Kokoschka. If he had talent, whatever that may be, I would say, "Go to it. When one is young, everything is possible. It may lead you to discover yourself."

Like my teacher, Guy Pène du Bois, I've always felt that one cannot be taught to be an artist, especially today. Art has become individualized and capricious; temporary "innovations" have replaced standards and traditions. I do believe, however, that even now students can gain from contact with a man whose work they admire. They seem to learn by osmosis; there is a certain inner rapport between the teacher and student, and verbal communication may not even be necessary.

September 22

The Tate Gallery has been completely reorganized since I was last there two years ago. I must say they've done a good job of putting things in order, making it easy and pleasant to follow the continuity of English painting from its early times through Wilson Steer, Walter Richard Sickert, Augustus John, and then, a break. What follows is the "modern" section of the Gallery. Except for the paintings of Bacon and Lucien Freud, this is a collection of all forms of non-representationalism, including the latest art of the moment, "op," "pop," "kinetic," and "cop." To apply the word "modern" to art is bad enough, in my opinion, but this is even beyond that. It should be called "momentary" art, if it is art at all.

I spoke to a couple of younger painters here, who told me that galleries and museums are reluctant to exhibit figurative work, that 99 percent of the art shown here is nonobjective, and that representational artists are losing confidence. As one of them said, "Even those who think figuratively paint nonfiguratively." How long will this liquidation of art continue? Until its extinction? What is the reason for it?

This summer I saw some of the Holbein inimitable portrait drawings. I saw the "Coronation of Napoleon" by David, battle scenes by Delacroix, genre paintings by Louis Le Nain and Pieter Breughel. They were the recorders of history and of daily life, the reporters and photographers of their day. But what is the artist today? What the devil is his role?

215

Several months ago I took part in a symposium called "Alienation of the Modern Artist," with the subtitle, "Must the Artist Communicate with his Public?" I here include my opening statement for that symposium, for it may answer some of the questions raised above.

I would like to express my reservations about the title of this symposium. They pertain to the word *alienation*, and to the phrase *modern artist*. The word *alienation* is being bandied about too much these days. I still don't know exactly what it means, and when I've asked people for a definition, I have never gotten a concise answer. Always there have been vague allusions to the various conditions of mankind. After thinking about it, however, I finally came to the conclusion that alienation has always been with us. There have always been alienated people, artists and writers among them. One calls to mind painters of any period: Leonardo, Uccello, Cézanne, Van Gogh, Soutine, Munch; writers such as Dostoevsky, Kafka, Camus, Genêt. We see alienated individuals among us every day, in every walk of life. Yes, the artist of today is alienated; doubly so, as I shall try to explain later on. It is not the word itself that I object to, but its use, as though it were a new concept.

Now, the phrase *modern artist*. I'm a painter and not a historian, but once in a while I like to ponder about the phenomenon of art, its history and philosophy. I cannot understand the application of the word *modern* to art. The word suggests ephemerality and transitoriness. I can accept the term *modern* in clothing, in housing, in decoration. I can even accept the phrase *modern life*. But art in its essence cannot be characterized as *modern* or *non-modern*.

In preparation for this symposium, I looked into Sir Herbert Read's *A Concise History of Modern Painting*, and the preface immediately aroused my anger. He says there that "a comprehensive history of modern painting is not at present possible because such history has not yet reached the end of its development." (Though when I look at the end of this book and see reproductions of paintings by Scott, Grippa, Kline and Hartung, I question how much farther towards absurdity this art can lead and into what kind of history of what he calls "modern painting" it can develop.)

Later in the preface Read says that to write this history he had to exclude the work of the realistic painters of today. He does not deny the accomplishment and value of such painters as Edward Hopper, Balthus, and Christian Bérard, to make "a random list," but "they do not belong to the history of the style of painting that is specifically modern." He regrets that he has had to exclude, among others, Rivera, Orozco, Siqueiros, Pascin, Utrillo.

To me, such a history is unthinkable both in title and in scope. I would suggest titles for a history that would encompass the many trends in painting today: *A History of Contemporary Painting, A History of*

Painting of the Last Fifty Years, or *A History of Painting of Our Time.*

Therefore, I would have preferred this symposium to be called "The Alienation of the Artist of Today."

As I mentioned before, artists have always been alienated in one way or another. Now I shall try to explain my theory concerning the double alienation of the contemporary artist. To put it briefly, pessimistic as it may sound, he is simply not *needed* in our society. His art or craft is not fulfilling a *needed* function for society anymore. The function of painting has been taken over by other media.

When I say that art has lost its function, I mean that our society no longer calls upon the artist to paint man's image, to depict historical events, to record the life of his time. For example, when the coronation of Napoleon took place, David was asked to paint the event, and the result is the magnificent canvas in the Louvre. He also recorded the death of Marat. Today, photography, movies and television graphically record the assassination of Kennedy, the visit of the Pope, the destruction in Vietnam; the skill and depth of the artist are no longer required for this. What is left for the artist to do?

He paints abstractly, nonobjectively, contentlessly, kidding himself that he somehow mirrors and expresses his time. For that, skill is not required, ability to draw is not required. The visible world is no longer a subject for the painter. His work has no intrinsic merit and therefore needs much rationalization and speculation to bolster it. But as you are aware, in spite of all the apologia and the sophistry on its behalf, the art just described is rapidly becoming passé, making way for other isms that follow one another in rapid and restless succession, pop art, op art, kinetic art, etc.—verily, the work of the artist who is doubly alienated.

Now for the subtitle: "Must the Artist Communicate with his Public?"—isn't that contradictory? There is an audience, which implies there is somebody to communicate with. If the artist claims it is unnecessary to communicate, then why exhibit? The important question is whether there is anything communicable in the profusion of work that is being shown in innumerable galleries and museums. In my opinion, there is not. Certainly there is an audience that visits exhibitions of such art, talks about it, and even buys it. I must say that, present company excluded, the audience of the subtitle is the most permissive, passive, and gullible that ever was.

September 26

Young artists in the initial stages of their career should be helped professionally by older, or recognized artists. I was. Today, however, young people have more opportunities and outlets for exhibiting their work and attracting a following. When I began to exhibit, New York

City was virtually an artistic desert. There were only a dozen or so galleries. There was no Museum of Modern Art, no Guggenheim Museum, and the Whitney Museum was in its embryonic stage and was known as the Whitney Studio Club. In a sense, life was simpler for a young artist, less confusing. When his work somehow became noticed, he would be introduced to the Whitney Club, which was then the main gateway to an art career.

Though I began to exhibit comparatively late, I was fortunate. My first pictures, shown in a group exhibition, attracted the attention of the brilliant, young, and already established painter, Alexander Brook. He sold one of them for me, and brought me into the Whitney Club. Thereafter, whenever I finished a painting in my spare time (I still had to do other work for a living), I would take it to the Club. Mrs. Force, the director, would emerge from her office, usually flanked by the two young artist aides (Carl Free and Edmund Archer), and ask: "How much do you want for this, Mr. Soyer?" I would mumble, "One hundred dollars," and she would pay it. One day, for a very detailed painting upon which I had worked many weekends, I asked for $200 and she gave it to me without hesitation. I went home and told my mother that now I felt like a real artist, people were paying good money for my pictures.

September 27

The famous 1929 crash did not affect me or my parents or anyone else I knew. We were poor and had nothing to lose. True, the Daniel Gallery soon folded up and was never able to make a comeback. I took four of my pictures and showed them around to other galleries. They all wanted to keep them on consignment, but because I needed money I wouldn't leave them on that basis. Finally, when I brought them to the Valentine Gallery, the owner paid me $500 there and then for the four of them. To me that was a huge sum.

The Valentine Gallery exhibited mostly French art. There I saw at close range paintings by Picasso, Soutine, Modigliani, occasionally even a Degas, a Monet and other Impressionists. I was allowed to pull these paintings out of the racks in the back room and examine them closely. Only a few American painters were shown there: besides myself, there were Eilshemius, Milton Avery, the American primitive John Kane, and that strange personality, Myron Lechay, who was a deep and interesting painter of semi-abstract still-lifes, interiors and

street scenes quite ahead of his time. Lechay is completely unknown today, one of the many unnoticed figures in American art. I remained with Valentine for several years and had three shows there.

Then about 1936 I left Valentine Dudensing, much to his chagrin, and joined the Associated American Artists, the precursor of all the lush galleries to come. Its director was the first to commercialize the fine arts on a big scale, but he finally strangled the gallery, and some of his artists too, with his entrepreneurship and excess zeal. I was enticed into joining this group by the charming and sincere Pegeen Sullivan, who herself left the gallery when it deteriorated into too much of a business venture. She had come to my studio at 3 East Fourteenth Street and assured me of the success and prestige of this gallery, pointing out that the three pillars of American painting of this period, Benton, Curry and Wood, had agreed to join. A more persuasive argument was a promise to see to it that I need no longer worry about my studio rent. In those days it was hard to maintain a studio.

September 29

The last time that Avrohom and Beyla came together to see an exhibition of mine was in 1933. Among the canvases was their double portrait painted a year before, somewhere in the Bronx. It shows them, not too old, but frail, in an atmosphere of melancholy foreboding, for my mother was already showing signs of her breakdown. It is emphatically not, as one of our "wise men" of art, Harold Rosenberg, expounded in a radio broadcast some time ago, when he cited this particular painting "by one of the Soyers" as a possible example of "Jewish art," a picture of an elderly couple sitting at ease after a Sabbath meal. Nothing was farther from my mind; I painted this under the spell of Degas's "Absinthe Drinkers," and my aim was to convey not a Sabbath atmosphere but a mood of everydayness, like the gray mood in the Degas painting.

I did one more portrait of Avrohom, sitting alone against the background of his books. He was now frail, gentle, well-groomed and lonely. Even his two daughters, with whom he lived at times and who understood him more and were sensitive to his needs, were unable to create a real home for him now that Beyla was away. After his death we knew that he had found for himself a substitute satisfaction in the close, personal relationship with his students. He no longer had to struggle with unruly children; for some years now he had been

219

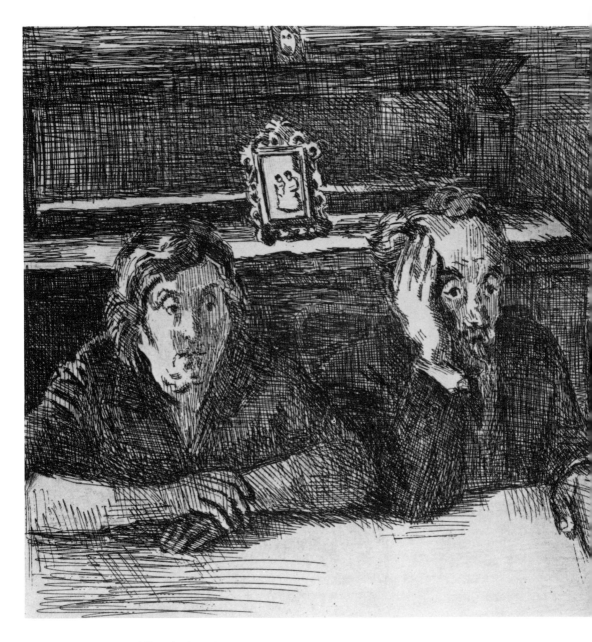

The Artist's Parents

teaching Hebrew literature at Yeshiva College and found a response and attention there which he no longer had with us.

We occasionally meet some of his former students, now in various professions. They tell us that he was more than an academic instructor, that he was their friend. They describe his warmth, devotion, imagination and sense of humor.

Avrohom died in 1940. I quote a line from his favorite Hebrew poet, Bialik: *"Hayah ish, v'ainenoo"*—"There was a man, and is no more."

I did not attend Avrohom's funeral; it was my turn to visit Beyla. I tried to tell her that Avrohom had died, but could not reach her. Her eyes were lustreless, as if without irises.

September 30

So many books are now being written about the 1930s. Fascism was then an established institution, and Nazism was gaining impetus. In our country, the long suppression of the Negroes was brought into focus by the *Scottsboro* case. Intellectuals were following with great interest what was going on in Russia, the first socialist state, and in 1936 the Spanish Civil War began.

I was made aware of the importance of these events, first by Nicolai Cikovsky, and later by my wife. Nick and I met in the Daniel Gallery. He had already experienced the upheavals in his native Russia. Naive as I was then, he represented to me sophistication in art and life and political outlook. He was gay, exuberant, and romantic. A strong bond was soon formed between us by the Russian language. He often sang Russian folk songs, accompanying himself on a mandolin. He came to this country already an accomplished painter, having passed through all the isms that were prevalent in the early decades of this century in Russia—Cézanne-ism, cubism, constructivism, futurism. By the time I met him, Cikovsky was enamored with the art of Matisse. His work was colorful, gay, animated. It has remained so throughout the years.

It was Cikovsky who introduced me to the John Reed Club of Artists and Writers, which was organized about this time. I went to my first meeting, taking along the girl who had been posing for me that afternoon. She was hanging around my studio as I was getting ready to leave and so I invited her to come along.

We came into a large, bare room, the walls of which were covered with American and foreign posters against Fascism and war. At a long, makeshift table sat a group of men, among them Nicolai Cikovsky, Bill Gropper, Adolph Wolf, Walter Quirt, Nemo Piccoli. I remember them so accurately because I made several sketches of them that evening, for in those days I sketched wherever I found myself. They stared amusedly and questioningly at me and the girl. After fidgeting self-consciously and realizing she was not expected, she said, "I'll see you tomorrow," and left.

The Club grew and expanded rapidly, with branches in several foreign countries. To me personally, the Club was of great significance, for it helped me to acquire a progressive world outlook, but I did not let it influence my art. My work never became politically slanted. I always painted only what I knew and saw around me. In the 1930s I painted many pictures of unemployed and homeless men, because I saw them everywhere. I did not paint so-called class-conscious pictures—flattering figures of workers, or overfed capitalists. But two of my paintings were done under the direct influence of the John Reed Club. One was of a girl making a speech to a group of demonstrators; later, inspired also by the resistance of the Spanish people to Fascism, I painted "Workers Armed."

Some of the artists who are well-known today were members of the John Reed Club. We held exhibitions in the clubrooms; we painted collective pictures satirizing the state of affairs and sent them to national exhibitions, signed "John Reed Club." Often the original sketches for these were made by Bill Gropper, known for his political cartoons. They attracted attention.

Important artists and writers who were not members of the Club were invited to speak. Once Heywood Broun came, big, sloppy lovable. Humorously, he told us how he once timidly picked up a *Daily Worker* and after cautiously looking around him began to read it and became engrossed in its sports page, completely forgetting that it was a nonkosher, Communist paper. A slight, young woman came and fascinated us with her account of how she wrote *I Went to Pit College.* I don't at this moment recall her name. Lewis Mumford lectured on Orozco and showed slides of his work. Both the talk and the slides were enlightening. It was my first serious acquaintance with the work of this Mexican draftsman and mural painter, and I still recall vividly one slide of a gigantic Christ chopping up his own cross.

Once I came to a meeting late and heard a familiar-looking young

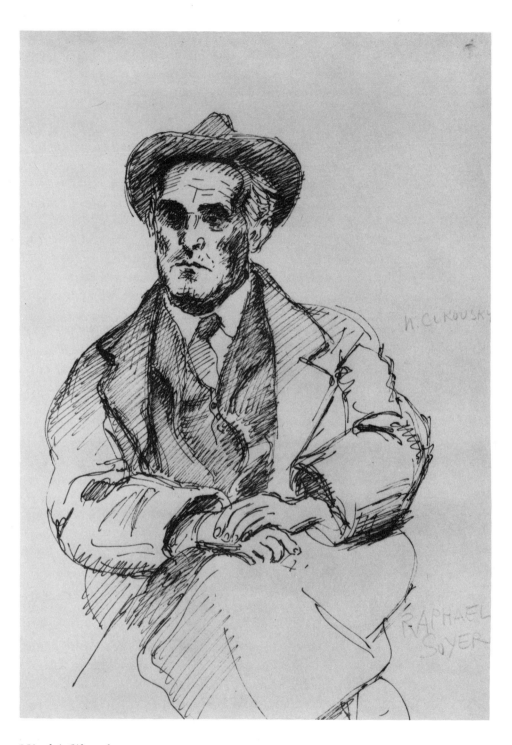

Nicolai Cikovsky

223

man talk about art. After the lecture he greeted me and I recognized Meyer Schapiro, a former classmate of mine at the National Academy. He was then becoming known as an art historian and teacher. One of his statements has remained with me. I don't recall in what context he made it, but it was probably in criticism of the Club's philosophy of social realism—"No *Kapital* on art has yet been written," he said. Ironically, he, and others were soon to formulate an art dogma of their own, preaching the "truth" of nonobjectivism and claiming it was *the* valid art of our times.

Mexican art was then very popular, and the members of the John Reed Club painted murals under the influence of Rivera, Orozco, and Siqueiros, depicting the imprisoned Tom Mooney, the Scottsboro boys and marchers with placards demanding their freedom. Like Rivera, we included likenesses of one another and self-portraits in these pictures. I remember posing for a young painter, Hideo Noda, who put me in a Rivera-esque mural.

One memorable evening Rivera spoke at the Club. A noisy attack on him was made by some of the leading members for his deviations from orthodox Marxism. I watched with fascination this immovable, gigantic man towering above his obstreperous attackers, and I sketched him in his blue shirt and red tie.

Siqueiros was also in New York about that time. He organized a workshop where young artists painted under his direction, making posters for the Communist Party election campaign—huge portraits of Browder, Foster, and others. For my taste, Siqueiros was too flamboyant, loud, and didactic.

I liked Rivera more; I was spellbound by him.

The Museum of Modern Art put on an exhibition of Rivera's work. Shortly thereafter he painted the Rockefeller Center mural, which was later destroyed by his wealthy patron because Lenin and Trotsky were in it. This act of vandalism created great consternation among us artists, and we demonstrated outside the center with placards of protest.

Rivera continued to work here. Without remuneration he painted a series of murals depicting the history of social struggle in America from a Marxist point of view. He worked long hours at the New Workers School, somewhere on Fourteenth Street. In the evening I would come to watch him and make sketches of this fat, patient, industrious artist as he worked on his huge, complex compositions with what seemed to me tiny brushes. Once I was introduced to him,

and we conversed briefly in Russian. Characteristically, I didn't pursue the acquaintance.

The Club established its own art school in which I was invited to teach. Completely unprepared, I timidly embarked upon my prolonged "extra-curricular" career as a teacher. We had many talented, enthusiastic and socially aware young students. One has remained particularly vivid in my memory, a dark, sinuous girl with aggressive and questioning eyes, Ruth Gikow, now one of our recognized painters. A show of her work was held in the school and I wrote an introduction to it. Even then, she painted ordinary people in their daily environment, a subject matter not different from the picture of hers I saw several years ago in a large exhibition of American art in Paris.

I hope that someday a serious history will be written of the John Reed Club: how it came into being, what forces gave it energy and what influence it had upon the painting and writing of that time; the prime movers, among them—I came in contact mainly with the artists—William Gropper, Anton Refrigier, Louis Lozowick, Henry Glintenkampf (affectionately called "Glint"), Nicolai Cikovsky, Walter Quirt (known as "Shorty"), and Phil Bard. Young Joe Jones, full of promise and enthusiasm, came from the Middle West and joined the Club. What a fascinating account it would be!

Jones, Glint, Phil Bard, and "Shorty" Quirt are now dead. Phil was the youngest and one of the brightest of the group. He died only a few months ago. He came to pose for me not too long before he died, gaunt, bearded, disheveled and poorly dressed. In spite of his physical handicaps, he kept all his sitting appointments. We talked about art, literature, politics. He even made a few sketches of me with his left hand during rest intervals.

The following is what I wrote for Phil's posthumous show.

> I became acquainted with Phil Bard when I joined the stimulating group of artists and writers known as the John Reed Club, in the early thirties. Most of us were quite young then, but one of the youngest was Phil, a charming fellow, talented in several fields, knowledgeable, even sophisticated for his years. What struck me most even then, was his optimism in the face of adverse situations that arose in those turbulent years. This courageous attitude, which manifested itself in his leadership of the Artists' Union and in his activity in Spain with the Lincoln Brigade, served him well in later years in his own personal life, when his ravaging illness left him half-paralyzed. With indomitable will he trained himself to draw with his left hand and was able to be active artistically till the very end.

225

These drawings are at once strong and sensitive, searching, expressionistic. There is an accuracy about them, an incisiveness, that belie the difficulty he must have had to overcome in making them. They are drawn mostly with India ink and sharp pen, giving them the appearance of etchings scratched into hard, resisting material. Each drawing is well-composed, self-contained. They are mainly of people, of men, women, children—an all-absorbing interest he had consistently all through his life.

The John Reed Club remains most vividly in my memory, probably because it was my first participation as an artist in activities with other artists. It offered me an outlet from my own self-involvement.

One of the most important events in the thirties was the meeting of the "American Artists Congress Against War and Fascism," which united artists of all esthetic persuasions throughout the country. Stuart Davis was the national executive secretary, and the National Committee included such names as Lewis Mumford, Kuniyoshi, Weber, Gropper, George Biddle, Moses Soyer, Rockwell Kent, Peter Blume, Paul Manship, Karl Knaths, Margaret Bourke-White, Louis Lozowick, and Niles Spencer. I quote from the introduction of the book *American Artists Congress 1936,* which recorded its proceedings:

> This was a meeting of 400 leading American artists, academicians and modernists, purists and social realists, who were brought together on a platform in defense of their common interests. . . .
> The purpose of this organization is to achieve unity of action among artists of recognized standing in their profession on all issues which concern their economic and cultural security and freedom, and to fight war, Fascism and reaction, destroyers of art and culture.

How valid these words, "war, Fascism, reaction, destroyers of art and culture," still are today, more than thirty years later! It is difficult to describe how deeply artists were affected by the events of the thirties, the anxieties, the struggle. Some artists were involved even to the extent of joining the Lincoln Brigade in suport of the Loyalists in the Spanish Civil War, and gave their lives for what they believed to be the cause of world freedom. My natural lowpulsed reaction was influenced to the extent of painting a canvas which I called "Workers Armed" to describe the people's army against Fascism.

Almost twenty years later I once more became actively involved in a project with artists. I initiated the publication of *Reality—A Journal of*

Artists' Opinion (1953, 1954, 1955). Looking back, it amuses me to think how long it took for us artists to come together, to get to know one another, to air our views on art and events, and finally to produce, once a year, those three slim issues of *Reality*. Our purpose was to discuss the changing and confusing art situation of the moment, to try to understand the abrupt ascendancy of abstraction and non-representationalism and their wholehearted promulgation by museums, art dealers, and critics.

In the first issue of *Reality,* Henry Varnum Poor tells charmingly "How This Group Began":

> The first meeting of this Group was in response to a postcard from Raphael Soyer in March 1950. About ten of us met at the Del Pezzo Restaurant in New York. I recall Kuniyoshi, Sol Wilson, Raphael Soyer, Edward Hopper, Ben Shahn, Leon Kroll, Joseph Hirsch, and Philip Evergood.
>
> We found it very pleasant to sit around a table and talk about what we believed in as painters, and of what we found wrong with the world. We felt that regardless of what might grow out of this, the meeting was worthwhile in just bringing us together, as otherwise we had very little communication with each other. So we met again, and the group kept growing.
>
> From the wide diversity of the work and points of view represented, it was obvious this would never be a close-knit group like "The Eight" in America, or the French Impressionists who were working with very closely related ideas. We have tried to state our common beliefs, make some sort of Credo, but without complete success. I was for simply saying that we believed in, and loved the "Object," the "Image." That we were all objective painters, and so, conversely, we thought nonobjective painting was a blind alley. But we found that what we were most "against" was not any way of painting, but the forces in our art world that threw things out of balance. Museums and critics were so quick to surrender all the values that we felt were permanent, and thus were making of our profession a thing of cults and fads, and obscurity and snobbery.
>
> So, like the liberals in a free society, it is easier to state what we are against than what we are for. We are for the maintenance of values and liberties that we already have. To restate them means reviewing the whole history of art, or making generalizations that seem like clichés. We are against all forces that set up false values, that substitute obscurity for clarity, and that imperil our democracy.
>
> So, here in this journal we make our statement. Whether we shall have a name, whether we shall form an organization, is all in the future. Now we are just "Artists."

It was not until three years after this first meeting that *Reality*

made its appearance with a statement signed by forty-six artists. Here is an excerpt from that statement:

> All art is an expression of human experience. All the possibilities of art must be explored to broaden this expression. We nevertheless believe that texture and accident, color, design, and all the other elements of painting, are only the means to a larger end, which is the depiction of man and his world.
>
> Today, mere textural novelty is being presented by a dominant group of museum officials, dealers, and publicity men as the unique manifestation of the artistic intuition. This arbitrary exploitation of a single phase of painting encourages a contempt for the taste and intelligence of the public. We are asked to believe that art is for the future, that only an inner circle is capable of judging contemporary painting, that everybody else must take it on faith. These theories are fixed in a ritual jargon equally incomprehensible to artist and layman. This jargon is particularly confusing to young artists, many of whom are led to accept the excitation of texture and color as the true end of art, even to equate disorder with creation. The dogmatic repetition of these views has produced in the whole world of art an atmosphere of irresponsibility, snobbery, and ignorance.

The first issue of *Reality* also contained a letter to the Museum of Modern Art requesting that "nonabstract forms of art be given the same serious and scholarly consideration that the Museum has extended to abstract art recently," and that a conference be called "to help resolve some of the problems involved." Such conferences were later held, but the directors denied they were giving undue attention to nonobjectivism.

We did not foresee the furious reaction our little publication would arouse on the part of the Museum of Modern Art, the critics, and other art publications. The Museum sent a letter by messenger to the members of our editorial board in which was implicit a warning against Communist influences. *Art News* stooped low enough to editorialize: "We prefer not to do a Voltaire to defend our attackers from the McCarthys or Donderos if and when the moment to do so arrives." In reply, in the second issue of *Reality*, we expressed our disappointment "in our enemies—we would expect issue to be taken with us on a higher level than proved to be the case."

I realize now that such hysterical reactions were inevitable in those McCarthy days. At the same time, however, we received ridiculous letters from some lunatic organizations wanting "to join in the war against the ungodly Communists of the Museum of Modern art and the *Art News*"!

Art Digest, for its part, accused the signers of our statement of purely materialistic motives—fear of loss of prestige and income as artists and art teachers. Looking through my old papers I found a letter I wrote to the editors of the *Art Digest* answering this charge and others:

To the Editor:

Now that the hue and cry is almost over, and the editorials and "open letters" have been written (only a part of one more issue of *Art Digest* is to be devoted to a symposium on *Reality*, with statements by several "seceders"), I would like to express some personal thoughts not only as a "reactionary totalitarian" signer of the now celebrated statement in *Reality*, but also as a reader of *Art Digest*. It is interesting and significant that these "seceders" bolted only *after* the Modern Museum's open letter and all other editorials in the art magazines were printed. One can make of that what one will.

I am writing this on my own. I have not contacted anyone else on the editorial board since they are all scattered for the summer. I am amazed at the personal attacks in the magazines. I am amazed that such a civilized publication as *Reality* should arouse such violent, personal diatribes. One editor hysterically threatened this group of distinguished artists with a "McCarthy" treatment!

Your magazine goes as far as hinting that most of the signers, "veterans in art," have an ulterior motive, to regain what you call their low prestige in teaching, which means a loss of pupils, and, therefore, of financial security. May I urge the editors not to worry about the prestige of these distinguished painters—it is as secure as ever. To follow your own line of thought, is it possible that the existing art magazines are fearful of competition from another art publication? Seriously, nothing like that entered into the planning of *Reality*, it is not a business venture. Isn't it possible to take at face value the thought expressed in *Reality*, that a group of artists of high achievement, without regard for their own financial status, were really concerned about the state of art in our country in our time?

Now, you may be interested to know that the response to *Reality* was overwhelming, both in number as well as in positive approval. We had to make a second printing of the first issue, the demand has been so great that even a third edition could easily be used. We have had some wonderfully intelligent letters from art students, teachers and museum directors all over the country, as well as from the lay public, lovers of art. You must be conscious of the impact *Reality* has had upon the art world, witness your own columns of open letters which, by the way, are not *all* antagonistic to the challenge of *Reality*. You yourself in answer to one letter, agree that "it is high time for some plain talk." . . . In the July 19 issue of the *New York Times*, Howard DeVree, in an interesting article evaluating the accomplishments of the various nonobjective movements

in art, seems to be doubtful of the permanence of their contribution to American art. I was glad to see that he deplores the negative attitude of young artists to the importance of good drawing and knowledge of tradition. Am I presumptuous in thinking that this article may be a result of the appearance of *Reality?*

These are indeed trying and confusing times. We have been called every name in the book, but has that ever deterred any forward-looking person from acting according to his honest convictions? What you call the "language of reaction" may really be the most advanced thoughts of these times.

From this letter one may get a fair idea of the reaction to *Reality*—the hostility on one side and the enthusiastic reception on the other. Needless to say, the letter was never printed, but neither was the announced symposium of the "seceders."

I learned much about the people with whom I worked on this venture. Some of those who replied most eagerly to my first call became the "seceders" the moment we were attacked, but others were steadfast. Henry Varnum Poor, from whom I got the most pessimistic response, became the prime mover and leading editorial writer once he joined.

As I look through the issues of *Reality* now, I am fascinated by such articles as "Fads and Academies," by Isabel Bishop; "Man is the Center," by Jack Levine; "Humanism in Art," by Honoré Sharrer; Hopper's personal credo; a letter to Huntington Hartford by George Biddle; letters from Paris by Guy Pène du Bois; letters from the Europeans Henry Moore, Bernard Berenson, Guttuso, Matta, Kokoschka, Marcel Gimond; three articles by Maurice Grosser devastatingly exposing the naive zeal and the ridiculous jargon of the early apologists for nonobjectivism. I find myself still moved by the eloquent letters we printed from readers all over the world, both artists and laymen, expressing their concern for the state of art.

Why did this magazine cease to exist after only three issues? Simply because we'd had our say, we could not go on repeating ourselves, and there was no one among us who could expand what we had already said into further articles.

All the material for *Reality* was sent to my studio. I kept it for some years and then sent part of it to the Archives of American Art in Detroit and the rest to Cornell University.

October 1

In April 1935, after one of my early one-man shows at the Valentine

Gallery, of which my share of the sales was $1,050, I went off by myself to Europe on the old *Ile de France*. It was a cold, miserable and rocky sailing, and it was cold for a long time after I reached Paris. In the morning I would rush from my room on Rue Vavin to the Dôme for coffee, and sit as long as possible near the potbellied stove. It was my first trip to Europe since my father brought our family over to America.

I was completely disenchanted with everything. I didn't have enough money, or friends, and I didn't know the language. Paris was bleak. Artists were standing on line for soup at the government kitchens. Those sitting in the Montparnasse cafes, and they seemed to be there all day long, were mainly from the Eastern European countries, not accepted by the native artists, yet snubbing the few Americans who were there for just a short time. They had been sitting stranded in these cafes for many years, and kidded themselves into believing they were Parisians.

Even the museums in Paris disappointed me. They had not yet been renovated and the walls were heavy with dark, opaque, badly lit paintings.

From Paris I went to London. I was cold there too. My stay coincided with the Silver Jubilee celebration of King George V, and Buckingham Palace was besieged by the populace waiting for a glimpse of the royal family who would appear on the balcony from time to time. People came from all over the country, poorly dressed, and they clung to the gates of the Palace like something out of Dickens, men, women, and children shivering with cold, their bad teeth chattering.

Even the huge British Museum depressed me strangely. Cold and dank, it seemed to me a graveyard of past civilizations.

Neither in London, nor later in Russia, did knowledge of the language help to dispel my feelings of disenchantment, loneliness, and irritability. Only when Rebecca joined me on my return to Paris did I feel relieved. Not for another quarter of a century were we able to go to Europe again.

October 3

In a London bookshop I picked up a slim volume of poetry containing selections from Gregory Corso, Lawrence Ferlinghetti, and Allen Ginsberg, and I've been reading it on the boat going home. I wonder how they are judged by the more universally accepted poets, how they

231

measure up in their ability to express and convey feelings, in their technique and imagery.

I know little about poetry, but I am moved by the plainness of Gregory Corso's "Marriage," "Man," and "Writ on the Eve of My 32nd Birthday"; by Ferlinghetti's "In Goya's Greatest Scenes," and by his evocative poem to Allen Ginsberg entitled "He." I regret that his "Autobiography" ends so soon; I could read on and on. Allen Ginsberg's outpourings in "Europe Europe," "America," and "Magic Psalm" encompass much of our time and our world. I like these compassionate blasphemous, hallucinatory poems; these poets, in truth, reveal themselves.

I once said to Allen Ginsberg, "Your style, the way you talk to yourself in your poems, and the way you mention your friends, Kerouac, Burroughs by name reminds me of Walt Whitman, or Mayakovsky, or Esenin. But their poetry, even the melancholy Esenin's, is so affirmative compared to yours. You know Mayakovsky's poem about the sun coming in to have tea with him. How full of life, how energetic it is! But you begin, 'You are rotting, Allen Ginsberg,' and you go on to describe your deterioration. I smell death, decaying flesh, when I read your poems."

"What's wrong with that?" Ginsberg answered. "I traveled in India, all over, not just where the tourists go. They don't bury their dead as we do, they burn them. Not in crematoria, but in the open. These funeral fires never cease. I saw burning corpses, I saw what happens to flesh, skin, eyes. People pass by these fires, children pass them by, without so much as looking at them. It's normal—death, mortality, decay of flesh are real, like life. Why not write about them?"

Is this kind of poetry analogous to avant-garde painting which also claims to mirror our confused, unhappy times? If so, the poetry makes more sense to me. Perhaps through the medium of words it is more possible to do what the avant-garde painters say they are doing with their various abstractions. For what meaning is there in imageless blobs of color on a canvas?

July 6

It's been months since I wrote in this journal. My exhibition is drawing near. This morning, before leaving for Vinalhaven, I was with Lloyd Goodrich, who came to discuss the material for the catalog (he calls it "the Book") for my retrospective exhibition due to open October 24.

Later, at Goodrich's request, we went to my studio where I showed him my unfinished composition, "A Watteau," which he praised, to my delight. This is a picture of what can often be seen these days in Central Park, groups of friendly young people playing musical instruments, beating drums, clapping out rhythms with their hands, sticks or with any other kind of object. The central figure is a girl with a rapt expression holding a daffodil in one hand, the other raised, open-palmed. She is symbolic, if you will, of peace, youth, goodwill, friendship.

I call the picture "A Watteau" because the scenes in Central Park bring to mind the paintings of Watteau: musical parties of men and women in parks. As a matter of fact, I based this composition on his large, well-known painting of the single, white-clad Pierrot on a hill with musicians below.

Quite a few of my pictures of contemporary life are inspired, either in spirit or in composition, by some classical painting.

Vinalhaven, July 12

It is so foggy that I decided to work on this journal instead of painting outdoors. We're in Vinalhaven after an absence of two years. The only perceptible change is that the neighboring children are bigger. As always upon our arrival, they came to greet us with their innocent frankness.

The landscape hasn't changed much, but here an old, unused pier finally crumbled and collapsed into the bay, and there the roof of an abandoned house has become less visible because the trees around it have grown. The major changes are on Main Street—the A & P burned to the ground in what must have been a spectacular fire in the middle of the night. Opposite this gap, at the entrance to the parking lot, now stands a traditional American eagle, one of the two salvaged from the demolished Penn Station in New York.

"The other eagle was made from Vinalhaven granite," we were told by a local housewife, "but for some reason we got this one."

Set up astride two slabs of native granite, this ghastly bird does not enhance Main Street, esthetically or otherwise.

The pace on this island is unusually slow this summer. There's less activity, fewer summer people, less traffic, making its insularity poignantly apparent. On the eve of my retrospective exhibition, this

233

remoteness is conducive to rumination and introspection. I find myself constantly mulling over the procedures of my art life.

In my mind I see my paintings on the walls of the Whitney Museum, from the earliest to "A Watteau" (I hope to finish it when I come back to New York). The first nude—which I painted independently after leaving art school—stands white against a red background, naked, chaste, with clasped hands. Then "Portrait of the Artist's Mother"—an immigrant woman sitting on a carved chair against a flower-papered wall, one hand on her abdomen as in Raphael's "La Bella Gravida" in the Pitti Palace, the other hand, with the wedding ring on her finger, listlessly hanging over the arm of the chair. She is heavy and melancholy; the yellowish lace of her red dress is like a golden chain in a Renaissance portrait.

"Portrait of the Artist's Father"—a head cut out from an ambitious composition which, lacking skill, I was not able to consummate then. Crude, with an implausible combination of overtones from Van Gogh and Rembrandt.

"The Bridge"—technically almost a beginner's work, but with the poetic naiveté of Rousseau's vision. I have never surpassed these early pictures.

How extraordinary is an artist when he is young! What a confusion of visions, emotions, perceptions, hopes, and plans embroils him! He is young and old at the same time, simple and instinctively wise.

It has always been my contention that with rare exceptions artists do not become deeper or greater with the years. They change, to be sure, they acquire technical skill and become complex and rich in color. With years of painting, however, it becomes increasingly difficult to hold on to the indefinable freshness of youthful vision and to spontaneous reaction. How often are the early, simple, self-contained canvases of well-known artists preferable to their later ambitious, flamboyant ones.

I'm amazed by the longevity of my early paintings. Hanging on walls, hidden in closets by relatives and friends, covered with dust, at times amateurishly cleaned or oversprayed with varnishes, they were preserved and eventually restored.

This fantasy about my forthcoming show was interrupted by my wife's exclamation, "Marusia Burliuk died!" She showed me the *New York Times* with the obituary notice.

How soon Maria Nikiforovna followed her husband, David

Burliuk, who died six months ago. There is a famous story by Gogol, "Old-Time Landowners," in which a husband and wife are described as so inseparably attached to each other that when one dies, the other follows shortly after. This is exactly what happened with the Burliuks; the devoted wife and companion of many years who was ever at his side while he was painting, writing, reminiscing, could not live without her husband. She was the curator, archivist and editor of his books, paintings and documents. She published "Color and Rhyme" for many years, a strange conglomeration of memoirs, notes, letters, reproductions, poems and newspaper clippings of everything pertaining to the life and work of David Burliuk and to all those who touched his life. This unique publication, half English and half Russian, was printed at their own expense and sent gratis to their friends all over the world.

Marusia Burliuk was unforgettable in her long, wide skirt, ruffled blouse, a small hat perched on her disheveled hair, her flushed face enlivened by wide-open, inquisitive eyes—like a character out of a Russian play.

Only three months ago I received this touching letter from Marusia Burliuk which I shall now translate as literally as I can.

My dear and kind Rebecca and Raphael,
 I am grateful to Raphael for the excellent article about Papa Burliuk. He is alive in it. I sent $8 to *Dialog* for 10 copies of the magazine with your article.
 The fifteenth of April I signed a contract to publish "Color and Rhyme No. 63" in the Russian language, containing Burliuk's poems and my memoirs for the years 1936-39. This will be the end of my 37 years of publishing. This was the last wish of the living Burliuk: "Don't mourn. Live by yourself and finish up my work." These, literally, were his last words.
 This week I'm staying with Jeannette, and I shall go to a specialist to find out about the pain in my chest which does not let me live or breathe. In the country the winds come from the ocean, the flowers are beginning to open up. In the home of Papa Burliuk there will never be any more living flowers. Neither he nor I need them any more. And in the garden, anyone who wants may pick them and carry them away. Burliuk never handled living flowers. He never touched earth. He was strangely allergic to it and it made him deathly sick. He almost died five times—in Russia twice, in Japan once, and in America twice. The last time his blood poisoning was checked by Dr. Rubler who came at midnight in 1950.
 All the still-lifes he painted were set up by me, and if Burliuk didn't like them he would ask me to rearrange them. Burliuk worked with materials harmful to his health, and I would sit near him and rub his

235

hands with a special lotion, not with soap and water, and his face, too. The fear of losing Burliuk was with me all my life. Our children did not know about this danger. These are a few lines about his hands and his face.

I thank Raphael again for the excellent article.

Greetings and love,

Marusia Burliuk, April 21

The article referred to in this letter follows:

David Burliuk died without knowing that he had been elected to the American Institute of Arts and Letters, the highest recognition for creative people in our country. How he would have revelled in this, for he was a great believer in honors, rewards, fame, immortality. I believe that history will catch up with this old "cubo-futurist," as he liked to call himself. He was, in his own words, the "father" of modernism in Russian art, one of the founders of *Die Blaue Reiter*, together with Kandinsky, Paul Klee and Franz Marc. In Russia, before the Revolution, he helped to organize international exhibitions of modern art in 1911-12, in which Matisse, Delaunay and Picasso participated.

In 1922 Burliuk came to the United States with other Russian artists. I still remember the mammoth exhibition of their work at the Brooklyn Museum, but after all the fanfare and the initial excitement of this show died down he was left neglected for many years. That was a barren period in American art. Even native artists found it hard to live by their painting.

But David Burliuk was indomitable, courageous and optimistic. He set himself to paint New York scenes: the East Side, the Bowery, the Bronx, and later the landscapes of Long Island, with the same gaiety and vigor with which, in Russia, he did "Ukraina," "Market Day," "Woman with Cow" and other themes. He remained profoundly Russian all his life in this country, often turning to his native land for subject matter: "Tea Drinkers," "Harvest," etc. I remember two variations of a particularly striking canvas, "Tolstoy and Lenin—Unconquerable Russia," in which Lenin and Tolstoy are shown plowing Russian soil, symbolizing the deep, great changes they caused in their country.

How hard it is for me to appraise fully the work of a man who lived 84 years and worked until the very end. I can only say how deeply I sense in Burliuk's art his one-ness with the visible world. I'm referring mainly to his work done in this country, which I know best. His landscapes of earth, water, flowers, sky are bursting with vitality, exuberance and elemental force. Scattered all over them are people, horses, cows, in many colors, without perspective, without logic. The effect is one of joy and life.

One hot afternoon on Long Island, Nicolai Cikovsky and I went with Burliuk to paint a landscape. I admired the energy with which he started

to work, how he applied great brush-strokes of thick paint on the rough canvas—*tachisme,* action-painting, but transferring living nature on the raw, dead surface of the canvas. After a few hours Cikovsky and I began to pack up but Burliuk turned his easel around and started to paint the scene from another angle. There was still some light and he couldn't bear to tear himself away from his work. We watched him in the fading light. Once in a while he would gently brush a mosquito from his face.

Years ago Burliuk presented my wife and me with a self-portrait which still hangs in our house. He sits before an open book with a pen in his hand. On the table are a globe of the world, a glass of wine, bread and fruit, a manuscript, an old watch. In the background are shelves of books, paintings, a head of his wife by Noguchi; through the window one sees a landscape with a setting sun and a rising moon. At the bottom of the canvas is his inscription: "D. Burliuk, painter and poet."

After the funeral we went to visit his family. The house we knew so well, filled with books and paintings, seemed strangely empty without the bent figure of old Burliuk in his stocking-hat at his easel. There were his brushes still wet with paint; his palette covered with a white cloth after the day's work to keep the dust from the paint; an unfinished still-life on the easel.

July 15

I wonder how my street scenes, painted so long ago and generally unknown, will hold up. I did them out of doors when the streets of New York were still accessible, when perspective and space had not yet been completely devoured by traffic. Today "Corlears Hook Point," "Under the Bridge," "Water Street" seem strangely idyllic. I remember the lyrical mood I was in while painting them. I was enamored of space; it had a positive existence for me and played the major role in the composition. How unrecognizable New York has become!

Then appear (as I imagine them on the walls of the museum) my brown paintings of the unemployed. The men in them are static, they just stand on street corners, and sit in parks, in missions, in relief stations. They don't reflect anger, not even frustration. I saw them all over, doing nothing. By temperament, probably, I chose to paint these silent, nondemanding figures rather than the demonstrations, clashes with the police so often painted by some of my fellow artists during the Depression. Among the "transients" I painted my own face, yawning, perhaps to emphasize the debilitating boredom of their lives.

To compose these pictures I would make sketches in Union Square, Washington Square, Sixth Avenue, or some corner of the

237

Bowery of Fourteenth Street. For the picture "Reading from Left to Right," I used a photograph by Ben Shahn of menus written with dissolved Bon Ami cleanser on a Bowery window.

Lloyd Goodrich told me that many of my portraits of artists will be shown at my retrospective. Some of them are studies from life for "Homage to Thomas Eakins"; others are the ones I painted in the early forties and exhibited under the title "My Contemporaries and Elders." I still regret that I painted them at a time when my work was at a low ebb.

I have observed that many of us pass through a critical period during our middle years, when our work often becomes pedestrian, dull, lethargic. Fortunately, some of us become aware of this static state and are able to pull ourselves out of it.

Several times in recent years one or another of these old portraits have turned up under wrong titles: a portrait of Moses Soyer was considered my self-portrait; one of Mervin Jules was called a portrait of Jack Levine; the one of Ernest Fiene was thought to be Thomas Benton, whom I never painted. When these were brought to me for authentication I couldn't decide whether to be annoyed or amused.

A quarter of a century has gone by. I kept a diary while I painted these artists, but I destroyed it one moody morning. Now many of them are dead, but they still live on in my memory, for I studied their faces and their gestures intently.

Joseph Stella came to my studio at 1 Union Square and sat down heavily on a wooden folding chair, both hands resting on his cane. That's how I painted him, large and ceremonious. He spoke loudly in vivid, rhetorical language, interspersed with four-letter words to emphasize his contempt for some people and things. With great drama he described the triumphs and defeats of his career. It was hard to capture his face, especially his eyes, which were never steady, at times opening wide, and then almost disappearing in his big, flabby face. But he encouraged me with loud exclamations: "You're getting my girth, you're getting my girth!"

I visited Stella at his place on East Fourteenth Street once when I was least expected (he had no phone). I can't forget that visit. He lived alone. I found him sitting at a table with his back to the door, eating minestrone from a deep bowl. To say he was informally dressed would be an understatement. He turned around quickly as I came in. His sparse hair was not combed flat as in my portrait, but was standing up, white, like a halo. "Excuse my attire," he said with dignified

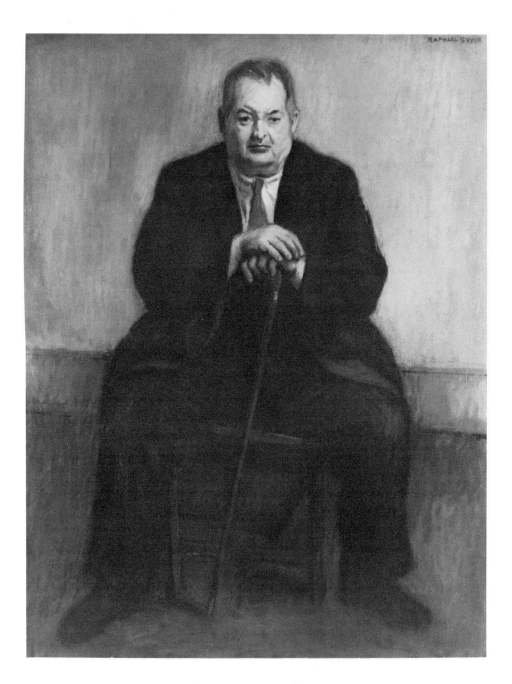

Joseph Stella

embarrassment. "You're an artist—you understand. I don't have to change. We're alone in the studio."

Stella showed me many pictures of different periods and styles, a variety of subject matter in many media: early skillful and delicate drawings in pencil and colored chalk; religious pictures; abstract studies for his Brooklyn Bridge and Coney Island compositions. He spread out on the floor pastels of lush tropical plants and flowers. In the center of one of these flowers a living bedbug was crawling. At the other end of this unattractive room was a crude sink stacked with unwashed dishes.

I felt a deep sympathy for this aging artist in his dismal surroundings.

How different he looks from the way he sat formally in my studio, I thought to myself. This is how I should have painted him. Here, against these walls of greasy, sickly yellow.

Burliuk was in his vigorous sixties when he came to pose, tall and upright. He arranged everything himself: he put the small table in the middle of the room: and on a sheet of white paper he wrote in block letters with a red pencil two lines of one of his Russian post World War I poems:

VSIAKI MOLOD, MOLOD, MOLOD,
V ZHIVOTIEH TCHERTOVSKY GOLOD,

which means, "We are young, young, young, In our belly a devilish hunger."

"Paint me as a futurist poet," Burliuk said. He sat down very straight, and composed his face in the expression he wanted, like an actor. He held the red pencil in a pose of writing and remained still, seldom blinking his one good eye.

I painted John Sloan in his studio in the Chelsea Hotel. His diminutive wife, Dolly, was still alive and darted in and out. He wore a white shirt and held a pipe. His beautiful pompadour was deceptive, it was just one big band of hair which he ingeniously combed over his bald expanse. At that time he was occupied with copying in oil one of his well-known etchings of two women in a fashionable carriage. He stood very close to the canvas, scrutinizing both the etching and the oil, his bulging eye peering through the heavy lens of his glasses. I saw him sideways, in profile. He copied skillfully and easily.

240

One morning I found Sloan in low spirits. He said that the curator of the Tate Gallery had come to look at his work and seemed to prefer a few of his early canvases, ignoring all that he had done subsequently. "I did those things when I was quite young, in my spare time. I didn't even consider myself a painter then," he grumbled. "Everything I've done since doesn't seem to count."

I tried to comfort him by saying, "The curator likes your early pictures probably because they make him think of Sickert, whom he admires. There's no denying that Sickert is one of the best painters in England today."

Arshile Gorky was a "contemporary." I knew him better than my "elders," Weber, Sloan, Hartley. He liked to come to my studio, which was across from where he and Agnes lived on Union Square. He would appear several times a week and sketch whomever I happened to be painting. When the Burliuks posed for me, Gorky sat quietly to one side and diligently drew them. His Seurat-like profile of Burliuk hangs on my wall today. He made many drawings of me too, and I painted and drew him whenever I had a chance. He was a fascinating subject—tall, thin, with deer-like eyes, a naive and haunted expression and blue-black hair. He had beautiful hands.

His clothes were like his paintings in color and texture, harmonious and esthetic: a brown corduroy jacket, a red scarf loose around his neck, its folds arranged with deliberate intent. How he kept it in place, even when he moved about, was a mystery. He loved soft, colorful stocking caps. His tweed overcoat hung on him, loose and long.

No one was more involved in art than Arshile, and not just his own. He lived intimately with art. His taste was infallible. He could point out the salient elements in a Vermeer, a Degas, an Ingres. He usually had in his pocket a small Ingres monograph which he would open and study earnestly, standing up, his body rhythmically swaying, as though reading a prayer book. In these small black and white Ingres reproductions he pointed out to me shapes and patterns, how self-contained they were, dissociated from one another, but how, together, they formed a great compositional unit.

While I was painting Arshile's blue-black hair, he said to me, "Why do you make this shine in my hair? It breaks up its shape, and the pattern of the whole painting is spoiled." I removed the highlight, and

241

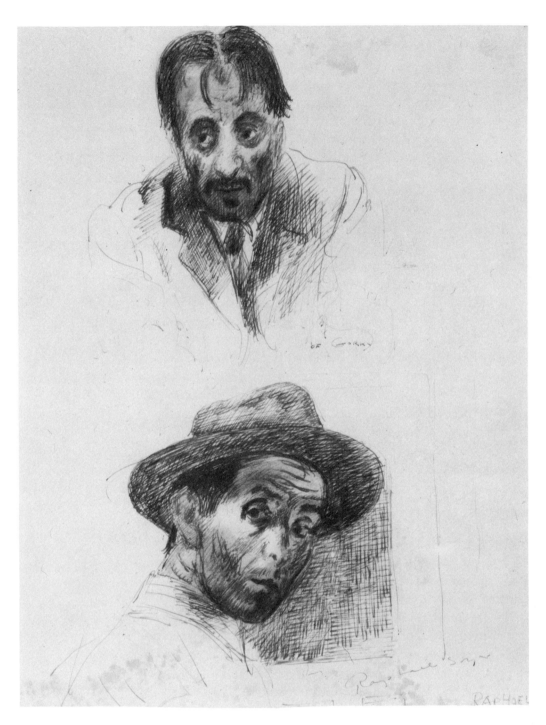

Arshile Gorky and Raphael Soyer

Arshile Gorky

to my surprise the picture improved. It was a small but important criticism.

I visited him very often, too. His large room on Union Square was like his art, like the clothes he wore, in impeccable taste. In one corner, against a gray wall, was a still-life on a table, almost a painting; one had no need to reproduce it on a canvas. No pictures were on the wall; they were all neatly stacked in the racks. The room was permeated with the warmth that emanated from his personality.

One late afternoon after a long conversation, Arshile impulsively

243

took out two small paintings from the racks, a self-portrait and a head of his sister, Vartoosh, and gave them to me. When I offered him at a later date the portrait I did of Agnes pregnant with their first child, he refused it, even though Agnes was anxious to have it. Sullenly he muttered, "Don't give it to me. I don't collect. You have a romantic life with pictures. I may someday suddenly paint over it."

In those days it was common to scoff at Arshile. Artists and critics alike considered him characterless, derivative, imitative to a point of plagiarism. He defended himself against such accusations by saying that he had a right to imitate the masters from whom he could learn, like a child who learns from his parents by imitating them.

"Yes," he told me on several occasions, "Cézanne is my father, Picasso is my mother."

I always felt there was an element of his own in all of Gorky's paintings, a poetic, indefinable quality no matter which masters they recalled. The portrait of his mother and himself as a child—how he labored on that painting—is pure Gorky, though one can trace in it Cézanne, Picasso, and Gauguin, as well as Coptic and even icon art. I can never look at this painting without emotion—how much this awkward, shy Armenian boy resembles the man Gorky whom I knew. After seeing it at the Whitney Museum, I wrote him that it was one of the most beautiful paintings of its time. He was then recovering from a serious illness, and when I saw him later he told me how much that letter meant to him at that moment.

"One other artist wrote me a similar letter," he said, "Yves Tanguy."

It may be presumptuous of me, but I must express regret at the fact that Arshile did not paint more pictures like the "Artist and His Mother," "Vartoosh," "Myself and My Imaginary Wife," and his flower pieces. Most of the work produced in the last five years of his life was done after he came in contact with the Surrealists, André Breton, and others then in America. How naively flattered he was to be accepted by them! He was essentially unsure, without faith in himself, humble, though on the surface he could appear arrogant and contemptuous of the work of others.

"Make my eyes as blue as hell," Marsden Hartley instructed me emphatically in his quiet voice. Were I painting him today, I would follow his instruction, but I was then, alas, engrossed in naturalistic rendering, and lost emphasis of any kind in the process of many

244

repaintings. His eyes were strikingly blue, and I should have painted them "blue as hell." As a matter of fact this portrait, the smaller one of two that I made of him, was never quite finished. Hartley interrupted it himself. He came one morning, opened up a little newspaper package to disclose two dental plates of upper and lower teeth. Deftly he set them in his mouth, pointed to the portrait and said, "Without the teeth my face was like a garbage can. Make a new one of me now, a big one."

Hartley was well-mannered, gentle, and vain. There was a fresh red carnation in his coat lapel every day. He told me that once another artist stared at him for a long time, much to his discomfiture. "Why are you looking at me so long?" Hartley asked him. "When I go home I'll paint your portrait from memory," the other artist answered. "He did, and it was awful," Hartley continued. "I even dreamt about it. I was standing near a body of water and I saw this weird head washed ashore."

I painted him just before Hudson Walker began to draw him back into the public eye. Apparently he had been in an artistic eclipse. Once, while he was posing, there was a knock at the door, and Hartley, who by now felt at home in my studio (he even ate his sandwiches there, which he brought wrapped in a newspaper) opened the door. He bowed politely to a tall, good-looking girl and said, "How do you do. I am Marsden Hartley."

"Who?" the girl asked. "I never heard of you." Her rudeness was unusual and unintentional. "Is Mr. Soyer here?" When the girl left, Hartley turned to me and said, "How pleasant to be obscure." His gentle voice was tinged with bitterness, I thought.

I preferred the small portrait I did of Hartley, with the toothless mouth like a cut in his face, and that was the one I exhibited. Hartley never forgave me. I saw him a few years later at the Rosenberg Gallery where he had his last show. He died soon after. He was then flabby, sleepy-looking, and slow moving. He put his limp hand into mine, looked at me in rebuke, and said in his peculiarly soft manner, "Why did you exhibit that toothless image of me?"

Vinalhaven, July 18

I started my independent painting in the mid-twenties at a time when the art of the Impressionists, the nudes of Renoir and Degas became fully accepted in this country. Until then the female nude was rarely found in American painting. The only great nudes were by Thomas

Marsden Hartley

246

Eakins in his portrayal of the sculptor Rush working in his studio. These I came to know belatedly. The nudes of Henri, Sloan, and Bellows left me cold, had no effect on my work. It was Pascin who created a cult among the younger artists for painting and drawing the female figure nude and semiclothed. His drawings and paintings which I saw first at the Daniel, Downtown, and Weyhe Galleries, stimulated me to hire my first model.

Is it because paintings of women are generally more appealing than those of men that my pictures of them became better known? Before I realized it I began to be called a painter of girls. But the Whitney exhibition will show that I have often painted men with great attention.

My early pictures were self-portraits—drawings, etchings, lithographs and the first efforts in painting with oils. I would look at myself in the mirror and patiently try to copy my features. Even later, whenever I lacked subject matter I would paint myself. Seen together, these pictures record the passage of time.

In the fifties I painted in quick succession a number of small self-portraits all in the same pose, my face resting in the palm of my hand. Once, alone in the studio as I usually was when painting myself, I began to think of the self-portraits of some of my favorite artists, and it suddenly occurred to me to paint myself in this pensive pose alongside self-portraits of Rembrandt, Corot, and Degas which I had copied from reproductions. Placing myself in their company was not a delusion of grandeur, but an expression of esteem and of love for their work.

October 24

Fifteen minutes before my exhibition opened to the public Rebecca and I were admitted to the Whitney. The first glance of rooms-opening-upon-rooms filled with my paintings was startling. It is hard to describe my feelings upon suddenly being confronted with so great a part of my lifework. I was engulfed in a panorama of canvases.

Looking at all these pictures I didn't know whether to be pleased or distressed by the sameness, the thread of continuity I found there. Though the men and women who people my canvases cover a span of forty years and more, they have changed little. Their costumes may differ slightly, but their bearing, their gestures, the atmosphere

247

emanating from them, are hardly changed. There is the same detachment, the same disassociation even when grouped together, the same withdrawal, the same involvement with oneself. From the first to the last canvas there is no abrupt or sudden activity, no drama. On the whole, I was struck by a sense of the static, of repose. The gestures are restrained, the arms never too far away from the body. Even the walking figures and those engaged in work have an air of arrested motion. This is true even of my latest compositions ("Pedestrians," "Village East"). Like stills from some contemporary film; sitting, standing, walking, there is a feeling of waiting for something that is not even expected to come. Beckett's *Waiting for Godot* suddenly came to my mind.

All these paintings were done in New York, of its people, its streets, of myself, the members of my family, my friends. "Art is local," I said to myself, quoting from my favorite aphorism by Derain: "Stupidity is national, intelligence is international, art is local." I recalled the paintings I saw this morning at the Metropolitan Museum by Rembrandt, Degas, Eakins. "Art is local," I repeated to myself.

At the exhibition I particularly missed David and Marusia Burliuk. On one wall of the Whitney is a large conversation painting of artists, models, and myself. Burliuk is pictured there, sitting venerably in the center. Another canvas shows him painting his patient wife. He would have been so pleased to see these, as if he himself were participating in the show. When I last saw him he complained softly, "Everything withers in me—my bones, my heart. Everything dries in me and shrinks."

Edward Hopper also looks down from these walls. In recent years I was flattered that he never failed to visit my one-man shows and always wrote me a curt note of praise. I missed him and his brief comments this time, for he died some months ago. He became so frail in the last two years of his life—after I painted him for "Homage to Thomas Eakins"—a huge, bent skeleton with skin like parchment.

Until about two years ago Rebecca and I would dutifully make a yearly visit to the Hoppers, climbing up the four steep flights to their home on Washington Square. Before each visit we had to phone several times, for Jo Hopper would invariably try to dissuade us from coming, either because "the house is in disorder," or because they had "not yet unpacked" from their return to New York even though it was

Avenue of the Americas

months since their arrival from Cape Cod, or simply because "Eddie isn't up to it." Finally she would consent to our coming, and would receive us with her fussy cordiality, ushering us into her studio, a sunny room facing south. We always brought some memento—a little book on Thomas Eakins, or some publication with a reference to Hopper.

In Jo Hopper's studio there was a permanent, never-changing exhibition of her paintings—pictures of her small, crammed world, of Truro, flower pieces, interiors of her room, and pictures of cats and pot-bellied stoves. Only once did we see Edward's studio, a large white-washed bare room with an etching press, an easel and nothing on the walls. Jo would daintily serve us bread-and-butter sandwiches and tea fragrant with a clove in each cup.

Once, years ago, we visited the Hoppers in their summer home perched by itself on one of the hills in Truro. Jo wrote us directions how to get to it and emphasized the difficulty of driving up the almost perpendicular road to the top. "Keep in the ruts," she warned. When we reached the house there was Hopper sitting in front of it looking out over the hills; we found Jo sitting in the back looking out over the ocean. "That's what we do all the time," she said sharply, "he sits in his spot and looks at the hills all day, and I look at the ocean, and when we meet there's controversy, controversy, controversy."

Their frugality amused us. When they took us out to dinner in Truro, it was not to any of the restaurants generally frequented by artists and their friends, but to "Bill's," a nondescript diner on the road. "The food here is better than in any of the high-tone places," Jo said with conviction.

Their house was stark and bare inside and outside, scrupulously clean and white. In a large room stood a huge easel which Hopper said he had made himself, pointing to a box in the corner containing the tools with which he made it. There was not a painting or even a bare canvas in sight. When I asked him what he was working on, he said, "I'm waiting for November when the shadows are longer and the landscape becomes more interesting, in fact, beautiful."

Frankly, a Hopper landscape has never enchanted me in the way a Corot or a Cézanne does. In spite of the universal acclaim for his work, I secretly find something lacking—intimacy, poetry, grace. I was never possessed by a desire to own a Hopper painting. But I liked him and admired him, and recognized his intelligence, integrity, and nonconformity. In any exhibitions of American paintings a Hopper stands out, uncouth, lonely, and silent—like his house, like his easel, like himself.

October, 25

Yesterday morning, before my exhibition opened, I was invited to look at my paintings installed on the walls of the Whitney. I was tempted to go but was filled with trepidation. Instead I visited the Metropolitan Museum, to which I retreat whenever I need reassurance. There, absorbed in the paintings of the masters, my own work became less important and I felt ready to face my retrospective.

Just as I have always identified myself with New York City, so have I with its Metropolitan Museum of Art. I can say without any illusions of self-importance that the museum and I have grown and developed together through all these years. I was taken there for the first time, a thirteen-year-old foreigner. For months afterwards there was a confusion, a montage in my head of fragments of Meissonniers, Gérômes, Pilotys, Makarts, Alma-Tademas. The dominating piece in this mental kaleidoscope was Rubens's dappled horse with its voluptuous tail. Then I began to go to the museum by myself, or with my brothers, on Sundays, walking from the South Bronx across a bridge on the Harlem River. For a long time I was drawn to the rooms on the lower floor, then provincially filled with original-sized casts of Michelangelo's Medici Tombs, his Moses, some Greek Venuses, the Discus Thrower. With adolescent wonder I would look at the figures of "Day and Night" and "Dawn and Evening." These rooms were usually almost empty. Once in a while some lonely visitor would approvingly tap a cast and be alarmed by the resounding hollow echo.

I became interested in the American Wing, at the time consisting mainly of the Hearn Collection, with a portrait of Mr. Hearn himself, pink-cheeked and silver-bearded; a painting of a lovely mother reading fairy tales to her starry-eyed children; a woman in white among purple tulips; and many autumnal and spring landscapes.

Soon, however, I was aware of some other works in the museum: a few Rembrandts, some Millets, a collection of small sculptures and drawings by Rodin.

A great day for the museum and for me too, was when the Altman Collection was installed. By that time I understood, with some depth, Rembrandt's "Young Auctioneer" and his "Woman with a Pink," the Frans Hals, the Memlings and the portrait of a man with hands in prayer by Dirk Bouts, still a favorite of mine.

251

And then the Havemeyer Collection! with its wonderful profusion of paintings by Degas, the Impressionists, the El Grecos.

Paintings by Homer, Eakins, Sloan, Bellows began to appear on the walls of the Metropolitan. The Dreiser Collection of precious Flemish pictures with the small, inimitable portraits by van der Weyden, Hugo van der Goes, was added. Breughel's "Rest of the Harvesters," the Bache Collection and many others were put on permanent display.

I am acquainted with the museum layout; I know its rooms, its walls and the particular location of the paintings I look at often. I studied in several schools for shorter or longer periods, but I did not learn much in any of them. My great school has been the Metropolitan Museum of Art.

Europe and Israel, 1968

Israel, May 25

Tel Aviv seethed with young people, for the most part dark-haired, suntanned, with high cheekbones and sensibly strong features. Their Hebrew is like a new language—gutteral, strong, living, completely unlike the Hebrew I knew as a child, and without the accents and intonations of immigrants.

Ninety-nine percent of the tourists are Jews. They are pilgrims just as much as those who journey to Rome and Mecca, mostly unprepossessing middle-aged and elderly couples. In the fancy hotels the pilgrims are better dressed but otherwise the same, except that they seem to identify with Israel more arrogantly than the others, perhaps because they have investments there, or because they may have contributed money or time to Israeli causes.

We divided our two weeks between Tel Aviv and Jerusalem. All of Jerusalem was open to us. The Old City is like El Greco's Toledo: stony, hilly, yellowish white in glaring light. With half an ear I listened to the routine monologue of the guide, who pointed out the places of interest to the three religions. At the Wailing Wall we watched the praying of the devout—the men noisily chanting and swaying, separated from the women who were more reserved, standing silent, their faces pressed to the yellow stones of the ancient wall.

It was the labyrinth of the narrow, shady, crooked alleys of the Arab section that fascinated us most. It is impossible for tourists like us to absorb that teeming, confusing spectacle: the merchants in their cave-like stalls hawking their wares; ragged children darting under foot; old porters bent under loads of baskets and crates; beggars of all ages and deformities; women with massive weights on their heads, their chests and bellies thrust forward like moving caryatids.

The much acclaimed new Israeli Museum in Jerusalem disap-

pointed me. The climb from the taxi-stop at the ticket window to the exhibition halls, in the cruel glare of sunlight in that bare, treeless area seems endless. Noguchi's sculpture garden, with its still stronger glare due to the white pebbles in it which reflect the sunlight sharply, is impossible. (When my wife complained to Sir Philip Hendy, the newly appointed director of the museum, that there wasn't even a blade of grass in that garden, he replied, "It's not supposed to have any grass." "Then it's like a desert," exclaimed my wife. "I'm fond of deserts," Sir Philip said.)

With a few exceptions the sculpture there is atrocious.

I was irritated by the interior of the museum as well: by its low, heavy, oppressive ceilings and unsatisfactory lighting. Except for the rich collection of Judaica, its contents are meager. One feels there is a wish to fill it with "names," so it has a Cézanne, a Gauguin, a Utrillo and a Kandinsky, none of them outstanding. The rest is what you see in any so-called modern museum anywhere: content-less pictures in the "international" style by artists with inflated reputations, plus all the claptrap of the moment.

The museum was holding a Chaim Soutine exhibition while we were there. Individually his intensely personal portraits, still-lifes and landscapes seem wonderful to me, but their collective impact was lost in the way they were presented. There seems to be something organically wrong with this museum. But on the same grounds is the Shrine of the Book, an appropriate structure of stone which houses ancient, excavated parchments relating to the history of the Jews. This smaller structure makes more sense functionally, historically and poetically.

Tel Aviv seems to be the cultural center in Israel, in a cosmopolitan sense, with its bookshops in various languages, its art museums and galleries. The Mann Auditorium is more pleasing than any glittering structure in Lincoln Center. There we met the seventy-five-year-old Reuben Rubin, painter, architect, sculptor and diplomat. I think of him as a kind of Rivera. Like Rivera he spent his early years studying and exhibiting in Europe, but returned at intervals to paint in his homeland of Palestine. He finally settled in Israel and, like Rivera, discarded the European influences. Like the Mexican's, his subject matter became steeped in the life and lore of the land and its people. He found a new style for this content, a kind of oriental

neoprimitivism somewhat akin to Persian miniature, but on a mural scale.

In Rubin's Tel Aviv home hangs his painting of a feast, a sort of "Marriage at Cana," where, around a white-covered table with a still-life of food and drink, sit Arabs and Jews, with himself, his beautiful wife and young son among them. "I even invited Christ to this party," he said, pointing to a white-clad bearded young Arab at one end of the table.

During that early period he painted the famous "Dancers at Meron" and a picture of pioneers against a background of sand and rocks, and extraordinary portraits of the philosopher Ahad Ha'am, of the playwright Peretz Hirschbein and his wife, and of himself with his family. Lately he has been painting landscapes of Israel's hills and olive groves, and rich, wild bouquets of flowers. As he says, "I paint what I love—my people, my family, my country. To paint means to sing."

Indeed there is in his work a singing, a lyrical quality.

None of Rubin's joyousness, of his inner peace, his confidence about his place in Israeli art, did I find in Naftali Bezem, the much younger Tel Aviv painter. In discussing his work he often uses the phrase "I despair." He told me that long ago he "gave up the effort of representing nature as it appears, because mankind, which mean also me, has invented other means of doing it, so that artists can occupy themselves with other human experiences."

According to Bezem, he is influenced by pre-Renaissance art because "it did not concern itself with representing nature." (I disagree; Giotto, Duccio, Fra Angelico, and Lorenzetti, among others, painted everything visible in this world.) In these conversations I found him searching but inconsistent, often enmeshed in sophistry and semantics. He considers himself a "figurative, unrealistic painter." He feels that realistic art is powerless to describe such events as the Nazi extermination of the Jews or the atomic destruction of Hiroshima. "I personally lean to a certain symbolism, which, together with the clear colors and bold outlines, will enable me to say something personal to some other people, and enrich their life."

I agreed with Bezem that it is impossible to paint the Nazi and Hiroshima horrors, or those of Vietnam, or the world turmoil of today, because other media perform this function. But I deplore this weakening of the role of the artist. For my part, I see no salvation in "a certain symbolism." Ultimately it leads to the extinction of the art known to us for thousands of years.

255

There is confusion in the mind of this talented artist, and I understand the reason for his occasional despair. For, after all his apologia, his work is a conglomeration of the influences of the pallid masters of the twentieth century: the recent work of Picasso, the decorations of Leger, the much repeated symbols of Chagall, the doodles of Paul Klee.

The third Israeli artist we met was Anna Ticho, the outstanding draftsman. She is elderly and still lives in the rambling old Arab house in Jerusalem in which her late husband, the eminent eye surgeon, Dr. Abraham Ticho, received his patients for many years. The little street now bears his name.

Anna Ticho's work reflects a deep, lifelong familiarity with the landscape around Jerusalem, which she depicts in all seasons and at all hours of the day. She works exclusively in black and white, yet she creates an amazing illusion of color. At times her drawings tend toward surrealism and semi-abstraction, but even in these there is the reality of the Israeli landscape, the substance and texture of its rocks and earth.

June 6

Agnon's friend and neighbor who took us to visit him told us that the old man is not in very good health, that he may be distant, and even annoyed by us. "And no sketches," he said emphatically.

We found Agnon with a book, in his garden. Politely he invited us into the house. Some attempts were made at conversation in Yiddish or Hebrew, and after a while I said, "Mr. Agnon, before I came I took a drink or two. My tongue is untied and I feel bold enough to tell you that when I was very young, my father, who would be about a hundred years old if he were alive today, used to talk about a young and very talented Hebrew writer in Palestine by the name of Agnon. And now I'm privileged to meet this young writer who became a Nobel Prize winner."

Agnon looked at me through inflamed, teary eyes and asked in a quiet voice, "Who was your father?" When I answered "Avrohom Shoer," his face lit up and he rose and warmly shook my hand. Speaking softly as if to himself, he murmured, 'Avrohom Shoer. I read his stories. He wrote in *Hadoar*. He was a writer and teacher."

Then Agnon brought out wine and cookies and called his wife, a

256

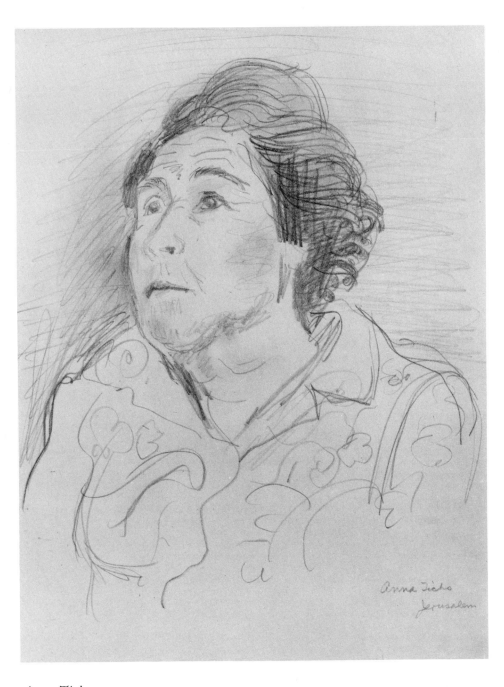

Anna Ticho

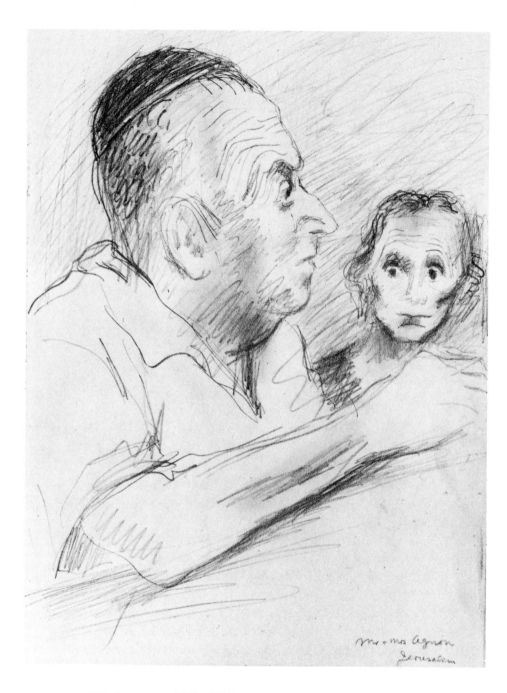

S.Y. Agnon and His Wife

258

frail old lady with a biblical face, and said to her, "This man's father was a Hebrew writer and storyteller."

Now our conversation was relaxed and warm. Agnon even consented to my drawing him, and I made a quick sketch of him and his wife while we were talking. In answer to my rather careless question as to who his favorite writers were, he said, "Well, one's favorites change as one grows older. There is Tolstoy . . . people mention him . . . I read your Dreiser, but what I remember is his unfavorable allusion to Jews in one of his autobiographical works . . . *Babbitt*—what was the name of the author? The book I never tire of reading is the Bible. This is the only thing I now read because of my bad eyes. Tomorrow I'm seeing the doctor about them."

At this point someone mentioned the unbelievable news that Robert Kennedy had been shot. We talked about violence in our country—where was it leading to?—about the unfortunate Kennedy family. Agnon said quietly as if to himself, *"Haim hatoo"* (they sinned), adding "Praised be the Lord that the attacker was not a Jew."

Both Agnon and his wife walked with us through the garden. He picked some fresh stems from a low bush, handed them to my delighted wife and said. "Rosemary." Mrs. Agnon then picked another twig and gave it to her saying, "Daphne." Her large sunken eyes were warm and smiling.

"It was your father Avrohom, after all, who introduced you to Agnon," Rebecca said to me as we walked to the car.

Vienna, June 11

I'm beginning to think that I'm a frustrated Expressionist, for I am so often drawn to the work of George Grosz, Otto Dix, and Egon Schiele. I shall be haunted for a long time by the spastically gesturing figures and contorted faces of Egon Schiele's drawings, shown at the Albertina in Vienna in commemoration of the fiftieth anniversary of his death. He died at the age of twenty-eight during the 1918 influenza epidemic. Only at the end of his short life was he able to master oil painting, but from the very beginning he was a great draftsman. It is hard to understand such early mastery of drawing; it usually takes a lifetime to achieve. As Tintoretto said poetically, "Beautiful colors are for sale in the shops of the Rialto, but good drawing can only be fetched from the casket of the artist's talent with patient study and sleepless nights."

Paris, June 14

Like a chain letter, we have been referred to people from New York to Budapest to Prague to Dresden to East Berlin. Everyone has gone out of his way to welcome us and show us what his country has been able to accomplish in spite of difficulties created by the hostility between East and West.

In Prague we came upon a small but choice collection of nineteenth- and twentieth-century paintings. There were two Daumiers: his best "Laundress," a heroic figure of a woman hurrying with her child, their shadows merging on the ground; and "The Family at the Barricades," unusually colorful. There were also Courbets, Corots, Pissarros, Cézannes, and a silly but wonderful full-length self-portrait by that inimitable primitive, Henri Rousseau, holding a palette inscribed "Josephine," and standing against a background of bridges, ships, flags, and flying balloons.

I stood for a long time in front of Delacroix's study for his masterpiece "Massacre at Scio"—that of the wounded and dying woman with a child clinging to her breast. This study recalled to my mind my conversations with the Israeli artist, Naftali Bezem. I agreed with him then that today artists could not adequately depict the massive horrors of our civilization. This live child, however, clinging to a dying mother, makes me retract what I said then. In such a detail it is possible to express a Vietnam or an Auschwitz. All the modern media of communication notwithstanding, one would wish to conjure up a Daumier, a Delacroix.

Berlin, July 1

If it were not for the collection of old masters in Dahlem, I would not bother coming to West Berlin. This is the third time I've been here, and my impression of this sector remains unchanged.

In East Berlin we met two sculptors: Fritz Cremer, who designed the Buchenwald Memorial and whose work we saw in the National Gallery (I especially liked his self-portrait as a dying soldier); and René Graetz, a charming, sophisticated, restless character, a self-styled admirer of Henry Moore who told me that his "sculpture is realistic" but his "graphic work is not." We had a lively discussion about art. I talked about the many paintings I've seen in European museums, how I

store them in my head and how I like to compare them in my mind with one another, unhistorically, without system or theory. I used Malraux's phrase "museums without walls," referring to the paintings in my head.

This aroused unanimous disagreement. I was told it was "useless" and "not correct" to do so, and the mention of Malraux brought forth a critical outburst from the hitherto silent Fritz Cremer: "Malraux's theory that art has not made any progress is sheer nonsense!" He went on to say that art is making progress, along with social progress and with the discovery of new materials. Unoriented as I am to this historical approach to art, I heard myself declaring, "Art does *not* progress" with which, to my surprise, the unpredictable René Graetz suddenly agreed. I said no more, and incorrigibly I mentally compared Otto Dix's World War I "Triptych," which I had just seen in Dresden, with Goya's execution paintings and with Picasso's "Guernica."

To my great pleasure, in East Berlin we met again Gabriele Mucchi, the Italian painter. We renewed our acquaintance, and he said to me in German: "Raphael Soyer, as socialists and painters, let us address each other as 'Du'" (the familiar form of *you*). I was delighted and honored by the remark.

Paris, July 17

Today we had guests. Since we have a small apartment in a Montparnasse hotel, for the first time in Europe we were able to be hosts. Two of our daughter Mary's friends, former classmates, came with their families; the room was alive with active children. We were charmed by them and were seized with longing to see our own little grandsons, David and Joey, and their mother and father. We were homesick for New York, and suddenly we felt that our vacation had been prolonged to the point of near-boredom. Though I filled my sketchbook, I still had too much time to spare. There were mornings when I'd wake up and mutter to myself, "What the dickens am I doing here?"

I think I'm one of the few who paint directly from nature today. My palette is a wooden rectangle. There is a self-portrait of Rembrandt in the outskirts of London in which he holds a palette like mine. When Edward Hopper once showed me the oversized easel he had made

himself, I exclaimed, "Why, it's like the easel used by St. Luke painting the Madonna and the Child in medieval Flemish pictures!"

How primitive are the tools with which I paint! How ancient is the art of painting as I know it! Can it still be the art for our times? Such thoughts are always with me while I work, for better or for worse.

How autobiographical my art is. All these portraits of myself, my parents, the members of my family; the pictures of the artists with whom I came in contact; the city I have known, and its people; the few landscapes of Maine—I have revealed myself in them long before this rambling chronicle was conceived, not only by the usual automatic revelation of the artist's personality, but through the subject matter which is my life.

To and from the Russians, 1965, 1969

April 17, 1965

Dear Andrei Chegodaev,

 I read your letter with great excitement and I shall cooperate with you in every way to give you all the material you may need. I feel greatly honored to have such recognition in your great country as to warrant a book about my work, and I am more than pleased that you, dear Chegodaev, are the one to do it. . . .

My gallery director is sending you many photographs of my recent work, beside, all the others you have asked for. I will send you the catalog of the Hopper retrospective exhibition and shall convey your greetings to him and Mrs. Hopper. Andrew Wyeth's address is Chadds Ford, Pennsylvania, U.S.A.

I am very glad that you have all recovered from the illnesses you have all suffered last winter. Please be well now. Congratulations to you all upon your new grandson and you may congratulate us, too. We also have a new grandson three weeks old. His name is Joseph. What is Michael's brother's name?

Will write again about exhibition, collection of drawings for Pushkin M. etc.

Greetings to you all from Rebecca

Yours, Raphael Soyer

Vinalhaven, Maine, July 7, 1965

Dear Professor Prokofiev,

Thank you very much for your *Manet.* Your foreword, Manet's correspondence, the reproductions, the footnotes, make your book of

great interest. Many of the paintings reproduced in it are well known to me, those in New York, Washington, and Boston museums, but I looked at them with renewed interest since I received your book. (I had occasion to be in Boston and Washington before I came here—to Vinalhaven, Maine—for the summer.) What a charming human being Manet was, and how brilliant and spirited his work. Manet and Degas are my favorite of the Impressionists. Do you contemplate a book on Degas? That capricious, paradoxical, contradictory aristocrat who painted with such understanding and truth the "Repasseuses," the tired millinery girls, the servants who bathed their lazy mistresses and combed their hair, the little "rats" who were trained in ballet to amuse the rich. After Rembrandt's great "Danae" in your Hermitage no nudes are more human and truthful (truthful again) than Degas's. It would be of great interest to analyze his draftsmanship, his composition, the esthetics, the plastic qualities of his art, its transcendence over mere illustration. But don't listen to me—once I begin talking about Degas I can't stop.

Your book, as I said, gave me great pleasure. It made my wife and me reminisce. We recalled the time we spent with you in the Tretiakov Gallery in Moscow and in the home of A. D. Chegodaev. How charming and understanding you were and how generous with your time.

And thank you for the beautiful way you inscribed your *Manet* to me.

Sincerely yours,

Raphael Soyer

July 22, 1969

Someone from the Four Continents Book Shop called to say that Chegodaev's book about my work was received, so I went down and bought the single copy they had and ordered about a dozen more to give away. The book had been in the making for several years. It's compact, unostentatious—the format neither too big nor too small—contains 125 illustrations, with the text by Professor Andrei Chegodaev.

I'm trying now to recall how this friendship with the Russians developed. About nine years ago I was amazed to receive a well-illustrated Russian book on the history of American art by Andrei

Chegodaev. That such a book could appear at the height of the Cold War was astonishing. It was a comprehensive history, beginning with the pre-Copley period and ending with the nonobjectivists and abstract expressionists. It was all the more amazing in that the author had never seen any of the original paintings, but based his book only on reproductions in catalogs, in art histories in English, and in magazines.

I didn't know who sent me the book. Could it have been one of the Russian artists who, about a year before, came to the United States on a cultural exchange tour, and visited my studio?

Then, shortly after, I received a message that the same Chegodaev was here with a group of Soviet tourists and would like to meet American artists. Would I arrange such a meeting in our house? Although there was very short notice, it turned out to be one of those rare events that remain in people's memories. I phoned a number of fellow painters to meet this Russian author of a history of American art, and everyone came: Edward Hopper, Henry Poor, Jack Levine, Ruth Gikow, Gwathmey, Anton Refrigier, Evergood. Chegodaev spoke English, and soon a very friendly and warm relationship was established between him and the Americans. At one point I heard the sepulchral voice of the until-then-silent Edward Hopper: "What would your government do if your country had a Daumier at this time?" The Russian's voice was too low, and I was unable to hear his answer to Hopper's loud, stern question. But I did see them shake hands at the end of their conversation.

The talk was general. Questions were asked of Chegodaev, some of them even provoking, to which he responded with gentleness and patience. At times I served as interpreter. My wife brought out drinks and refreshments, and Hopper, who had again lapsed into silence, exclaimed at the sight of a tray of cookies, "Oh, little cakes!"

Before he left, Chegodaev told me it was the most memorable evening he spent in this country. He was so delighted and moved to meet some of the painters who are in his book.

The last time we met was in November of 1963, when both Chegodaev and his wife were here again on tour.

Europe and New York, 1969

A t a glance I knew that most of the paintings were familiar to me. I have seen these Rembrandts on and off, in New York, in Boston, in the Louvre, in Dresden, in Leningrad. Because of this, and because it was difficult to get close to the paintings, I did not rush to see them at once but looked at the people. They came from all parts of the world—all ages, all races, nationalities, young men and women—some with infants strapped to their backs, the usual guides with their flocks of tourists, art teachers and students, a Pestalozzi with his children. Their clothes fascinated me—from formal dress to shabbiness, to the unisex costumes of the young people.

One more impression—I noticed that Rembrandt's self-portrait as St. Paul, toothless, his round eyes dimmed with resignation, seemed particularly to attract the young. Why?

September 23, 1969

The twenty-four paintings, familiar as they are, plus the "Syndics" and "The Nightwatch" in another part of the Rijksmuseum—without even taking into account the more than 100 drawings and the entire collection of his etchings—overwhelmed me. How three dimensional are the figures in all his paintings, from the earliest to the last: "The Ship-Builder and His Wife," the man and woman in "The Jewish Bride." And the spatial depth!

"The Ship-Builder and His Wife" are in a specific room, with books and manuscripts on the table and on the window sill. Here Rembrandt functioned as a photographer, rendering the likenesses of his subjects in their detailed environment. The background is consistent with the tangible and solid figures. In "The Jewish Bride,"

the man and woman, also particular people, have acquired a universal humanism. The background is indefinable and mysterious. Rembrandt transcends the role of the photographer. Here there is not only spatial depth, but also depth of feeling.

What a story-teller he is in "The Wedding of Samson and Delilah," "Jacob's Blessing," and the superb "Bathsheba"—so unrestrainedly emotional.

Story-telling, emotion, involvement with life, with reality, are frowned upon today. The proper thing is to "cool it," to reject any show of feeling.

Paris, September 29

They're still renovating the Louvre, rehanging the paintings. And they're doing an excellent job. The room with the Géricaults, the Delacroixs and the Courbets is breathtaking. Even after Rembrandt these paintings hold their own. "The Raft of the Medusa," "The Massacre at Scio," "The Burial at Ornans" and "The Studio" are huge, dramatic story-telling, emotional pictures calling forth from those who look at them an emotional response. Courbet, in the "Burial" and in "The Studio" is like Rembrandt, absolutely, in tone, in color, in depth. Like Rembrandt too these artists composed "not only laterally and up and down on a flat surface, but inwards in three dimensions, in the cube, not merely on the surface, thus humanizing the void." (I am quoting Berenson, *Italian Painters of the Renaissance.)*

Manet was the first who began to discard the elements that gave epic character to painting: story-telling, emotion, three dimensionalism, light and shade, etc. He flattened his paintings, minimized expressiveness. Nevertheless there is still enough humanism, reality, even characterization in his figures. The nude in "Déjeuner sur l'herbe," while it lacks the fullness, the warmth of Bathsheba, is earthy and real. But this trend begun by Manet was continued by Gauguin, Matisse, Braque, Picasso, and painting has become increasingly abstract, till it has reached today the "ad absurdum," the "minimal" in art.

I am omitting much in this rambling, and historically, what I am writing is full of gaps, but what I am trying to say is that painting has become so thin, so pallid since Courbet, so unrecognizable. Nothing but sheer esthetics, pure, like sterilized water.

I recall Arshile Gorky's last visit to my studio, a few weeks before his suicide. In a particularly melancholy mood he pointed to a newly stretched bare canvas and said. "This is art, anything done to its surface in color or charcoal will destroy its innate beauty." In other words, he reached a point of no art. But the very masters whom he admired—El Greco, Ingres, Goya, Poussin, Degas, among others—destroyed the purity, the whiteness of the raw canvas, molded, stained it, underpainted it before composing their pictures. The original canvas was no more, it became something else, absorbed within the painting.

New York, October 25

My intention was to see the exhibition of "American Painting 1940-1970," and the reinstallation of the permanent collection of the Metropolitan Museum, both being shown on the occasion of the museum's one hundreth anniversary.

It seemed strange to have to ask the guard where the European paintings were, after having come here for so many years, and having known exactly where each painting was hanging. What a long, labyrinthian walk from the entrance to the collection!

It always interests me to see a painting rehung on a different wall, in a different room, in different light. The picture itself begins to look different. One discerns some new aspect in the painting. Some slight variation in color, a brush stroke, some nuance not perceived before may reveal itself. But here all the paintings collected in the hundred years of the museum's existence were rehung wholesale, relegated to inadequate rooms in the deep interior of the building. It is a pell-mell hanging of pictures, some in three tiers, one above another, without breathing space between them, scrambled in content. Some of the greatest paintings are "skied" so that they look dark and blotched. The museum's celebrated collection of the Impressionists is hanging in a particularly badly lit corridor and the beauty of the Cézannes, Renoirs, Degas, and Monets is lost.

One would think that for a one hundreth anniversary a museum would go out of its way to show to best advantage the great pictures it collected in the century of its existence. It has done the contrary. Now it looks like a provincial museum with its red carpeting. Even if this is only a temporary arrangement it is a desecration. Inexcusable. I was too late to see the 1940-1970 show today.

November 28

I finally managed to get to see the "American Painting 1940-1970." In a small room were some Hoppers, Milton Averys, and a couple of semi-abstract Stuart Davises, serving as a sort of introduction to the Jackson Pollocks, to the Rothkos, to the de Koonings, and so forth—on to the Olitzkis, Rosenquists, Rauschenbergs, Warhols. These paintings occupy the walls upon which used to hang Rembrandts, Veroneses, the Flemish masters, the Cézannes, the Manets, the Degas. The rooms are large, the light exceptionally good, and the brightly colored canvases seem even brighter than they are. But all this glitter cannot hide the unbelievable shallowness, flatness, and sterility of this show.

There is a theory today that with our advances in science, in technology, in exploration of space, in psychology, and with the discovery of new materials and new techniques, there are possibilities for a much deeper, more varied and unusual art than has ever existed. How wonderful it would be if this were so. But the paintings here that claim to be the products of such advances belie this contention. There is nothing in these huge canvases, but raw paint, chaos and void.

On Books, 1966, 1971

December 30, 1966

Dear Lloyd,

Mrs. Bella Fishko told me that you were interested in reading the manuscript of *Self-Revealment,* which I wrote last summer during our European trips. This is to be the final book of the trilogy. (*A Painter's Pilgrimage, Homage to Thomas Eakins, Etc.* are the first two.)

Frankly, I can't explain what impelled me to write these books. *Self-Revealment* is the most intimate of the three as the title implies, the most autobiographical. I haven't shown it to anybody and it would mean a lot to me if you are the first to read it. It is not yet in its completed state. There are passages that need to be reconsidered. I also want to include other art activities in my life, such as the involvement in the magazine *Reality,* and to end it with my retrospective at the Whitney.

As I was writing *Self-Revealment* I kept asking myself "What is its raison d'être?" I would appreciate it greatly if you would be patient enough to read it through and tell me if it has any value.

With best wishes for the New Year
Sincerely
Raphael Soyer

I have illustrations for almost everything in this book.

December 21, 1971

I'm becoming impatient with the long process of publishing the book about me by Lloyd Goodrich.

December 22, 1971

Dear Harry Abrams,

Many times since I saw you last in my studio and since you visited us with the late Mr. Fox I have had a desire to communicate with you, to visit you, to talk to you. But knowing that you're a very busy man, beset by people who claim your attention, I refrained. Your sending the charming Christmas book to us gives me the impulse to write to you. But first let me wish Nina and you and your children a very happy, healthy, and active 1972.

Now, what I really want to talk to you about is the book about me that is in the process of being published by you. Frankly, I don't know all the mechanics that go into making a book of this scope, but I have a grest desire for the process to be accelerated. Is it possible? For, as you well know, we are all getting older. I find it hard to accept the fact that I'm seventy-two years old this Christmas.

I have painted and drawn all my life and I believe I have added to the art of our country. I am tremendously proud that the art historian, Lloyd Goodrich, the author of books on Eakins, Homer, and Hopper (who was my friend) is the author also of the book about me. In this sense I am in the mainstream of American art, not the ephemeral, restless turnover of art styles and fads. On the other hand, at this moment of drinking my Scotch on ice and dictating this letter to my wife, I feel that I am the "last of the Mohicans" of that painting of which Lloyd Goodrich is the historian.

I have not had an exhibition of paintings and drawings since the retrospective at the Whitney Museum of American Art, and I am pressed by my dealer to have a show. I resist it because I've had enough exhibitions in my life, but if I do have one I would like it to coincide with the publication of the book. This would indeed be a great event for me. Is it possible to know when the book will appear?

Again, my wife and I wish you and your family all the best for the New Year.

Raphael

An Exchange of Letters, 1967-1973

April 23, 1967

Dear Rudolf Baranik,

I am writing this to you because I know you best in the group of the "Angry Arts." I know how much effort and time you gave to this project to express the anger of the artists and writers at the unbearable war that our country is now waging.

As usual the avant-garde poetry makes more sense to me than the avant-garde art. There were some poems displayed on the walls that did convey anger and compassion: "Altars in the Street." "To a Spanish Poet," "The Room." But except for Leon Golub's bloody head and Cajori's pile of bodies, no anger was evident in any of the prints. Nothing, absolutely nothing, was felt. Think of the anger of George Grosz, the compassion of Käthe Kollwitz, or even that of the artists of the thirties in their protests.

I am sure that all the artists in this group angrily oppose this war. Then why this unbelievable gutlessness and sterility? Is it because of the self-imposed limitation of nonobjectivism? The inability of nonrepresentationalism to communicate?

Sincerely yours,
Raphael Soyer

November 21, 1971

I received a little brochure from Rudolf Baranik: his interview by the art historian, Irving Sandler. Rudolf sent it to me with a little note: "Both the language and the ideas may be utterly alien to you." In the

brochure Sandler's questions were loaded toward acceptance of abstraction, and Rudolf answered as expected. This plus his note is irritating to me.

I have known Baranik for many years and watched his work changing and finally becoming abstract. His social awareness and dedication to human values appeal to me. The theme pervading his work for several years has been his protest against the Vietnam war with its horrors, its napalm crimes. He calls this continuing series of canvases *Napalm Elegy.*

Although in principle, I am opposed to pure abstract art, I was influential in his being awarded a grant by the National Institute of Arts and Letters.

November 24, 1971

Dear Rudolf,

When your work was shown to the committee for grants at the Institute, I called attention to the inadequacy of the slides. "They do not do him justice," I said. I told the jury that although I'm not an abstract artist myself, I have a deep feeling for your work, that it moves me in a way I find difficult to describe. To myself I said, "could it be that I respond to your painting because you are a friend and I know you, your humanism, your sincerity, your calligraphy, your wife." I said to myself that a saying by a Greek poet, Simonides, of twenty-five centuries ago—"a picture is a silent poem"—can be applied to your work.

And now, for your interview with Irving Sandler. Neither the language nor the ideas in it are "utterly alien" to me.

I have read such rhetoric often, and how can one escape such sophistry today? I shall not try in this brief letter to go into all the nuances of the questions and answers. I want, however, to list some of my disagreements:

1. Are you serious in comparing Kaprow's ". . . New Yorkers walk in one direction" with the revolutionary march led by Fidel Castro and Che? How preposterous!

2. The sound "Guernica" still is for me the bombed town like the towns Hiroshima and Nagasaki, although not Picasso nor anyone else painted the latter two.

3. I absolutely disagree that Giacometti and Munch are not figurative artists and that the subject of Vermeer is not a room. That's

273

what I mean by sophistry. The young woman in Munch's painting "Voices" IS Norwegian. (I saw women in Norway who look exactly like that.) Munch's work is local. Vermeer lived in Delft and painted it. Their local art because of its transcending quality becomes universal. Vermeer painted a *room*—its walls, the chair, the checkered floors, tangibly, made these objects exist. (How difficult I find to make a wall exist in a painting). And to the horror of nonobjectivists he even painted a pregnant woman reading a letter in the room. The beautiful mood, poetry, abstraction are there—elements that help create a masterpiece.

4. Now what do you mean by saying that the best of art has always been reductive? *Ad absurdum?* It leads to nothing.

5. A young girl who posed for me taped burps (belches), which she released in the quiet room of a public library. "Witty?" She is a conceptual artist, her "art" was reviewed and praised in the *Village Voice.*

The above are my main disagreements. I could comment on the artists you most often mention in your answers to Irving Sandler: Pollock, Rothko, Reinhardt, De Kooning, but frankly they do not interest me enough to quibble with you about their art, their relative importance, and who of them "opened" or closed the door to art.

Well, enough said for now.

Regards to May.

Raphael

The MacDowell Colony, August 1972

Dear Raphael,

For more than seven months I have been poring over your letter in an attempt to answer it as clearly and as honestly as I can. In fact, I have discarded a much longer, rambling version of this letter, partly because I did not want to burden you with that much reading, partly because some of my opinions changed since I started writing.

First, I want to thank you for writing to me about the Irving Sandler interview. Your remarks made me rethink many things and clarified a great deal. But perhaps equally important is the gift of sharing the ideas of an artist who cares with a rare combination of logic and sensitivity. But before my preface again gets too long—to the points you raise.

1. My comparing Kaprow's imagined march of the noontime

New Yorkers to the revolutionary march led by Castro and Che from the Sierra Maestre does seem strained in retrospect. I was not, of course, comparing Kaprow to either Fidel or Che; rather the visual image of all those people leaving the cafeterias of the city, smashing their plates and starting to walk, en masse, in one direction seemed a very vivid counterpart of the theater of the absurd, a surreal and in itself meaningless revolt against life's greater meaninglessness. I do think that such a fantasy by Kaprow, or even a "wrapped coast" by Christo, are not pranks, but aborted reachings toward the expression of grandeur and meaning, not too different from the overdramatic skies of Turner, though the reaching is greater than the inner poetry. They cannot reach the night sky of Van Gogh.

2. Does the sound "Guernica" still mean the Basque town bombed by the Germans? That depends on how one feels about the painting. To me it is the universal symbol of an anguished outcry, epitomized in the image of the fallen head and outstreached hand. It is true that no one painted the tragedies of Hiroshima and Nagasaki. In my Napalm Elegy series, and in Leon Golub's Burnt Man paintings the tragedy of Vietnam tries to find a voice. But it is also an elegy for people close to me on a country road in Lithuania, my little sister as well as a child near Danang. In Guernica, I think Picasso painted this Elegy too.

Delacroix's "Massacre at Scio" if you admire it, must mean more than Scio, must speak even to those who have no idea what happened at the place, must it not?

3. Yes, Munch's work is local and Vermeer, in Delft, painted a room—with fidelity and exactitude. Yet I am right in saying that Vermeer's subject is not a room and the girl in "Voices" is not Norwegian. Many Dutch painters painted interiors with as much technical skill and professional ability. Many painted a young woman in moonlight. But the light and serenity in Vermeer and the mystery in Munch come not so much from the ability to capture visual phenomena, as from the distillation of a mood through stringent selection of the visual. Corot's birches at Ville D'Avray are also *beriozkas* at Oriol, and Munch's young woman is also a young Indian girl in Uttar Pradesh.

That's what I was trying to tell to Reinhardt, who looked down at all paintings of recognizable, objective subjects. I was appealing to him to shed his stylistic sectarianism and to grasp the poetry in Vermeer and present-day Vermeers, as I would appeal to you to see the poetry in the silent pulsation of a lyrical painting by Mark Tobey.

When I say that Giacometti, Munch, etc. are not figurative artists,

it is not sophistry but the truth, as long as Brackman is also called a figurative artist. It is a wrong division line, and I am fighting for a more meaningful division: artists of the deep spirit (so-called figurative and so-called abstract) on one side, and the shallow manufacturers or work, both figurative and abstract, on the other. Quality is elusive, hard to define, personal, subjective, yet better that than brotherhoods based on style.

4. Reductive. No, not ad absurdum. Ad sublimum. Reductive means (to me) single winded, extreme, deep—leaving out the nonessentials. The night sea in Ryder, "like a patient etherized upon a table," as opposed to the accidental, coyly waving sea in Homer. The beautiful old mattress and few draperies, repeated again and again in your paintings, as opposed to the porcelain shapes, whatever they may be, in the objects of Koch. And when Ivan Albright paints the wrinkles of age engulfing every corner, he is reductive in delving deep into this obsessive mood, no matter how complex his work is.

5. I am as little responsible for the young girl who taped her burps as you are for the paintings of Walter Keane. Every direction has its vulgar hangers-on.

Actually we are not so far apart. The silent, the intimate, the poetic, the understated, the subtle, the sensitive, the inverted force are what we share. Alongside the dark brooding poets—Munch, Ryder, Van Gogh, I love the poets of intimacy and reverence—Vermeer, Vuillard, R. Soyer. It is this brotherhood of spirit, which has little to do with skill, effort, style, or professional devotion, that I look up to. I would like to see tradition in essence, not trappings. When on Thursday evenings I walk into the League, the smell of oil paint is enough to make me feel I am in a temple. Yet when a student of talent creates a mysterious statement in dark, smoky lucite, I forget the material, the "newness" (unimportant!) and see it as another Expressionist painting. How else?

Our differing reactions to Abstract Expressionism and other modes are possibly more a result of history than of sensibility. Gorky, Rothko, and the others were your contemporaries, you knew them personally, their careerism, their rhetoric. I encountered their art during my developing stages. I never tried to like their work or anybody else's—I am certainly not fashion-conscious. I think I go my own way, looked down upon by those who hail the loud and the new, more or less ignored by those who cherish formal tradition. You are one of the few artists whose opinion is important to me. Perhaps it is

inevitable that we disagree, given our different history and experience. What is marvelous is that we find some common core underneath it all.

May, like Rebecca, corrected my spelling and punctuation. We send both our love.

<div align="right">Rudolf</div>

August 1972

Dear Rudolf,

I am not surprised that it took that long to answer my brief outburst at some of your replies to Sandler's questions. My task was easy—to refute abstraction; you had the burden of the defense.

I always had a vague suspicion that abstract painters are poets. They confuse media. The ideas they try to convey are more easily conveyed in poetry. I admire the poetry of your letter, but I must take issue with the point of view.

You are a tortured artist. You are struggling to reconcile in your heart and in your art representationalism with nonrepresentationalism. This is the quality in your work that appeals to me and that is absent in the work of other abstractionists.

And now:

About comparing Kaprow's happenings—the imagined march— to the revolutionary march of Castro and Che. I accept your explanation that you referred to the "visual image" rather than the significance of the march. I have a visual image too, both morning and evening on my way to and from the studio—of the march of people to and from work. It never occurred to me to liken it to the Siera Maestre March. It is not an "artificial happening" but an everyday occurrence, which, if one wants to, however, is as surreal as Kaprow's march, and if one wants to think deeply and pessimistically, quite as meaningless.

You mention Picasso's "Guernica" and Delacroix's "Massacre at Scio." I grasp this opportunity to tell you how much more meaningful to me is the "Massacre at Scio" that happened long ago, where and when I do not know, than Picasso's painting of an event that happened in my lifetime and in which we were all deeply involved. Again I must be honest and tell you that I could never understand why this magnified semi-abstract doodle of Picasso became a glorified symbol accepted by people of all persuasions—by artists, by Rockefellers, even by Franco. But is it plausible, one may ask, for an artist of our technological civilization to attempt to depict realistically the massive

<div align="right">277</div>

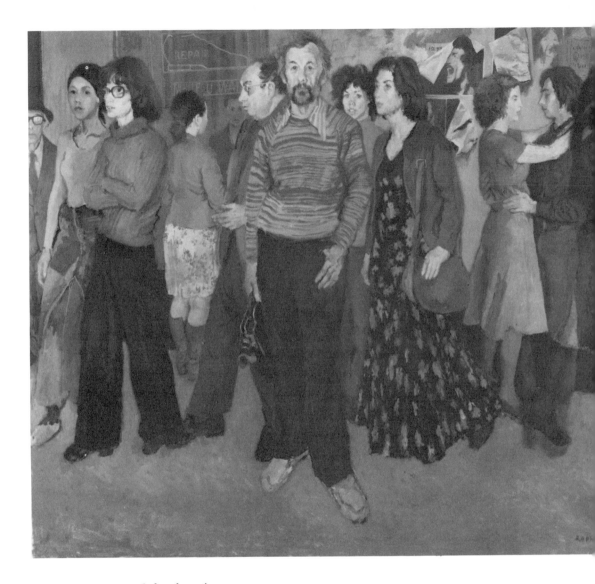

Columbus Avenue

horrors of our time? In a museum in Prague I stood for a long time in front of Delacroix's study for his "Massacre": that of the wounded and dying mother with a living infant clinging to her breast. Surely with such a fragment of realism, all the modern art media notwithstanding, it is possible to express the tragedies of Guernica, Hiroshima, Nagasaki, Auschwitz, and Vietnam.

I still adhere to the basic and simple classification of representationalism and nonrepresentationalism in art as opposed to your "more meaningful division of artists of deep spirit, etc." To me it is not a question of good or bad artists, be they representational or abstract. I simply reject the premise of abstraction. The few artists you mention by name (derogatorily) are not part of what we're talking about. They are not in the mainstream of art. I've just come from Rockport, Massachusetts, which is filled with them. They are not relevant to our discussion. But the girl who taped the burps and released them in the quiet of the library is. Her activity is the latest outgrowth of Kaprow's "fantasy" and Christo's "wrapped coast" (and may I add Acconci's masturbating) which you call "abortive reaching toward the expression of grandeur and meaning" and which you liken irrationally to the work of Turner and Van Gogh. To me all this frenzy is evidence of the process of extinction of the art that I know and love.

And I still insist that Vermeer, Munch, and Corot were representationalists in the full sense of the word, that their art was local but universal. It transcends time and place.

It seems that "reductive" has different meanings for you and me. You talk about "reductive" ad "sublimum" and refer to the extreme, single-minded, deep, obsessive art that leaves out nonessentials. You describe well the work of Ryder and Albright. But then you would include Vermeer, Munch, Corot, Rembrandt and Cézanne—great *representationalists* all. When I said reductive ad absurdum I had in mind the sterile work of Barnett Newman, Still, and poor Reinhardt who according to you "could not grasp the poetry in Vermeer."

February 6, 1973

Dear Rudolf,

This letter is not a continuation of our polemics, but rather an epilogue to it. I enjoyed our correspondence but I realize that artists cannot expand on their thoughts indefinitely. Nevertheless, an

exchange of ideas like ours should be a more common practice among artists. Art judgments should not be left to professional critics and historians only.

The current exhibition at the Whitney and my conversation with the publisher, Harry N. Abrams, about his collection, and about art in general, prompted this letter. I shall be brief about the Whitney show.

It is beyond squashed cars, chopped up pianos, kinetic contraptions. As John Canaday said in the *New York Times*, February 4: "To burn everything would be easier than getting it back to the exhibitors."

The offices of Harry N. Abrams are filled with paintings and sculptures by big and not-so-big names in "avant-gardism." To his discomfiture my response to the work of Warhol, Rauschenberg, Rosenquist, Chryssa, etc. was negative. To be fair to Abrams he does not completely reject representationalism—he has a few examples of it. He justified his choice by claiming that it was the art of the time, of technology, science, of the inventiveness of the human mind. I agreed that these works are the products of our technological civilization, but I added a footnote that technology is destructive of the art that, since cave days, has been done by hand, the product of the human spirit. "This heritage," I said, "must be continued and extended if the art that I know and love is to survive."

Technologians themselves are uneasy and frightened as to where technology may lead them and how it will affect man. I, as an artist, cannot help but be aware of its already disastrous effect on art.

<div align="right">Raphael</div>

1974–1977

December 18, 1974

I have seen the Centenary Exhibition of Impressionism at the Metropolitan Museum of Art several times. It was exciting to see again Manet's magnificent portrait of Zola, his balcony painting, a beautiful Monet from the Hermitage collection, and the outstanding group of Degas's paintings, including the "Cotton Exchange," which I had never seen before. I had pangs of sorrow that Moses Soyer did not live to see these paintings. He loved them so. It is now a little more than three months since he died.

February 15, 1975

About 1917, several years after I came to this country, I had saved enough money to buy a volume of the *Klassiker der Kunst* on Rembrandt. In the early 1920s my brother Moses Soyer sent me from Paris my first book on Degas, by Paul Jamot. In 1933 I bought Lloyd Goodrich's biography, *Thomas Eakins*. Since then I have acquired many books on these three artists, some of them attractive, costly, lush, full of jazzed-up color reproductions, but none has influenced me as much as those three early, modest books. I still have them, and although my eyes are not as sharp as they were, I still like to leaf through them occasionally. The German and French texts I am unable to read, but the Goodrich book I have read several times.

I was asked to review this new book by Gordon Hendricks* on the day the Centenary Exhibition of Impressionism opened at the Metropolitan Museum of Art. One of the paintings in the exhibition is

* *The Life and Work of Thomas Eakins* (Viking, $37.50).

281

"The Cotton Exchange," painted by Degas in New Orleans in 1873, which the critic in *The New York Times* (December 14, 1974) calls "the most beautiful picture ever painted in America." This exhibition contains not only paintings of the Impressionists but also work by their non-Impressionist contemporaries to point out the innovations made by Sisley, Pissarro, Renoir, even Degas and Manet, and also to show the existence of other tendencies in painting.

Besides these French pictures there are two rooms of the so-called American Impressionists: Twachtman, Robinson, Childe Hassam, etc. Just as non-Impressionists were included in this exhibition—Cabanel, Bastien Lepage, Reignault—the greatest non-Impressionist of the Impressionist era, Thomas Eakins's masterpiece, "The Gross Clinic," could have been included. It was painted at about the same time as "The Cotton Exchange" and if "The Cotton Exchange" is "the most beautiful painting ever painted in America," then certainly "The Gross Clinic" is the most powerful painting ever painted in America. In 1917 Henry McBride, art critic of the *New York Sun* wrote: "The portrait of Dr. Gross is not only one of the greatest pictures to have been produced in America, but one of the greatest pictures of modern times anywhere."

This praise by McBride was written after the death of Eakins. No full-length article about him appeared anywhere in his lifetime. When he died *The Art News* wrote: "Poor Eakins, he had to die to get a page in the Sunday papers." While he was alive, from the time "The Gross Clinic" was exhibited, his art was attacked or ignored, but seldom praised. No wonder he bitterly complained: "My honors are misunderstanding, persecution and neglect, enhanced because unsought."

Since Lloyd Goodrich's book in 1933, many articles have appeared in various periodicals, and catalogs of occasional exhibitions of Eakins's paintings were written, some again by Goodrich. John Canaday, in a well illustrated article in *Horizon* (Autumn 1964) called him "probably the greatest American painter, and certainly one of the greatest 19th century painters on any acceptable international list." Not until 1959, however, was there another full book, Fairfield Porter's *Thomas Eakins*. Recently there has been a rash of books: *Eakins* by Sylvan Schendler (1967), *Eakins' Watercolors* by Donelson F. Hoopes, *Photographs of Thomas Eakins* by Gordon Hendricks (1972), and now this encompassing new book by Hendricks.

Like that of the new breed of art historians, Hendricks's writing is

"cool," objective, factual. His idea of a biography of Eakins is contrary to Eakins's own conception of his life. In the well-known letter to an editor of a biographical dictionary, Eakins sums up his life and ancestry in a few words, and ends with: "For the public I believe my life is all in my work." In Hendricks's book the multitudinous minor details about Eakins's pictures, personal life, family relationships with cousins, uncles and aunts tend to militate against the wholeness of his book, and weaken it. There is very little analysis of Eakins's work, which meant so much to me in the writings of Goodrich, Porter, and John Canaday. And when Hendricks does express an opinion I often disagree with it, because I find it contradicted by Eakins's work itself. For instance Hendricks says: "Eakins had generally had his greatest success with portraits of men rather than women." But the portraits of Mrs. Eakins in the Hirshhorn Museum, and the one of Amelia Van Buren in the Phillips Collection in Washington are as great as the portraits of Dr. Gross and Dr. Agnew. In John Canaday's opinion the Van Buren picture "may well be the finest of all American portraits."

Another point of disagreement: Hendricks claims the late version of "William Rush" (1908) "shows fatigue, carelessness and boredom, and little of the spirit that made the painter the artist he showed himself to be in the earlier." I agree with Fairfield Porter: "The second and third versions of 'William Rush' are more relaxed than the first one. His last paintings are freest, without any sacrifice of his sure drawing."

Hendricks's chief contribution to our knowledge of Thomas Eakins is the letters, which make the book important, many more in this book than in any of the others I have mentioned above. These letters, beginning with the early ones to his parents from Europe, and those to some of the people whom he painted, to his students, as well as his correspondence with the art establishment of his time, present a portrait of the man and the artist. There is a wonderful letter in which he refused an invitation to talk to a club for workingmen, repeating a previous comment that an artist's appeal to the public is through his work and shows his sensitivity to the feelings of working people and his regard for their intelligence: "The working people from their close contact with physical things are apt to be more acute critics of the structural qualities of pictures than the dilettanti themselves, and might justly resent patronage."

There are also descriptions of and letters about Eakins not found in other books. One of them, by Harrison Morris who posed for him,

gives us a precious glimpse of Eakins at work: "I stood day after day while he patiently transcribed me, for his method stuck closely to the object; and I watched his large underlip, red and hanging, his rather lack-lustre eyes, with listless lids; his overalls of blue, and his woolen undershirt, the only upper garment." This description gives a more vivid picture of him than the many photographs in this book.

Artist Elizabeth Burton, a former student of Eakins, whose portrait he painted in 1906 (and by the way, one of my favorite Eakins portraits) writes much later to the Minneapolis Museum of Art, which had acquired her portrait. She describes Eakins's gift:

> His way of giving the portrait was characteristic of his generous, loving heart. After I had gone so far away to live, Mother wrote me that Mr. Eakins appeared at our home one afternoon, with the picture under his arm, handed it to her and said with his usual gentle simplicity: "I thought you might like to have it, Mrs. Burton, now that Elizabeth has gone."

In calling this book an encompassing one I had in mind Hendricks's inclusion of Eakins's interest and work in photography, sculpture, anatomy, and perspective. To me however, Eakins is the great American painter, head and shoulders above all others, and so I limit this review to his paintings.

One comment on the illustrations in this book: The black and white pictures are small, with too many placed on one page. There is hardly a distinction between the reproduction of a painting and a photograph. They are all dull and lusterless. It seems to me that there are too many photographs in this book, especially since Hendricks has devoted an entire book to Eakins's photography.

Some of the color reproductions are quite good and some, as it often happens with color plates, are awful. For some reason (negligence?) two color reproductions, the self-portrait in the frontispiece and "Lady with a Setter Dog" (plate 32) are facing the wrong way.

On the whole Hendricks's book is a valuable addition to the literature on the artist. It contains a comprehensive, illustrated checklist of Eakins's life work, a full bibliography, and interesting notes to the text, but sadly, it lacks the warmth of the book by Lloyd Goodrich.

May 18, 1975

I have always loved to do portraits—at first of members of my immediate family and later of friends and fellow artists. Often I wanted

to paint people whom I admired for one reason or another but was seldom given the chance.

When I was told that Golda Meir might pose for me, in spite of her limited time, and I, to do it would have to interrupt my work in the studio, I accepted the suggestion. I was full of misgivings, but the temptation was too great. For here was an opportunity to paint a former Prime Minister! Moreover, there was an added poignancy in that, many years ago my sister Fannie shared an apartment with Golda Meir, when they were both young, in Palestine. So, though I knew I would have only two sittings, I agreed to do it.

We were taken by limousine (Rebecca came along with me) to a place in Connecticut. We went under the strictest secrecy. No one was told what I was going to do nor where I would be. The house in which Mrs. Meir was staying was surrounded by U.S. security men, and within were several Israeli security men. Mrs. Meir commented how unfortunate it was to need such precautions.

In two sittings, in very unfavorable light, I painted the head and sketched in the figure. I finished the portrait in my studio, with my wife posing in a dress I saw Bella Fishko wearing, and although the print design was completely different from Mrs. Meir's dress I thought it would be appropriate.

I was impressed by the absence of pomp and pretense in Mrs. Meir's appearance and behavior. She was friendly, warm, and cooperative. She posed extremely well, with great patience. Once in a while she asked for a break to smoke a cigarette or take a sip of water. I felt completely at ease with her. While I was working I regretted more and more that I had so little time in which to do this painting. She has a wonderful face, strong, wise and kind. Her eyes, her eyebrows, the temples of her forehead, the entire head structure impressed me. There is something deep, symphonic about that head.

The second day we interrupted the sitting and had lunch—the hostess, Mrs. Meir, my wife and I and several guests. The conversation was interesting and lively—in English, Hebrew, Yiddish, and Russian. From an occasional serious tone in this conversation one realized that the State of Israel is indeed the center of Golda Meir's thought and life.

1975

Last night I saw the exhibition "Jewish Experience in the Art of the Twentieth Century," international in scope. I was impressed by the painting "Burial of a Zadik" by Hirschenberg from Poland; by a group

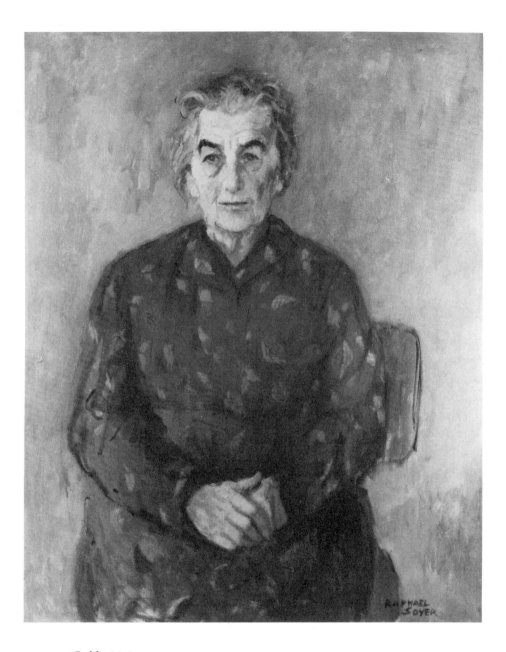

Golda Meir

of paintings of melancholy Jews at prayer in a synagogue by another Polish artist; by some well-known early paintings by Chagall, one of my favorites, a "Beggar Walking over Roof-tops," and some characteristically abortive paintings by Soutine and early paintings by Jack Levine. My two brothers, Isaac and Moses as well as I, are represented—Moses, by a brilliant study of an old, bearded Jew, which he did in his student days, and Isaac, by his well-known painting, "Employment Agency." I have several paintings in this show, one of which is the portrait of my parents.

In my opinion many artists who should be included are left out, Maurice Sterne, Joseph Floch, Benjamin Kopman, among others.

January 3, 1976

Dear Andrei Chegodaev,

I am writing this in my studio. On one easel is a life-size portrait of a young woman with the oval face of a Sistine madonna, on the other easel is a large painting of a nude model in my unswept studio with a background of gray walls stained by time and neglect, a broom, a blouse on a wire hanger, an electric heater with its rubber cord coiled like many snakes. These paintings are not quite finished. I became seventy-six years old, and wonder at my longevity, my drive, and energy to paint. But every day I think of my contemporaries who passed away. You met them all in my house—Edward Hopper, H.V. Poor, Lozowick, Wilson, Dobkin, Evergood, Kroll. My twin brother Moses died. I have no one with whom to speak Russian anymore. He died a year ago at his easel.

I am sending you photographs of several recent paintings. One I call "Portraits at a Party." It is of young artists picturesquely dressed, in a "loft." In the distance, in the right corner, are my two brothers and myself—a small, gray group of older people. By the way, the young woman in the white blouse is Mary, our daughter. She is the mother of three beautiful children. The other painting is also a group portrait of artists. I call it "Columbus Avenue," the street where my studio is located. The figure on the far left is myself again. Also am sending you photos of some portraits: one (detail) of Leon Kroll, ninety years old, a year before he died.

And how are our Moscow friends? Prokofiev, Pimenov, Shmarinov, Soifertis, Ludmilla Tolstoia? From Vereisky and the

Petrovskys we received letters. Give them our regards, also to Yegorova who was in our house and spoke to a group of artists, and later sent us her books on Van Eyck and the museums of Holland. Do you know the poet Romatovsky (I think that is his name) and his charming wife, an art historian? They visited us. Give them our regards.

Our best wishes to you, to Madam Chegodaev, your daughter, and her children. Be well and active. One does not have to exhort you to write. I am amazed by the amount of writing you have done and are doing.

Raphael Soyer

June 10

I decided that my posthumous portrait of Moses Soyer is finished. I painted it from snapshots, from several sketches and from memory. It was difficult. The last painting for which Moses posed, a study for my group painting "Portraits at a Party," was easier to do. My first idea was to paint him posthumously sitting in his studio with a nude model in the background and a suggestion of his studio furnishings. But in the process of work I eliminated the figure of the model and everything else, just leaving Moses against gray walls.

I could have painted his face, ravaged by illness, more expressionistically, but I held back for reasons I cannot fully explain. Perhaps it was too painful to reveal the physical deterioration of his once magnificent head, which I liked to paint many times. Even several years before, Moses looked at a portrait I did of him and said, "You missed doing an Otto Dix of me. Or you could have painted me like the portrait of the hunchback poet, Neisse, by George Grosz, which we saw at the Museum of Modern Art."

June 11

Moses was a sociable man. He had many friends. Students, models, fellow artists, owners of his paintings were in close contact with him after (his wife) Ida's death. But he was lonely. In the last portraits I did of him I felt and tried to express the loneliness of his last years. Gradually I think, he began to accept his solitude, even to like it. He spent most of every day in his studio, and when not painting he would

288

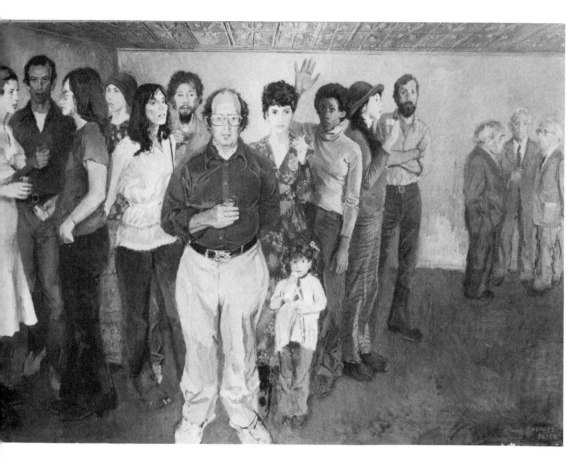

Portraits at a Party

occupy himself with translating Russian poems into English. One day he phoned me to say that he read a translation of a Russian poem by Nabokov, one which he, himself, had translated some time before. With quiet pride, he said: "The translations were exactly alike except for one word, which, I must concede, was more apt in Nabokov's version."

We would phone each other every day and speak in Russian, a language we both loved.

He was courageous. His illnesses did not keep him from going to his studio every day. Once in a while he would complain of pain, of not feeling well, of being in low spirits. He would say "This week was a disaster. I have not accomplished anything." He told me that since Ida died he thought of death every day. He died while he was painting the young dancer, Phoebe Neville. His last words were, "Phoebe, don't frown." Some of his last paintings are among his best.

London, June 23

How interesting that Irving Howe, in his now famous book *World of Our Fathers,* chooses my painting, the "Dancing Lesson," which I did fifty years ago, as a basis for discussing the question "that has troubled many critics and few artists. Is there a distinctive, contemporary Jewish art?" I painted the "Dancing Lesson" when I had not yet considered myself an artist, when, under the influence of Guy Pène du Bois, I began to paint subjects of ordinary interest that were part of my immediate life, in a frank, almost naive, manner.

Of the four artists whose work Irving Howe reproduced in his book, Max Weber, Ben Shahn, Abraham Walkowitz, and myself (how strange it is to be the sole survivor of this group) I was the least involved with Jewish content in art. Weber purposefully depicted religious Jews in prayer and study; Shahn became interested in Hebrew calligraphy, and illustrated Haggadahs; Walkowitz published a book called *Ghetto Types.* I can mention only three paintings of mine that have Jewish content of some sort: The "Dancing Lesson," in which my immigrant mother is holding a Yiddish newspaper; a painting of a Lower East Side New York street with a Yiddish sign advertising rooms for rent; and a portrait of my father shortly before he died holding his own book called *Dor Holaykh, (The Passing Generation).*

Shahn, Walkowitz, and Weber were poetic, imaginative artists. They did not paint Jewish subjects from their own experience, from

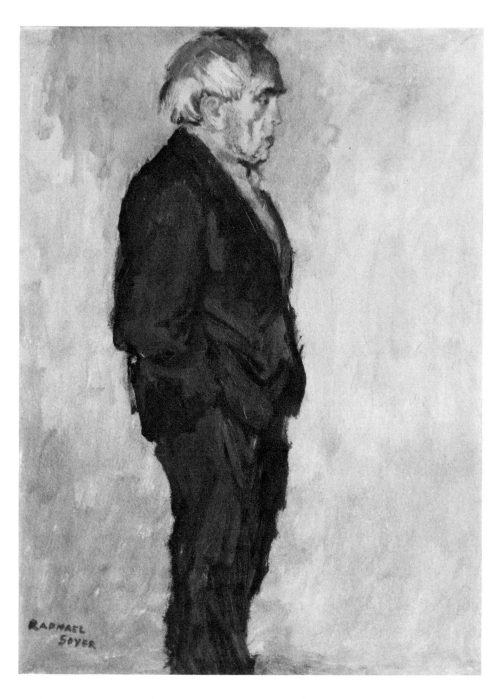

Study of Moses Soyer for "Portraits at a Party"

life, but from knowledge derived from their cultural heritage. I have trained myself from childhood to draw and paint from life only, what I see, never trusting my memory or imagination. I witnessed my sister teaching my twin brother Moses dance, with other members of the family in the background, and that became a painting. They posed for me.

I was moved by Howe's description of it, and I now recognize that it "communicates something about the immigrants' experience," that "the postures of its figures are a little fearful and clumsy. These immigrant postures held through decades seem now to be shaping the very contours of the picture." While I was painting it, however, I was not aware that I was doing something so meaningful.

It is surprising that after having so perceptively interpreted the "Dancing Lesson" Irving Howe should accept the schmaltzy comments by the art critic Harold Rosenberg about my other painting discussed in the *World of Our Fathers*. It is a simple portrait of my parents revealing their environment and their daily mood. There is no "Friday night dinner" there, no celebration or any ritual. I painted it directly under the influence of Degas's "Absinthe Drinker," which may make it a "French painting." The "golden glow as of chicken soup," which according to Rosenberg "permeates the picture," is nothing more than cheap yellow varnish. The painting has now been cleaned and restored to its original gray tonality, to its mood of everydayness.

Amsterdam, July 2

This morning at the Rijksmuseum Rebecca and I went straight to the Rembrandts and saw the beautifully restored "Night Watch." It is now strangely luminous, in spite of so much black in the painting. Is it because of the special way it's lit up? Anyhow, it is brighter and more *"plein-aire"* than any Impressionist painting. I mused: How powerful are paintings like "Night Watch," Da Vinci's "Last Supper," the restored Mantegnas that we saw last week at Hampton Court. So many vicissitudes befell them during the centuries: neglect, vandalism, bad restorations. And yet they survived. They are so strongly drawn, blocked in, and underpainted, so well-planned as to make them indestructible.

The "Jewish Bride" is hanging in daylight, it is not lit up dramatically. And yet it is also extraordinarily luminous. As always we were mesmerized by it. "As it is hanging now," I suddenly heard

Rebecca say—"What could prevent some maniac from slashing it, as was done to the "Nightwatch?" "Perish the thought!" I exclaimed.

July 3

At the Van Gogh Museum the paintings were well exhibited, but seemed skimpy, smallish, and stingily framed. I was most impressed by the studies for the "Potato Eaters"—those stark dark individual heads of men and women painted with a kind of ferocity. His later impressionistic landscapes and flowers looked mild and almost pretty in comparison, except for the several paintings done at Anvers before his suicide, particularly the unique, frenzied landscape with the black crows, so predictive of death. In a sense, Van Gogh's drawings— honest, strong, and rough—appealed to me more than his paintings. The soup kitchen for the poor, and a group of miners, are more poignant than, say, drawings of similar content by Käthe Kollwitz (whom I admire). They have the intensity of the post-World War I drawings by George Grosz, minus his satire and morbidity.

July 10

Van Eyck's Altar Piece in St. Bavo's Cathedral in Ghent is the national treasure of Belgium, just as Rembrandt's "Nightwatch" is Holland's national treasure. In an explanatory brochure given to us in the small chapel where the altar piece is displayed we read the following: "The sacred work of art was saved from the fury of the iconoclasts. . . . It endured three wars . . . fire could not destroy it, it stood the ravages of time . . ." Again an indestructible masterpiece like "The Night Watch," Leonardo's "Last Supper," Mantegna's mural.

It's hard to grasp the conception, the planning, and the execution of this triptych. It would be too much to delve into an exploration and analysis of it. I regretted that such a painting is not on a museum wall, without floodlights. But it was wonderful to see it. My eyes were glued to the figure of pregnant Eve. She is not earthy like Rembrandt's Danae; not exhuberant and voluptuous like the nudes of Rubens and Titian. This nudest of all nudes is so human, strangely modest, spiritual, vulnerable. When I look at her I feel she is a mortal being. I think this is the ultimate rendering of the nude in European art.

Paris, July 18

Yesterday, in this hotel we met an architect and his archeologist wife, Jim and Cleo Fitch, who knew Moses and Ida many years and spoke about them with great warmth. As a matter of fact they saw them here in Paris, several years before Ida's death, happy and excited about this beautiful city and its art. They remarked about my resemblance to Moses. They had not known that Moses and I were twins, and the conversation turned to the peculiar problems which often beset identical twins. They were amused by two incidents I told them about:

Moses once appeared in a TV interview. Next day a woman, passing me in the street, said: "I saw you on TV yesterday." "It was Moses, not I," I said. Looking at me closely, she questioned, "Are you sure?"

Another time I was having lunch at a counter in a Village coffee shop. From the other end of the counter a girl waved, picked up her plate, came, sat down next to me, and said, "Hello, Moses." "I'm not Moses, I'm Raphael." Whereupon she took her plate and without a word, returned to her former place.

There were many other similar occasions that I didn't mention. One, of many years ago, when Moses and I were quite young, is still surrealistically vivid in my memory. I was walking briskly along Fifth Ave., when I suddenly saw Moses walking briskly toward me. But then I quickly realized it was my own reflection in one of the tall, narrow mirrors jutting out from a store.

July 31

I hold my breath when I open the door of my studio, this always happens after being away for a long time. A feeling of mystery and familiarity comes over me as I enter the silent room. The smell of turpentine and oil, the diffused light. The canvases I was working on before I left are neatly stacked against the wall. The completed paintings, recent and old, are safe in the racks. The several easels, usually in constant use, stand empty and seem to be resting. The originally white walls, which haven't been painted in ten years, are stained and patinated by time.

Here and there on the walls are groups of reproductions and original drawings, some thumbtacked, some scotch-taped: reproduc-

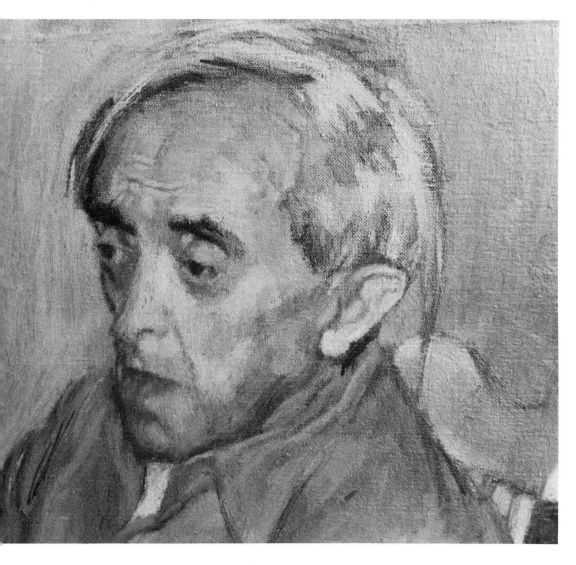

Posthumous portrait of Moses Soyer (detail)

tions of a famous photograph of the old Delacroix; of the etched self-portrait of Degas; of a caricature of me by David Levine; an astrological crayon drawing made for me by Gregory Corso; several drawings by George Grosz, and Lambro Ahlas's self-portrait in gouache. Also a drawing in pencil of me and of himself by Isaac Bashevis Singer. He drew it especially for me.

Here is the old wooden, clumsy furniture that follows me from studio to studio: the chairs, the desk, the table, the cot with its striped,

sagging mattress. No matter how many times I move, my studios assume the same character—bare, no comforts, just a place to work in. The old sink is encrusted with paint and oil from washing brushes. On the floor, dust. "There's so much dust under the cot," a model said, "you can plant there."

I prop up unfinished canvases against table and chairs, adjoining one another—a one-man show all to myself. I examine them. Am I pleased? Am I disappointed? I take from the racks old paintings done in the thirties, forties, and fifties and put them alongside the recent ones—a retrospective exhibition. Have I progressed? Have I changed?

Stonington, August 7

We are in Stonington, the tip of Deer Isle, Maine, after spending five days in New York upon our return from Paris. Before we came out here I had enough time to improve and finish the portrait of Elia and Herman Rose, and I also worked on the "Street Scene with Self-Portrait."

Still under the spell of Van Eyck's Ghent altarpiece, I brought alone K. C. Yegorova's scholarly and detailed book in Russian on Van Eyck. I'm rereading it now very carefully. According to her, Van Eyck was unacquainted with classic sculpture. His work was strangely uninfluenced by Italian art, not even by that of his contemporaries, Donatello and Masaccio, which played a great role in the "international style" of painting of that period. Nor was Giotto known to him.

Yegorova maintains that Van Eyck's art was based upon accurate and keen observation of nature. Unlike the Italians, who idealized man, Van Eyck painted man as he is, but affirmatively. According to her, he painted portraits from life. The figures in his religious compositions he painted from imagination except for Adam and Eve, which for a northern artist of that period like Van Eyck, presented a difficult and unusual problem. It is this nonidealization of Eve and Adam, their human nakedness, their vulnerability, that moved me so much.

August 29

Most of my reading is done during the weeks I'm away from my studio. This time, spent in Europe and in Stonington, Maine, it seems to me I

read more than on other vacations. I began in Europe with Irving Howe's book, *The World of Our Fathers*, then a collection of *Famous English Short Stories*, and a book of rather slow-moving novelettes by Doris Lessing. Also a pocket book of *Modern American Short Stories* in which I found my favorites, Faulkner's "The Evening Sun Go Down," and Conrad Aiken's chilling story of a child going mad, "Snow." In Stonington, where there are no museums, I read more—Joyce Carol Oates' morbid and sordid short stories, oozy with talent. Here I studied Yegorova's Russian book on Van Eyck and even copied in my sketchbook several illustrations there. The only art book I had at hand. And the third volume of Ilya Ehrenburg's autobiography, which I found in my daughter's house in Vinalhaven, describing the post-World War II period 1945-1954.

But the big thing in my summer reading are my periodic encounters with the work of Henry Miller. Now and then all through his avalanchian, wordy, uninhibited, meandering writing—gab rather than writing—I find items of personal interest.

One summer, I came upon a sentiment in one of Miller's books, where, quoting Emerson: "A man is what one thinks of all day," Miller said, "If that is so, I am a big empty gut." I remembered Burliuk's poem: "We are young, young. In our bellies is a devilish hunger." Both Burliuk and Miller, in different countries, at the same time between the two world wars, talked obsessively about their youth, their poverty, and their real hunger.

Another summer I picked up again one of Miller's books and found a characteristically exhuberant account of a surprise meeting with the Yiddish poet Nahum Yud. Now, I knew Nahum Yud in the 1940s. He wrote poetry and fables in Yiddish, uninhibitedly, in his way, like Henry Miller, but lacking Miller's genius. It made me remember a long-forgotten luncheon with Nahum Yud somewhere in a Second Avenue restaurant. We talked. Loudly, in a rasping voice, he used language in Yiddish and English similar to Miller's vocabulary. Suddenly a young man appeared at our table, bent down, his face close to Nahum Yud's, saying with angry emphasis: "Mister, if you say another dirty word within the hearing of my lady-friend, I'll punch your nose!" I still can recall Nahum Yud's face expressing surprise, shock, and guilt. After a moment of silence, he made a lengthy, gracious, conciliatory speech asking the man please to convey regrets and apologies to his lady-friend. And the young man, irate the moment before, went pacified back to his table.

297

Again—before we came to Stonington, Rebecca picked up in a second-hand bookshop a paperback edition of *Black Spring* by Henry Miller. And again I found something of surprising interest. In a chapter called "The Angel Is My Water Mark" he described how he painted a watercolor. (I knew that he had been doing watercolors and have seen some. They are no great shakes.) It is impossible to summarize all the crazy things that happened to this watercolor, accidentally and on purpose, while it was being made, with its final submersion in a bathtub. This must have been written in the late twenties or early thirties, as long ago as that.

Reading this hilarious account, Jackson Pollock, Abstract Expressionism, action painting, all that has transpired in art since the 1950s came to mind. "This was the process," I said to myself, "of 'creating the masterpieces' of nonobjective painting." I wonder if the critics, the apologists for the avant-garde in art, and the abstractionists themselves have ever read this chapter in *Black Spring*. It was never referred to by any of them.

September 8

Yesterday I had lunch with my dealer, Bella Fishko. The conversation of course, was about the New York art world, the economic outlook of the coming season, not a bright one. As in the last year or two, Bella pressed me to have a one-man exhibition, and as usual, I voiced my reluctance.

"Let's have it in the usual course of events," she said. But since I am fed up by now with the ordinary run of shows, I spoke vaguely about a different kind of show, a museum show, a second retrospective maybe. Then Bella suddenly said that it would be an interesting idea for a museum to do, perhaps a joint exhibition of the works by Hopper and myself.

Well, this struck me as preposterous and inappropriate. I never saw an affinity between his work and mine. I once saw a collection of still lifes, street scenes, interiors by Hopper, Sheeler, Spencer, O'Keeffe, and others. Not a human figure in any of those cold, precious, prophylactic pictures. I remember having at one time called this group of artists, somewhat resentfully, "the aristocrats of the so-called indigenous American art." I consider myself in the other stream of American art, formed by those who came with cultures from Europe that added to the pluralistic culture of this country.

Bella's suggestion, however, worries me. I knew Hopper well and visited him in New York and Truro. He posed for me several times, and I was fond of him and admired his intelligence and integrity. I came home and looked at the two books by Lloyd Goodrich about Hopper and me, and began to see, to my surprise, some basis for Bella's idea. There is an element in the work of this Anglo-Saxon American that is also found in my work—an element of loneliness. A different kind of loneliness, naturally, differently depicted. There may be a basis for comparison.

September 30

Am reading Virginia Spencer Carr's remarkable biography of Carson McCullers. There is a description of McCullers coming late to a party, partly in her honor, tearful and distraught. She had just read Edmund Wilson's unfavorable review of her book, *Member of the Wedding*. When someone tried to console her she burst into uncontrollable sobbing.

I was touched by this reaction, so common among creative people, for it shows how vulnerable they are, how susceptible to adverse criticism. Of course in this case it was Edmund Wilson, probably one of the most esteemed of American critics. But criticism by anybody in the press can wound a writer or an artist.

The often supercilious or pompous criticism of art annoys me, too. I once asked a well-known author: "Is the criticism of books on a higher level than the criticism of art?" He answered "No," and after a minute or so, he added "It's on a lower level." There was a tone of hurt in his reply.

The brilliant Manet had always been eager for acceptance, for approval by critics. He craved awards and honors. When, ill and exhausted toward the end of his life, he was notified by a friend that an honor had been bestowed upon him, he said it was too late to "repair twenty years' lack of success."

There are artists and writers, however, who are able to ignore both praise and criticism. Degas, for one, despised critical reviews, even favorable ones. Chekhov's opinion of critics I found in a book somewhere, cut it out, and have carried around in my wallet for years:

> "Critics are like gadflies which bother a horse as it ploughs. The horse is working away, all its muscles are taut as the strings of a bull-fiddle, but no, a gadfly has to alight on its croup and start tickling it and buzzing.

The poor horse has to twitch its skin, to switch its tail. What's the gadfly buzzing about? It's hardly likely the gadfly itself understands that. It's simply of a restless disposition and wants to make its presence known— 'There now, I too live upon this earth! There, you hear?—I can even buzz; I can buzz about everything!' I've been reading criticism of my stories for five and twenty years, yet can't remember a single hint of any value, haven't heard a single bit of sound advice. Only once was any impression made upon me—by Skabichevski: he wrote I would die under some fence, in a state of intoxication."

One late summer afternoon I was a guest at an outdoor party on the estate of a *noveau riche* couple. There I saw Isaac Bashevis Singer luxuriating in a hammock and enjoying nature. He looked up at me, his eyes as blue as the sky, and said, with a relaxed smile, "At a moment like this, how trivial seems a review in the *New York Times*."

Pasadena, California, February 5, 1977

Am pleasantly surprised by the Norton Simon Museum in Pasadena. Good examples of minor old masters. A fantastically skillful Tieopolo. A sensitive and living portrait of a child by Rembrandt. A good collection of nineteenth-century French paintings—Impressionists and post-Impressionists.

There's an alcove with paintings and sculpture by Degas. Seeing Degas brings to mind the forthcoming exhibition of his work at the Metropolitan Museum. I'm looking forward to it eagerly.

Los Angeles, February 11

Saw a huge, unusual show at the Los Angeles Museum—"Women Artists—1550-1950." The scope was impressive. The self-portrait of Sophonisba Anguisola and the compositions by Artemisia Gentileschi (what beautiful names) are good examples of sixteenth-century painting. There are characteristic works by Berthe Morisot, Mary Cassatt, Modersohn-Becker, paintings by Isabel Bishop and Alice Neel, a drawing by Käthe Kollwitz, a portrait by Frieda Kahlo Rivera of Diego Rivera and herself. Oh, yes—a beautiful still-life by Anne Vallayer-Costa, a painter I never knew of.

San Francisco, February 19

About a year ago a Russian woman, a museum curator, visited us with her husband. When I learned that her husband was a poet I showed

him a book of contemporary Russian poetry. He quickly leafed through the book, and said, half-humorously and half-regretfully: "It's a bad book, I'm not in it."

I am saying this apropos a historical survey of American drawings, from the colonial days to the present, at the Museum of the Legion of Honor. To my regret I am not included in this show, but, unlike my Russian poet, I consider it a good show. The great drawing, for me, in this exhibition is Eakins's large study in hard pencil for one of the scull rowers of his painting.

Phoenix, February 25

In the small but adequate Museum of Arts I found two old paintings of mine. One I had completely forgotten: an interior of my old studio in the Lincoln Arcade Building (since demolished to make way for the Julliard School, part of the glittering Lincoln Center complex). It's a small painting, of a wall and a sink and a sketchy figure of a nude woman stepping out from behind a screen. Probably a study for a larger painting that included myself at work. That was a discovery for me. The second one is of a young woman in a colorfully patterned dress, painted more recently.

New York, March 1

Yesterday, an extraordinary mild and sunny day for this time of the year, we returned to New York. I realize again how attached I am to this city, its streets teeming with people. This morning I went to the Metropolitan Museum to see the Degas show. My first reaction was keen disappointment. The exhibition consists only of the museum's own collection, paintings that I have been studying for many years, and that, in time, I have come to know almost as intimately as my own paintings. I had expected a comprehensive show including works from other museums from here and abroad, and from private collections, too. Surely such an exhibition will take place eventually. But when? Will I be here to see it?

All his sculpture, however, was shown, and that was quite exciting. Most certainly, Degas and Rodin were the great nineteenth-century sculptors. The paintings were cleaned and revarnished, increasing my pleasure in them.

March 4

Saw the Degas show again. This museum is indeed rich in Degas—the "Woman with the Chrysanthemums," the "Portrait of Tissot," the little masterpiece called "Bouderie," the pastel and the oil painting of "Dancers' Rehearsal," the several magnificent pastels of nudes, and the pastel of the violinist and the dancer, so loved by my brother Moses Soyer, and many more.

Added to these I would have been thrilled to see several paintings from the Chester Dale Collection in Washington: the beautifully restrained "Mlle. Malot," the portrait of "M. and Mme. Morbilli," so tentative and intriguing, the late large canvas of "Four Dancers" (large for Degas), the Boston Museum's painting of Degas's father listening to the guitarist Pagans, the Chicago painting of the young woman surrounded by hats on hat stands, some paintings and pastels from private collections like the two variations of the Manté Family pastels, the extraordinary pastel called "The Tub" in which the nude is bending over completely double, her head below her knees grasping a sponge in a round tub. I looked forward to seeing "Le Viol" which Degas called "my genre painting." That is the painting to which Theodore Reff, who arranged this exhibition, dedicated a whole chapter in his book, *Degas, the Artist's Mind.* And, of course, the Jeu de Paume paintings: the small head of a young woman (as fine as Vermeer's Girl with a Turban, plus the additional element of Degas's psychological insight) "L'Absinthe" and "Les Rapasseuses."

It would have been good to see some of his early paintings, like the "Spartan Girls Teasing the Boys." Also the portraits of Duranty and Diego Martelli, which are somewhere in Europe.

About two months ago, before we left for the West Coast, the painter Lennart Anderson and I were talking about Degas in anticipation of this exhibition. He too, is a Degas enthusiast. Fervently, he said: "I hope they'll show some late Degas, his late pastels."

"The desperate ones?" I asked, "Yes, yes, yes," he exclaimed, the desperate ones."

We had in mind the great tragic pastels of the late 1890s and early 1900s when Degas was almost blind. Several of these pastels and drawings by Degas of nude women strangely recall to my mind the Randannini Pietà—the last pietà by Michaelangelo—late works by two aged geniuses.

There seems to be a revived interest in Degas in this country.

Several years ago there was an exhibition of his work in the Boston Museum. Now there is this exhibition at the Metropolitan Museum, and books about him have been published in recent years: *Portraits by Degas* by Jean Sutherland Boggs; *Degas Pastels* by Alfred Werner, *Complete Etchings, Lithographs, Monotypes by Degas* by Jean Adhemar and Francoise Cachin, with foreword by John Rewald; *Degas, the Artist's Mind* by Theodore Reff, and *Sketchbooks by Degas* also by Theodore Reff. There is a book just out, *The Sculpture of Edgar Degas* by Charles Millard.

Yet, in the 1920s, even in the 1930s, Degas was seldom mentioned in this country. Everything was Cézanne. Even my classmates in the Academy School painted apples on tilted tables, men playing cards, peasant-like women against flowered draperies.

It may have been after Ben Shahn and I left the Academy Art School and began painting on our own that we once stood in front of the painting that is now hanging in the Metropolitan Museum show, "Dancers, Pink and Green." Ben Shahn tried to convince me of Cézanne's superiority over Degas saying: "Degas rubs me the wrong way. I don't like his color, his technique, even his brush strokes."

Manet, Renoir, Cézanne, Monet, after the usual initial rejection of anything new, were soon accepted in the art world of this country. Painters like Glackens, Henri, George Luks were influenced by them. Monet's influence was particularly strong. Glackens at first painted like Manet and later like Renoir. Even academicians fell under the spell of Renoir. There were "Renoirs" all over the place. But no Degas! (I recall one exception, a poor copy of a Degas by the illustrator, Everett Shinn.)

Generally speaking, Degas had no influence on American art. I believe I understand why. There is nothing flamboyant, sparkling, bright, superficially impressive or attractive in his work. It is severe, private, nonspectacular. Although he exhibited, he shunned publicity and rejected the questionable, artificial fame created by the power of the press.

What would Degas say today about all the media and techniques that create fleeting reputations in our outrageous art world?

Pimen: "Yeshcho odno posledneye skazanye i letopis okoncheno moya . . ."
Pimen: "One more tale and my history is ended . . .

from *Boris Godenov*
A.S. Pushkin

Washington, May 23

"You know," I said to my young editor, "if the Thomas Eakins exhibition to which I am invited tonight will inspire me, I may want to write about it. Don't you think it would be fitting to end this diary of an artist with an entry on Thomas Eakins?"

She agreed.

To my pleasant astonishment there was my large painting. "Homage to Thomas Eakins" at the entrance leading to the exhibition of the Hirshhorn Museum's Thomas Eakins Collection.

I like such exhibitions. There were only several of his great portraits, the greatest of them, that of his wife, Susan Hannah Macdowell; early paintings and many studies for paintings; drawings, sculpture, photographs by him and of him; also letters and other memorabilia. All this made me feel almost in living contact with the man himself, his milieu, his habits, his daily routine.

No matter how often I look at this portrait of Eakins's middle-aged wife, it never fails to make me wonder how he was able to put so much in a face. It is so penetrating. It not only pictures her features, but also reveals her state of mind. The way her eyes are painted gets me— the irises, the pupils, the red-rimmed eyelids, the highlights in the pupils. All this naturalism, however, is miraculously transcended.

Eakins was the least ingratiating of artists. In a sense, he was the least esthetic. The blood on the hand of Dr. Gross is not the blood so harmoniously blended in Delacroix's battle scenes. It is real blood, sticky, thick.

May 24

Attended talks by Lloyd Goodrich and Evan Turner on Thomas Eakins. They showed slides. Both speakers were informative and warm in their appreciation of Eakins, the man and the painter. The slides were at times breathtakingly beautiful, but I couldn't help thinking, deceptive, for they are transparent, lit up from within, whereas the original paintings are not luminous. They have an opaque quality of their own.

It was Turner who pointed out that Eakins was not appreciated in

his lifetime. He mentioned contemporaries of Eakins who were praised and constantly placed before the public eye: Sargent, of course, Chase, and the now completely forgotten Celia Beaux.

I did not attend the afternoon session of this symposium but took a plane back to New York, went to my studio, and examined closely my own paintings.

Index

307

314

Composed in Garamond and Bembo by New Republic Books, Washington, D.C.

Printed on seventy-pound Mohawk Vellum by the John D. Lucas Printing Company, Baltimore, Maryland.

Bound in Holliston Kingston by The Delmar Company, North Carolina.

Designed by Gerard Valerio, Bookmark Studio, Annapolis, Maryland.